NEW SMALL SPACES

Edited by Francesc Zamora Mola

COLLINS DESIGN

An Imprint of HarperCollins Publishers

HarperCollins books may be purchased for educational, business, or sales promotional use.
For information, please write: Special Markets Department, HarperCollinsPublishers,
10 East 53rd Street, New York, NY 10022

English language edition first published in 2008 by:
Collins Design
An Imprint of HarperCollinsPublishers
10 East 53rd Street
New York, NY 10022
Tel.: (212) 207-7000
Fax: (212) 207-7654
collinsdesign@harpercollins.com
www.harpercollins.com

Distributed throughout the world by:
HarperCollinsPublishers
10 East 53rd Street
New York, NY 10022
Fax: (212) 207-7654

First edition published in 2008 by:
Loft Publications
Via Laietana, 32
08003 Barcelona. Spain

www.loftpublications.com

Executive editor:
Paco Asensio

Editorial coordination & text:
Francesc Zamora Mola

Art director:
Mireia Casanovas Soley

Graphic design and layout:
María Eugenia Castell Carballo

Cover photo: © Teun van des Dries
Back cover photos: © Alchemy Architects
 © Matteo Piazza

Library of Congress Cataloging-in-Publication Data

 New small spaces : good ideas / edited by Francesc Zamora Mola. – 1st ed.
 p. cm.
 ISBN 978-0-06-114985-6
 1. Interior architecture. 2. Space (Architecture) 3. Dwellings–Remodeling. I. Mola, Francesc Zamora.

NA7125.N486 2008
729–dc22
2008026574

Printed in Spain

First printing, 2008

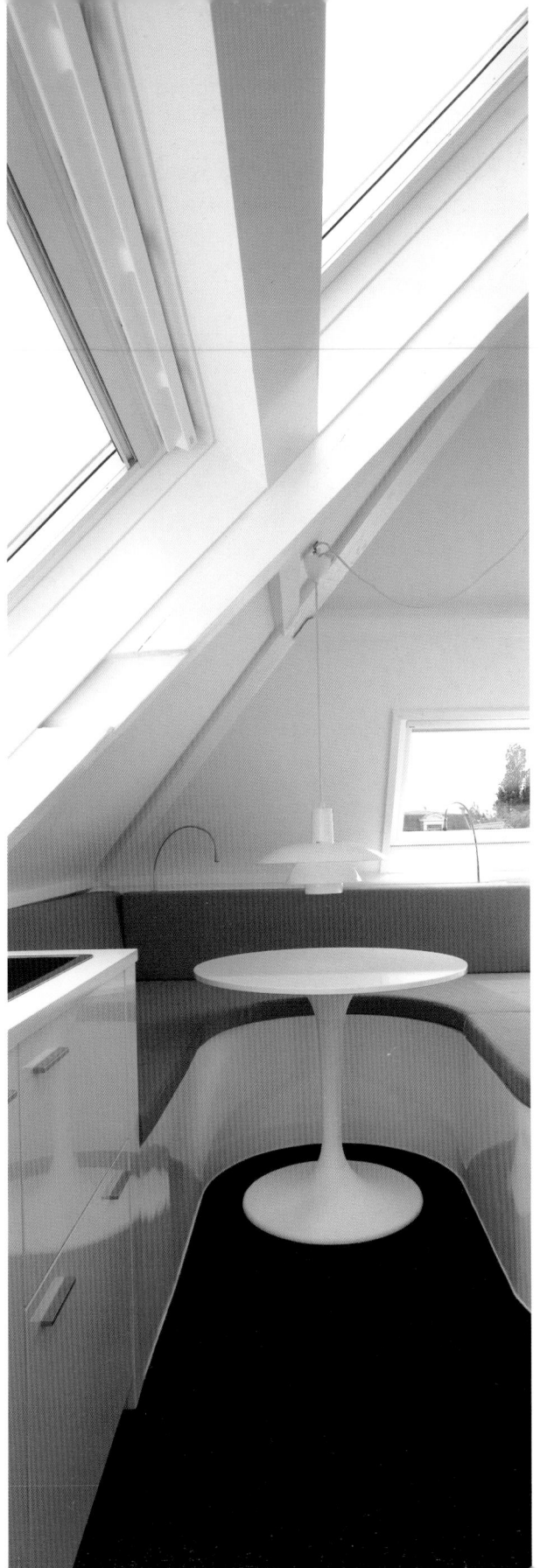

Contents

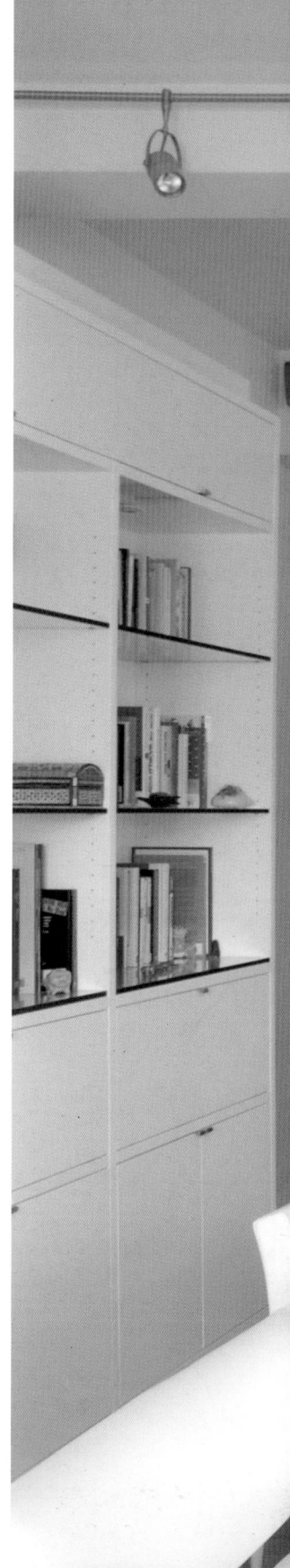

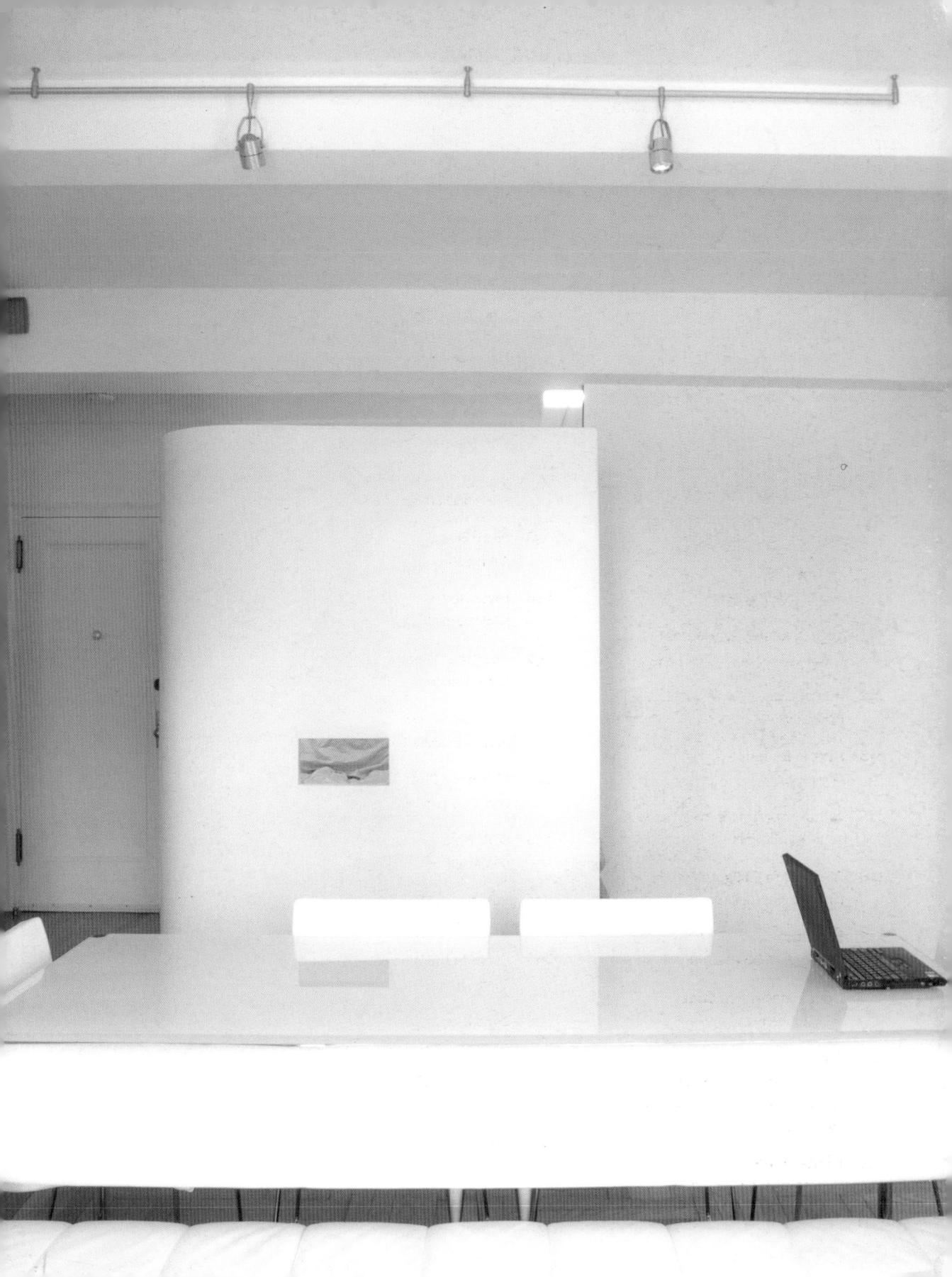

Introduction

The concept of small spaces is not merely about small scale; rather, it involves a much more complex process of evaluating the limitations which can be spatial, economic, or environmental, and developing appropriate responses to them.

A motivation that may lead dwellers to move into smaller homes is the desire to simplify their lifestyles or the concern for social and environmental issues. In fact, small spaces require less energy, less building resources and create less strain on the environment. Such concerns have brought architect and artist Sami Rintala to design the "Boxhome 2007": a compact house with a mere 205 square feet that incorporates all the functions of a common home.

For designers, planning a small space requires confronting the challenge of finding creative solutions that don't sacrifice commodity and aesthetics. These spaces pay meticulous attention to light, energy, functionality and proportion. The projects included in the book are examples of the remarkable possibilities in small space living: one key element in the design of reduced spaces is flexibility. Often these structures appeal for their multipurpose characteristics such as a combination guest house/yoga studio, or an art atelier/living space. Designers strive to create spaces that people can adapt to suit their needs.

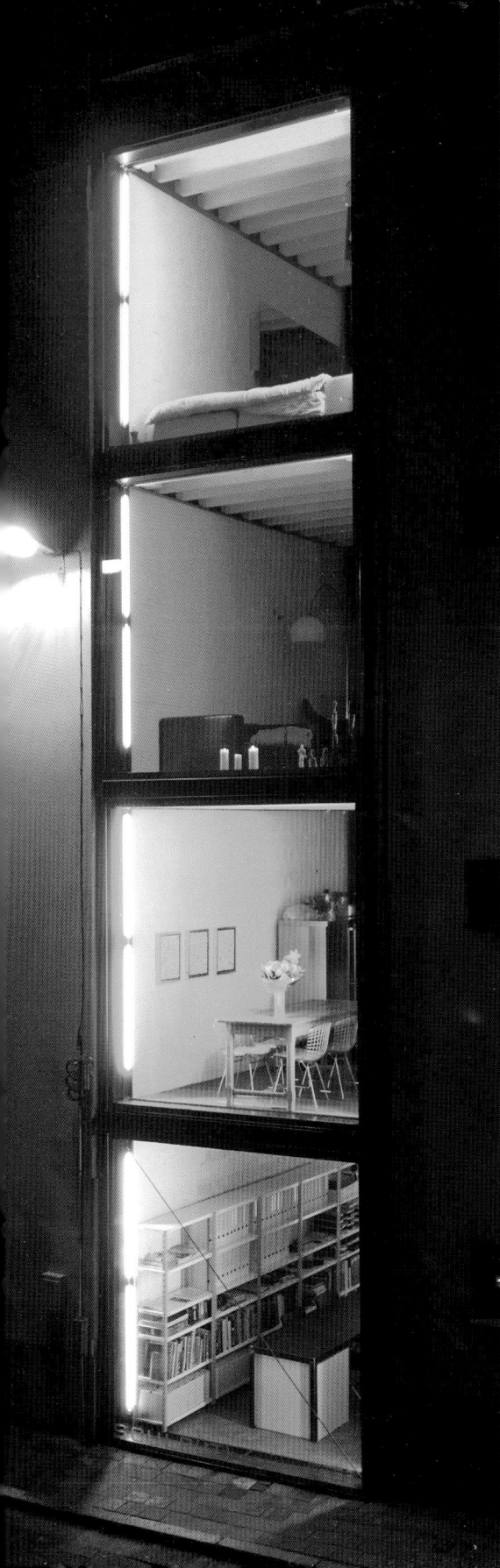

Dwellings can be partioned with a push on a sliding panel to close up a sleeping area or open up a space to accommodate a bigger than usual group of people. Circulation areas such as hallways and stairwells are minimized while allowing for more unusable space or, in some cases, for an increase of the much needed storage space. All the solutions aim to optimize the use of the space available.

This book offers a selection of projects in which usable area does not exceed 900 square feet.

These projects are examples that show that the concept of small spaces is not limited to the urban environment.

Casa Paludo, Attic in Donosti, Mini Loft, Z-Box, Bavaria Road Loft, Apartment K, Softbox Apartment, Maff Apartment or DT Loft are representative of the limitations often presented in dense urban cores. Cabin in the Woods, Watershed, House R or Concrete House contemplate the habitat in a natural environment.

These constructions illustrate how impact is minimized by reducing size and using materials that facilitate the integration of these structures in the site. Finally, miniHome, Drop House, mkLotus, iPad and ONV House are homes designed to be easy to assemble structures and often appeal for their mobility.

Watershed

100 sq. ft.

The owner of Watershed is a writer and her first request was for a roof that would let her hear rain falling. The site is a small piece of land in the Willamette Valley along the Marys River. The design of the studio made it easier to shop fabricate the different parts offsite, then bring them in for assembly. The first stage of construction was the site-poured foundation piers that are cast to spread the weight of the building on the ground and to drain water away from the steel frame. The second stage, the steel frame, was shop fabricated and dropped in a single piece onto the piers. Dado-grooved cedar 2x6 boards are bolted to the frame and the final tongue-and-groove cedar and glass enclosures are inserted in these grooves. The studio can be taken apart as easily as it was built and can be reused or recycled.

Architect: FLOAT Architectural Research and Design

Location: Oregon, U.S.

Completion date: 2007

Photographer: © Gary Tarleton

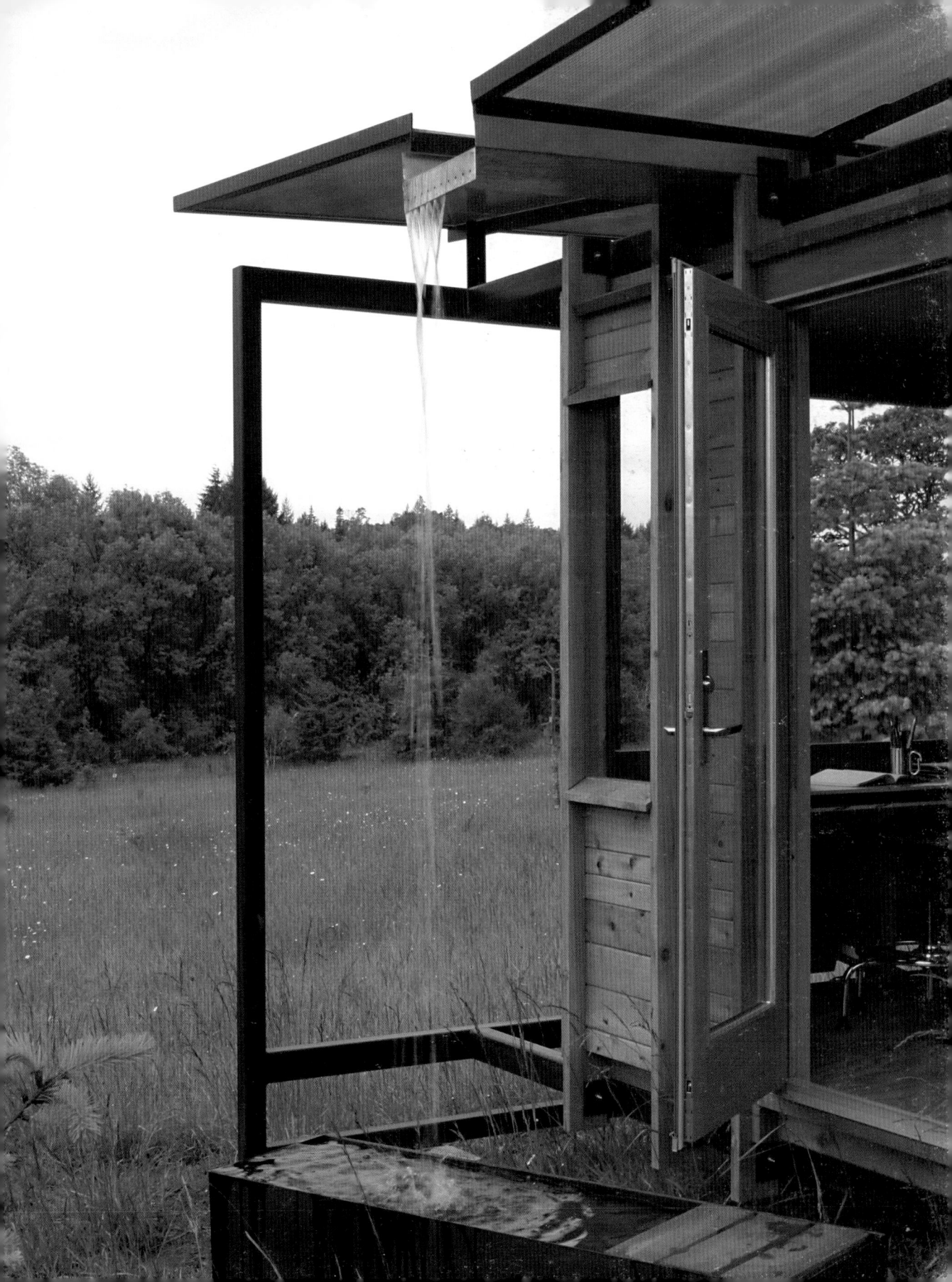

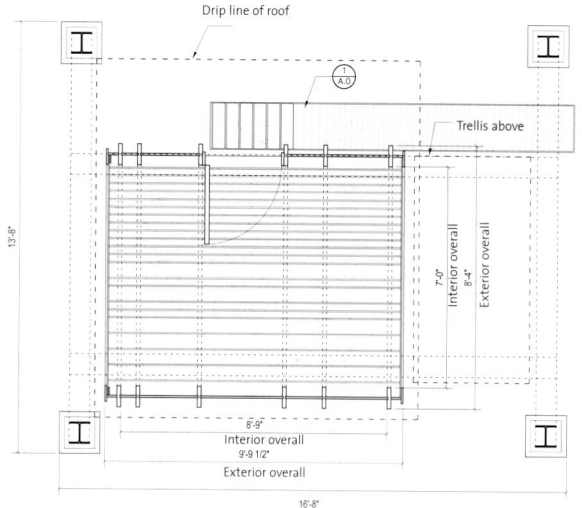

Drip line of roof

A.0

Trellis above

13'-8"

7'-0"
Interior overall 8'-4"
Exterior overall

8'-9"
Interior overall
9'-9 1/2"
Exterior overall

16'-8"

Floor Plan

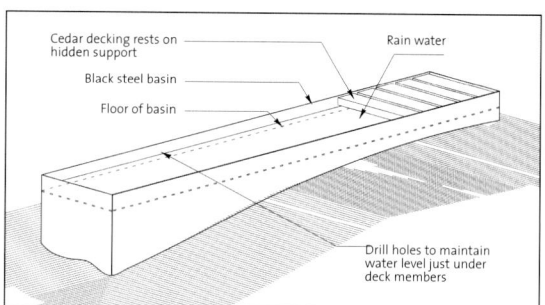

Cedar decking rests on hidden support

Rain water

Black steel basin

Floor of basin

Drill holes to maintain water level just under deck members

Entry step and reflecting pool

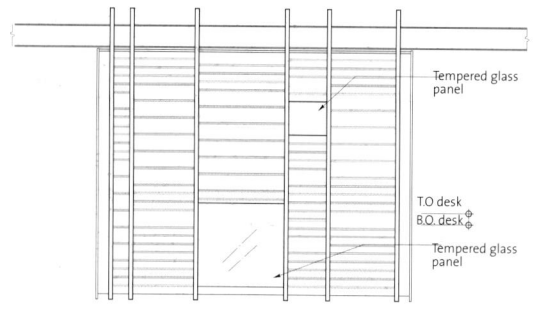

Tempered glass panel

T.O desk
B.O. desk

Tempered glass panel

West Elevation

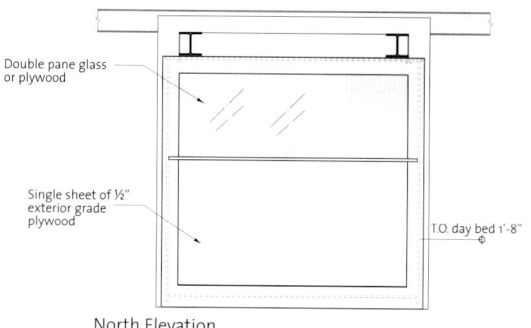

Double pane glass or plywood

Single sheet of ½" exterior grade plywood

T.O. day bed 1'-8"

North Elevation

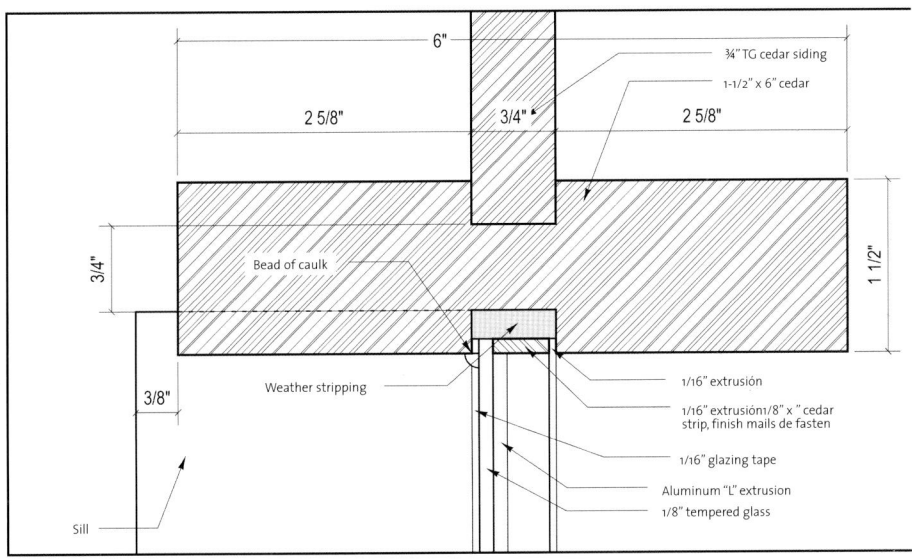

Plan at Window Jamb

¾" TG cedar siding

1-1/2" x 6" cedar

6"

2 5/8"

¾"

2 5/8"

1 1/2"

3/4"

Bead of caulk

3/8"

Weather stripping

1/16" extrusión

1/16" extrusión1/8" x " cedar strip, finish mails de fasten

1/16" glazing tape

Aluminum "L" extrusion

1/8" tempered glass

Sill

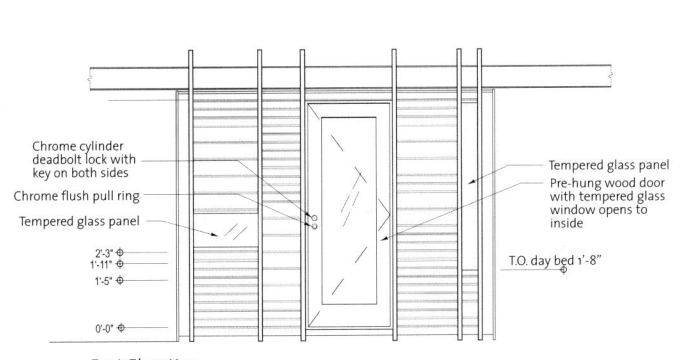

East Elevation

Chrome cylinder deadbolt lock with key on both sides

Chrome flush pull ring

Tempered glass panel

Tempered glass panel

Pre-hung wood door with tempered glass window opens to inside

T.O. day bed 1'-8"

2'-3"

1'-11"

1'-5"

0'-0"

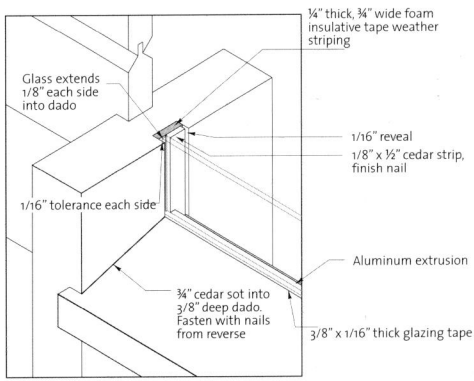

Detail Axonometric View at Window

¼" thick, ¾" wide foam insulative tape weather striping

Glass extends 1/8" each side into dado

1/16" reveal

1/8" x ½" cedar strip, finish nail

1/16" tolerance each side

Aluminum extrusion

¾" cedar sot into 3/8" deep dado. Fasten with nails from reverse

3/8" x 1/16" thick glazing tape

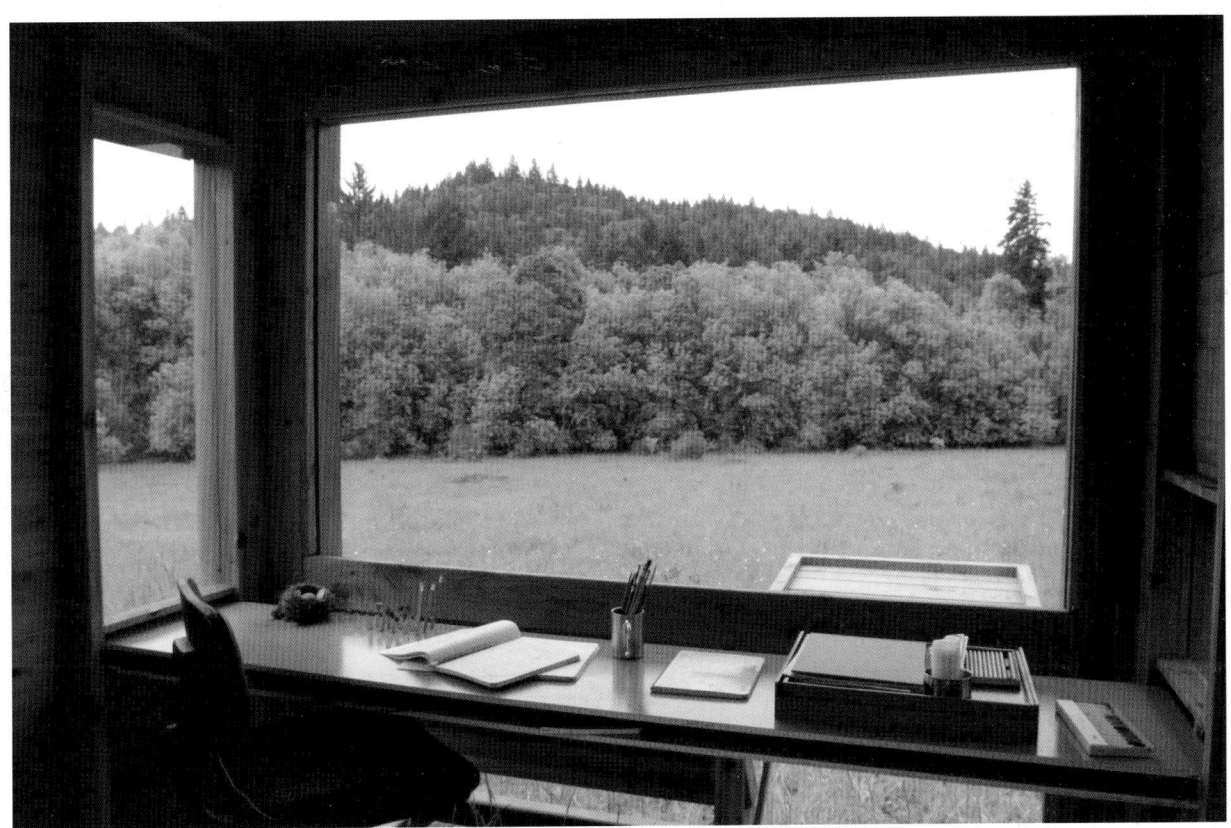

Wide windows looking out across a broad, green meadow are merely the most obvious of many devices designed to reveal the ecological complexity of the site. The water collection basin that doubles as the front stoop attracts birds and deer. Rare reptiles and amphibians are drawn by small tunnels under the studio, and viewed through a floor level window.

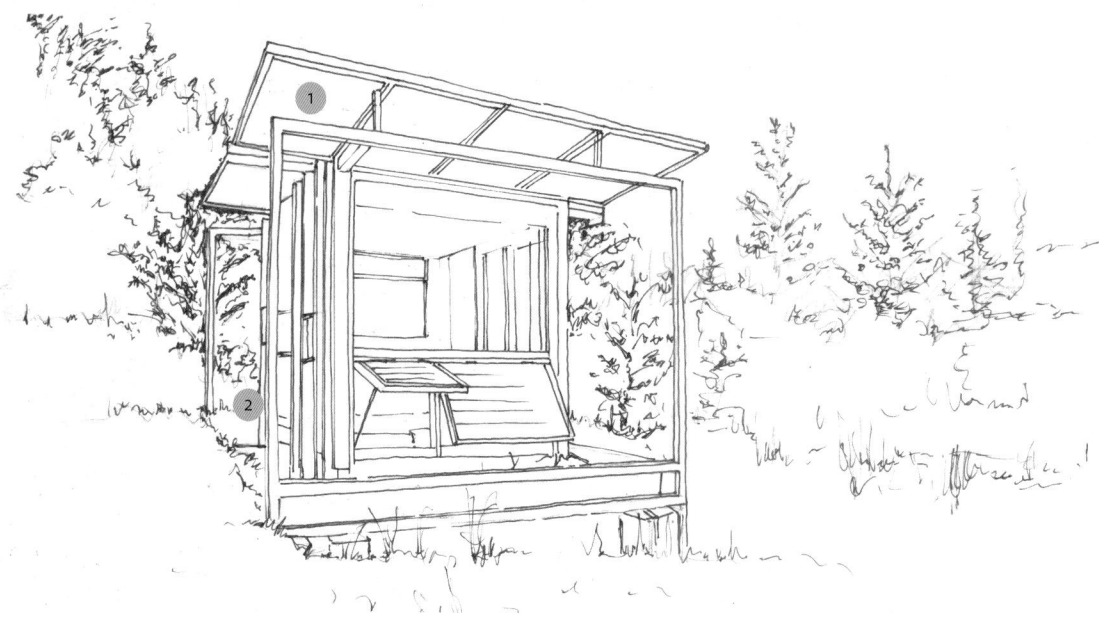

1_ A very wide and deep overhang shades the large windows that give directly onto the writing desk, keeping it shaded throughout the day while still providing uninterrupted views of the meadow. Without shading the desk would be unusable.

2_ The necessity of building a structure that could be prefabricated in a shop, as well as easily disassembled, led naturally to a design that comes in pieces. These pieces read clearly in the composition: steel frame, roof, wood box, concrete piers.

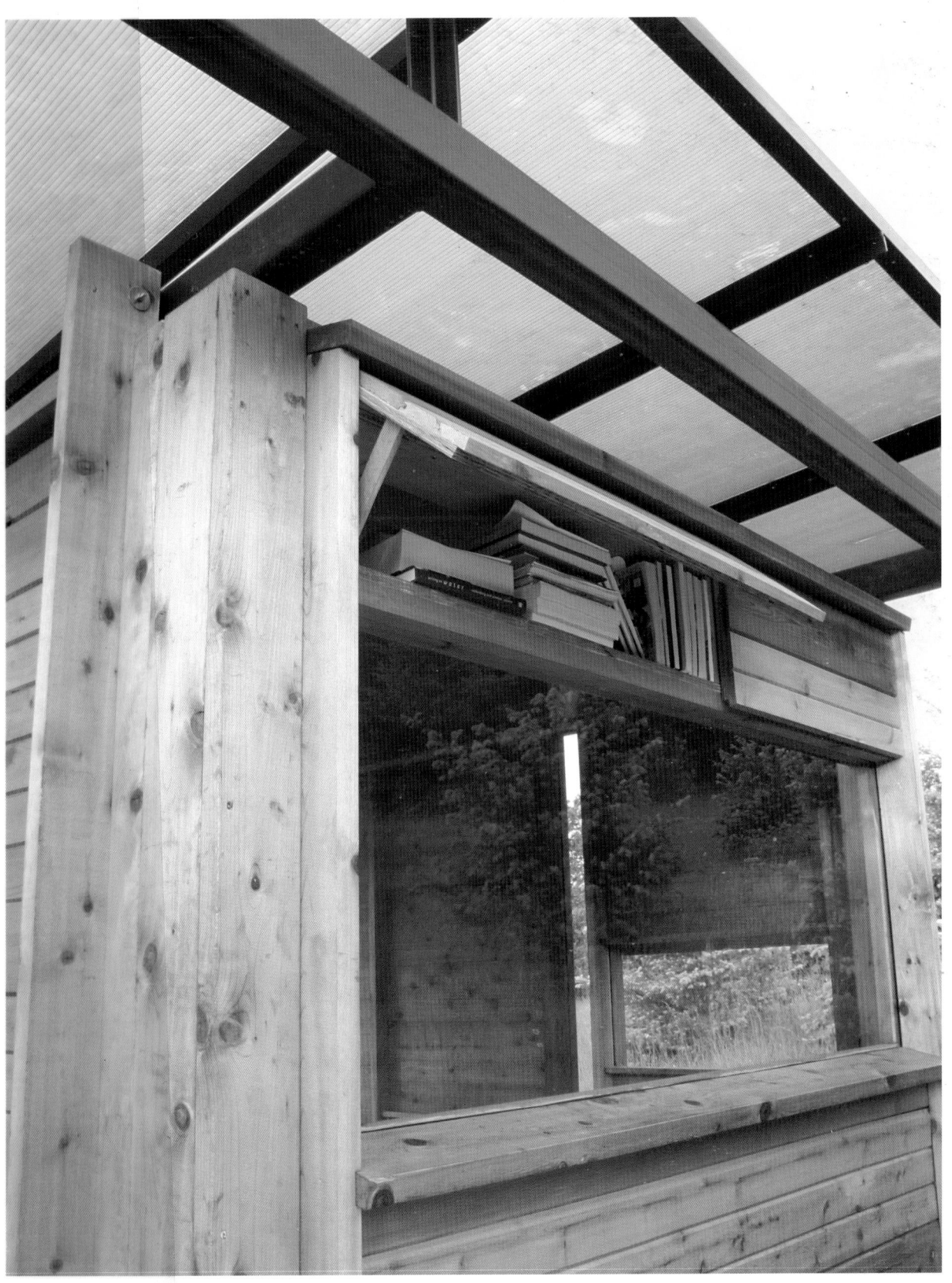

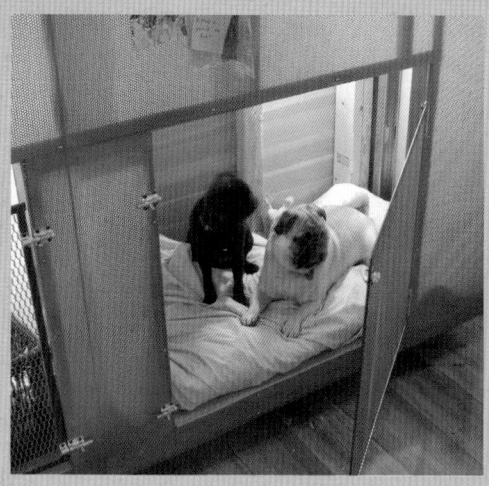

Z-BOX

144 sq. ft.

The intervention takes place inside a light-flooded 1,500-square-foot loft space in Massachusetts. The project required the incorporation of functions the occupants were lacking in spite of the size of the existing space. The concept consisted of the insertion of a box within the existing shell. Based on the needs of his clients, the designer Dan Hisel created a multifunctional 12-foot-square by 10-foot-high cube.

This artful cube was conceived to contain a sleeping area, shelves and storage space, a full-length closet along one side and a pen for the two pug companions. It was strategically located to separate the living and dining area from the painting studio at the southwest end of the loft.

By concentrating as many utilities as possible within the new structure, the rest of the space is left to be enjoyed.

Architect: Dan Hisel Design

Location: Lynn, Massachusetts, U.S.

Completion date: 2006

Photographer: © Peter Vanderwaker

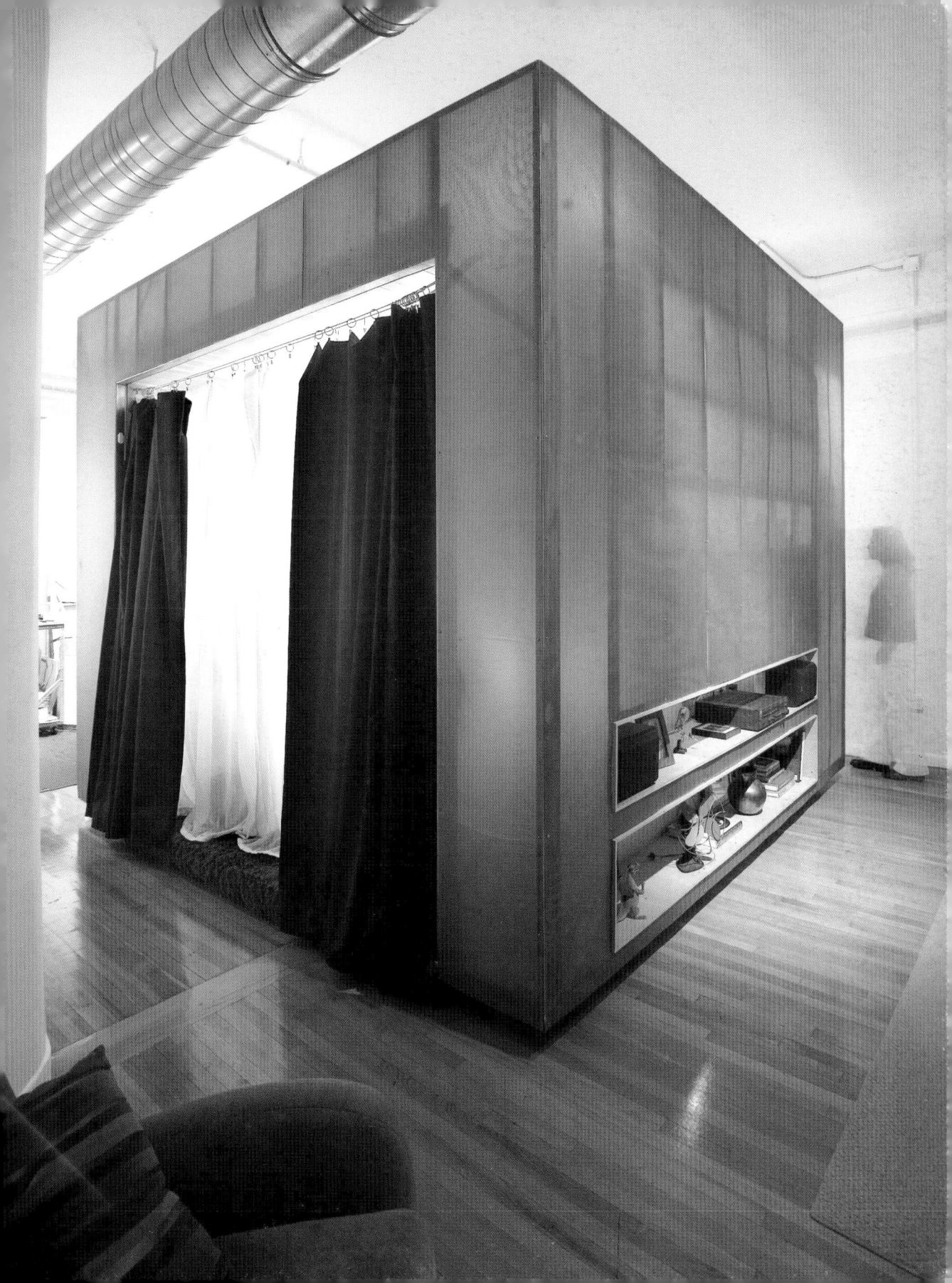

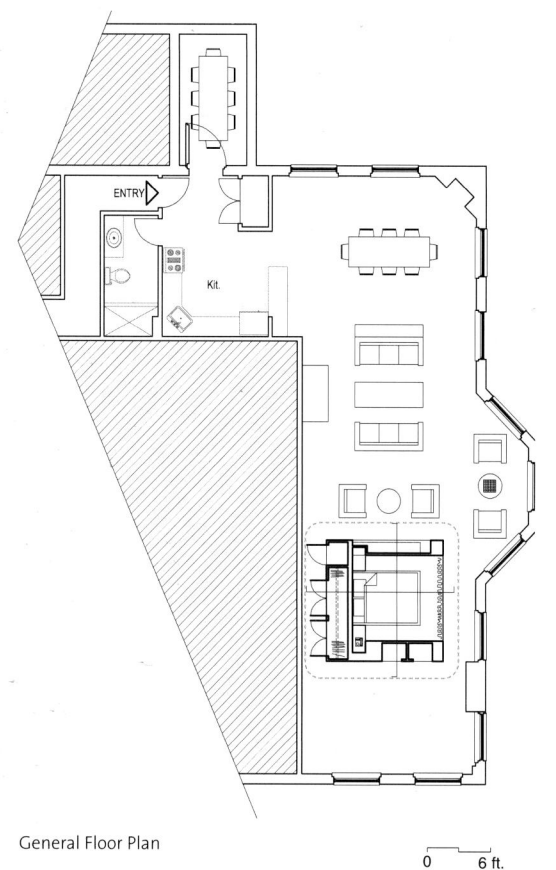

General Floor Plan

0 6 ft.

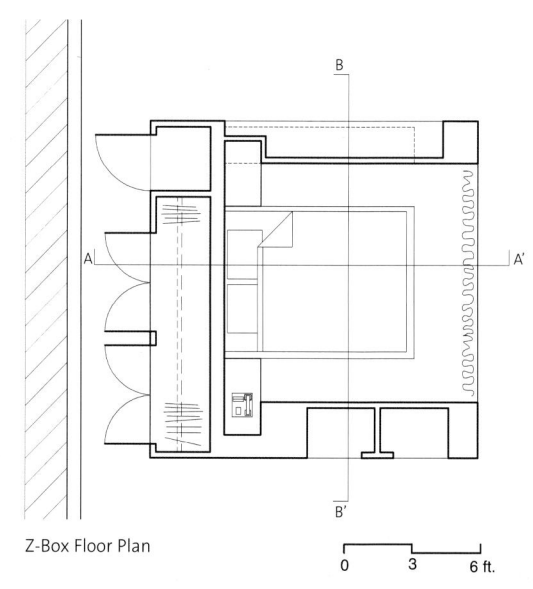

Z-Box Floor Plan

0 3 6 ft.

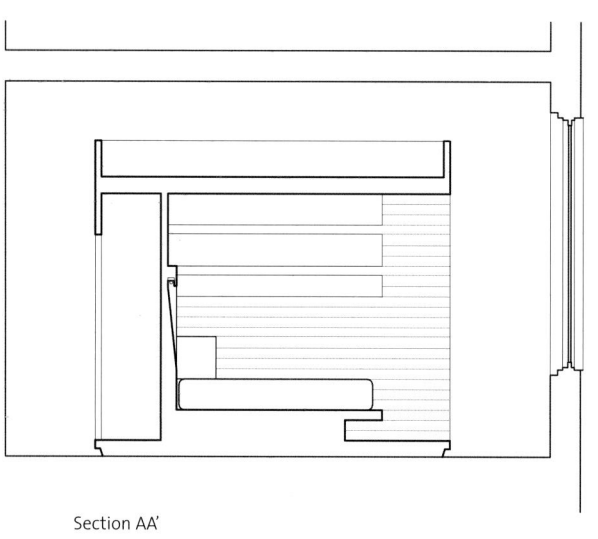

Section AA'

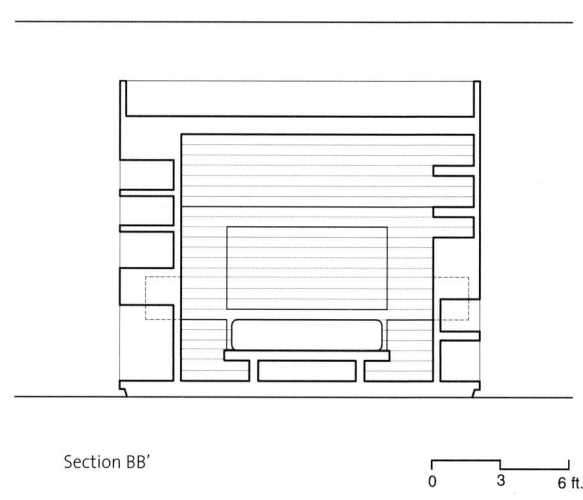

Section BB'

0 3 6 ft.

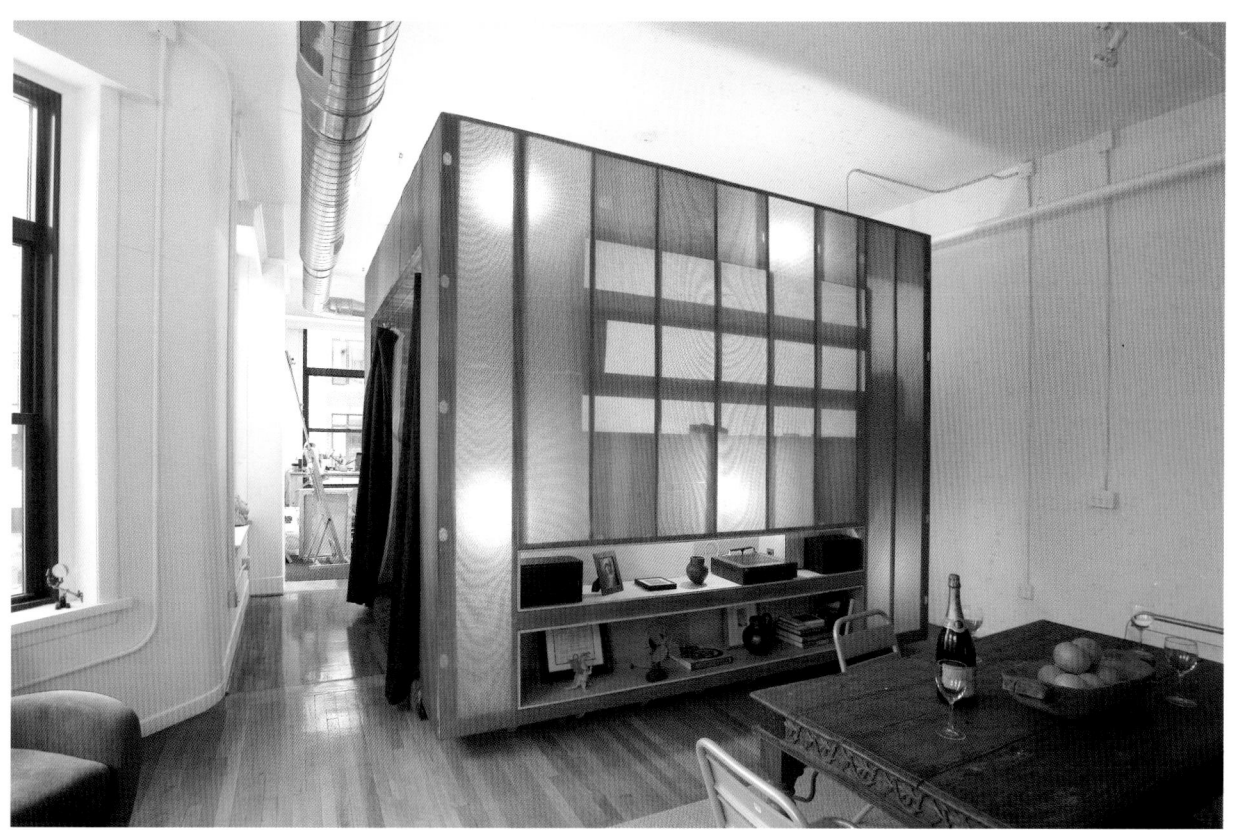

The free-standing cube acts as an organizer of the space dividing the different functions that take place in the loft.

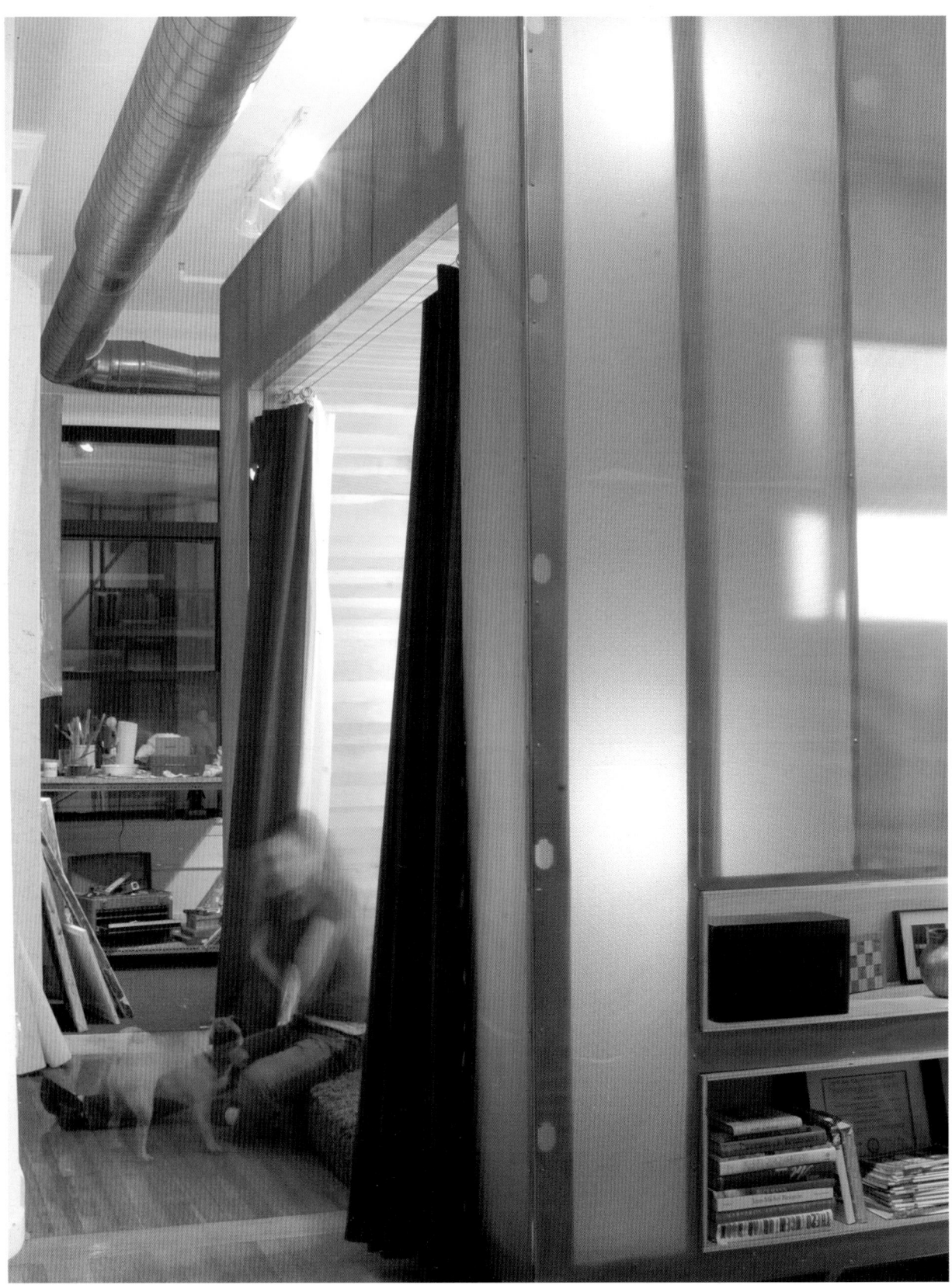

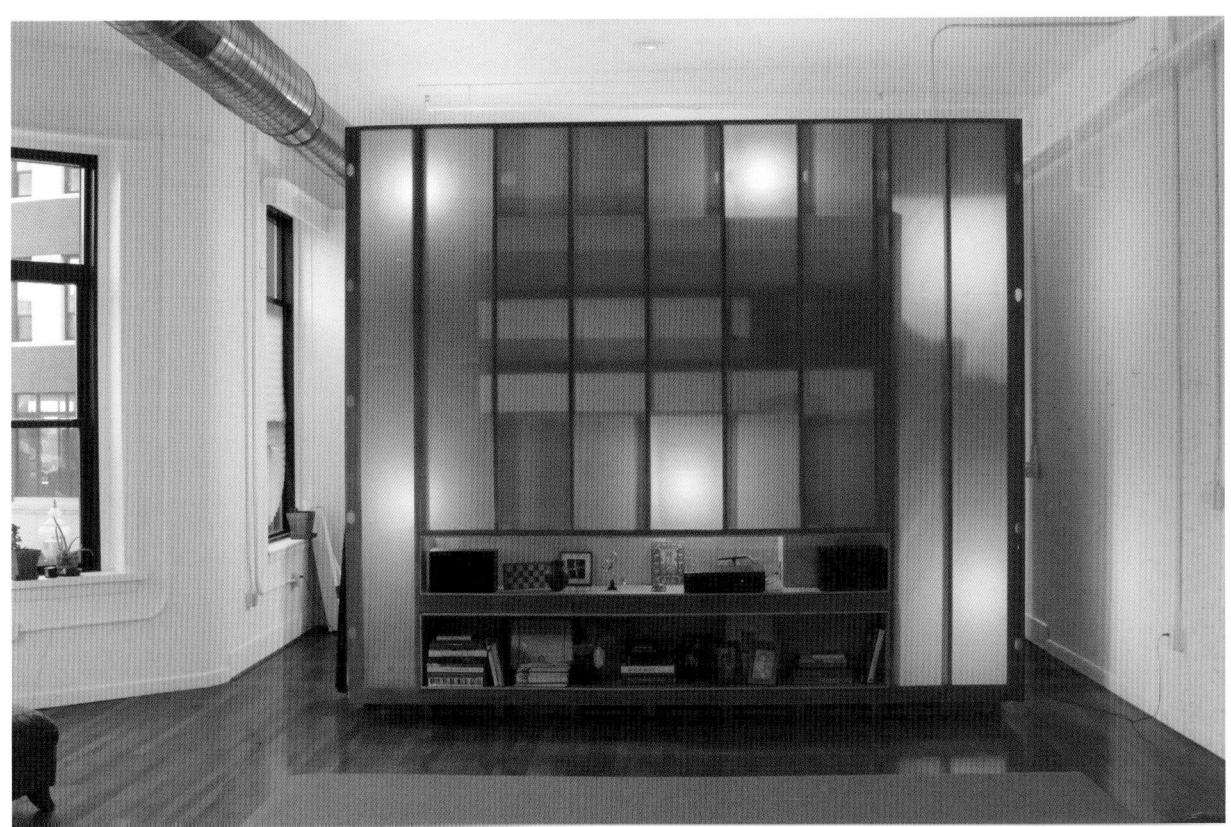

From the outside, the cube appears as an art installation made of fir. Its translucent skin, made of polycarbonate sandwiched between the wood and perforated steel, glows when the lights inside are turned on.

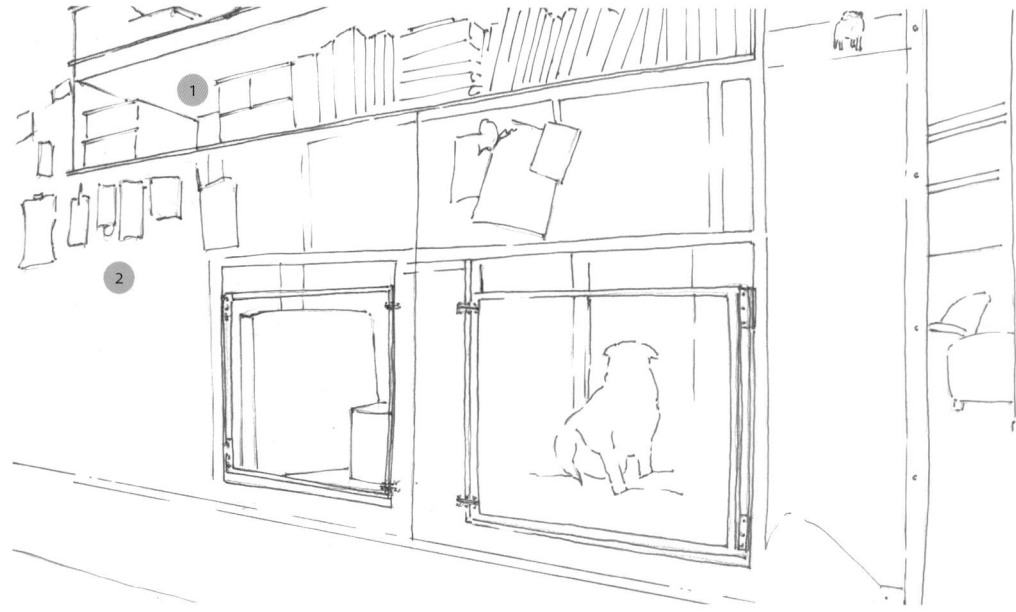

1_ The cube incorporates bookshelves both on the outside and on the interior, above the bed.

2_ The metallic exterior skin contrasts with the warmth that is emitted from the fir-clad interior. Compositionally, the cube presents a series of surfaces used as pin-up boards and openings for storage, including shelter for two pugs.

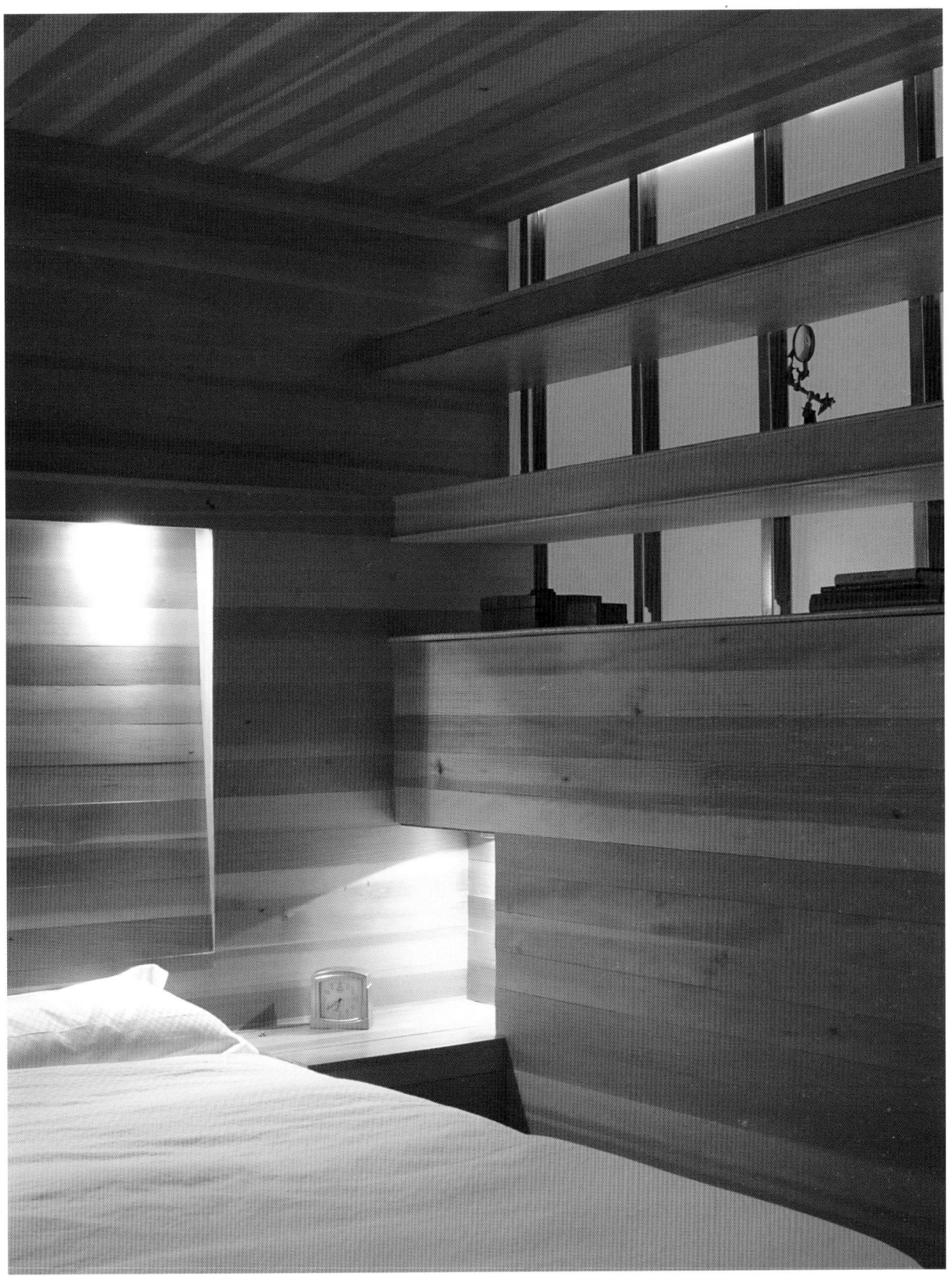

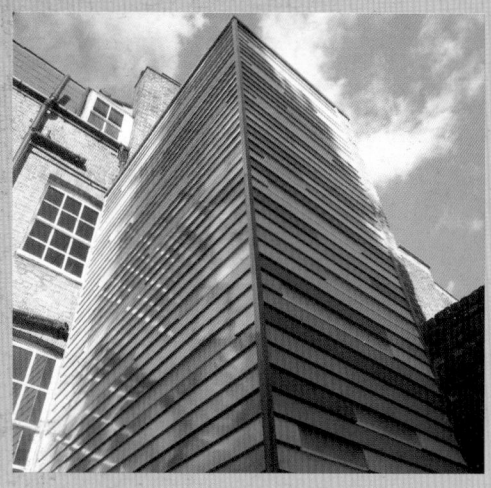

Shouldham Street Extension

161 sq. ft.

The motivation for this extension was generated by the idea to restore the original layout of a Georgian townhouse in central London. The house, a typical example of a defined typology, needed to be preserved as is. Also, the "Society for Protection of Ancient Buildings" recommended that the remodel should be easily reversible to restore the house to its original configuration. This simple and at the same time stunning project is proof of how obstacles can be seen as opportunities when dealing with projects in historically sensitive areas. The extension incorporates two bathrooms and a toilet that does double duty as a utility room. These rooms are not habitable and therefore requirements for operable windows for light and ventilation do not apply. This allowed for an opportunity to experiment on the treatment of the shell of the extension.

Architect: Henning Stummel Architects

Location: London, U.K.

Completion date: 2003

Photographer: © Luke Caulfield

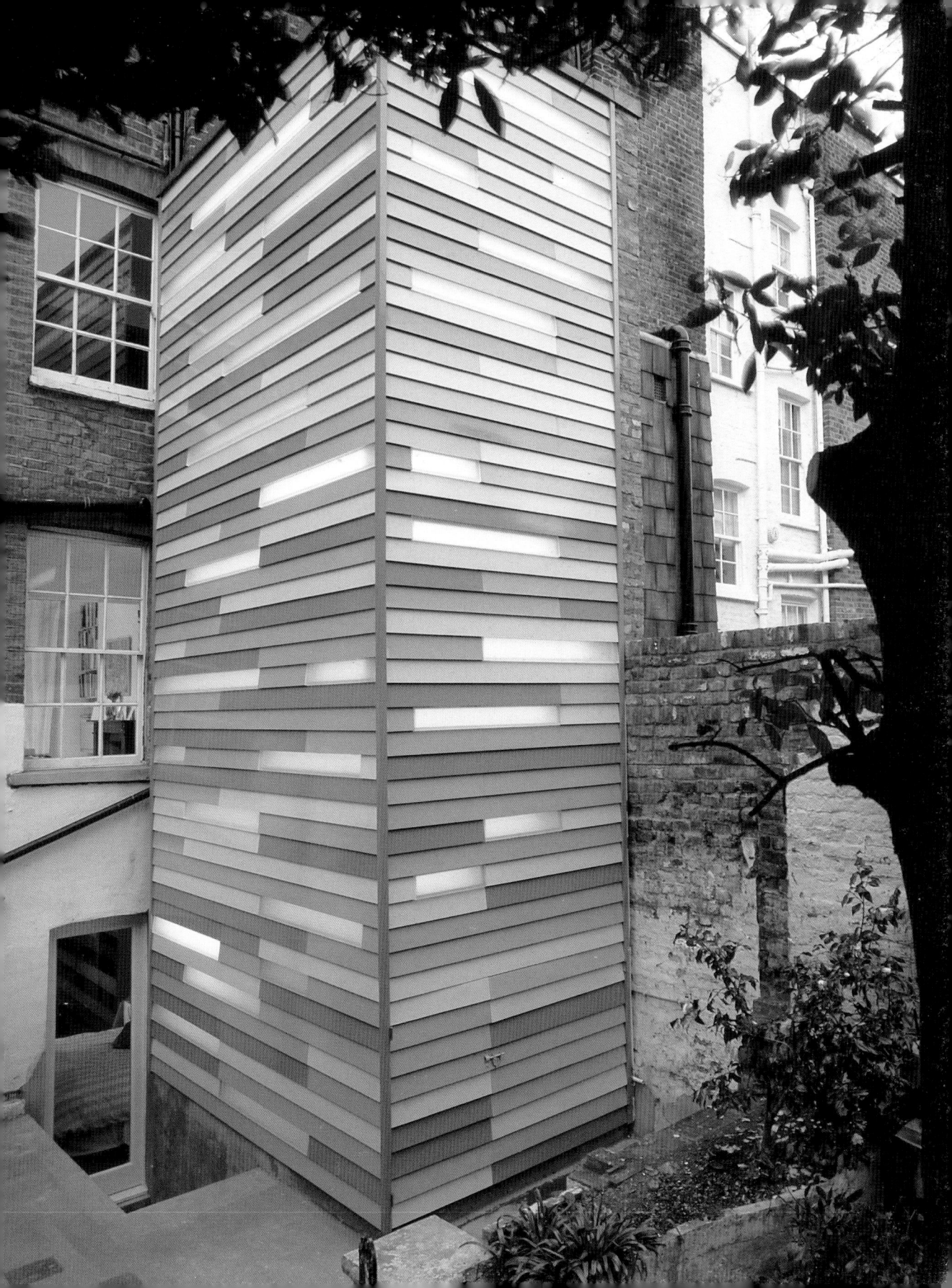

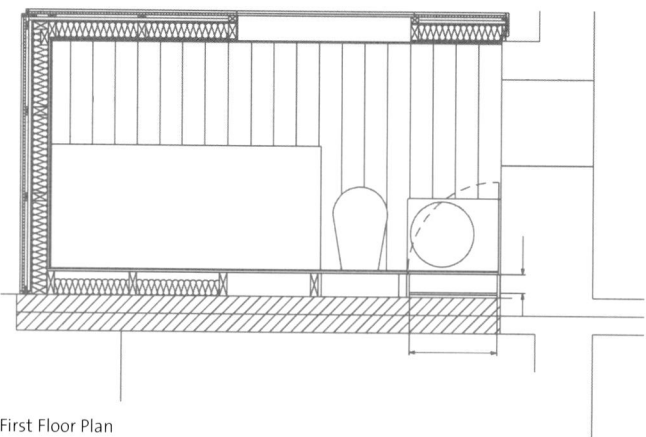

First Floor Plan

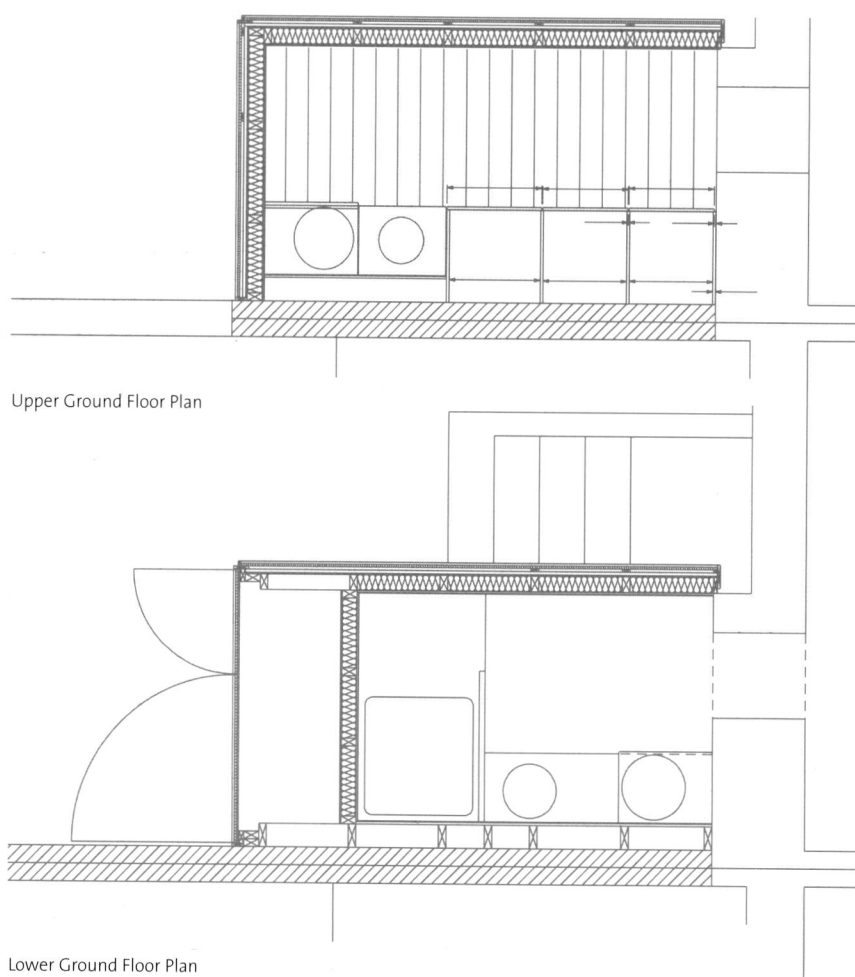

Upper Ground Floor Plan

Lower Ground Floor Plan

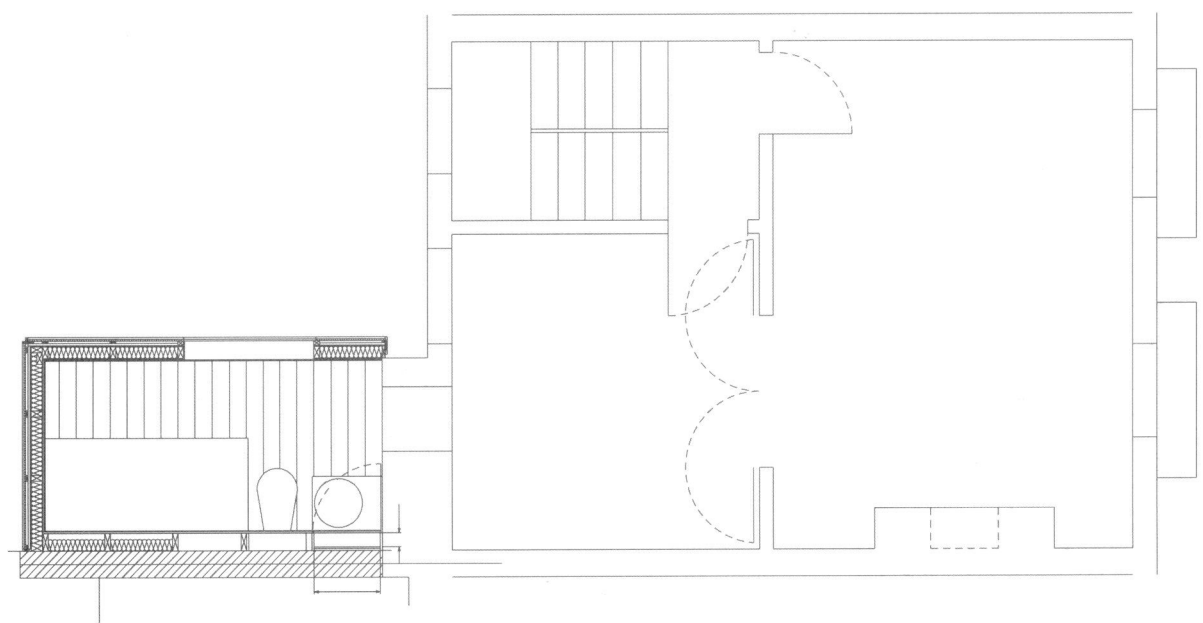

Typical Floor Plan

Side Elevation

Section

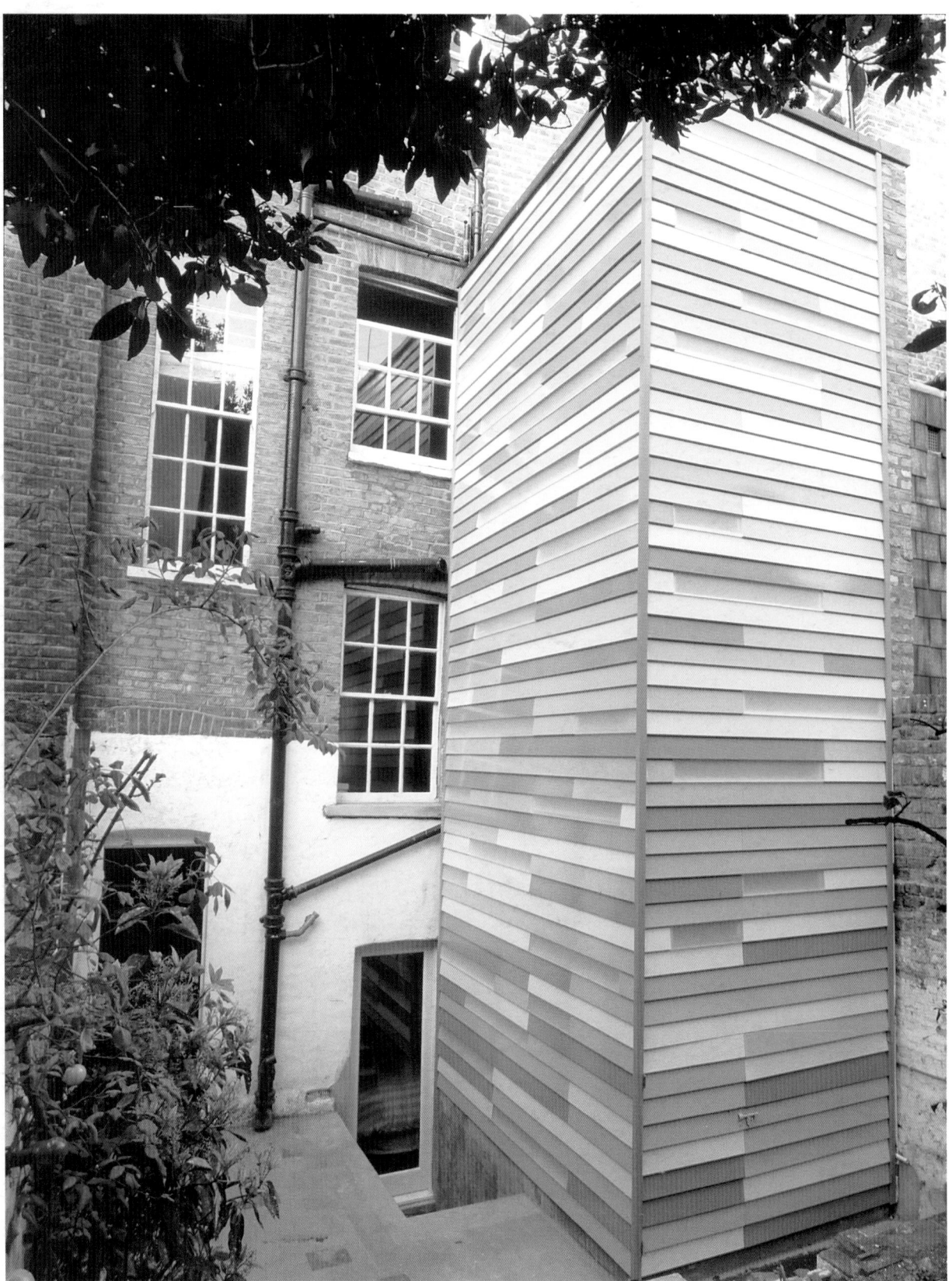

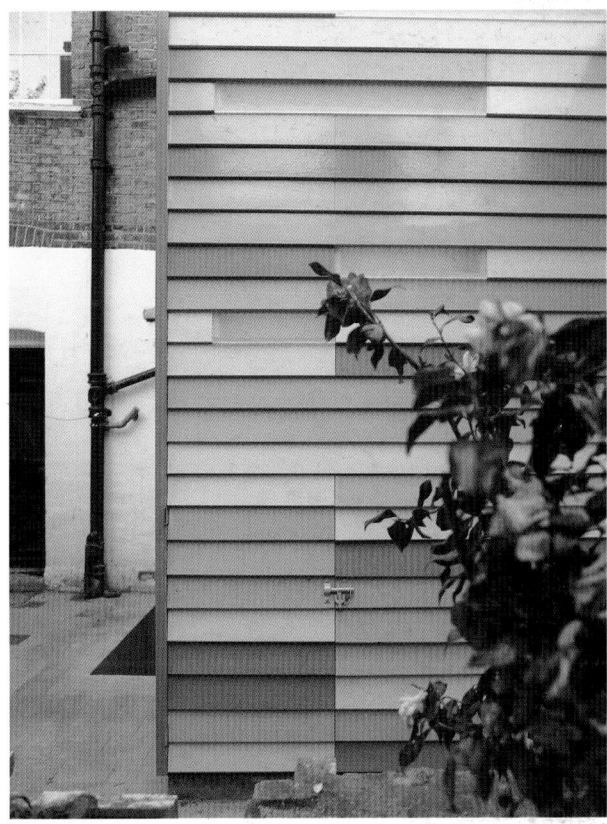

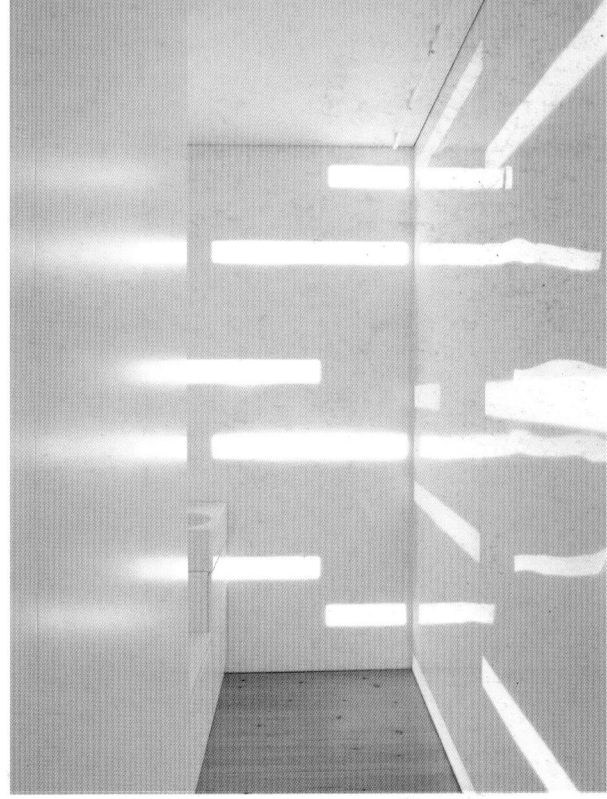

In the interior the walls are gloss white while the exterior is finished in lap wood ship siding painted in various shades of gray. Interspersed are sanded Plexiglas planks that take the place of random siding boards to create a pattern of horizontal strip windows, creating a vibrant interior space.

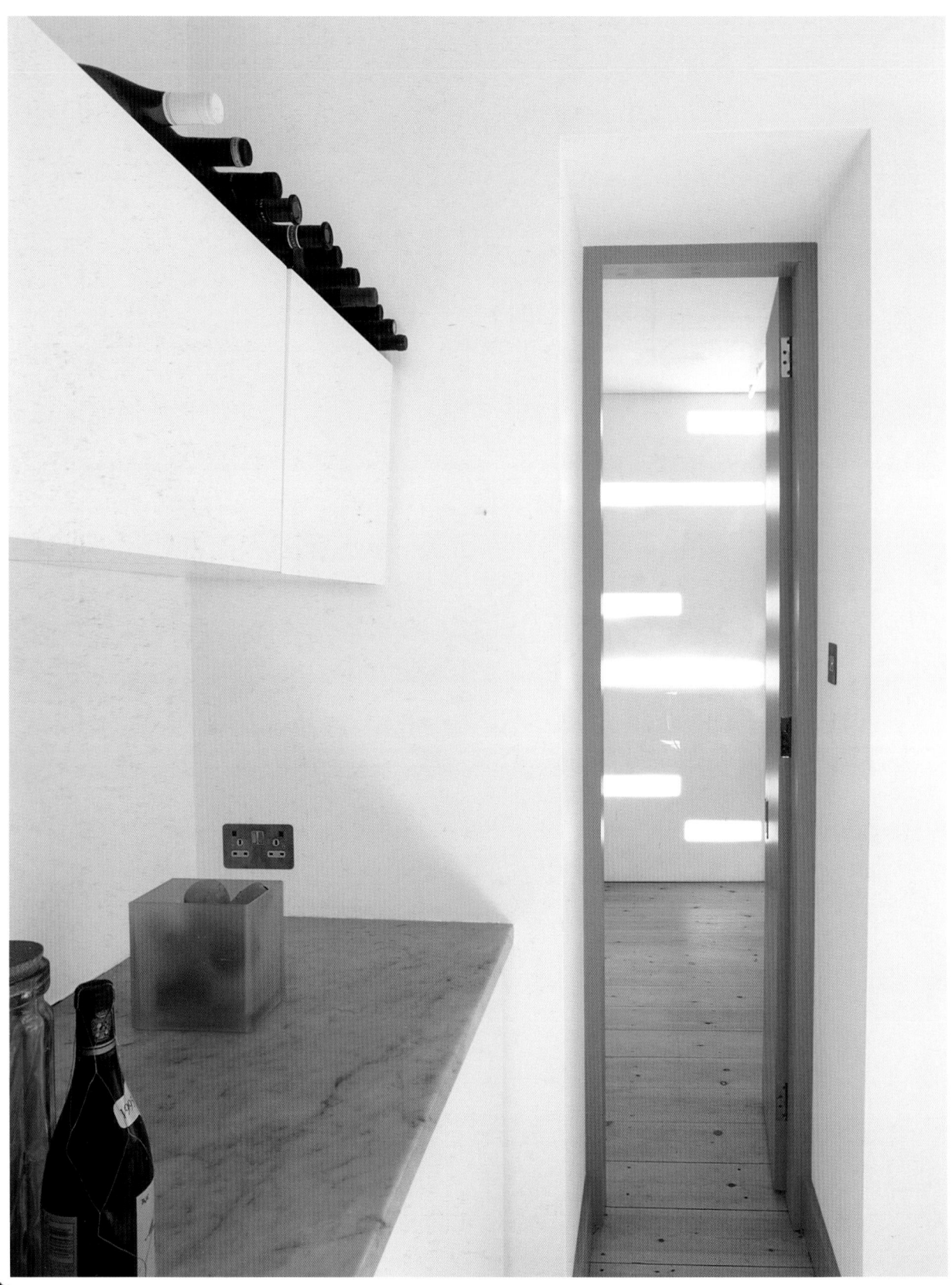

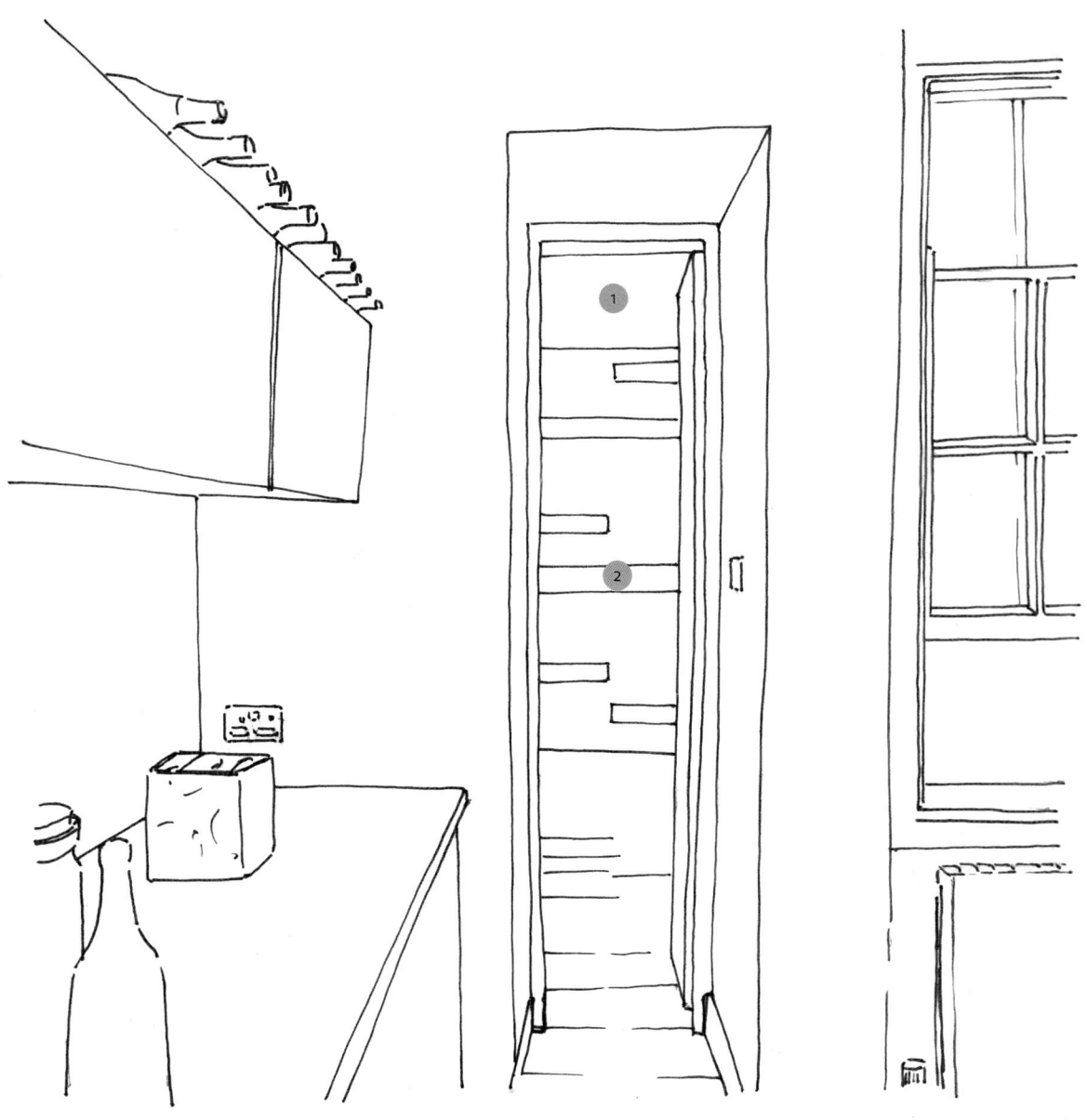

1_ The rooms of the addition are "wet" rooms, which require moisture-resistant and washable surfaces. The uniform high-gloss finish reflects the light of the slot windows.

2_ The narrow opening to the small spaces of the addition is made inviting by the interesting visual patterns set up by the slot windows and glossy surfaces.

WeeHouse

348-840 sq. ft.

Interest in prefabricated homes has increased as the market for traditional housing continues to price out buyers with more modest budgets. Alchemy Architects successfully combines creative construction technologies with sustainable, modern designs. Increasingly, potential home buyers are coming to understand that quality, good aesthetics, efficiency and durability are not exclusively associated with traditional onsite construction. Without compromising the integrity of the basic module, limited to fourteen feet because of road restrictions, different combinations generate spaces of different sizes and layouts. The designs range from a studio size to multi-bedroom dwellings characterized by their efficient layouts and the use of sustainable materials and techniques such as bamboo flooring, fiber cement siding and in-floor heat.

Architect: Alchemy Architects

Location: U.S.

Completion date: 2005

Photographer: © Alchemy Architects

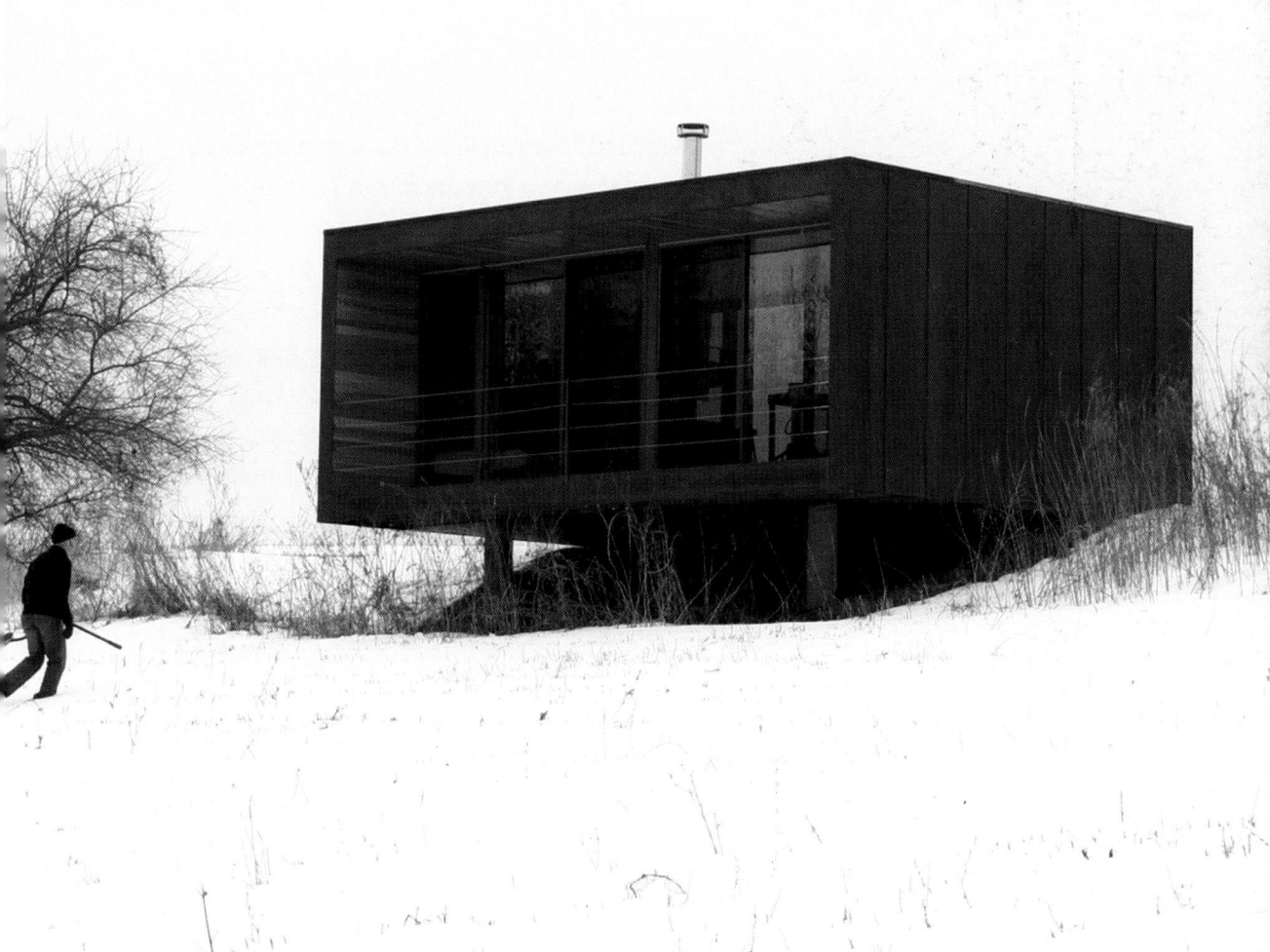

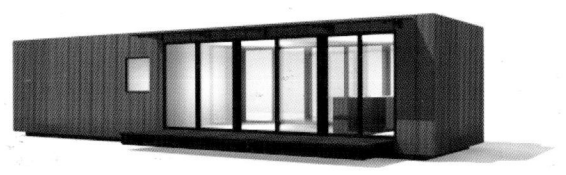

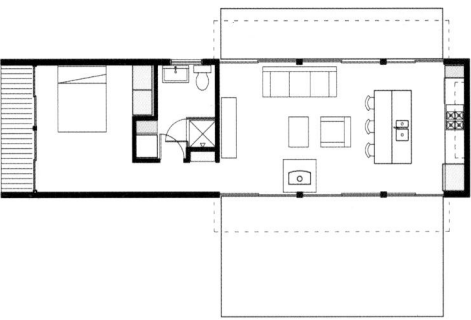

WeeHouse Medium 672 sq. ft.

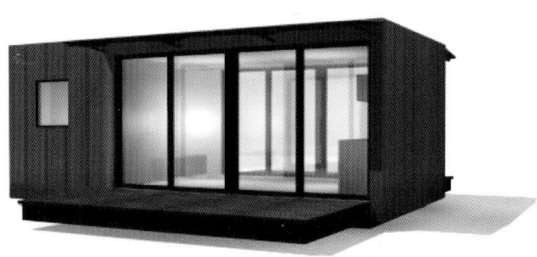

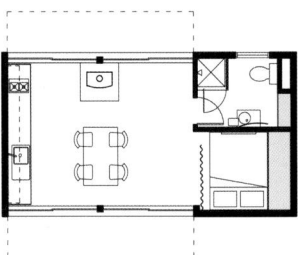

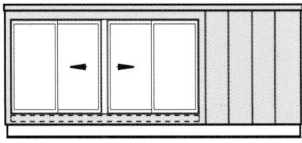

WeeHouse Small 348 sq. ft.

0 8 16 ft.

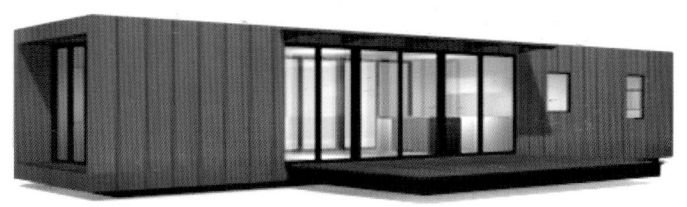

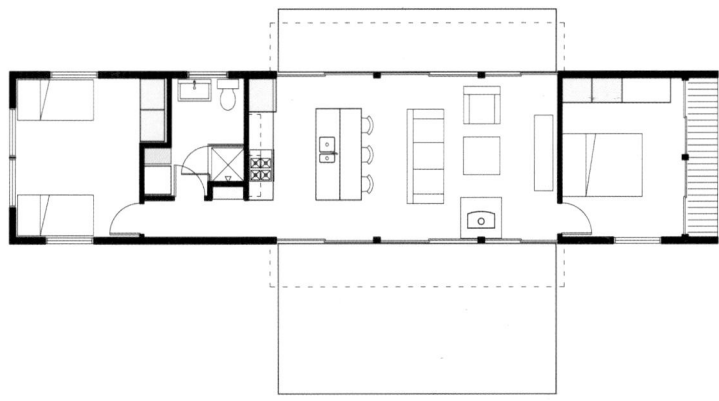

WeeHouse Large 812 sq. ft.

0 8 16 ft.

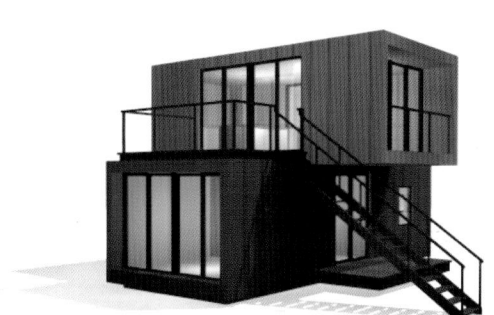

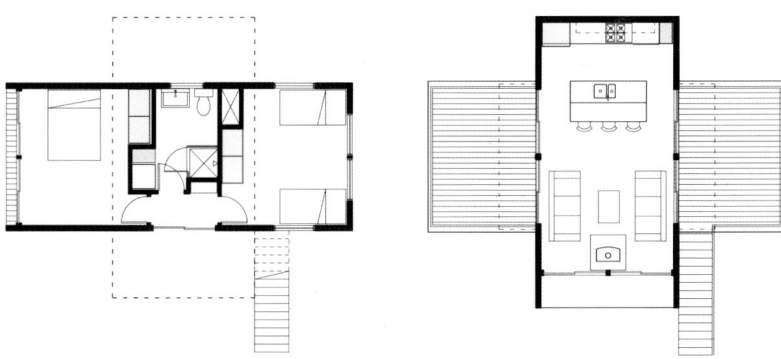

WeeHouse 840 sq. ft.

0 6 12 ft.

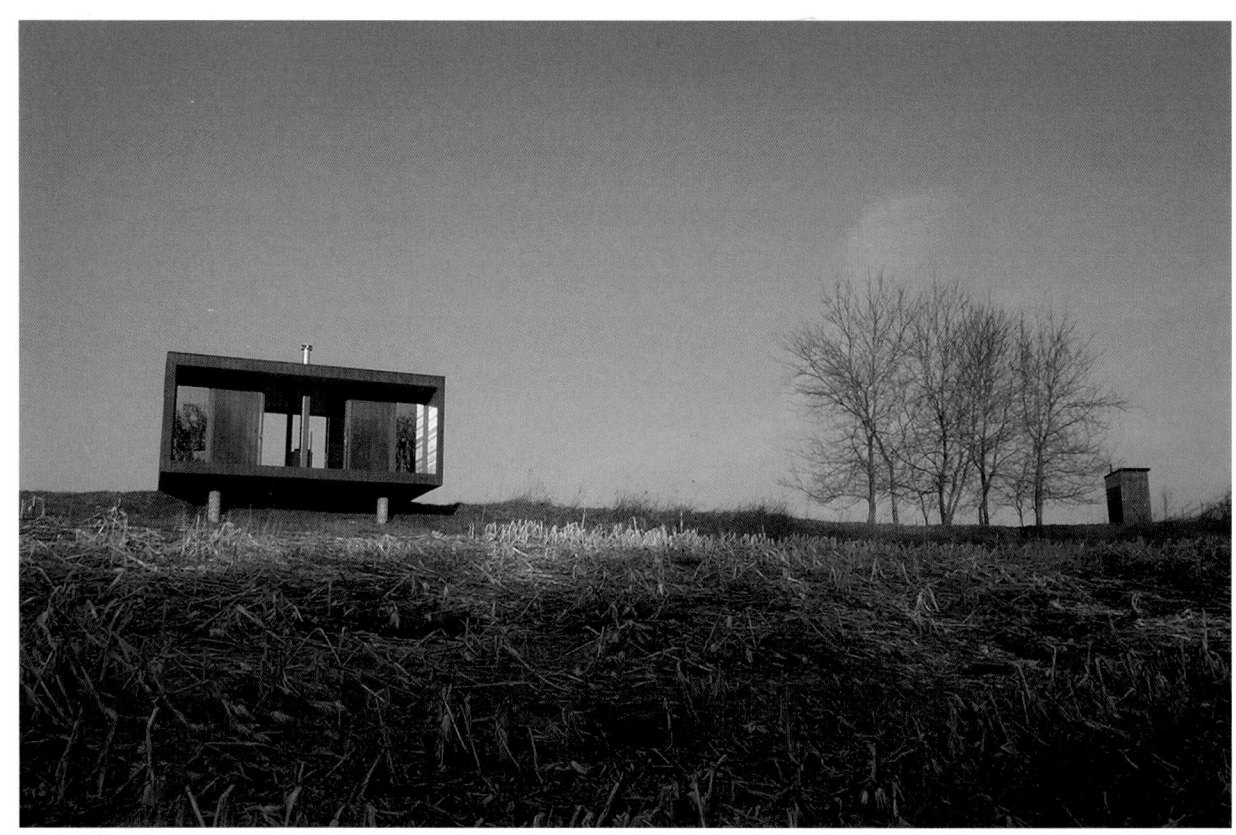

The prefabricated WeeHouse is set on pier foundations. Regardless of the module combination, the construction features wood walls and ceilings, built-in cabinetry with appliances included, a tiled bathroom and high-efficiency LED lighting.

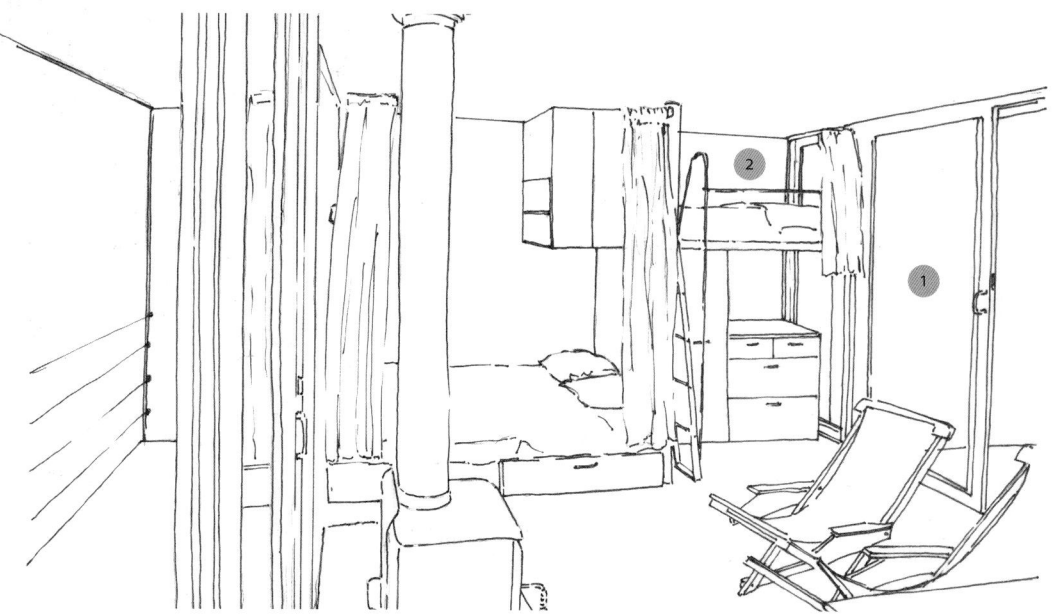

1_ The housing solutions feature efficient industrial, yet house friendly, elements including container or corncrib siding and eco-friendly Andersen windows.

2_ Spatial flexibility is a concept that the team at Alchemy gives priority to while exploring ways to maximize the utility of its designs.

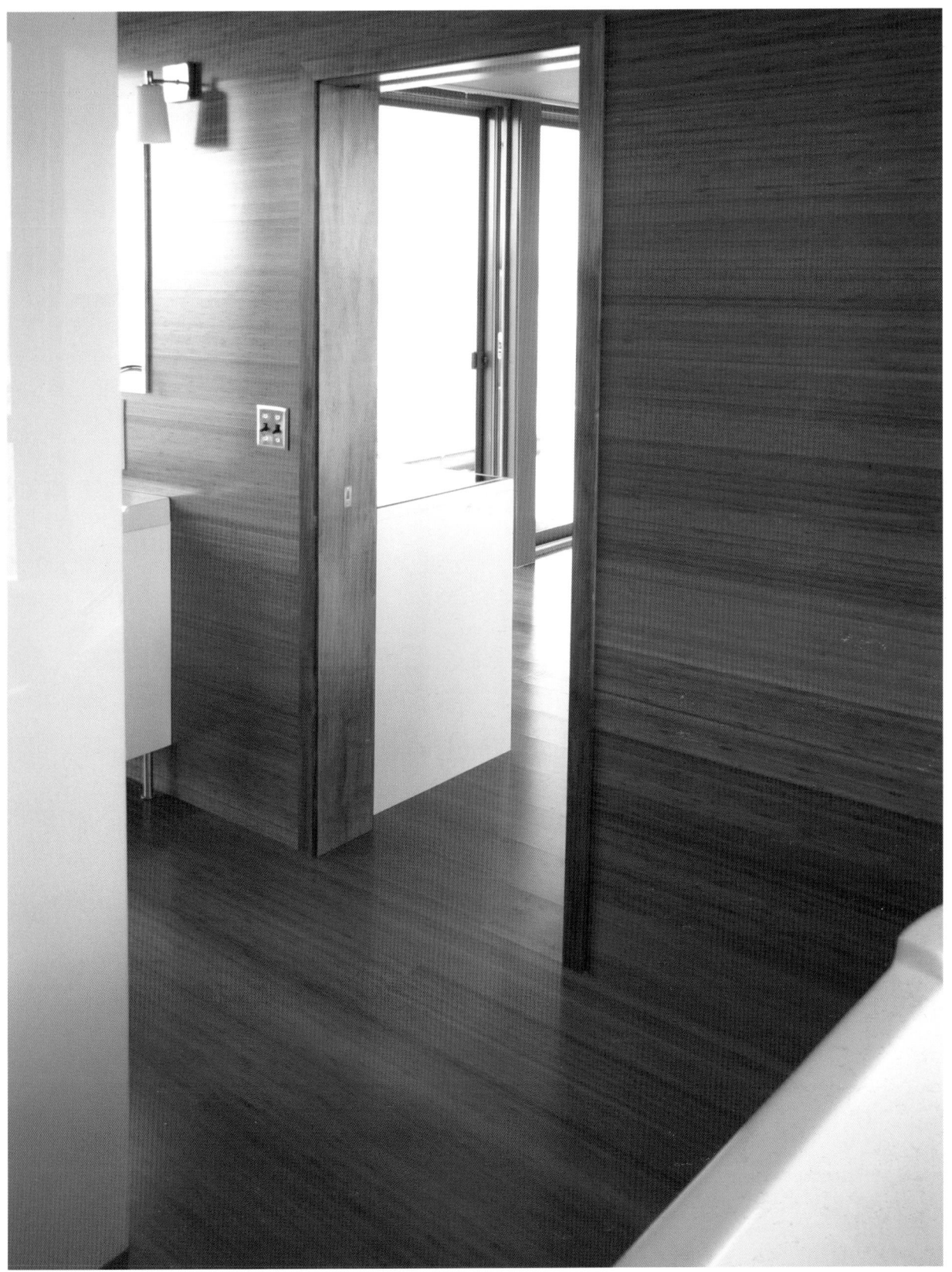

Boxhome

205 sq. ft.

The increasing use of energy has sounded an alarm for many environmental concerns and the reduction of energy consumption is a key requirement for tackling the climate change problem. Construction activity absorbs an important part of energy and material resources. Therefore, producing smaller homes would bring about a considerable economical and ecological benefit.

Boxhome is a 205-square-foot dwelling with four rooms covering the basic living functions: kitchen with dining, bathroom, living room and bedroom. The project focuses on the quality of the space, material and natural light, and tries to reduce unnecessary floor area. Also, it was important during the design development to create a peaceful small home, where a person can withdraw and forget the intensity of the surrounding urban environment for awhile.

Architect: Sami Rintala
Location: Oslo, Norway
Completion date: 2007
Photographer: © Sami Rintala

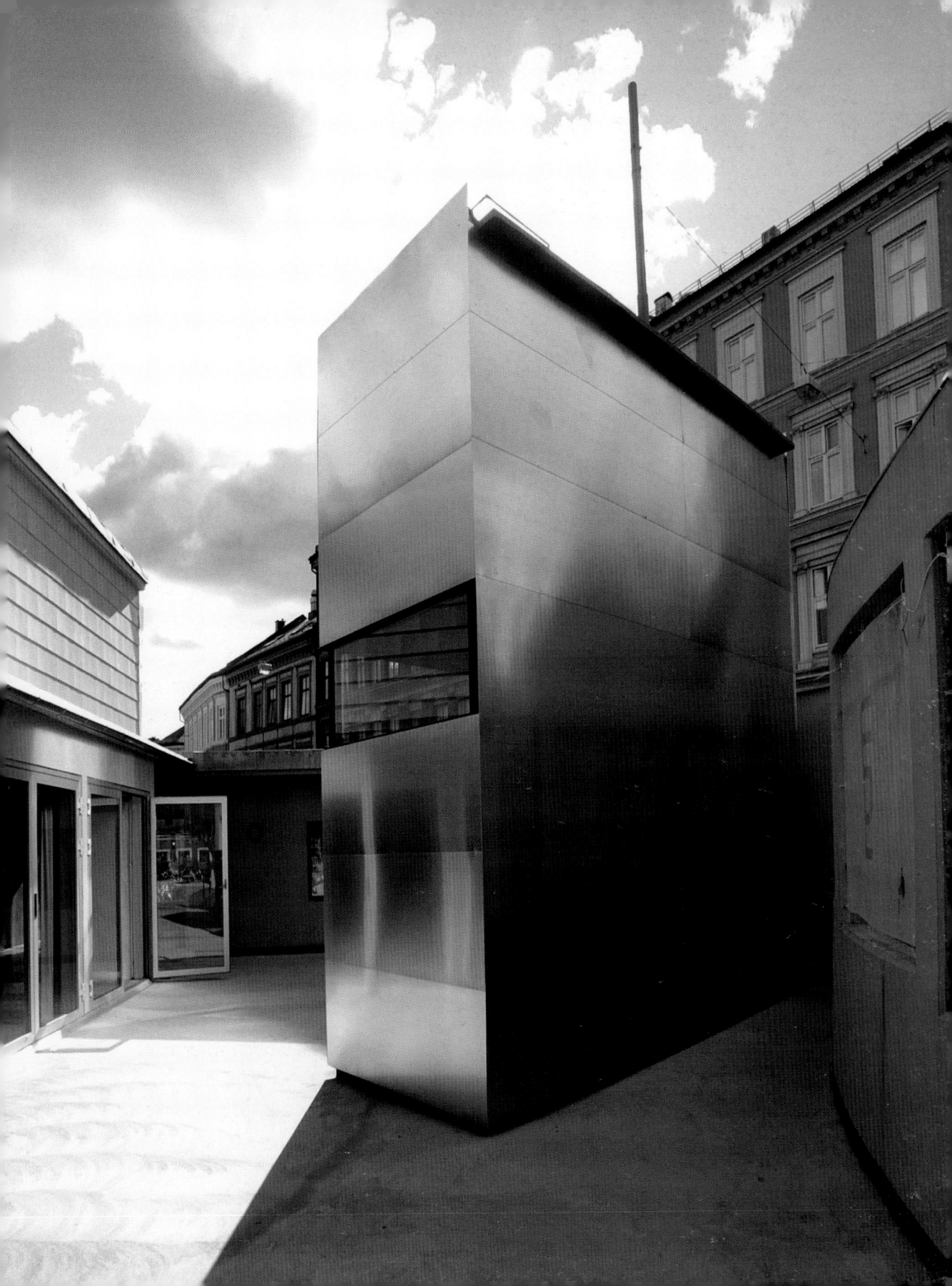

Floor Plan

Elevations

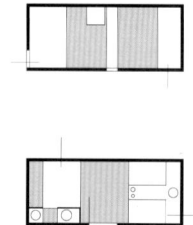

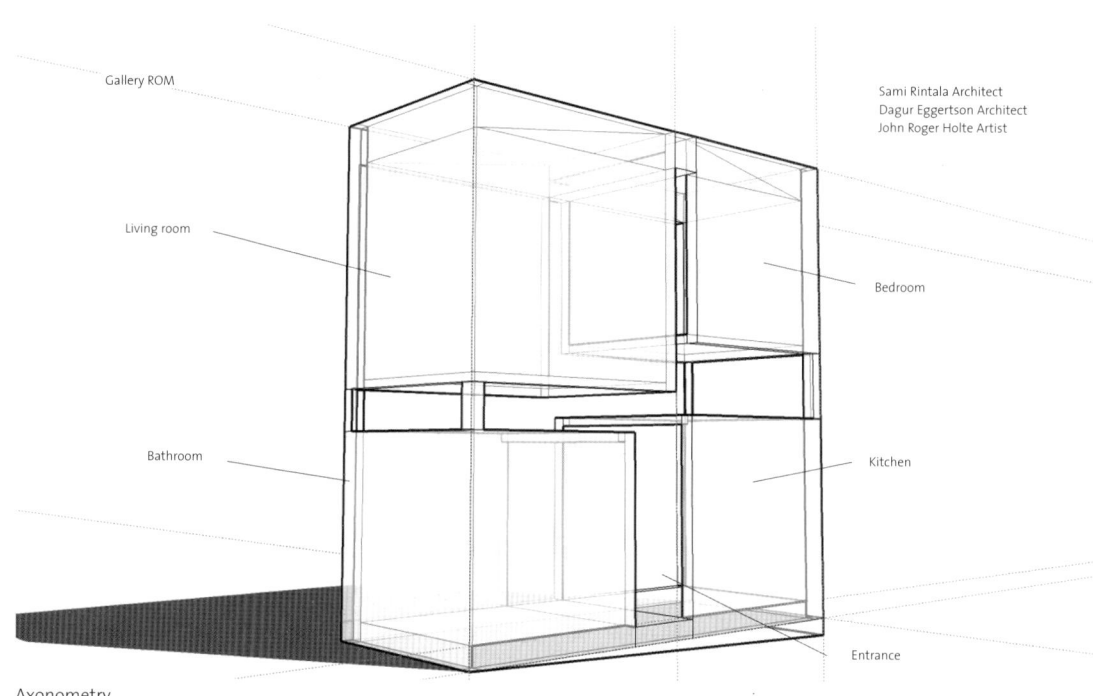

Gallery ROM

Living room

Bathroom

Sami Rintala Architect
Dagur Eggertson Architect
John Roger Holte Artist

Bedroom

Kitchen

Entrance

Axonometry

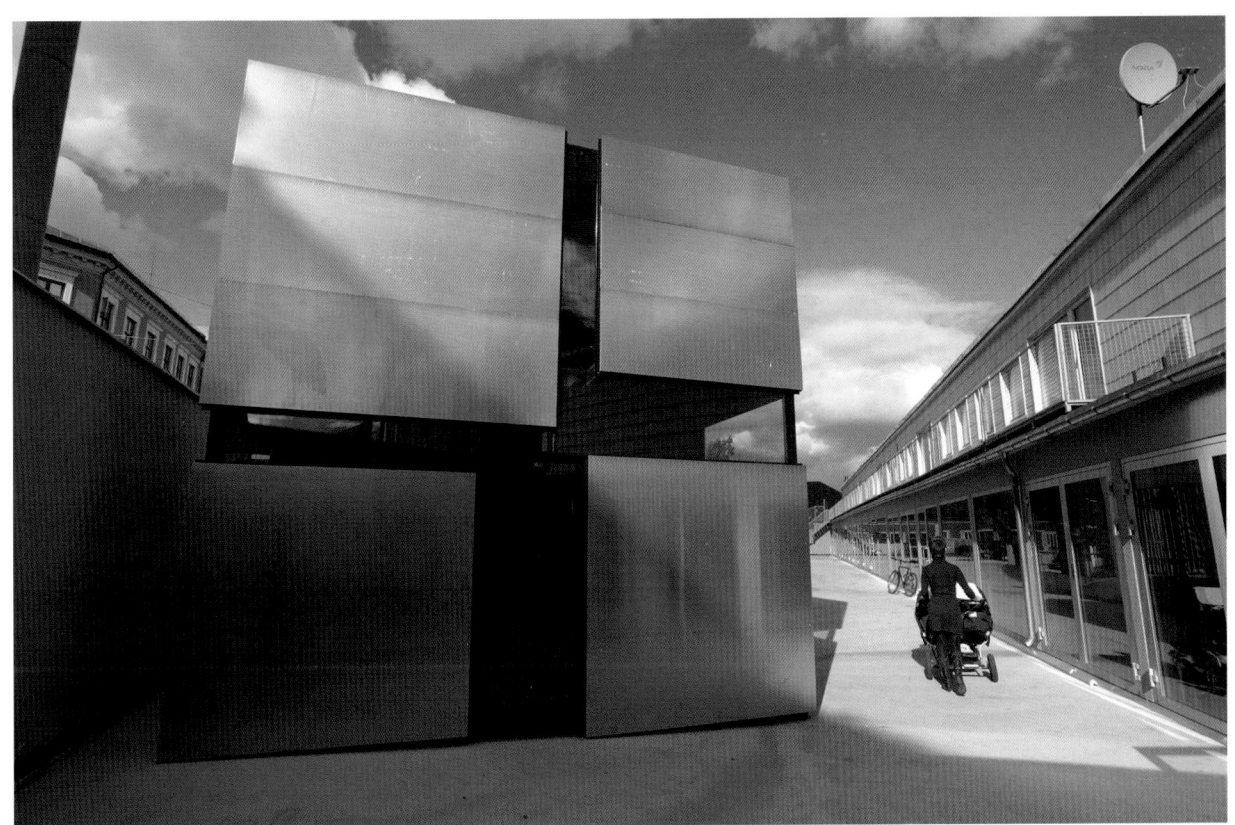

The Boxhome, which for now is a prototype, appears like a shiny gray metal-clad box crisscrossed with ribbons of glass. The interior is finished with dark-stained cypress wood commonly used to make crates. The detail is rough and each individual plank is visible and enhanced by the bright light that pierces the box.

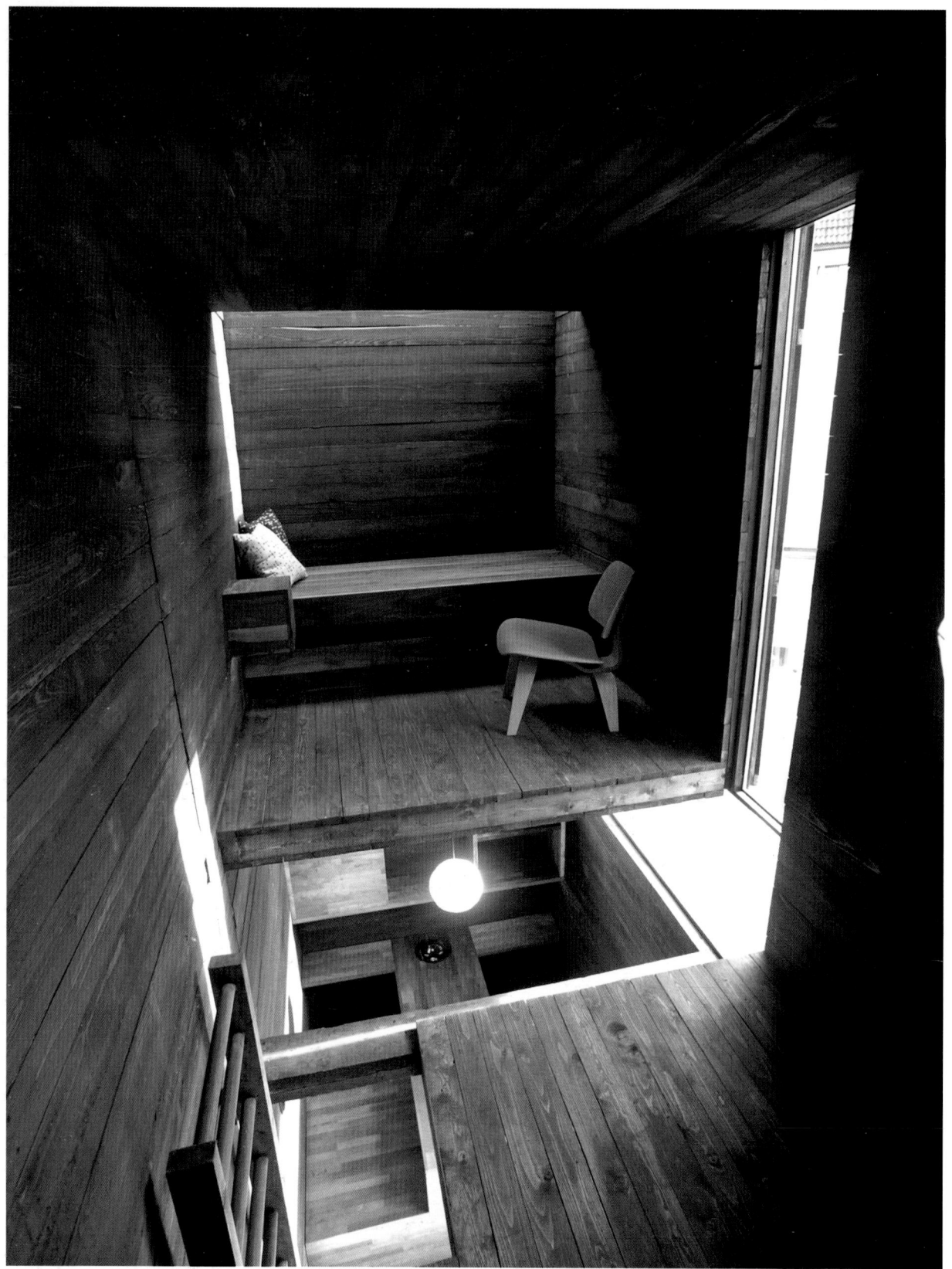

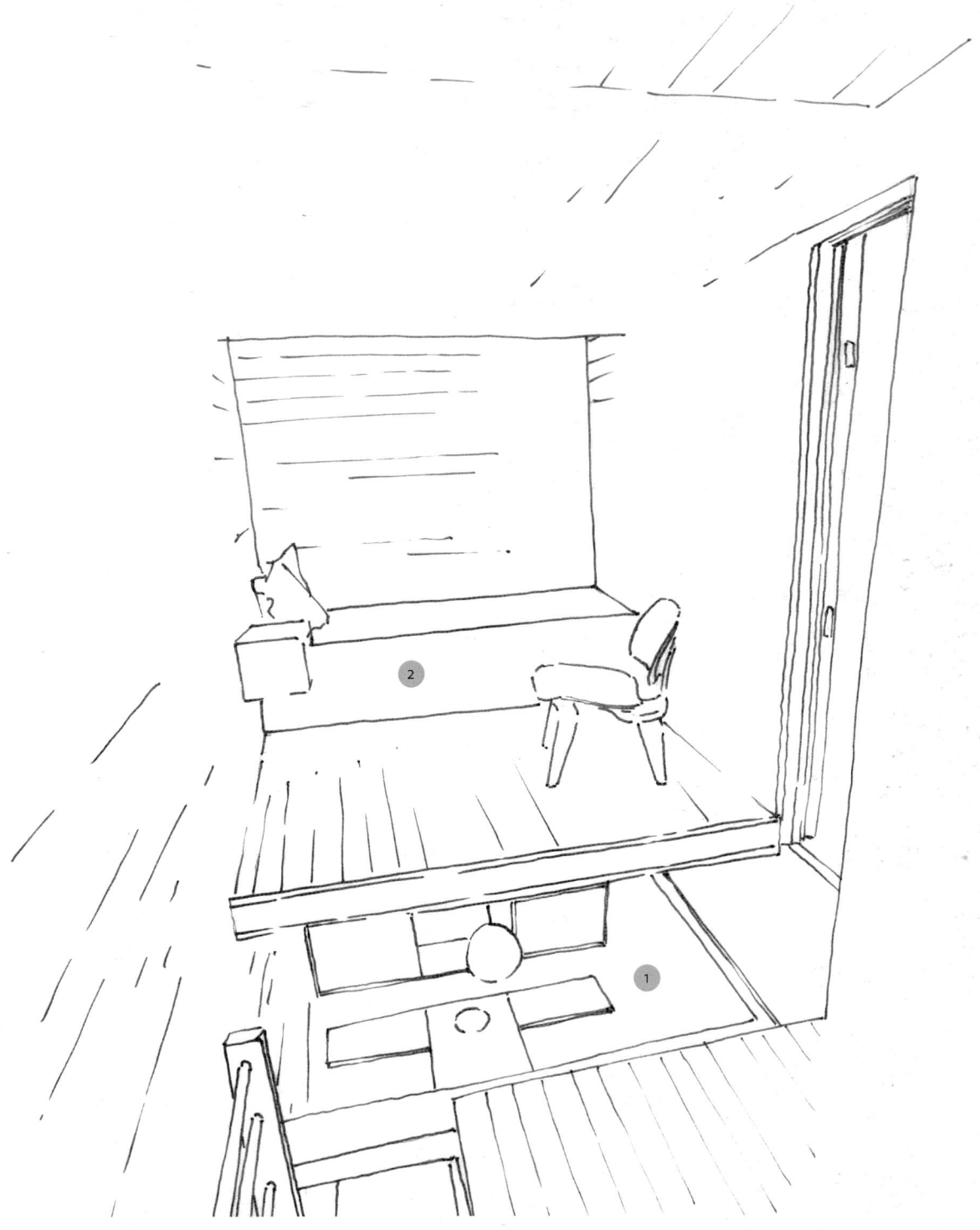

1_ The ground floor of the Boxhome is a fully integrated kitchen and dining room, the style of which reminds one of the traditional Japanese tea room.

2_ The color and texture of the birch, cypress, red oak, spruce and nut woods used in the interior stand out in contrast. The staggered arrangement of floors allows long views to various windows and gives an unexpected sense of space.

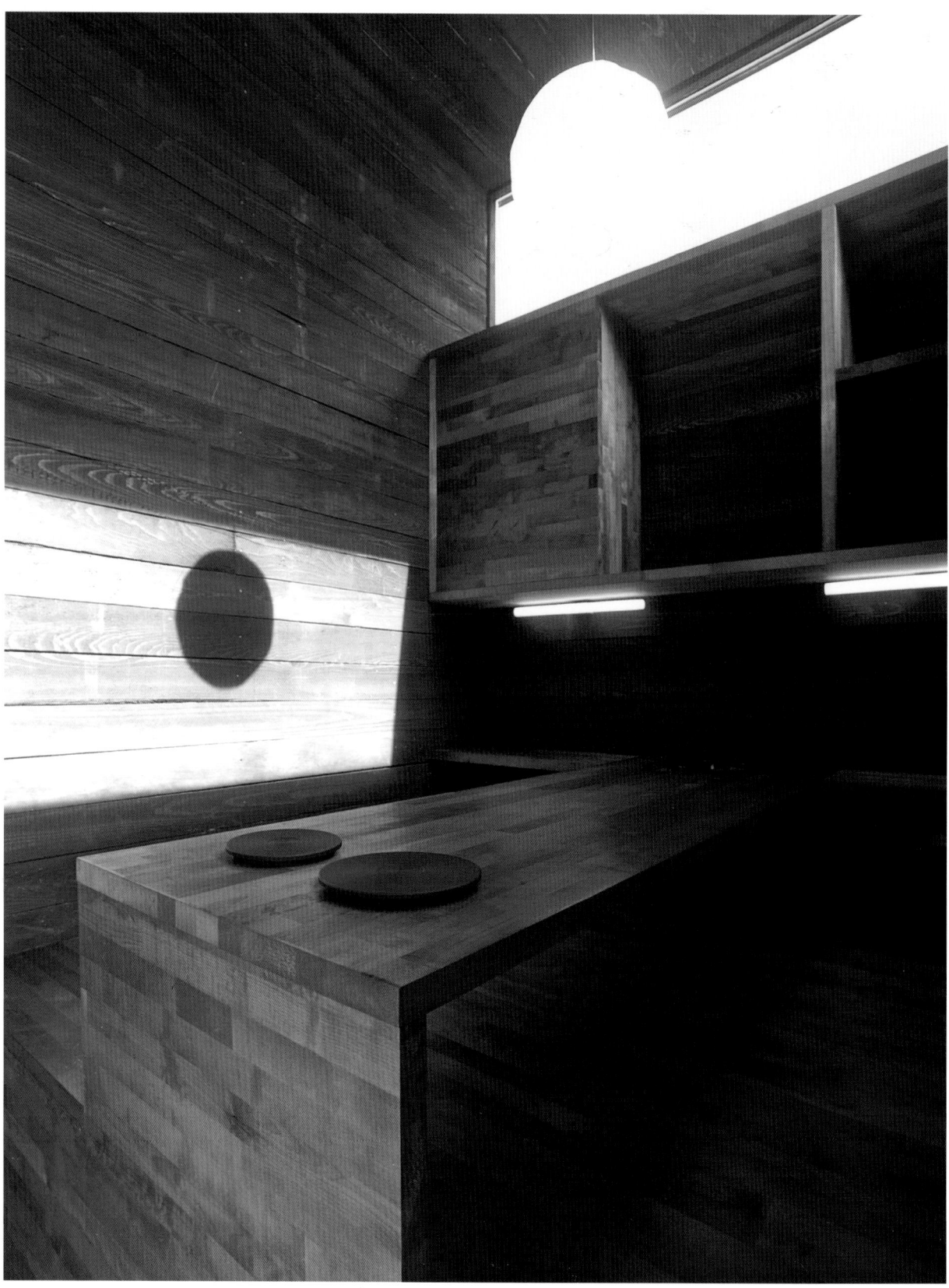

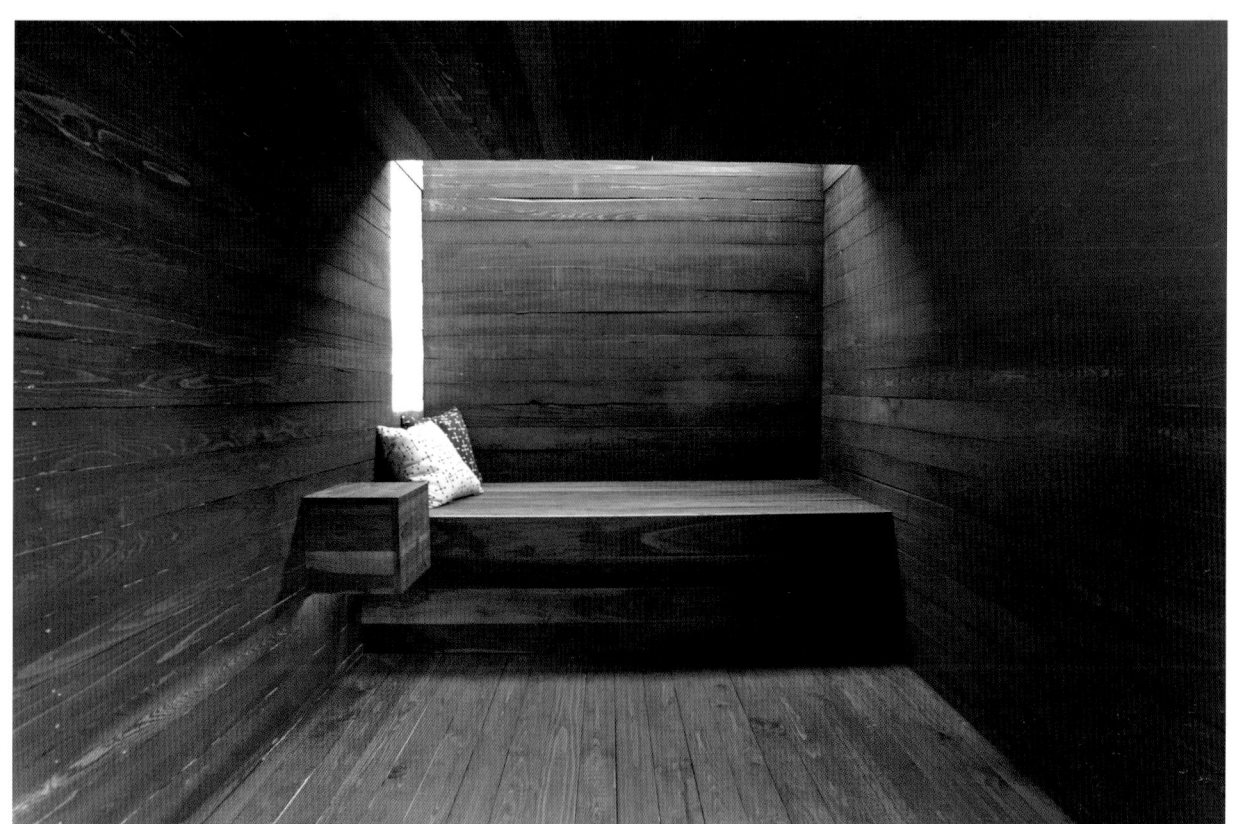

Although the Boxhome was designed for single occupancy, it can easily accommodate guests. The platform in the seating area becomes a twin bed. A bare nook in the house, like a monk's cell. The whole house expresses tranquility. A retreat from the frantic activity outside.

Monolocale

301 sq. ft.

In this extremely small space, just 301-square-feet by 10-feet tall, all of the functions of a regular one-bedroom apartment have been inserted like interlocking puzzle pieces. Not a single cubic centimeter has been wasted. Each functional space has been given a volumetric area to occupy that has been sculpted into the most efficient form. The disciplines of ergonomics, anthropometry, and the design of yacht interiors have been called upon to create this space. As intricately as it is planned, it is essentially one continuous space, with the exception of the enclosed bathroom. The circulation path forms one continuous "S" through the space, efficiently accessing every corner, and "double loaded" along its entire length. The bed sits up on a raised sleeping platform with wood slat screens that partition it off from the lower areas while still allowing the space to flow.

Architect: Andrea Lupacchini

Location: Rome, Italy

Completion date: 2005

Photographer: © Beatrice Pediconi

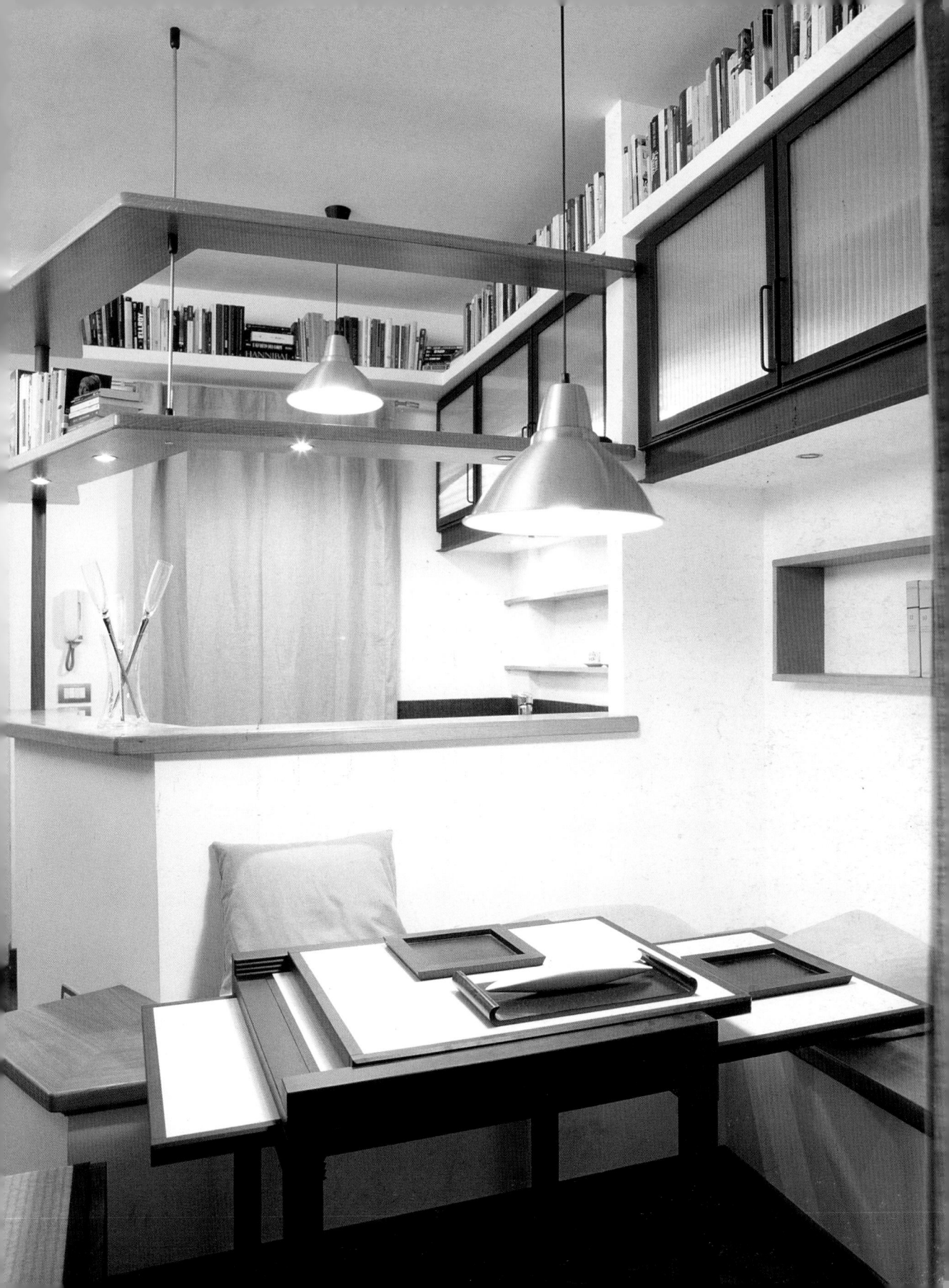

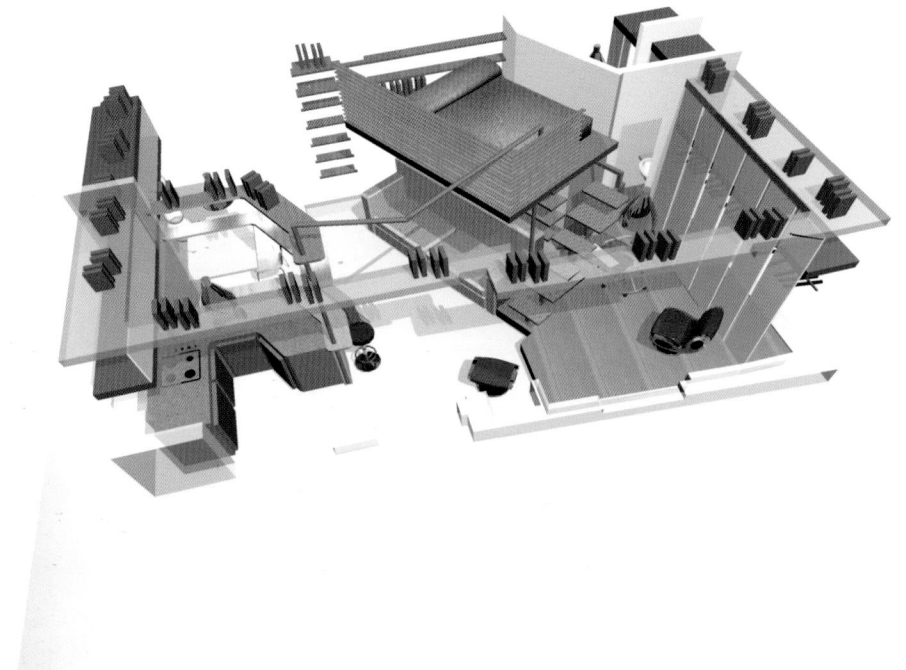

Axonometry

Interior Elevation

Functions Diagram

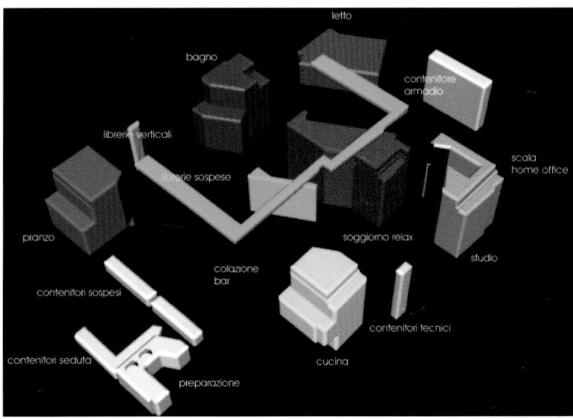

Exploded Functions Diagram

Floor Plan

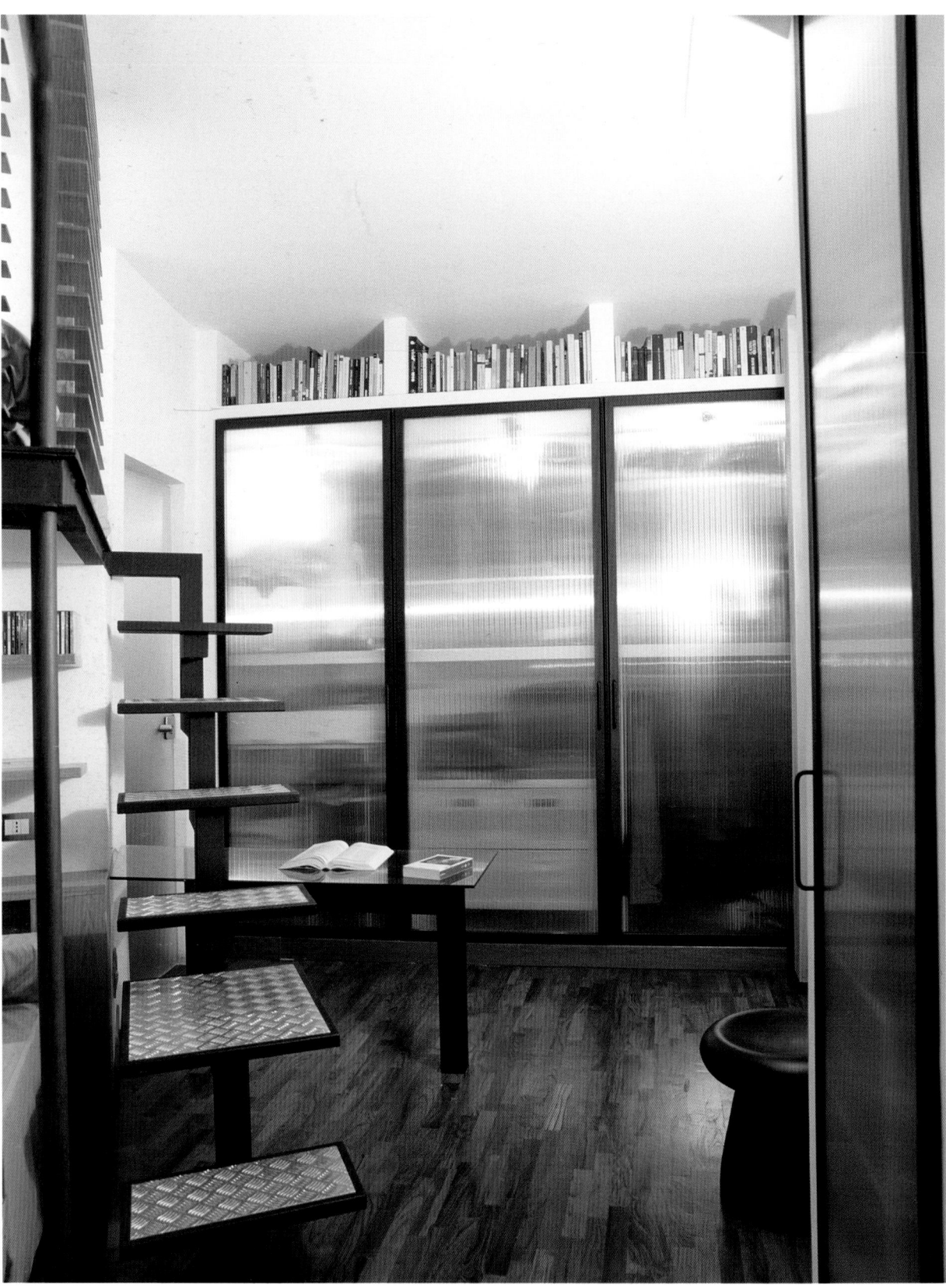

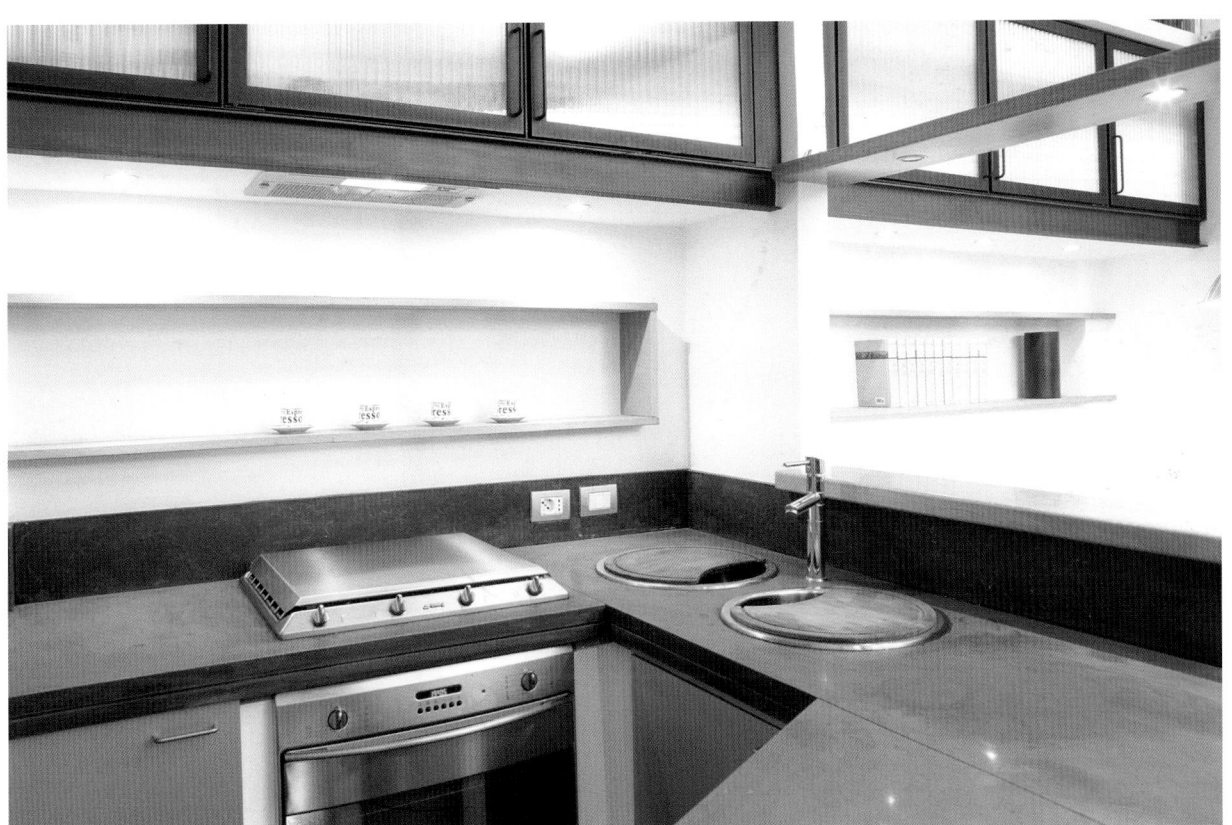

A functional kitchenette fills one corner near the
entry; its glass-fronted upper cabinet is repeated
above the dining area beyond. Available void space
in the thick walls is opened up as shelf niches, lined
in the same cool gray stone of the kitchen counters.
Even here in the kitchen area is the continuous
bookshelf that forms an ersatz crown molding
around the entire apartment.

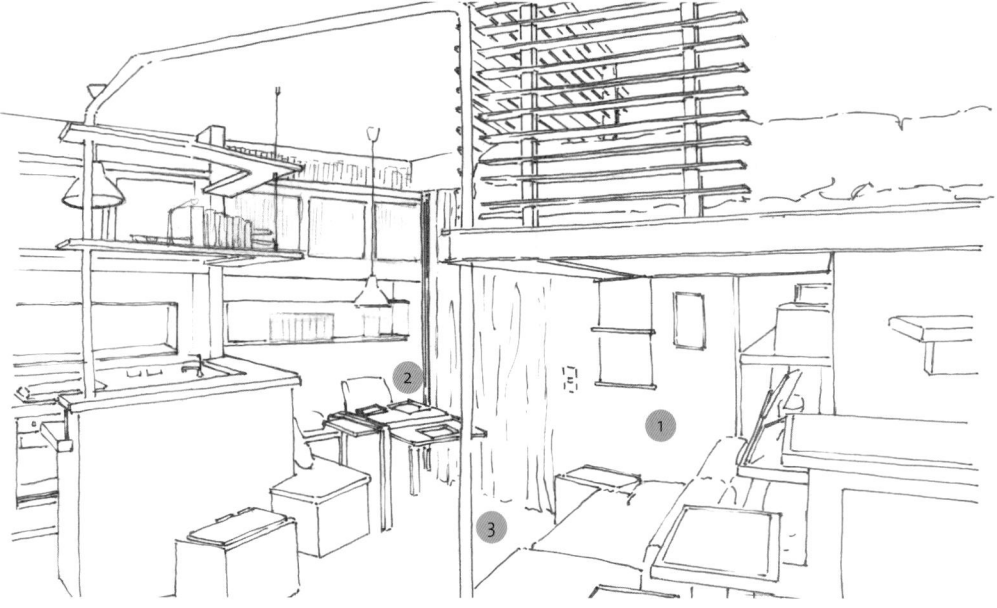

1_ In this 3-meter-high space the bed platform is placed over areas that do not require a standing-height ceiling, such as the sitting area couch and bathroom storage and fixtures.

2_ The small custom dining table can be extended to comfortably seat up to eight people. A built-in bench along two sides saves space.

3_ Thin yet strong steel structures support the stairs, bed platform and shelving without taking up too much space.

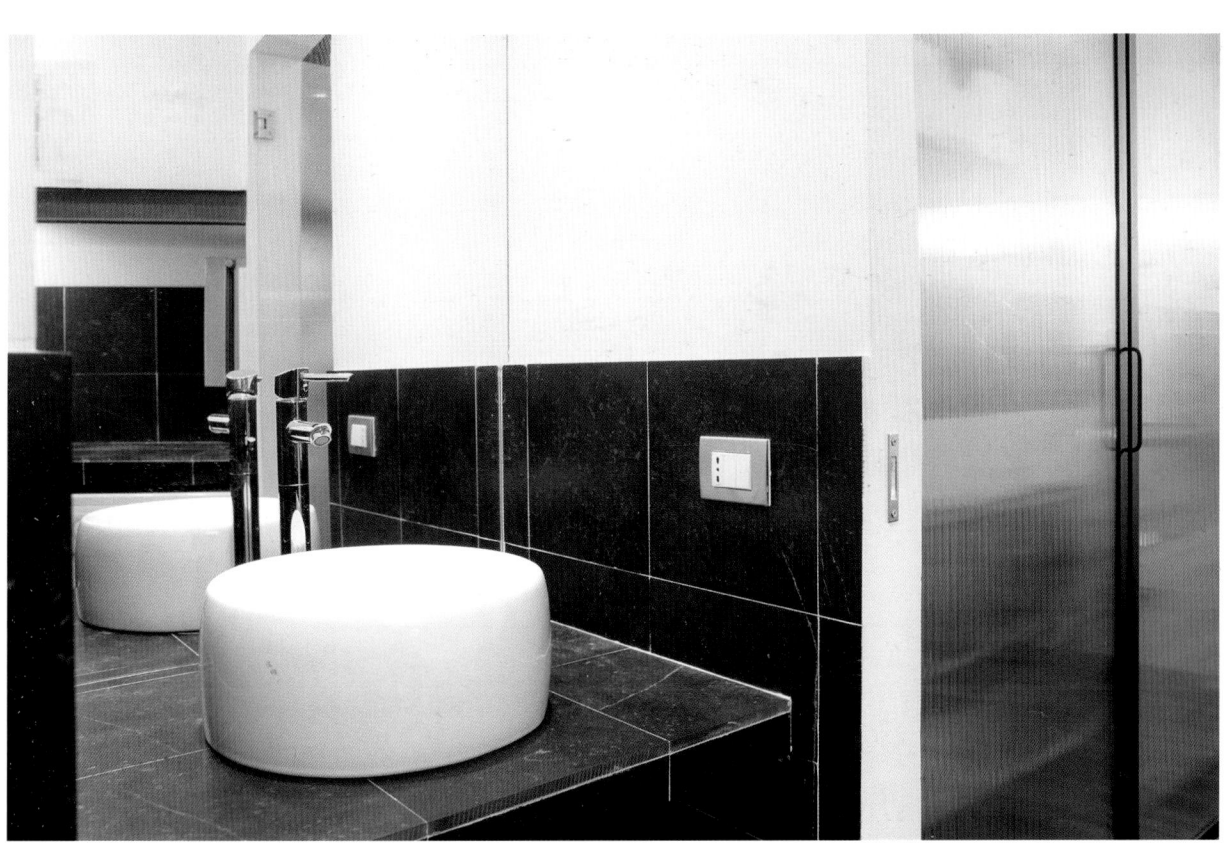

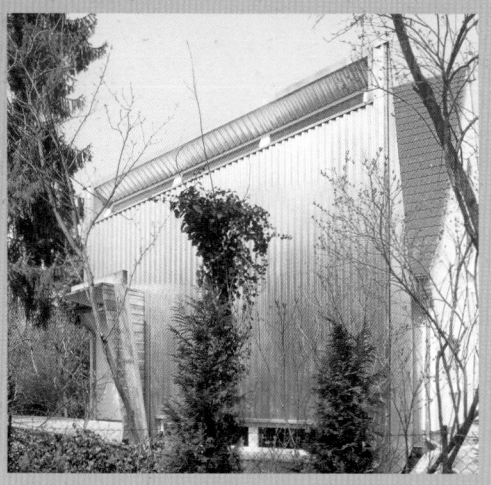

Trichterweiterung

301 sq. ft.

The "Trichter" (funnel in English) is the extension to an old house built in the 1930s in Berlin-Dahlem. The existing house was subjected to a more extensive interior renovation that resulted in the creation of two apartments. As part of this renovation, the ground floor, where the artist lives, expands into a new studio space: the "Trichter," directly attached to the existing house, is accessed via an opening into the house's south wall. Although depending on the existing house for different functions, the "Trichter" can be interpreted as an individual construction with its own identity. This addition is placed over the exterior steps that lead down to the basement which serves as storage for the artist's artwork. The new volume, clad in corrugated metal sheet, stands out amongst the traditional types of construction in the area.

Architect: Peanutz Architekten

Location: Berlin-Dahlem, Germany

Completion date: 2005

Photographer: © Stefan Meyer

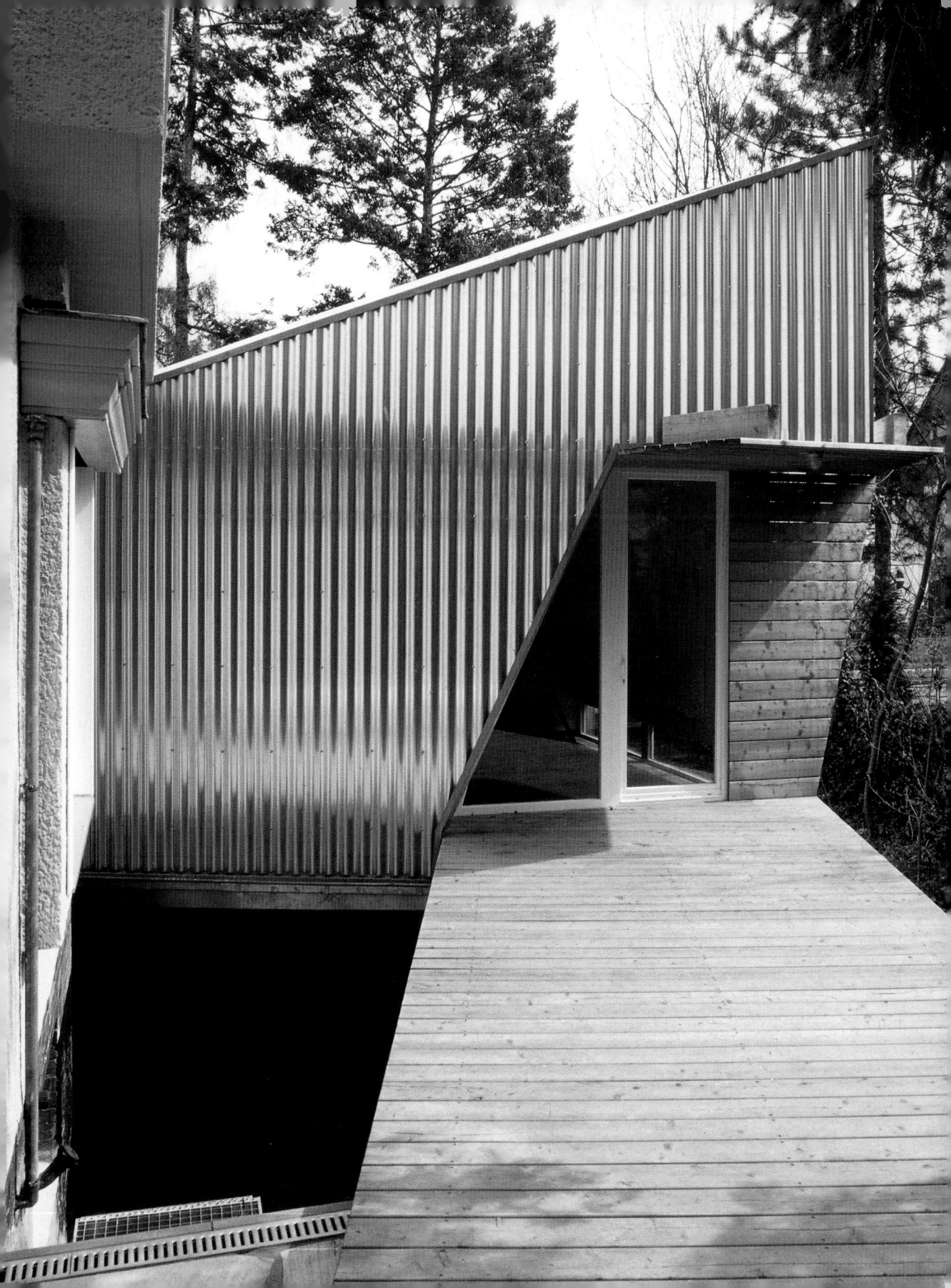

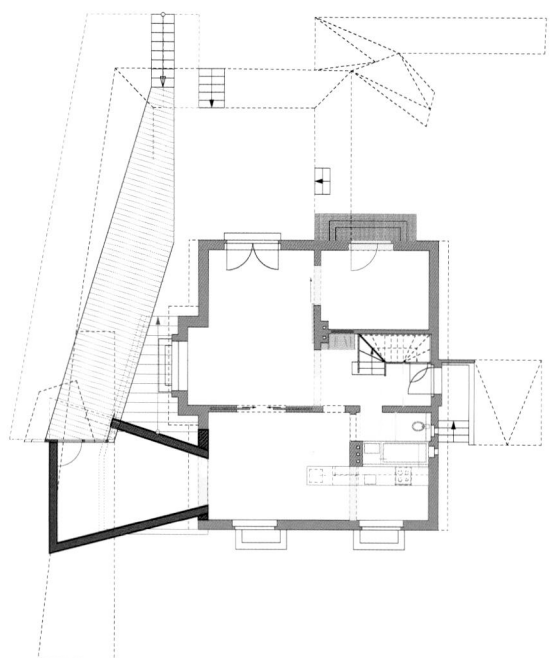

Ground Floor Plan

Basement Floor Plan

Section

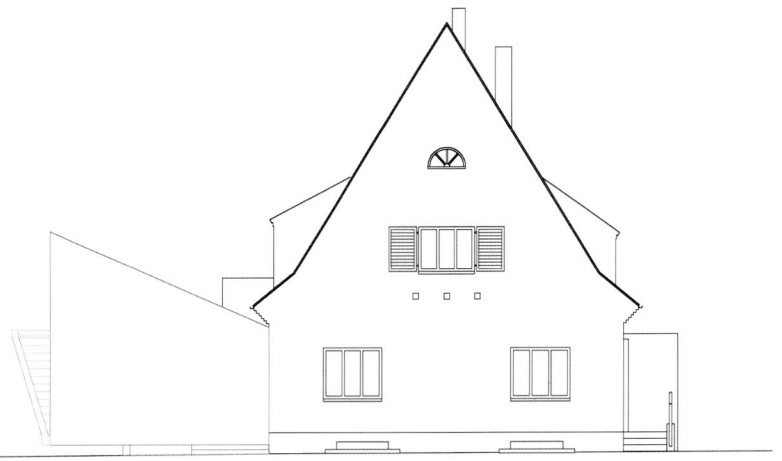

East Elevation

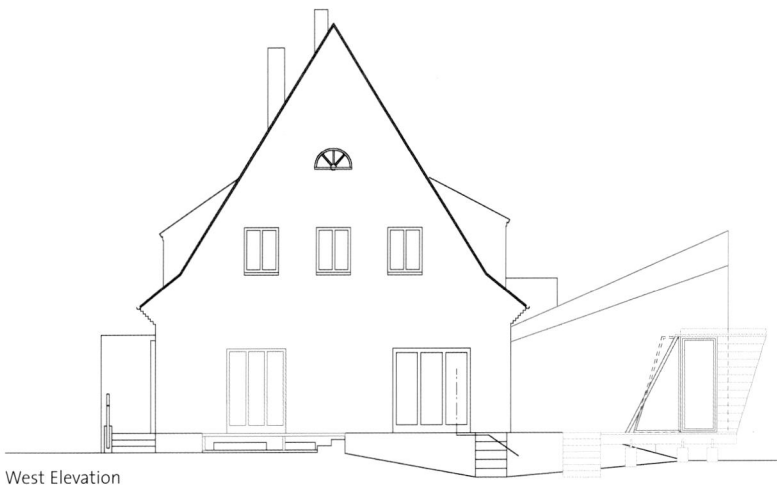

West Elevation

South Elevation

0 6 12 ft.

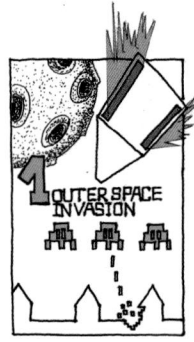

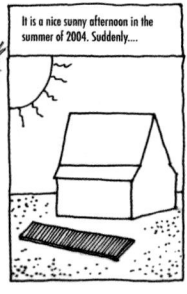

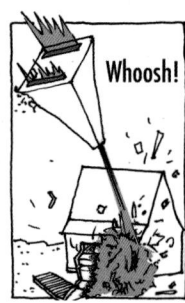

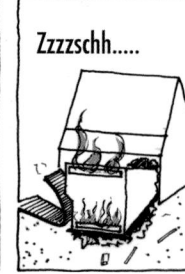

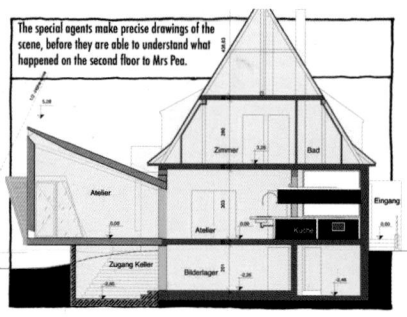

1_ The walls of the new studio have very low windows so that most of the vertical surfaces are left available for artwork.

2_ The remodeled kitchen is open to the room adjacent to it and to the new studio. The long kitchen countertop reinforces the directional axis that connects the kitchen with the new addition.

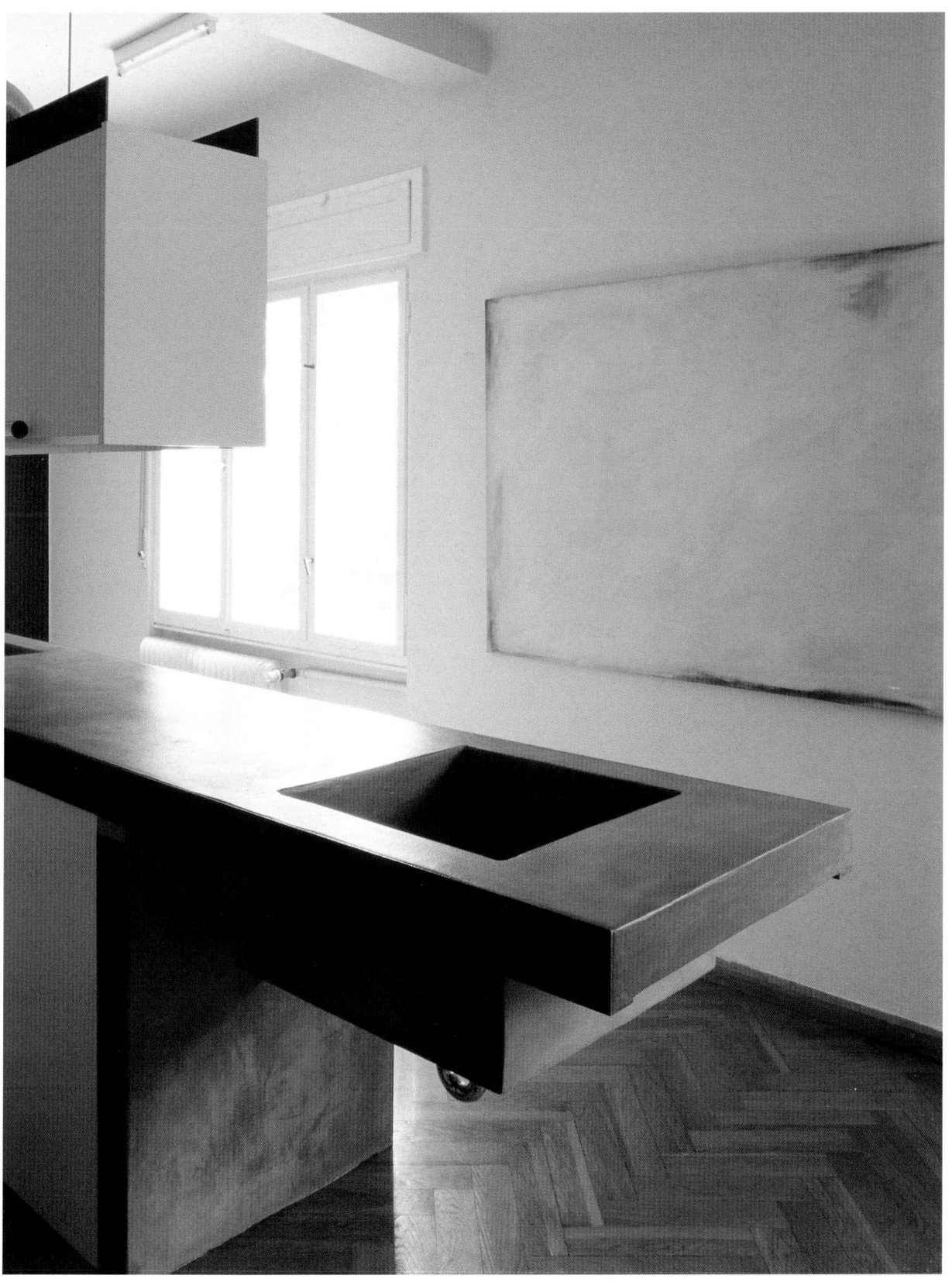

Trichterweiterung

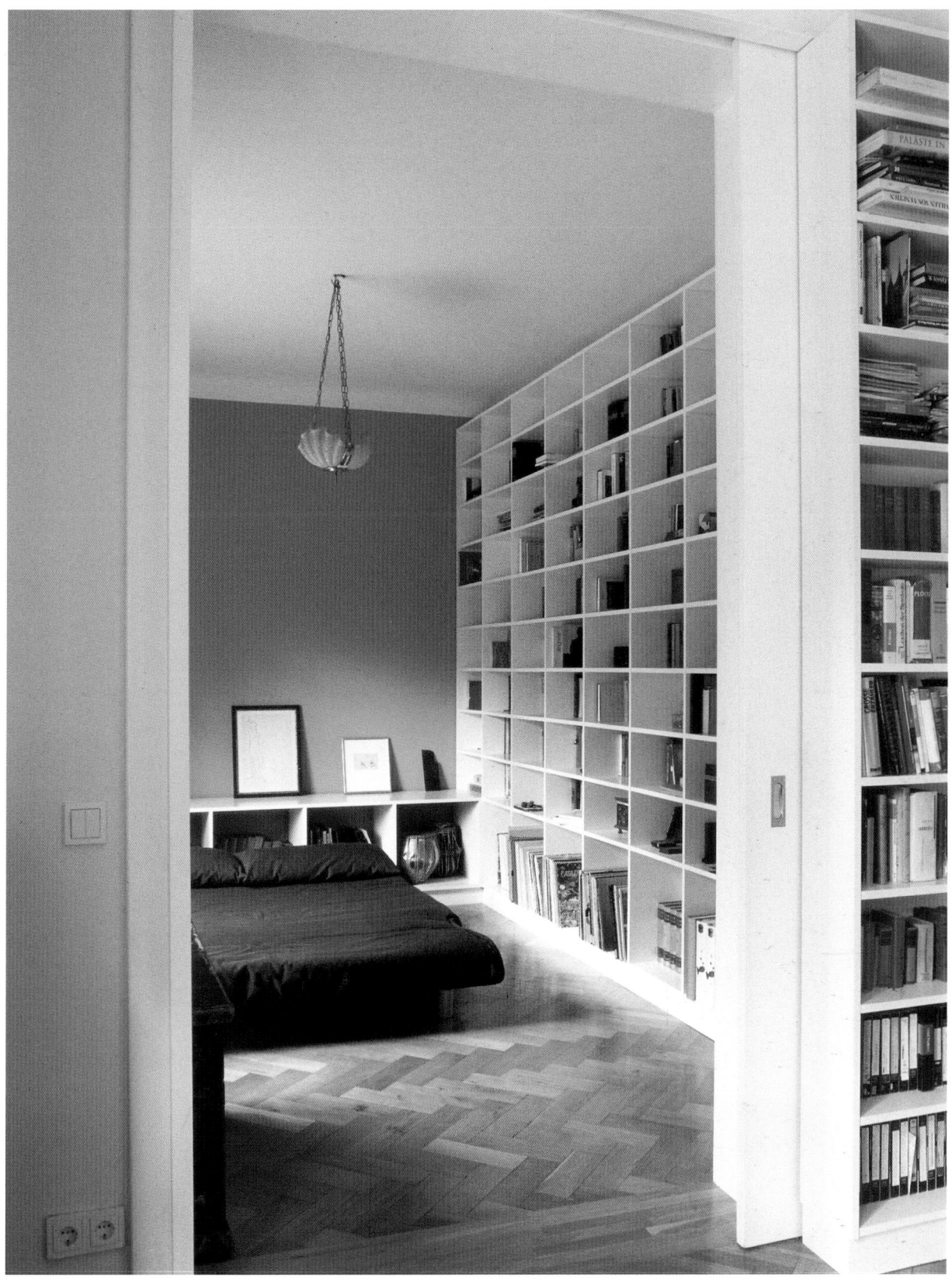

Lodge House
301 sq. ft.

An existing out-building in the backyard or a row house (student housing in a previous life) was stripped of its stone façade and converted to a guest cottage. In place of the stone facing is a two-story glass wall opening onto the garden. The glass skin folds open on both levels transforming the small lodge house and garden into one continuous space. The upper floor is a guest room/library, while the lower floor contains a kitchenette and bathroom. The small structure is topped off with a planted green roof. Although the façade, facing the main house across the small garden, is entirely glass, it has been given a treatment to make most of it obscure glass, with just three oblong blobs of clear glass. This provides a measure of privacy in the tight spaces of the little guest cottage and rear yard. At dusk the whole glass skin radiates a blue light, in concert with the dark blue twilight sky. This little project is an architectural response to living in the city in a very restricted area: a search for maximal spatial feeling within minimal constraints.

Architect: Guerrilla Office Architects

Location: Leuven, Belgium

Completion date: 2006

Photographer: © goa

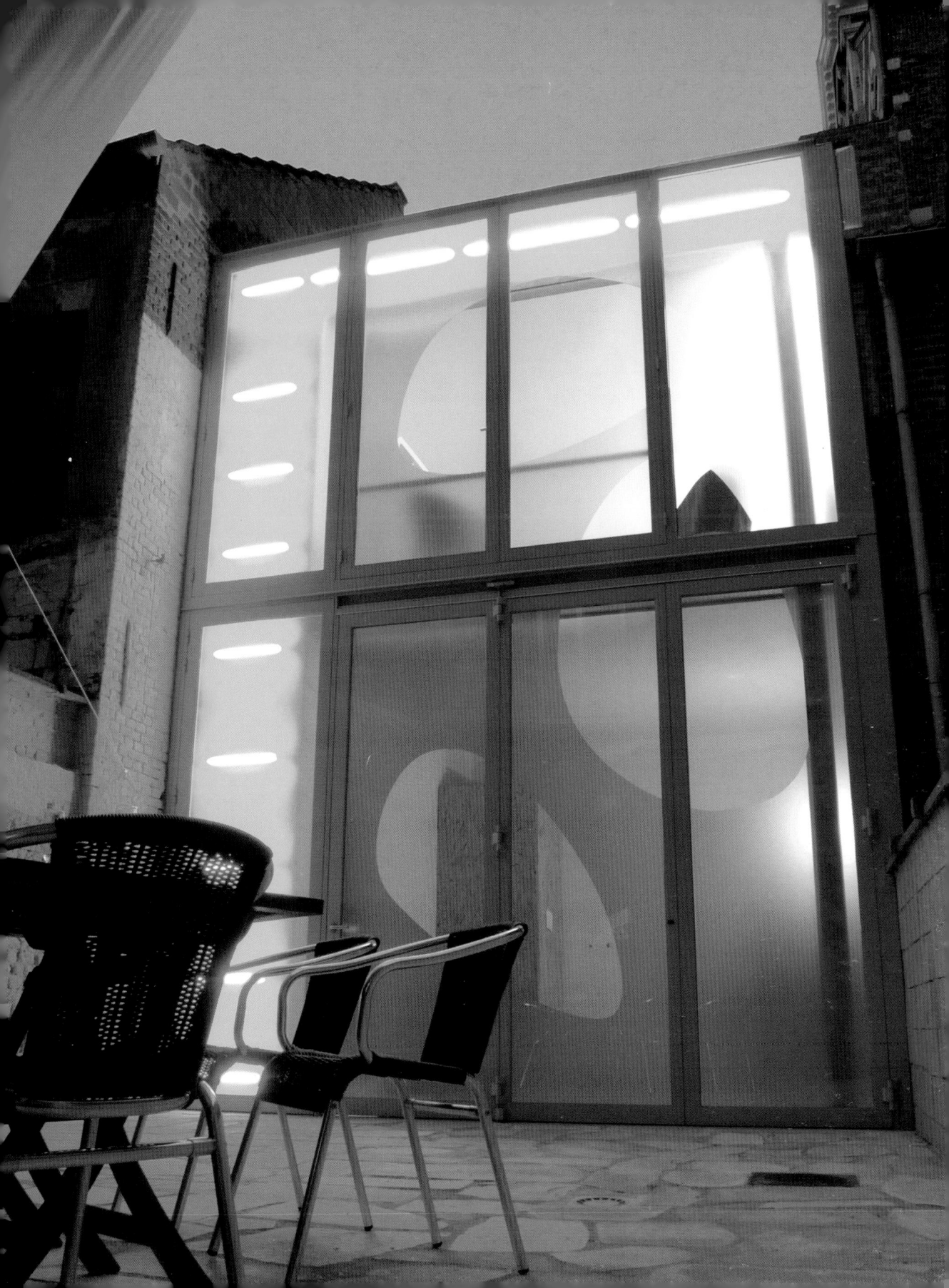

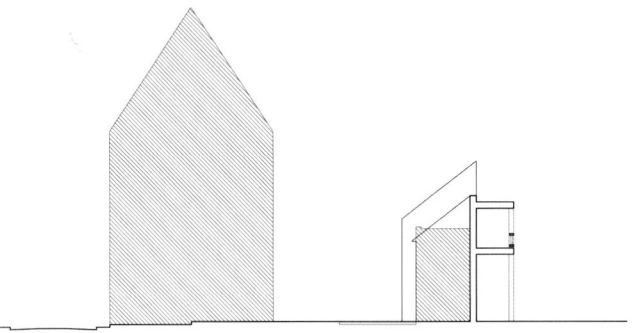

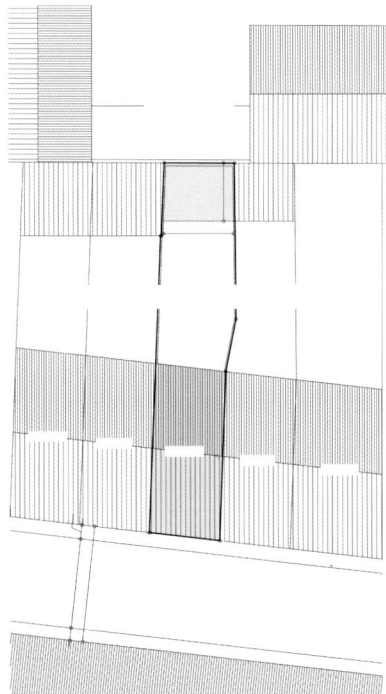

Site Plan and General Elevation

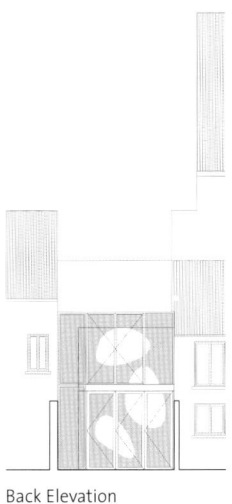

Back Elevation

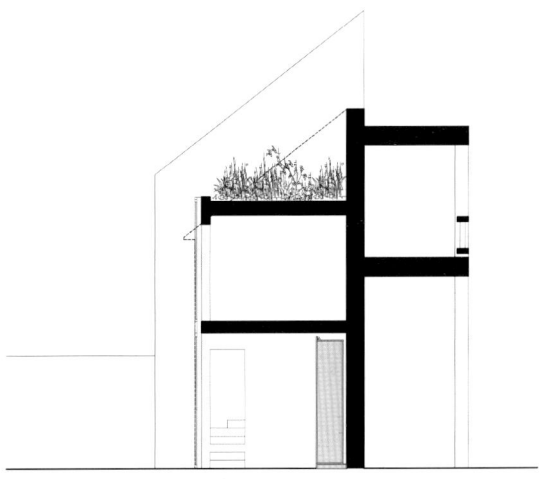

Section

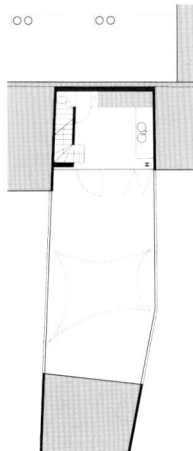

Ground Floor Plan

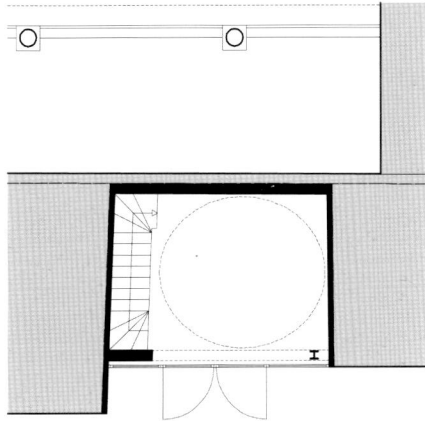

Upper Floor Plan

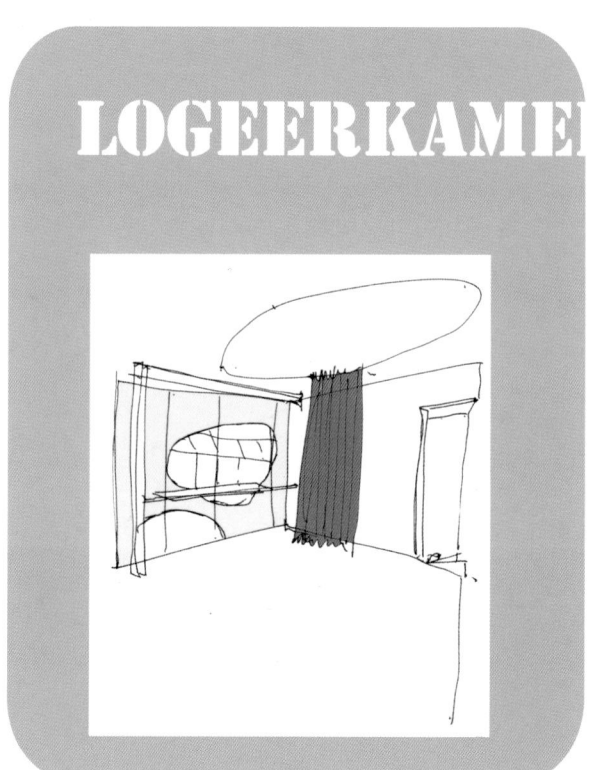

LOGEERKAME

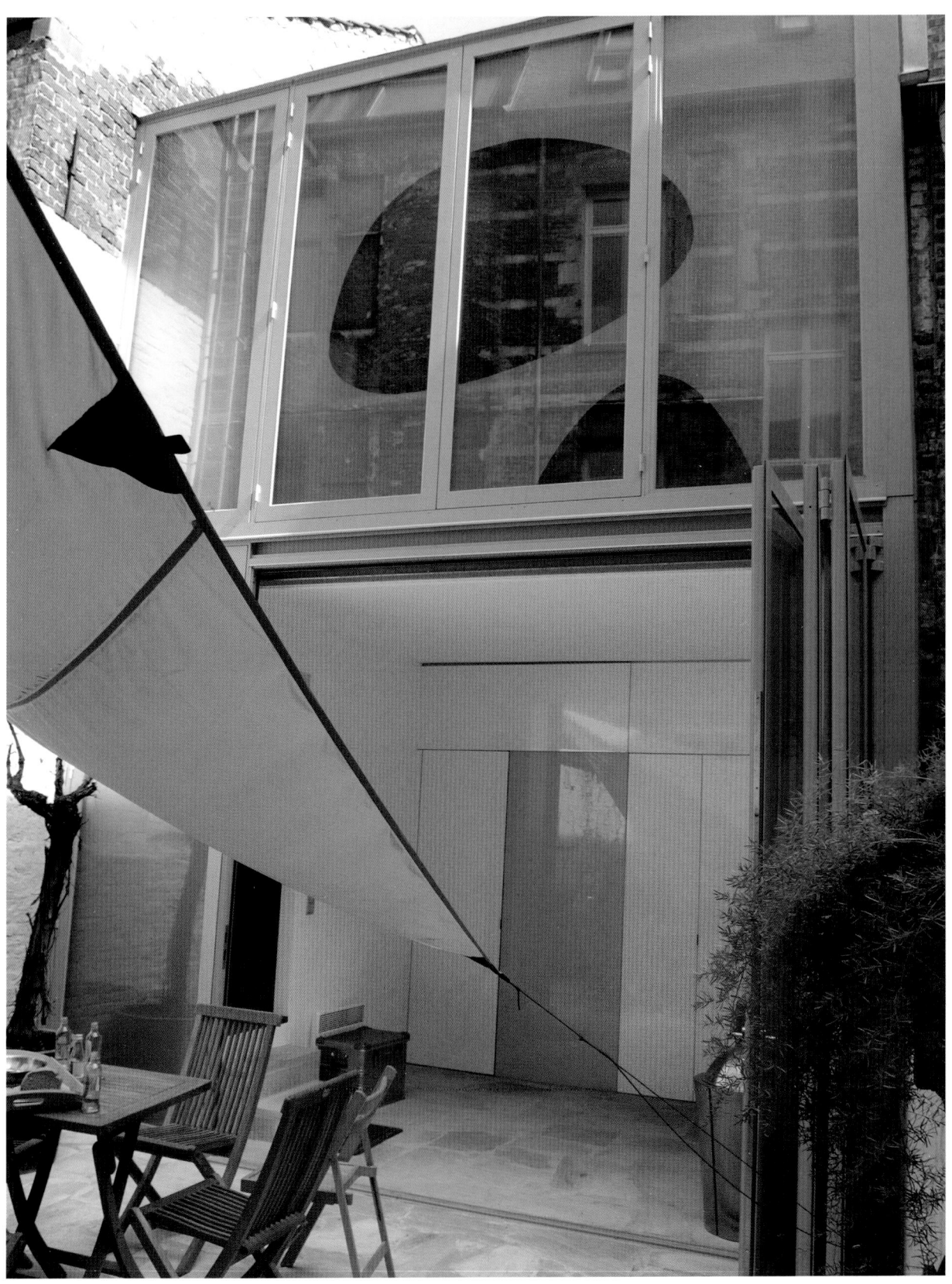

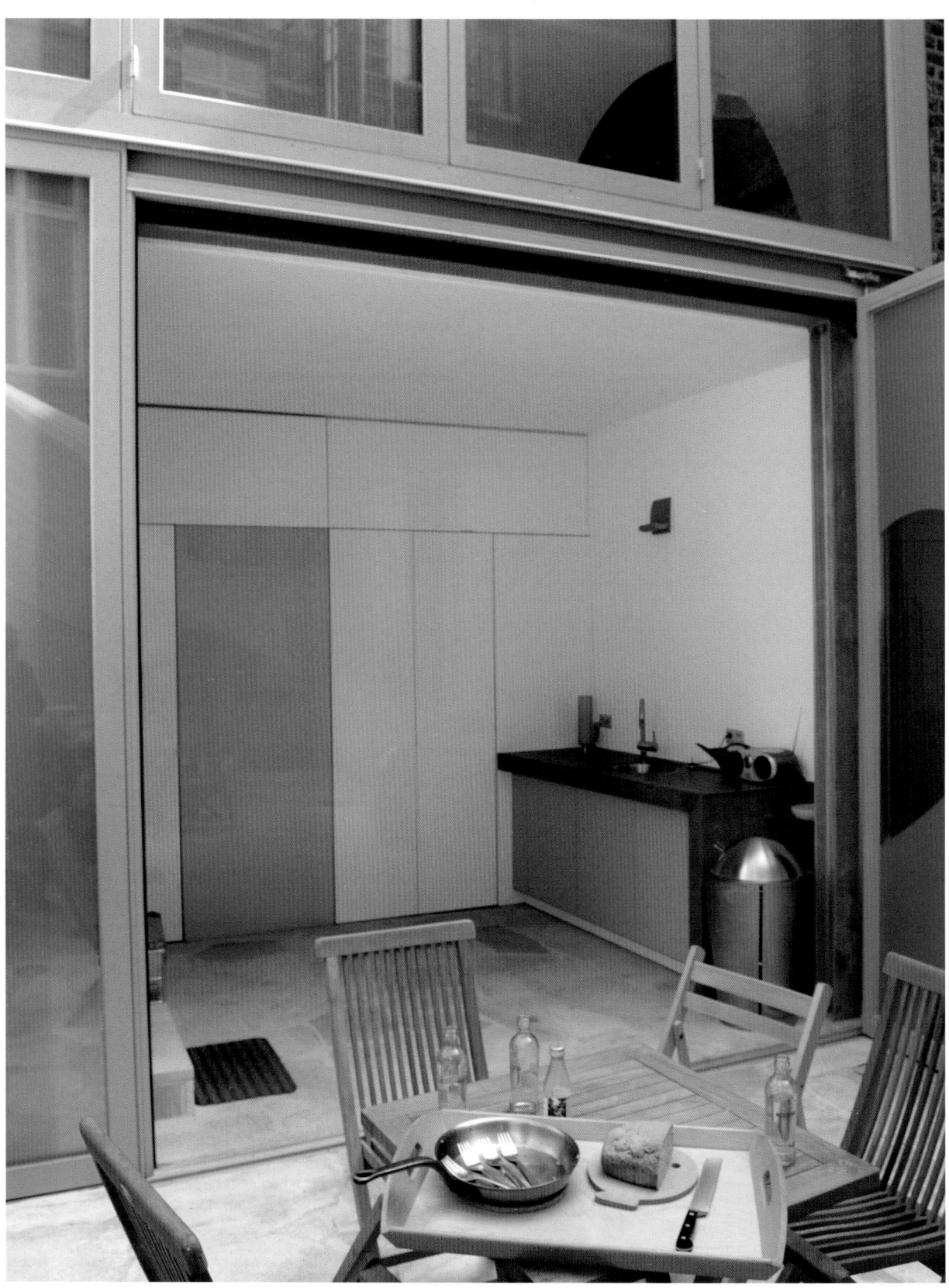

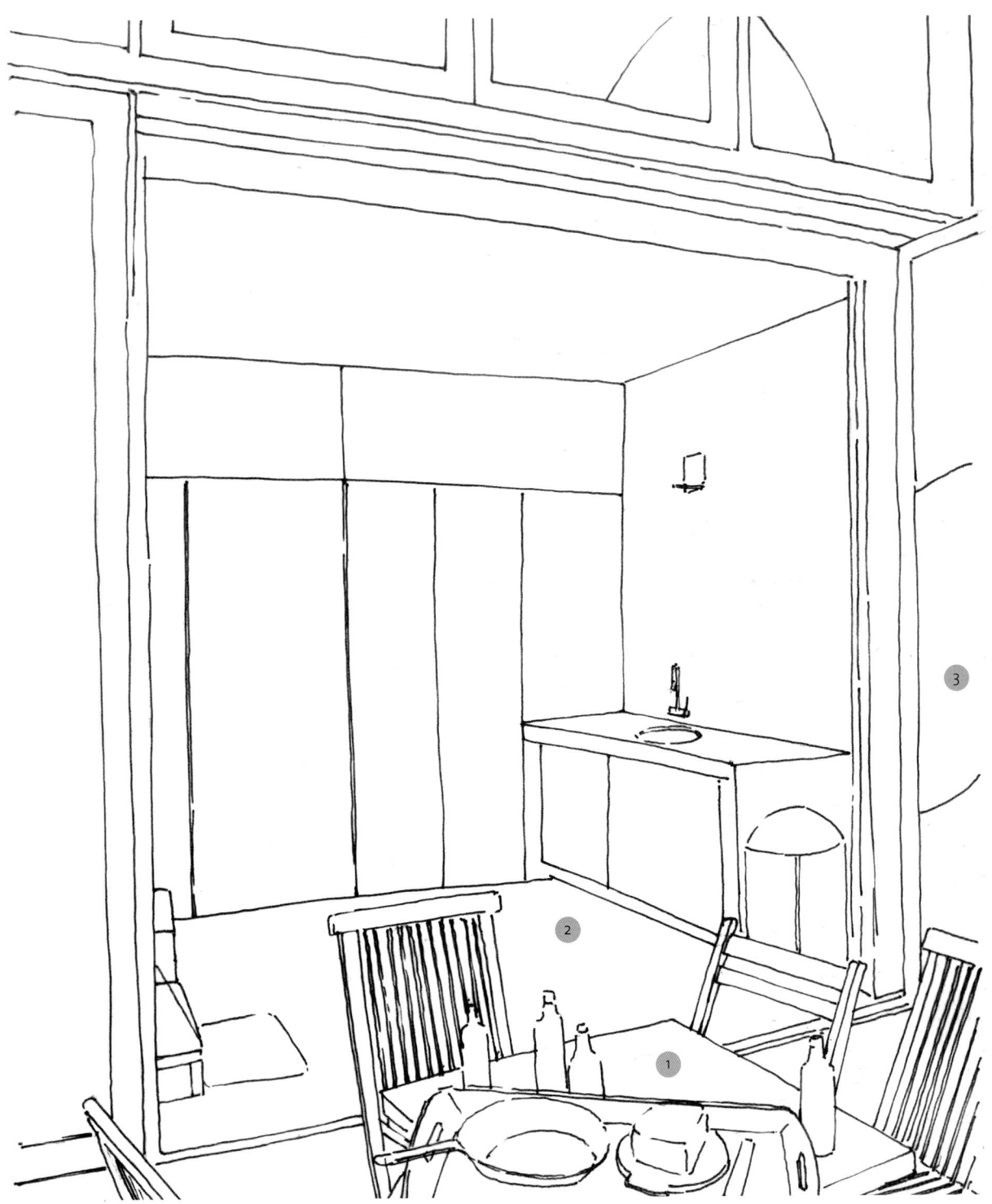

1_ In fair weather the interior and exterior form one, larger room. This design is all about bringing air and light into the building, and opening the building out to the exterior.

2_ The continuous pavement both indoors and out helps to blend the spaces more seamlessly. The shapes of the stones in the pavement are mimicked by the blobs in the windows.

3_ The accordion-fold door allows a wide opening to be made fairly easily.

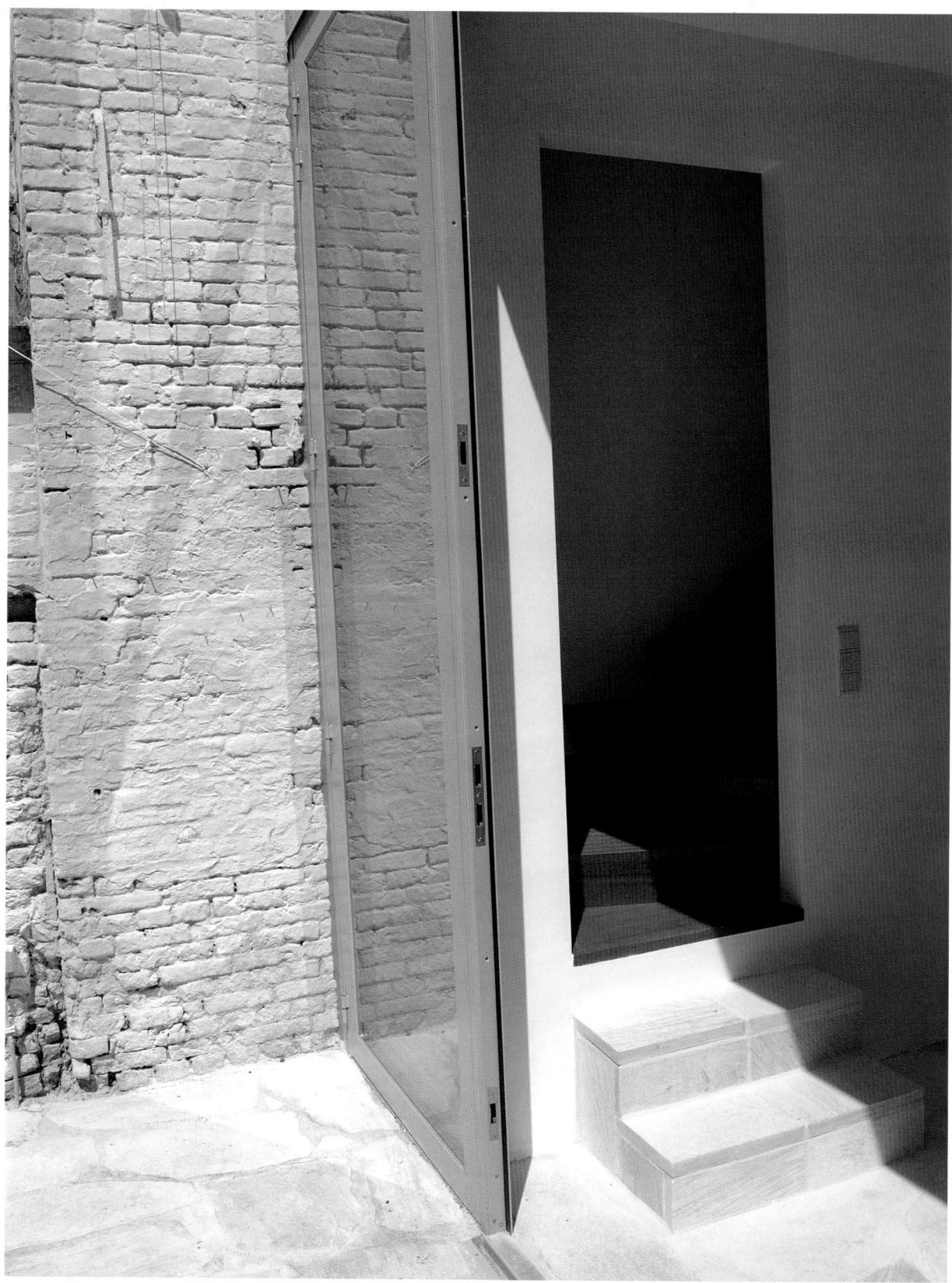

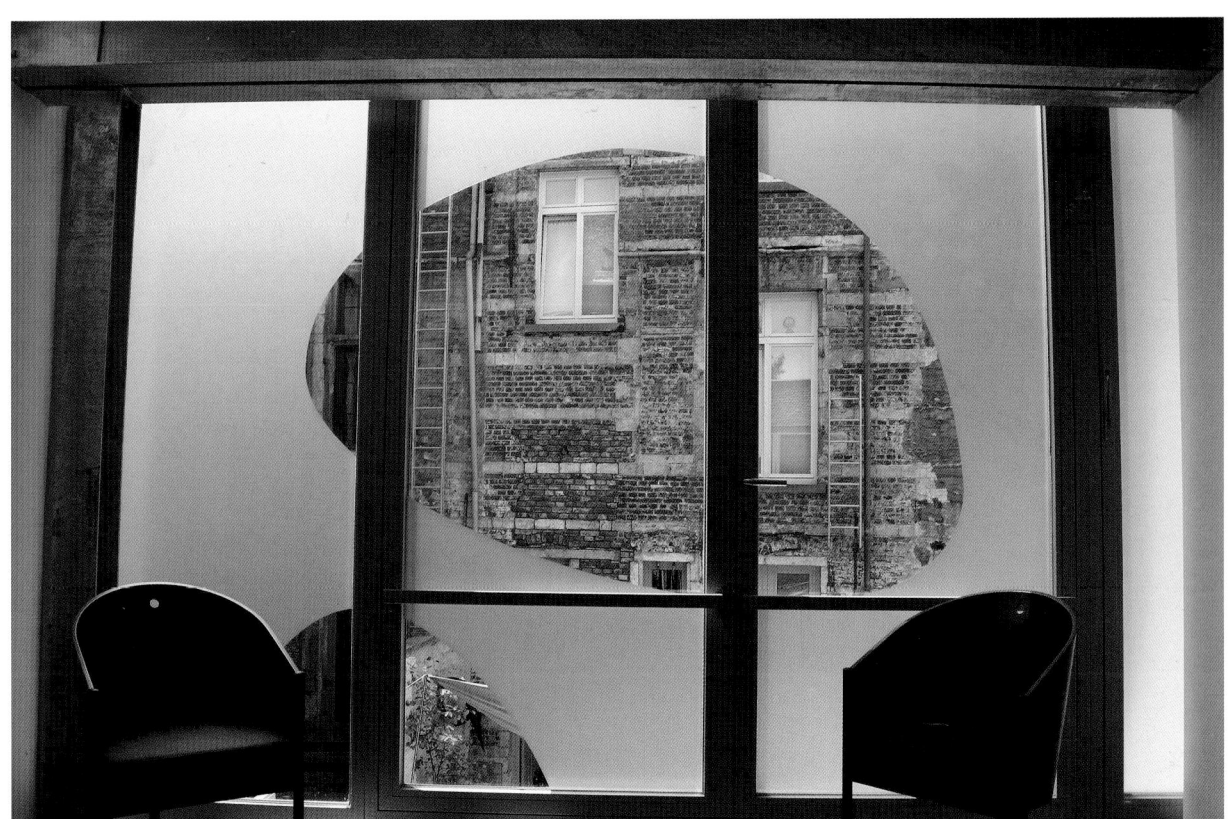

From the upper level the view through the closed glass panels is as truncated as it would be by a typical window opening, providing some privacy, but light floods in across the entire wall. The frosted portions of the glass spread the light more evenly across the space. The shape of the clear "window" can be anything, and these shapes are charming and relaxing.

Studio Apartment in Antibes

323 sq. ft.

Located along a rampart close to the seaside, the Grimaldi Castle and the former studio of Picasso, now the main offices of the Picasso Museum, this 323-square-foot apartment consists mainly of a big open space (26,9 x 10,8 ft.). A large window opens towards the sea.

The client, who owns a larger apartment on the floor above, intended to convert the space into a comfortable place for guests.

A new masonry wall was built, oriented along the axis that connects the entry door and the window. The new space organization was accomplished by means of custom-designed built-in cabinetry. A free-standing volume contains the bedroom. Along the wall near the entrance is a fully equipped kitchen. Two openings in the volume allow the possibility of enjoying views of the sea from the bedroom.

Architect: Luca Rolla

Location: Vieille Antibes, France

Completion date: 2002

Photographer: © Matteo Piazza

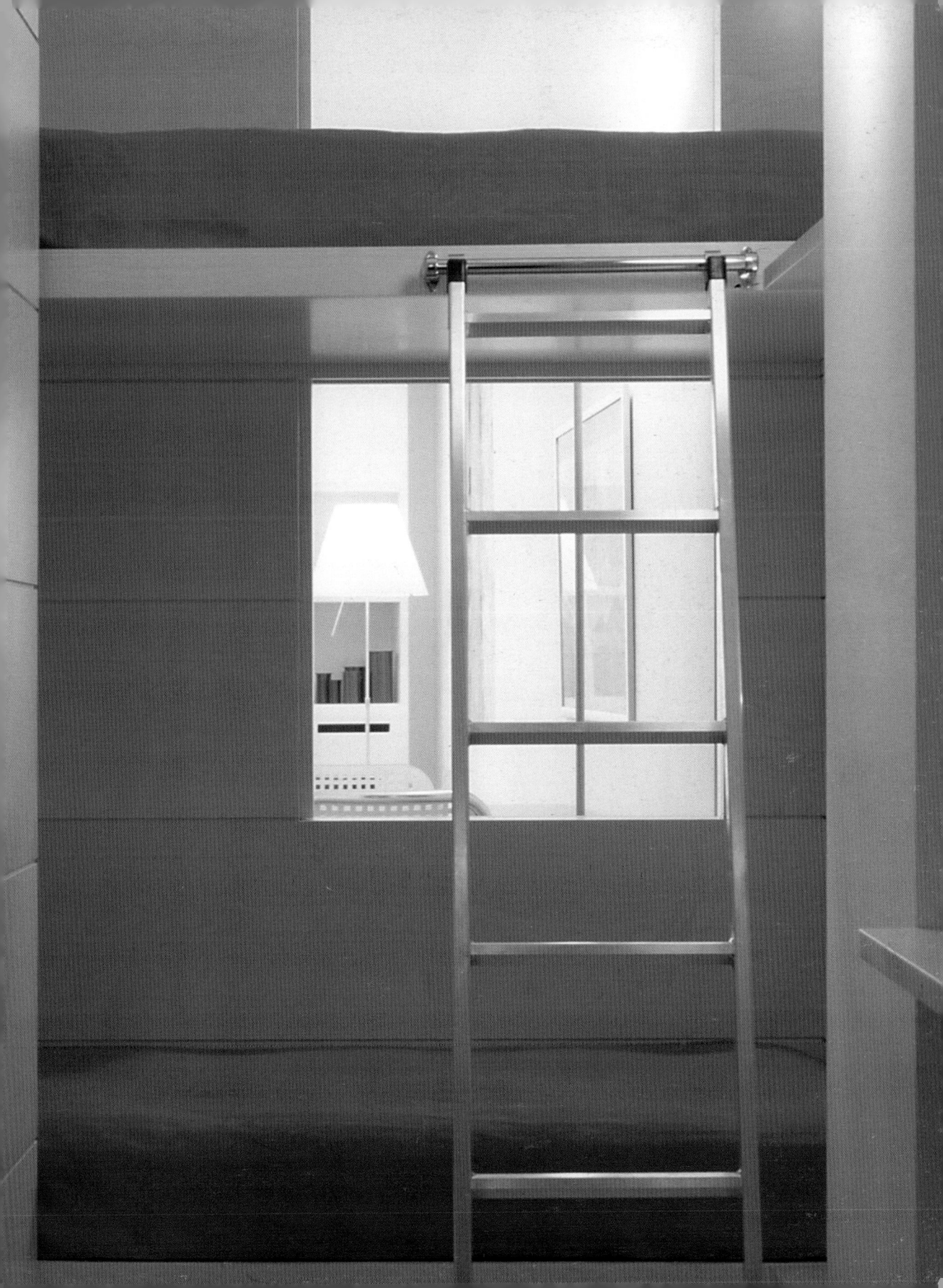

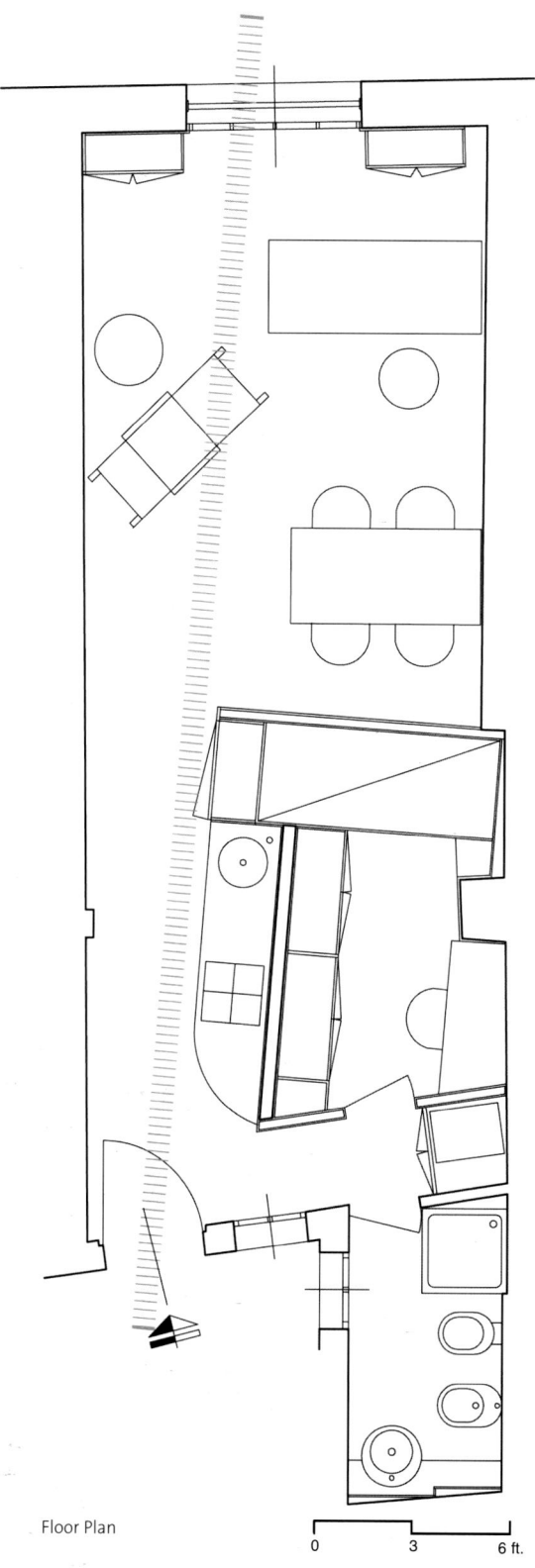

Floor Plan

0 3 6 ft.

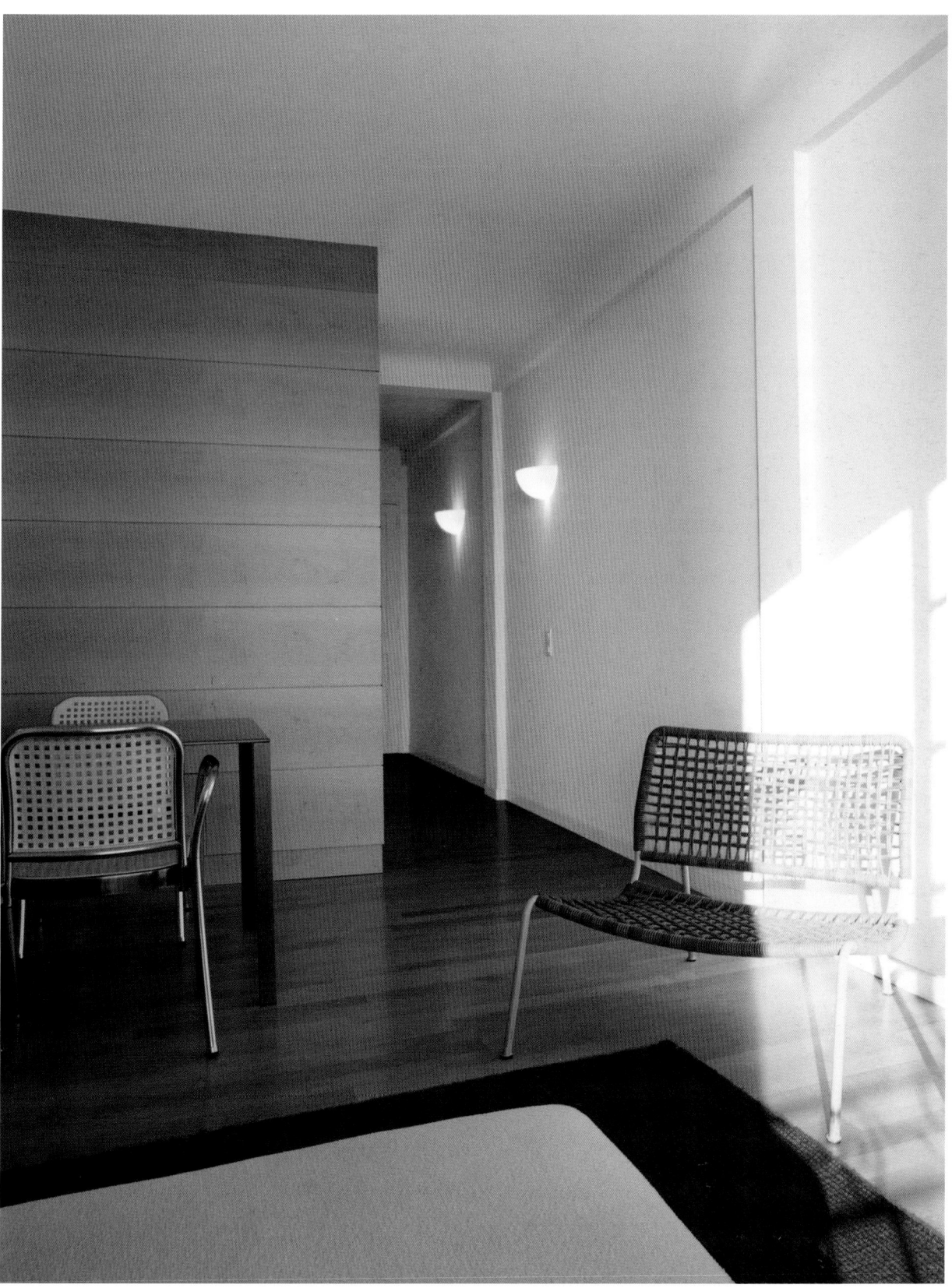

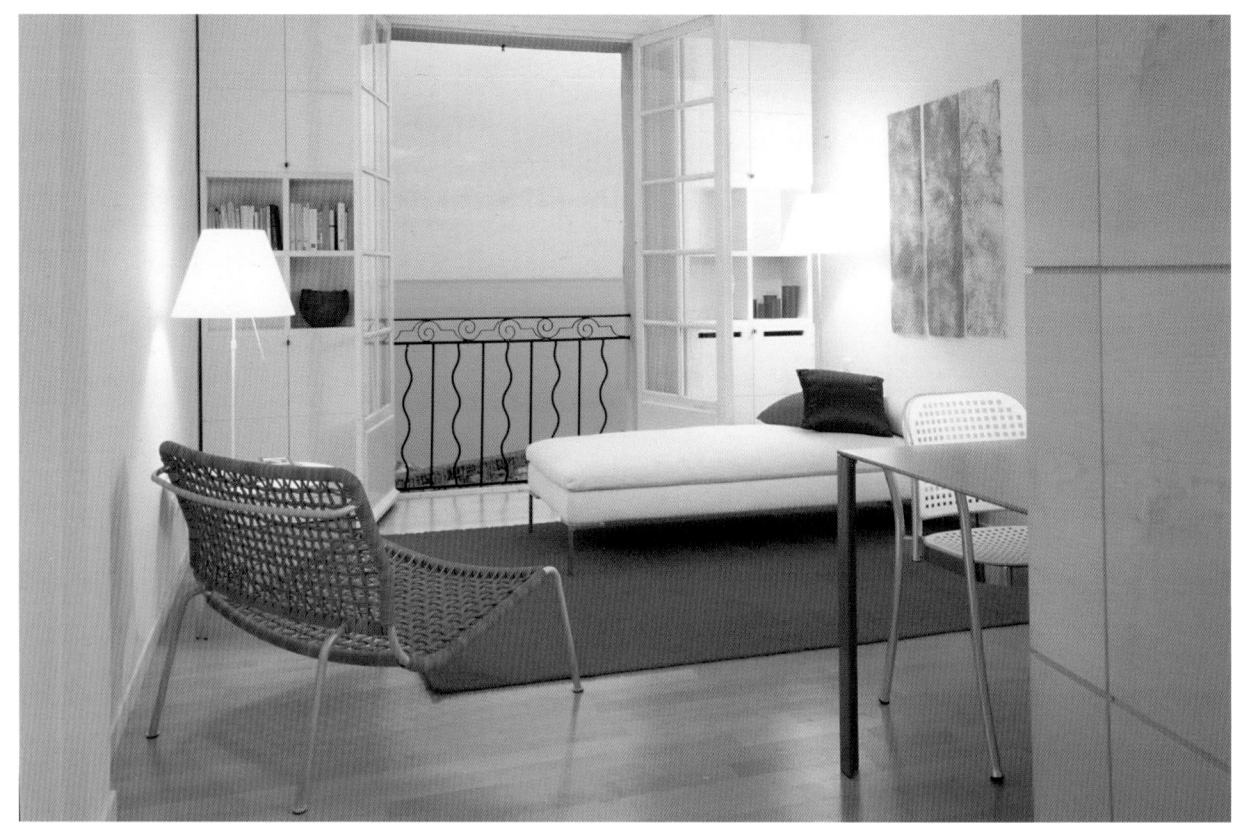

It was determined that the window was to be an important element of the design, which would emphasize and frame the view of the sea. The rhythm of the grid of window panes continues onto the flanking casework elements.

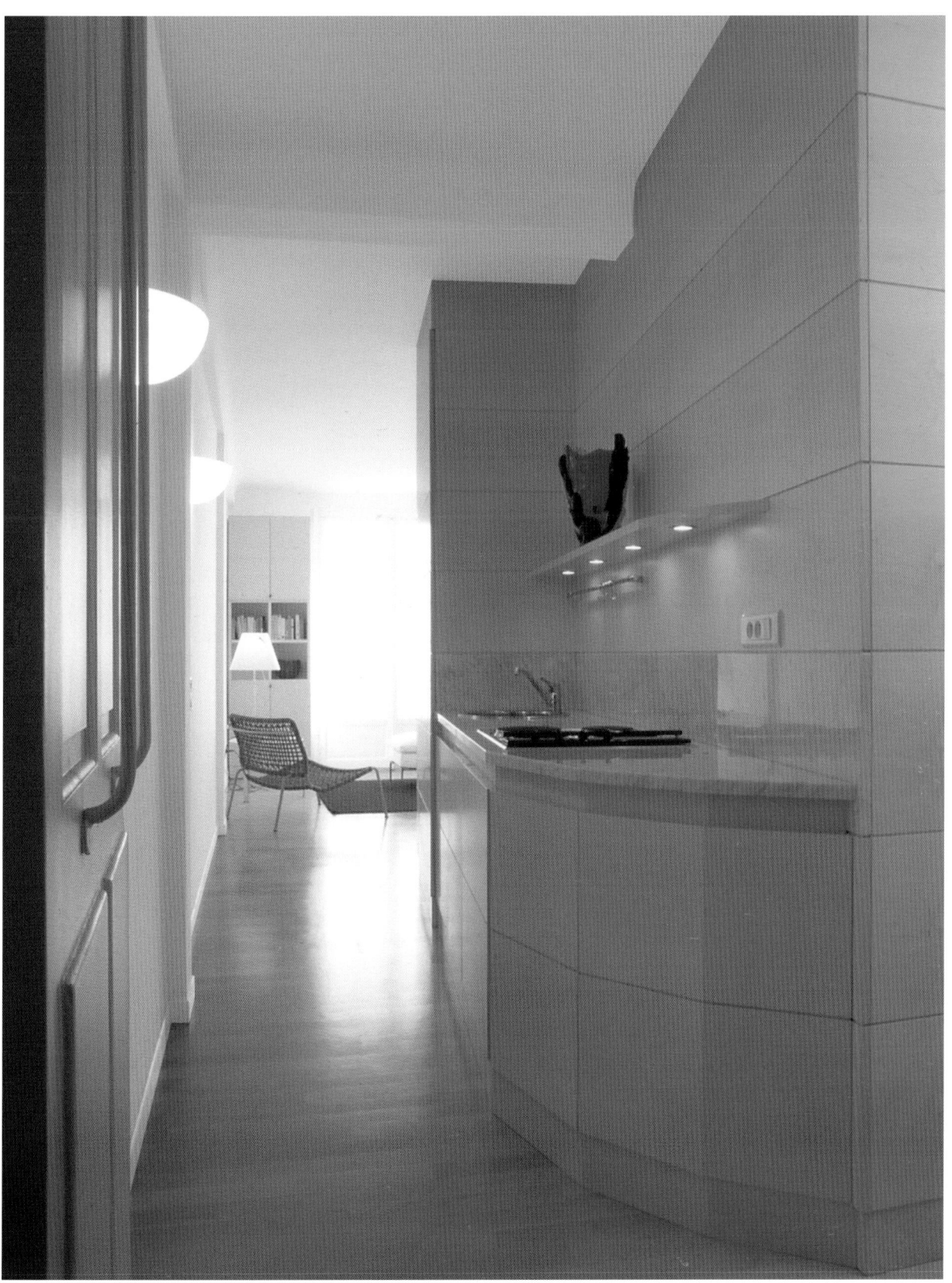

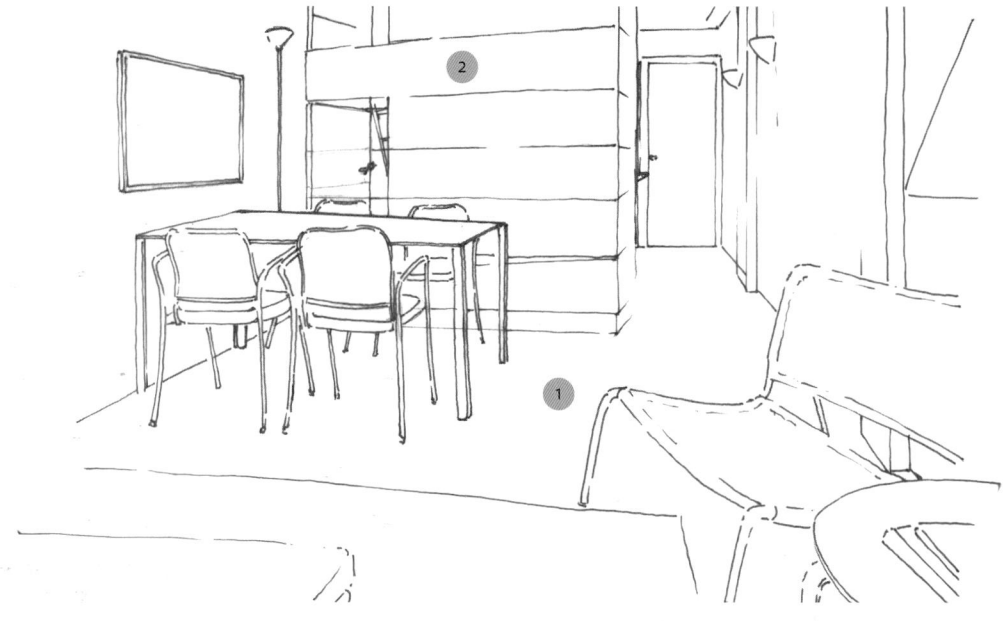

1_ The main space is entirely white while the volume is clad in maple wood panels. The same wood is applied to the flooring, giving the space a golden shade.

2_The horizontal grooves between panels run along the volume enhancing the sense of perspective.

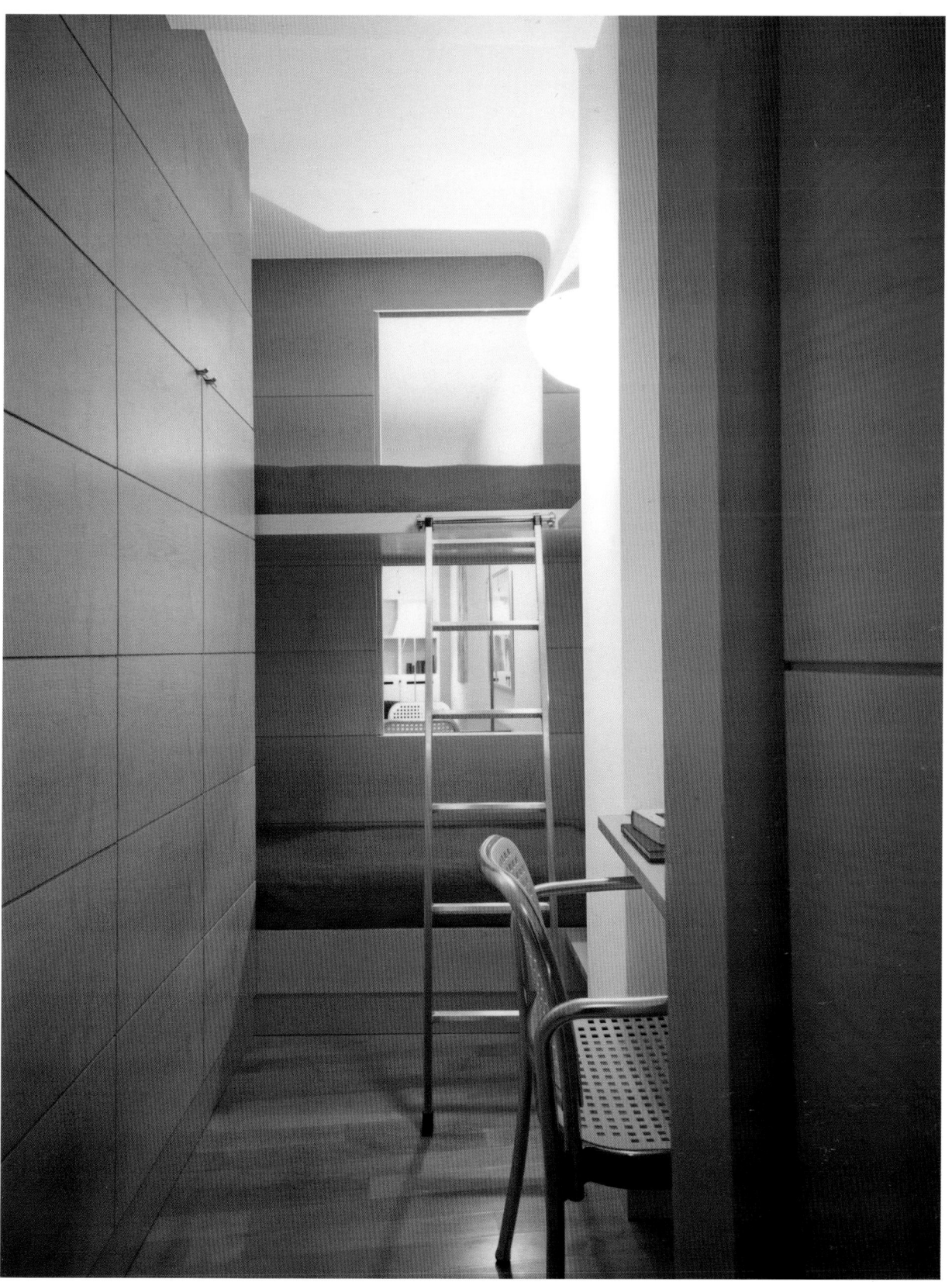

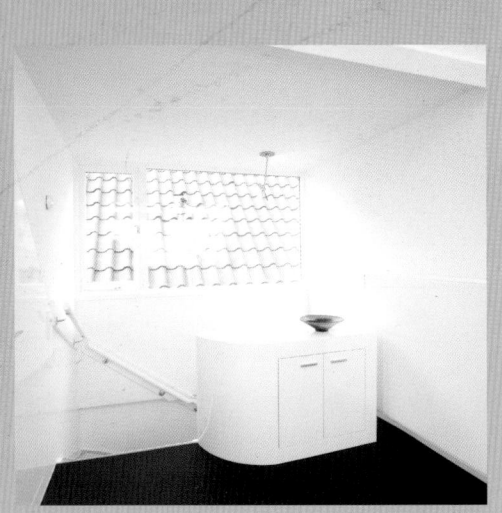

Maff Apartment

323 sq. ft.

Maff Apartment is a hotel room located in the attic of a private house in The Hague. The limited floor space of 323 square feet permitted a layout that incorporates the basic facilities of the home: a sleeping accommodation for two, a dining area that seats four, a kitchen, a toilet, a bathroom with shower and generous space for storage. By means of a thoughtful design, a spacious environment is created in spite of the reduced area; comfort is nonetheless a key element not to be sacrificed. Also, the Maff Apartment has a clear and strong identity that provides the occupants with a sense of uniqueness. The various functions are organized along the perimeter of a central open space that receives daylight from the large skylights. The kitchen links the toilet, washbasin and shower at one end of the apartment to the dining area and the sofa bed at the other end.

Architect: Queeste Architecten

Location: The Hague, The Netherlands

Completion date: 2007

Photographer: © Teun van den Dries

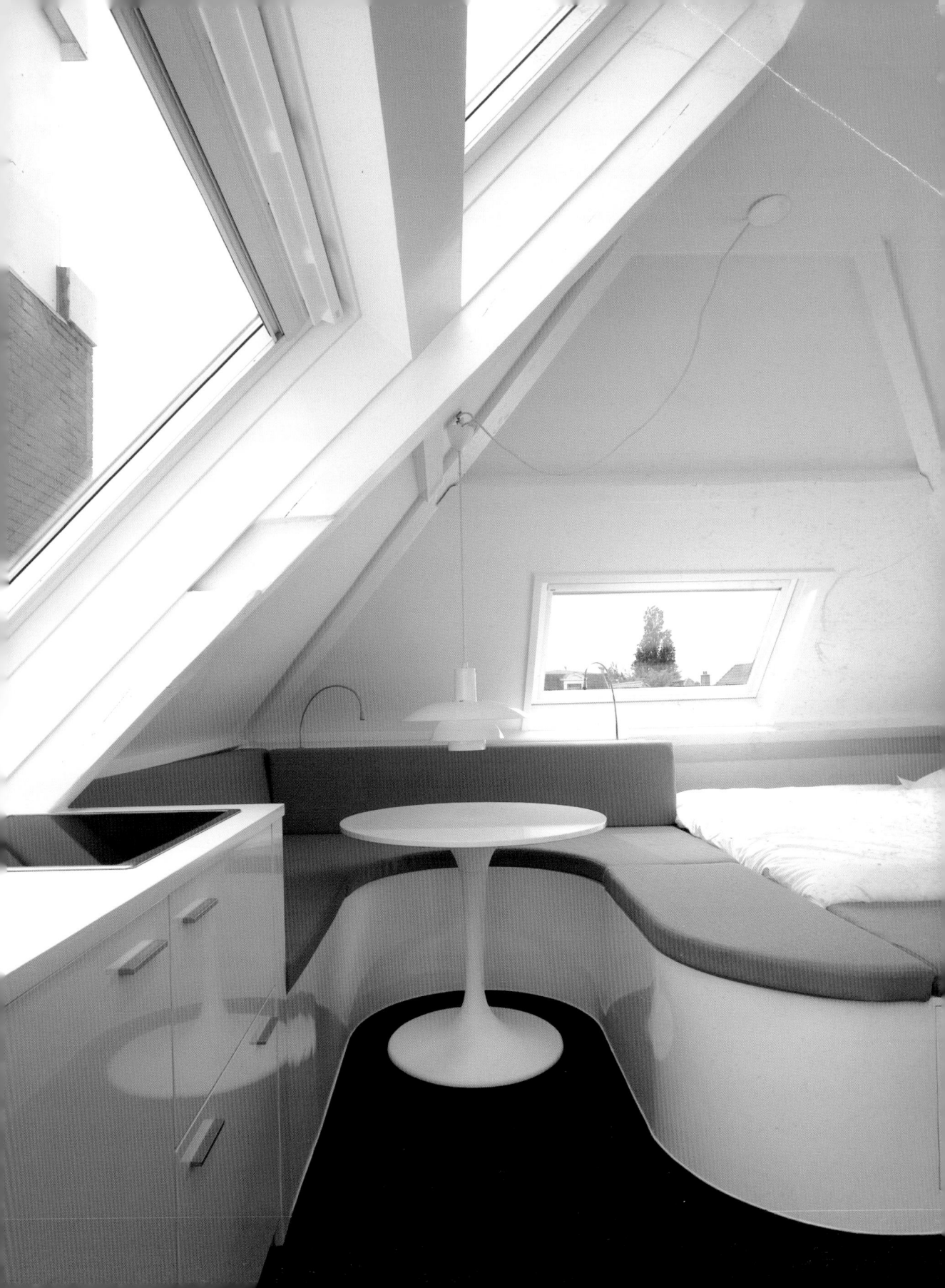

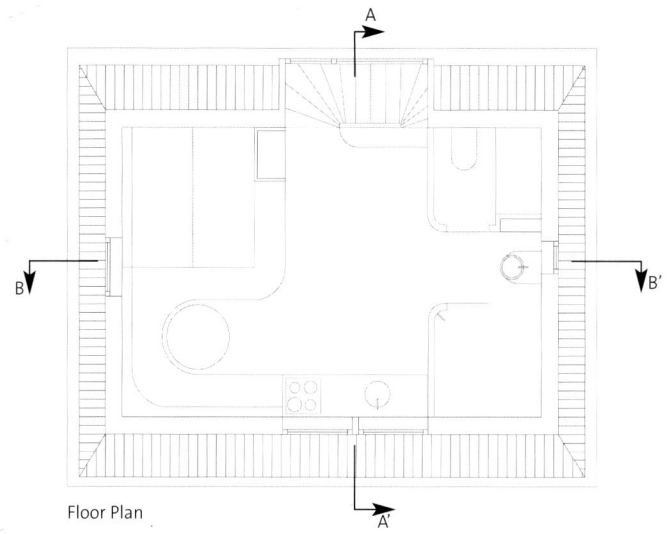

Floor Plan

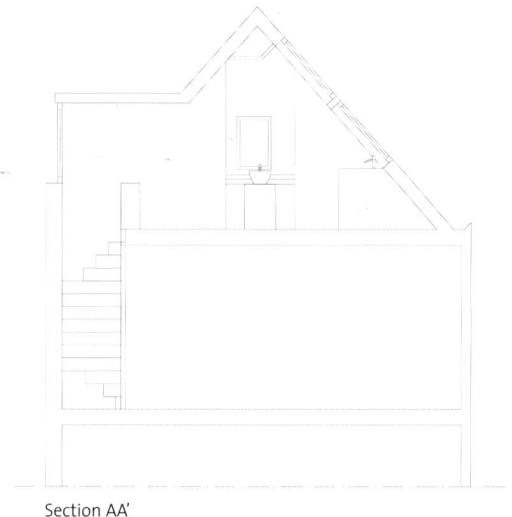

Section AA'

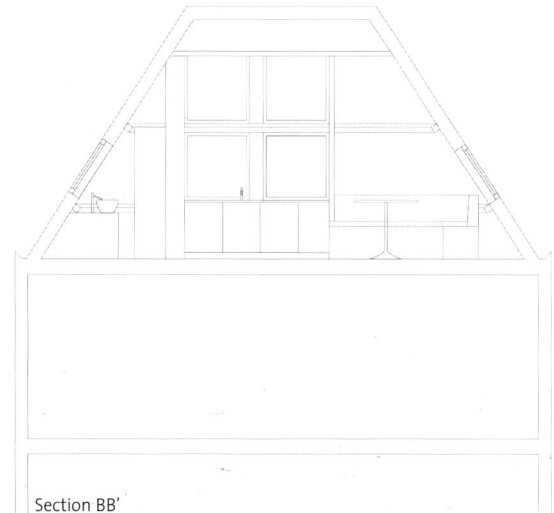

Section BB'

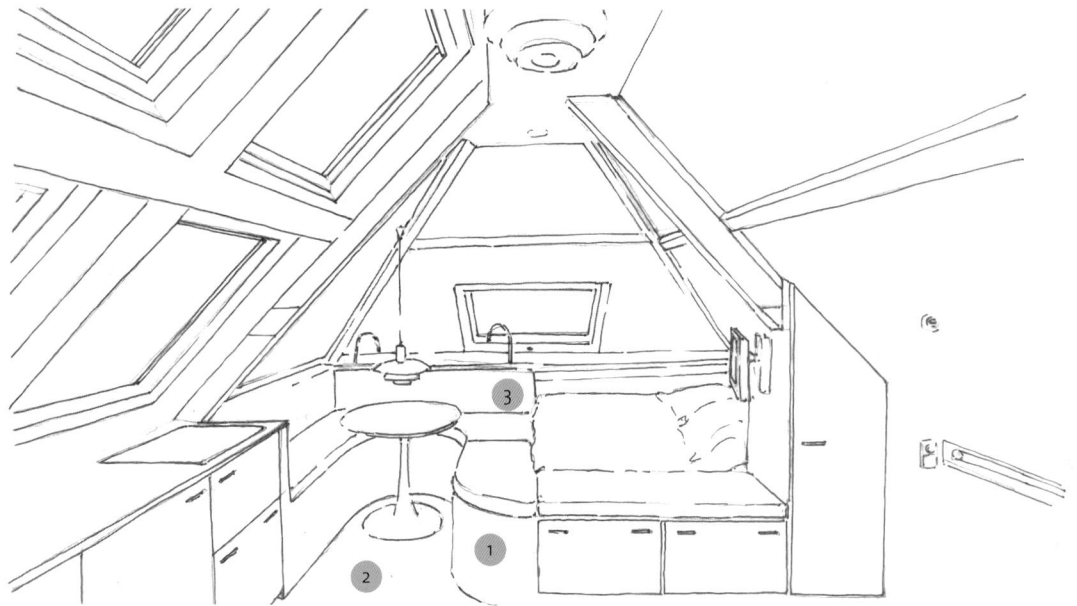

1_ Rounded corners were used throughout to imbue the small space with a sense of softness.

2_ The seamlessly poured anthracite epoxy floor is used to bring unity to the space and emphasize the continuous line of built-in furniture.

3_ The color scheme is kept minimal. The bright orange color of the sofa pillows alludes to the rooftops of the historical center of The Hague.

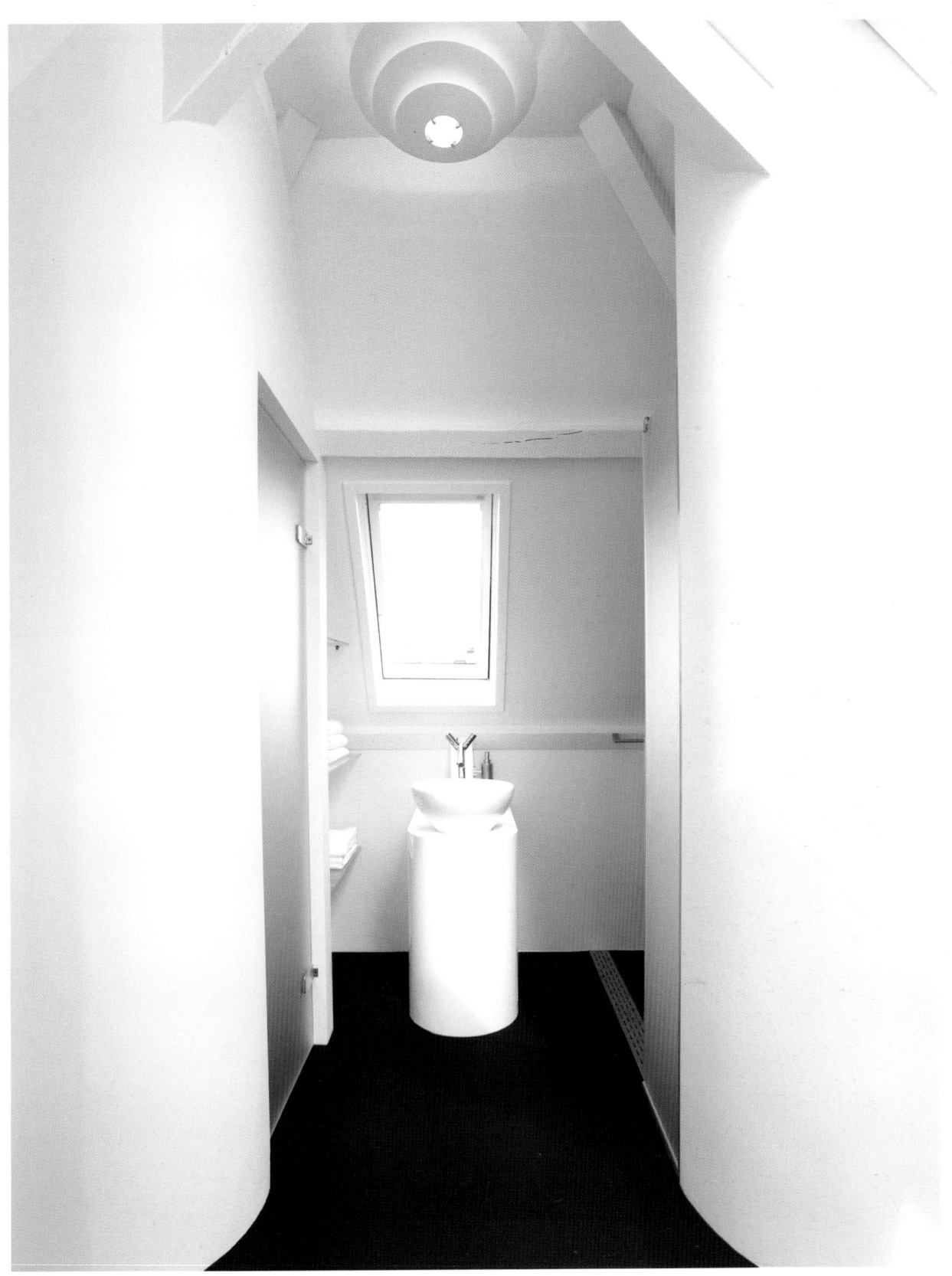

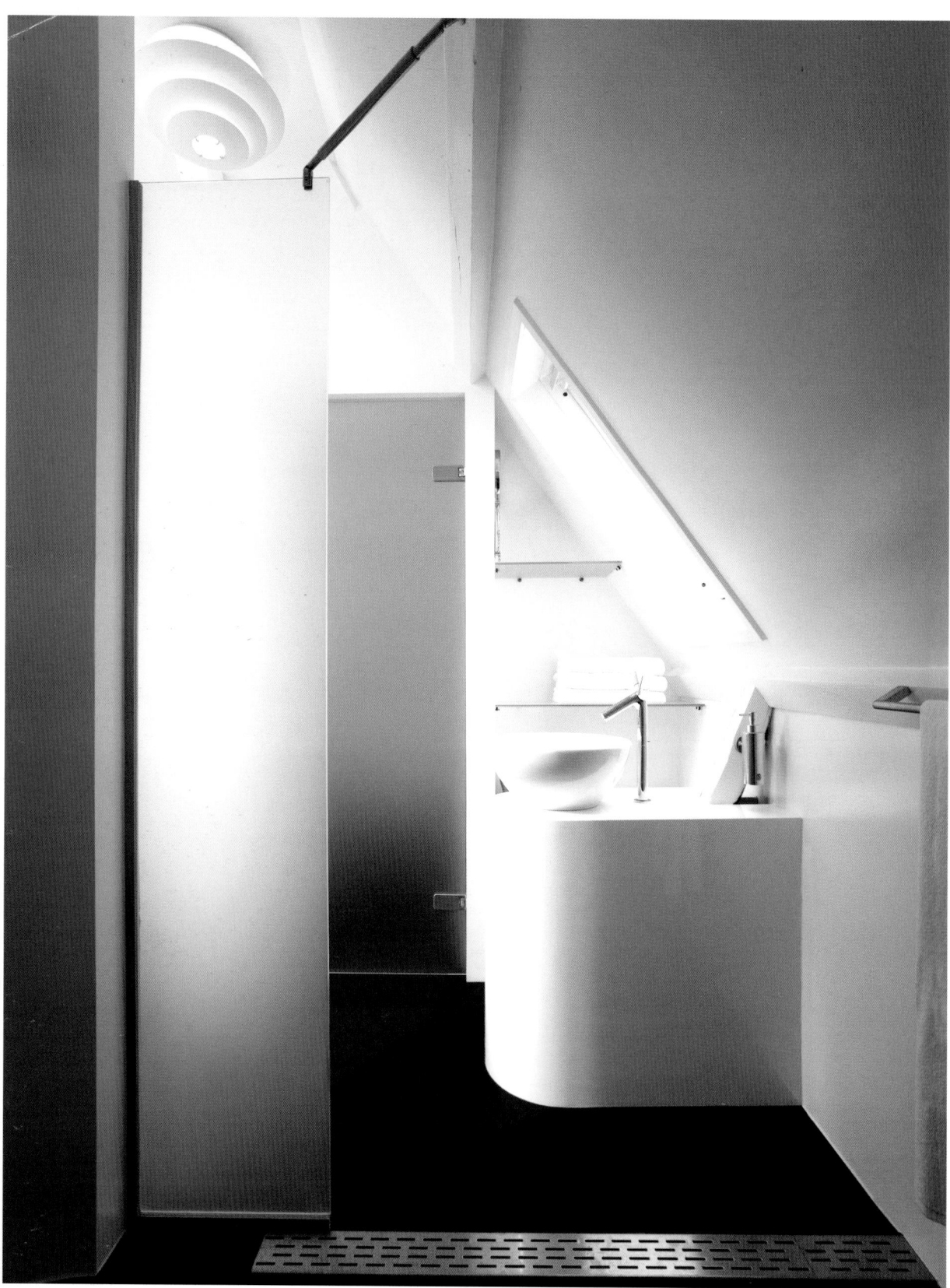

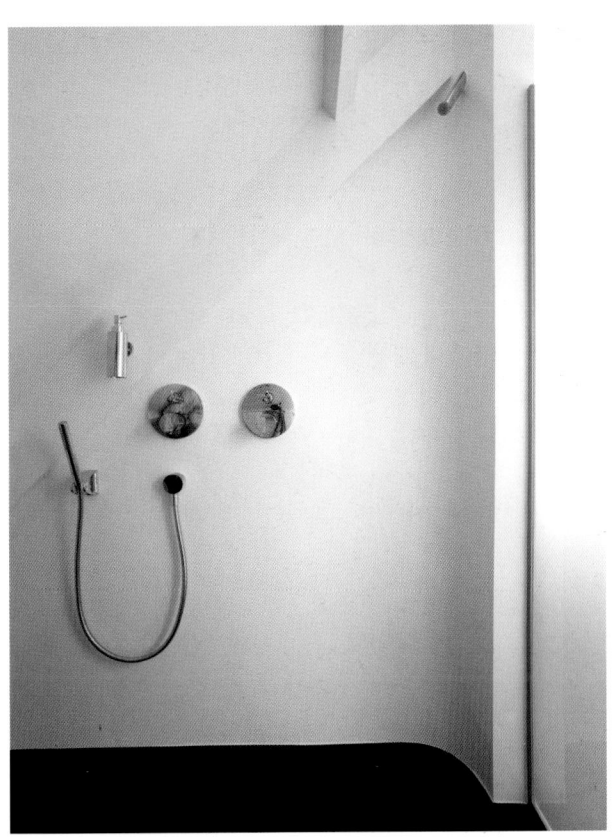

miniHome

340 sq. ft.

The miniHome is categorized as a recreational vehicle with the facilities of a comfortable small apartment. The miniHome is a self-contained, sustainable and modular response to environmental issues, and the increasingly high prices of real estate and resources. The construction materials were carefully selected for their durability and minor environmental impact without sacrificing the visual aspect. The result is an energy efficient 340-square-foot space that is easy to operate.

The interior is cleverly organized, making the best of every corner for much-needed storage space, and creating solutions for workspace by means of multi-tasking furniture. Large, operable windows and double high ceilings help amplify the feeling of spaciousness while additional features such as the hybrid energy system and intelligent controls provide the necessary comfort.

Architect: Altius Architecture Inc. & Sustain Design Studio

Location: Canada and U.S.

Completion date: 2005

Photographer: © Altius Architecture Inc. & Sustain Design Studio

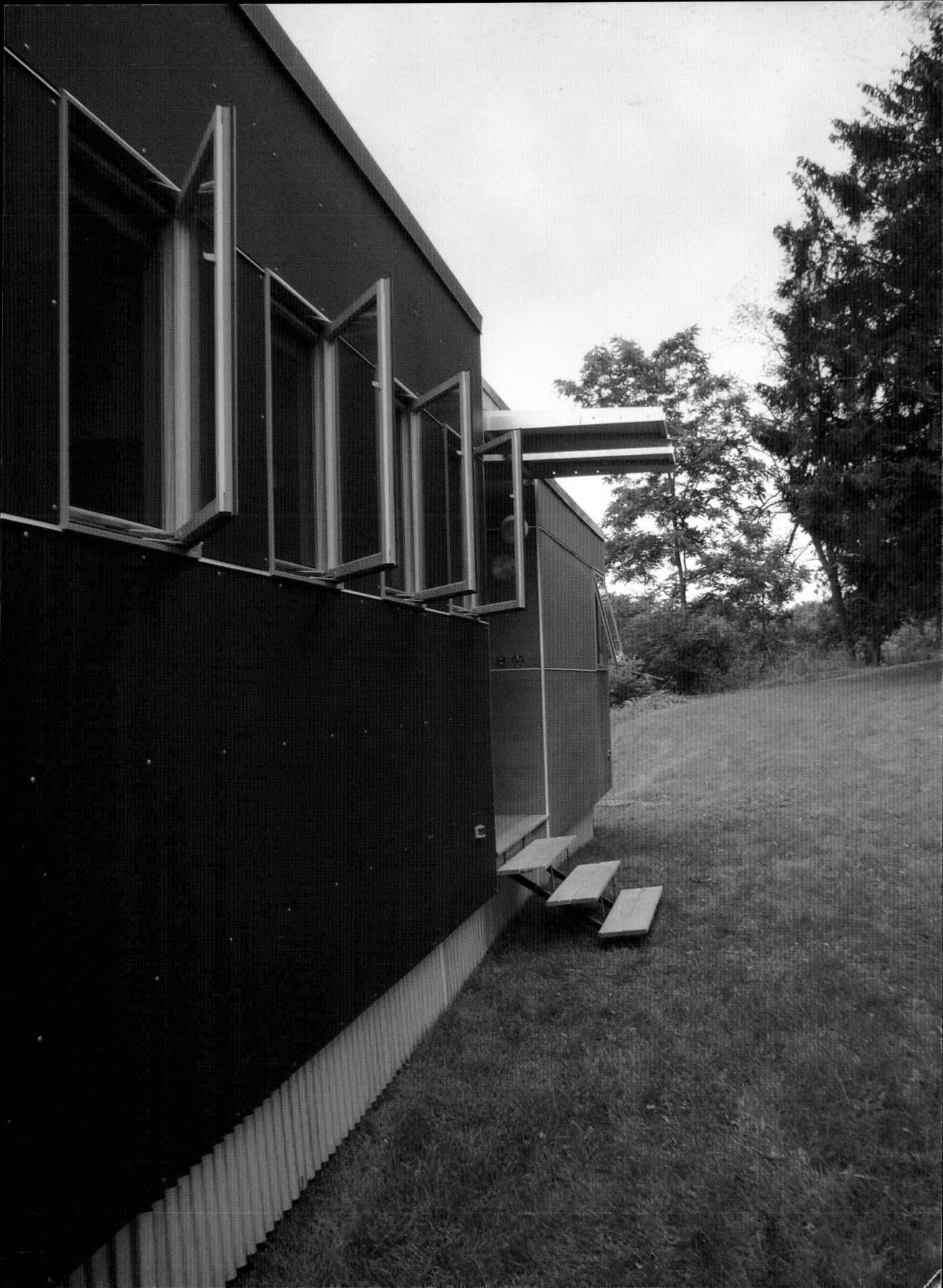

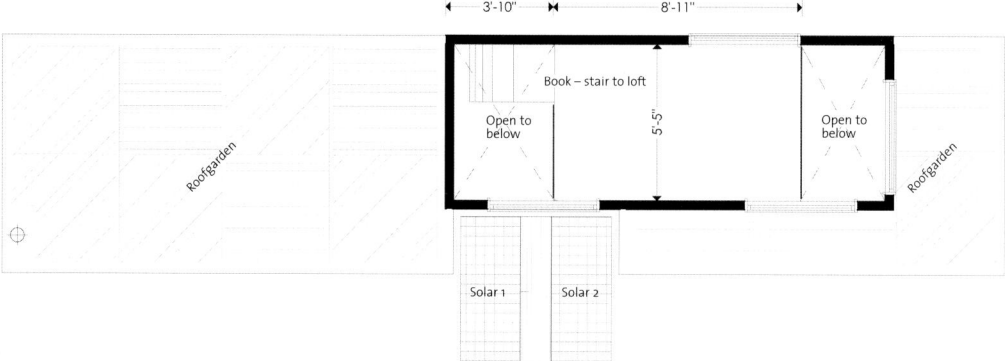

3'-10" 8'-11"

5'-5"

Roofgarden

Book – stair to loft

Open to below

Open to below

Roofgarden

Solar 1 Solar 2

Upper Floor Plan

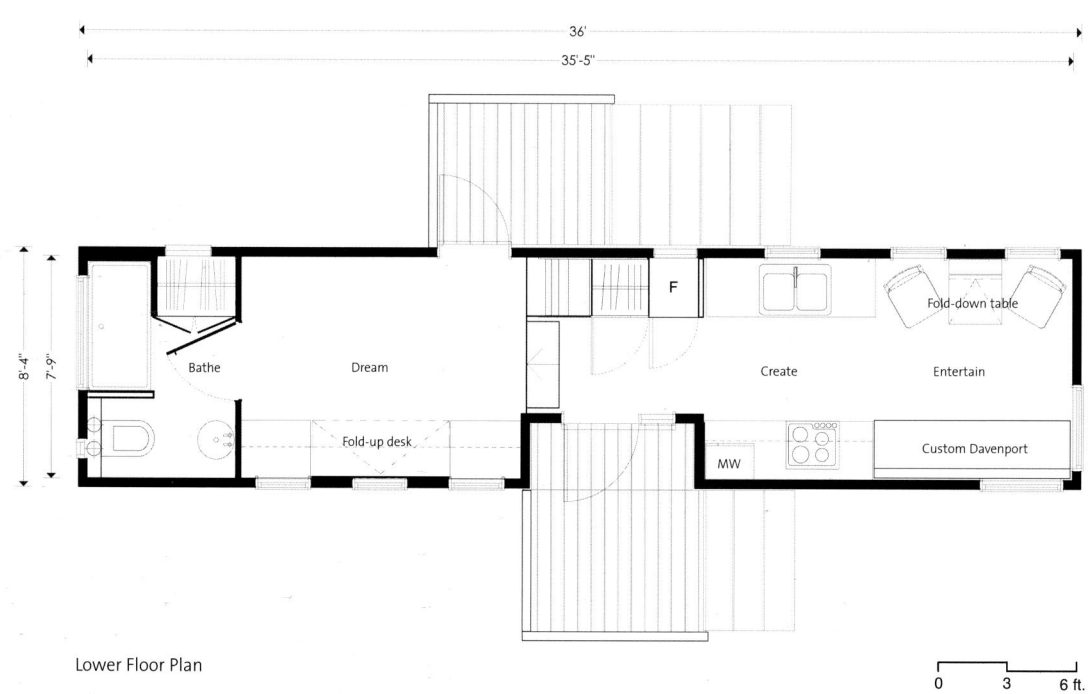

36'

35'-5"

8'-4"
7'-9"

Bathe

Dream

Fold-up desk

F

Create

Entertain

Fold-down table

MW

Custom Davenport

Lower Floor Plan

0 3 6 ft.

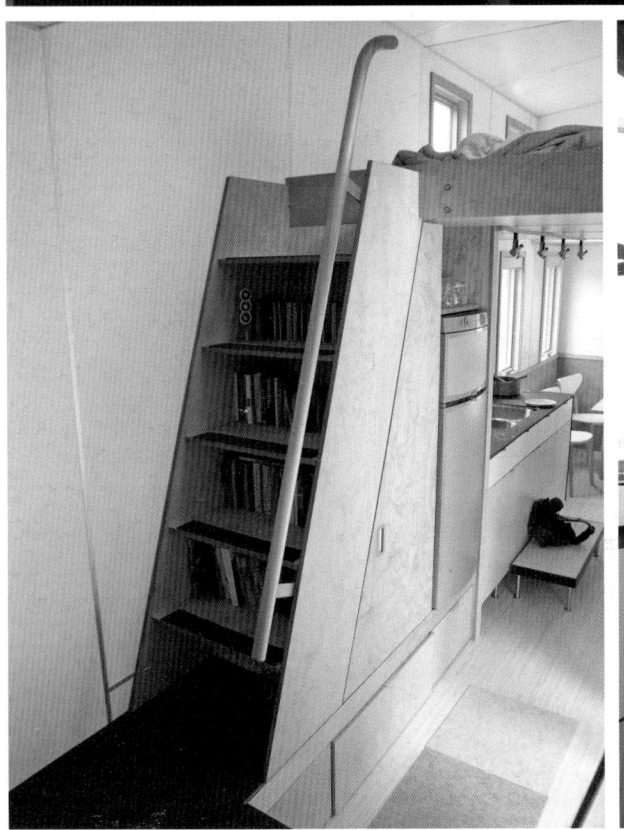
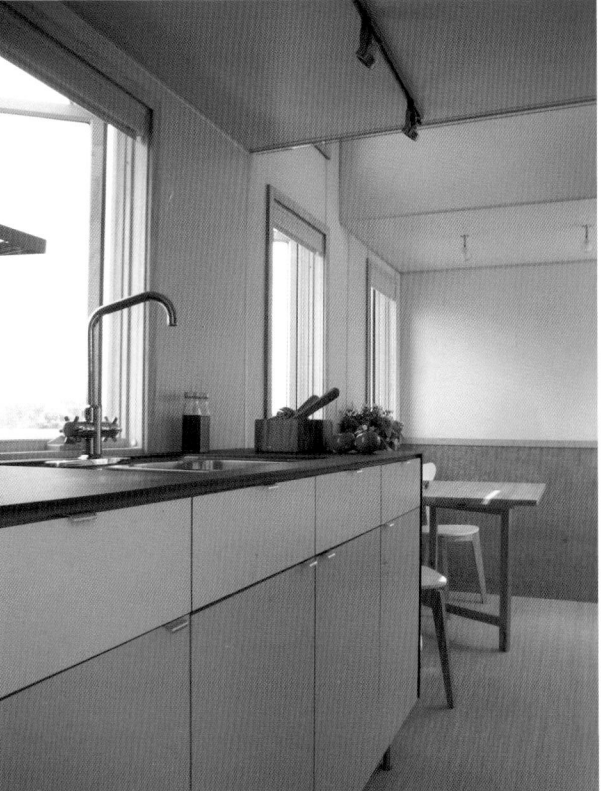

The bed occupies the loft above the entry and dining area, freeing up space below. Nonetheless, to accommodate an occasional visitor, a sofa bed is available down on the main floor.

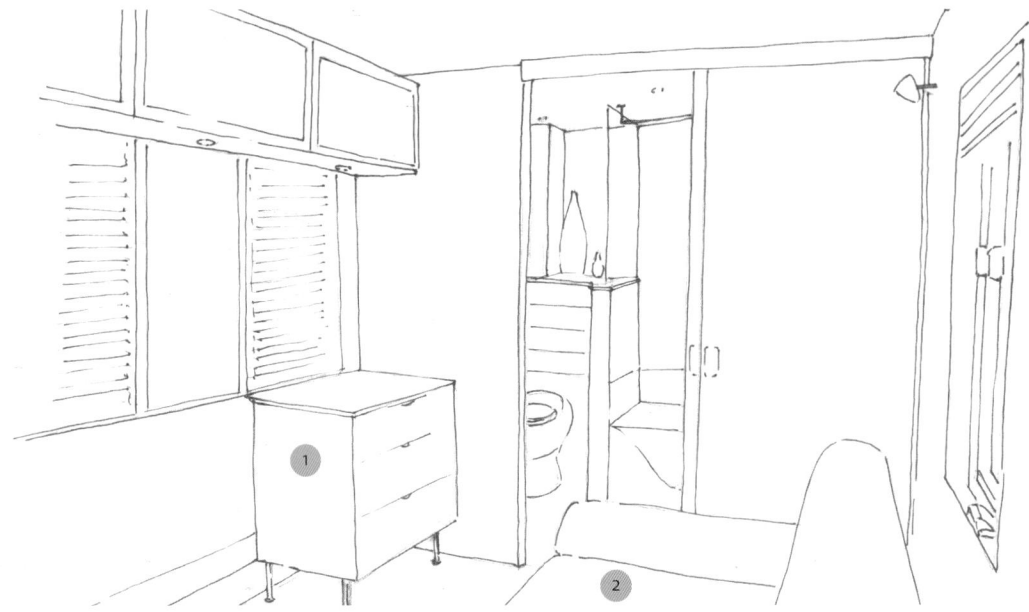

1_ Unlike conventional trailers with their cluttered interiors and cramped furniture layouts, the miniHome utilizes full-size residential furniture to great effect.

2_ Solutions such as folding tables and a sofa bed make the most of the reduced space, avoiding crowding the valuable space unnecessarily.

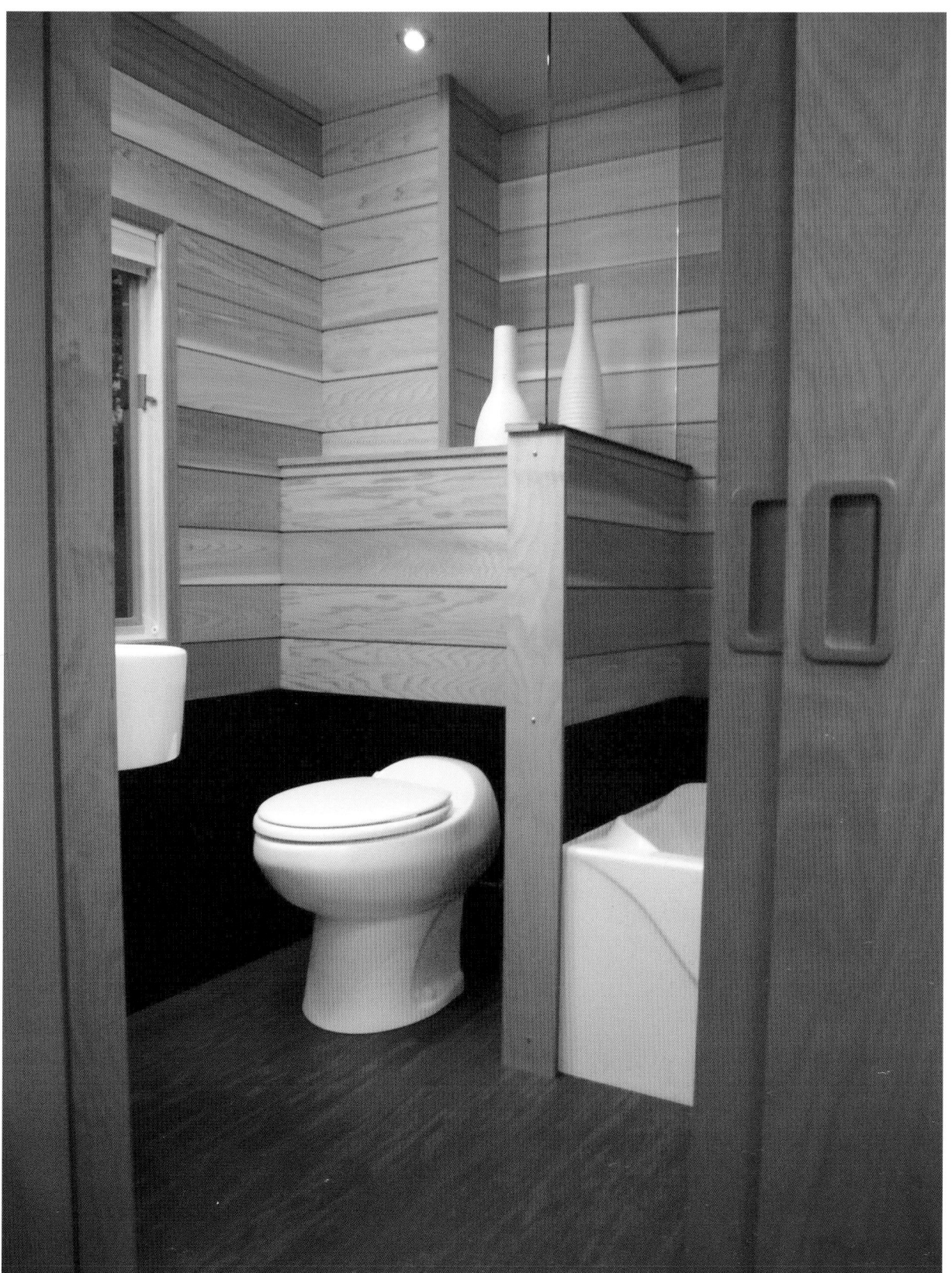

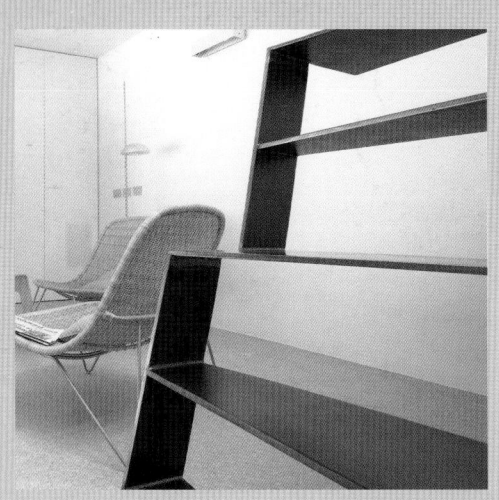

XXS House

463 sq. ft.

XXS House is located in the historic center of Ljubljana. The site of a former service structure adjacent to a traditional house, the general dimensions set by the area's ordinances dictated the overall shape of the house.

The task was to integrate all residential functions in an extremely small volume which would serve as a pied-à-terre for a couple who normally lives in the countryside. Since the house faces north, bringing daylight into the ground floor of the house was a challenge. However, the heritage protection rules allowed light shafts on the roofs. This presented the opportunity to create a fully usable attic space. A large sliding door opens up the space to the private deck and allows for indirect lighting.

Architect: Dekleva Gregoric

Location: Ljubljana, Slovenia

Completion date: 2004

Photographer: © Matevz Paternoster

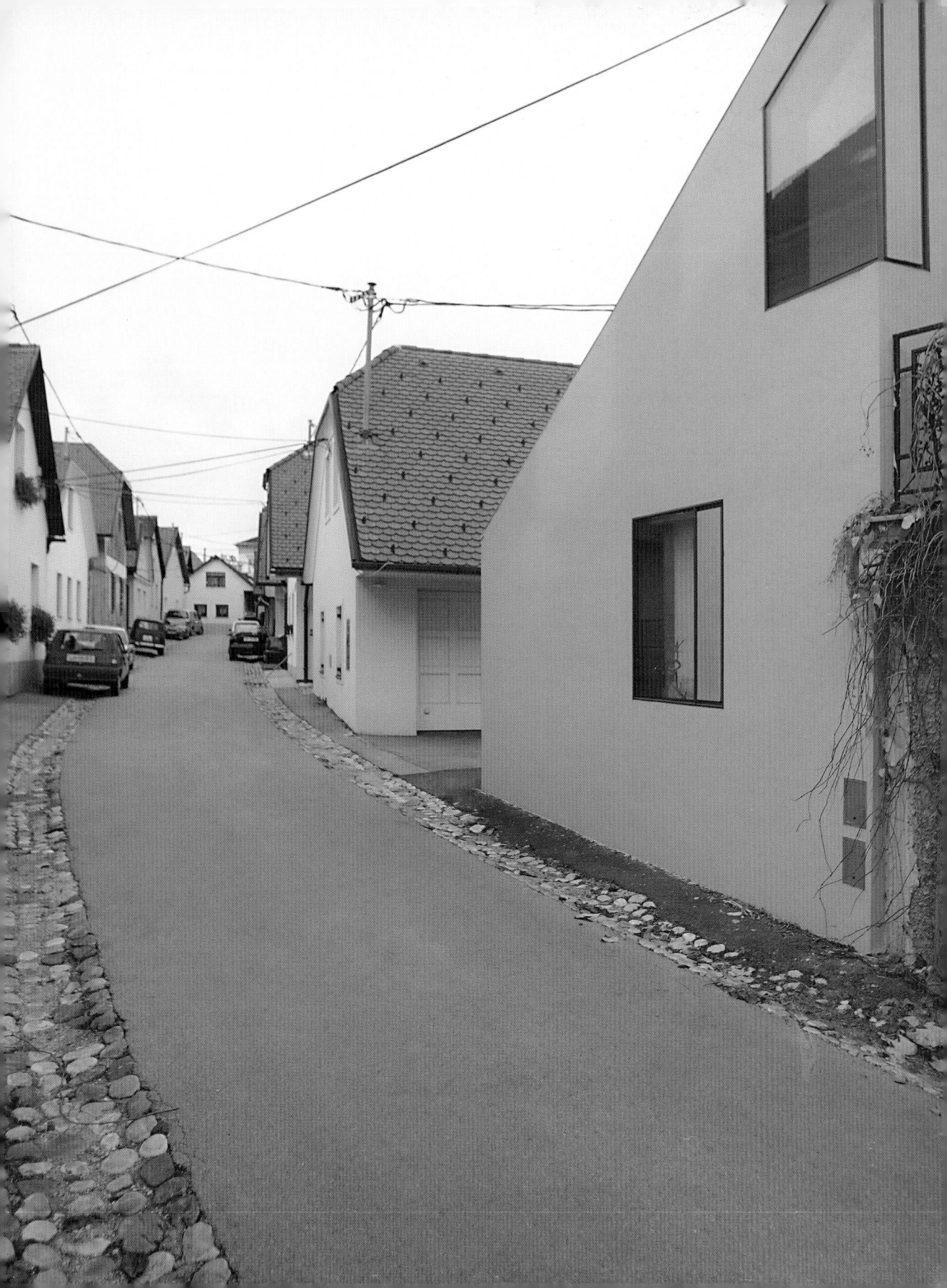

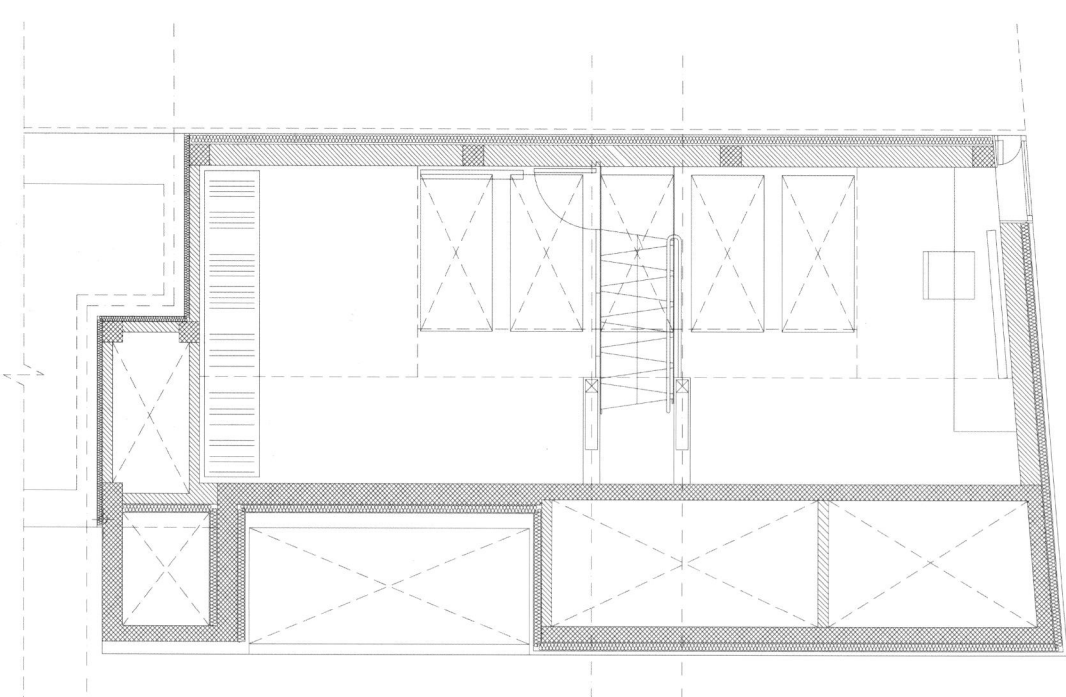

Upper Floor Plan

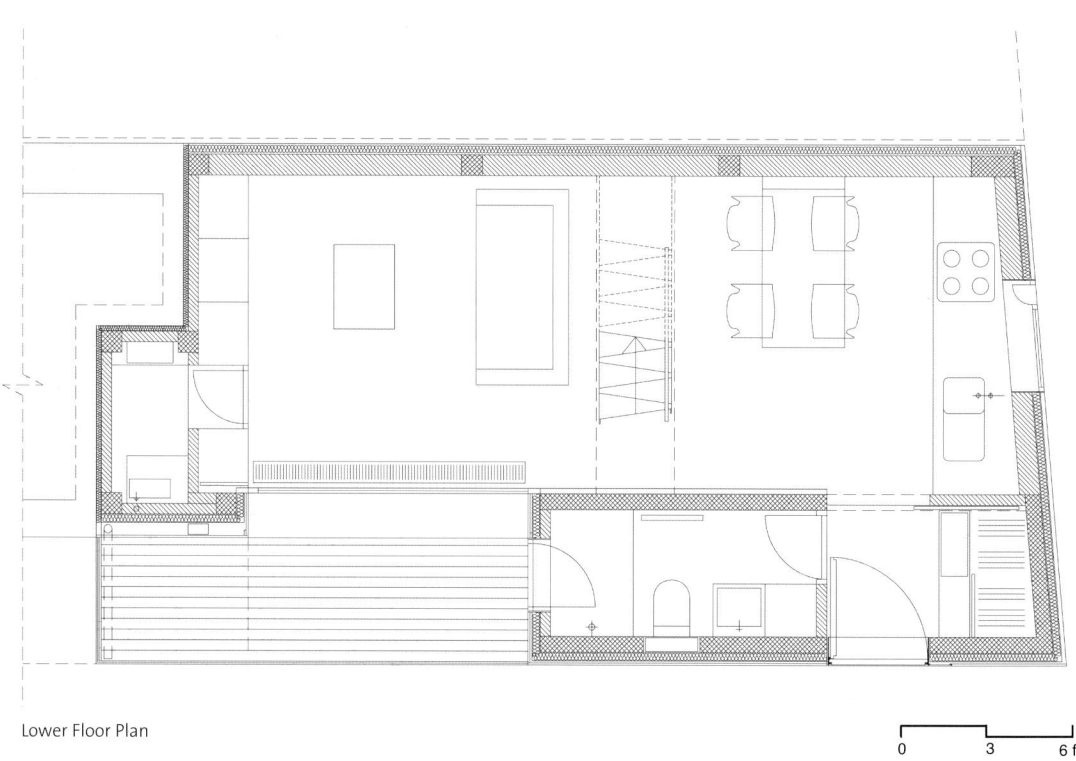

Lower Floor Plan

0 3 6 ft.

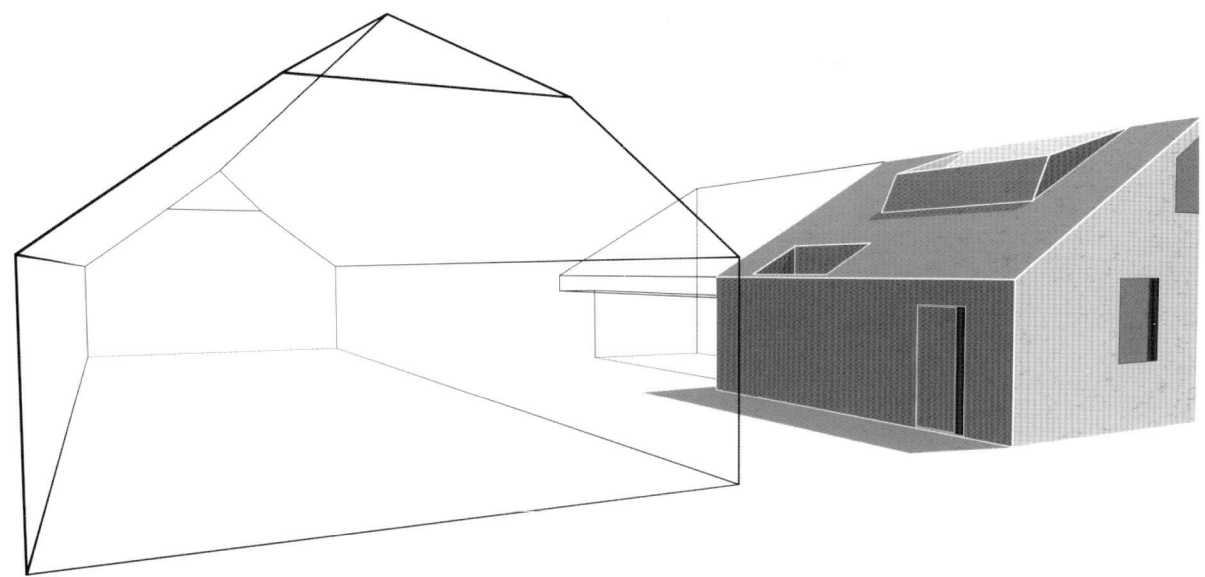

XXS House Rendering and Context

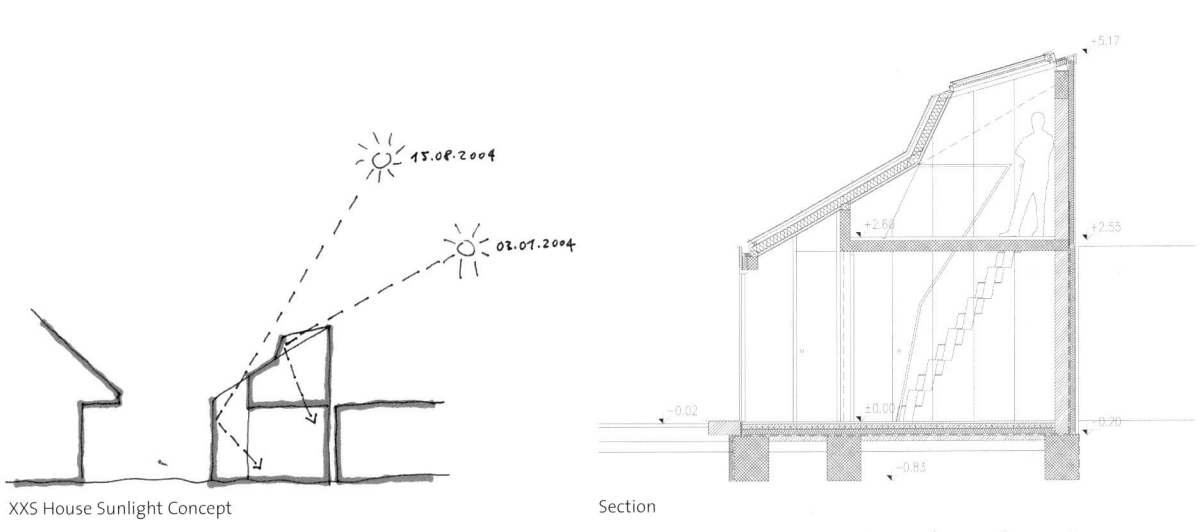

15.08.2004

03.07.2004

XXS House Sunlight Concept

Section

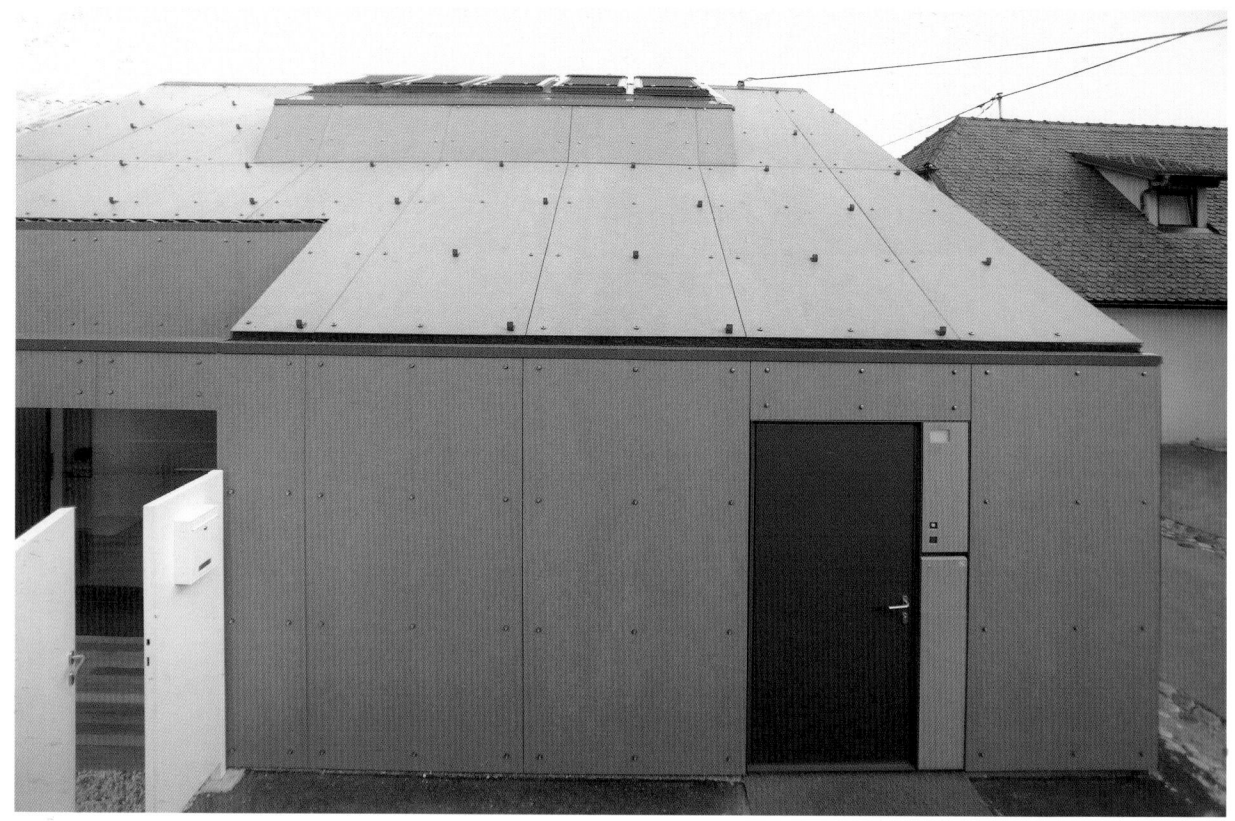

The selection of the façade materials and detailing provide the desired industrial appearance of the house: both the exterior walls and the roof were clad in fiber cement panels. Inside: exposed concrete, terrazzo, plywood and iron.

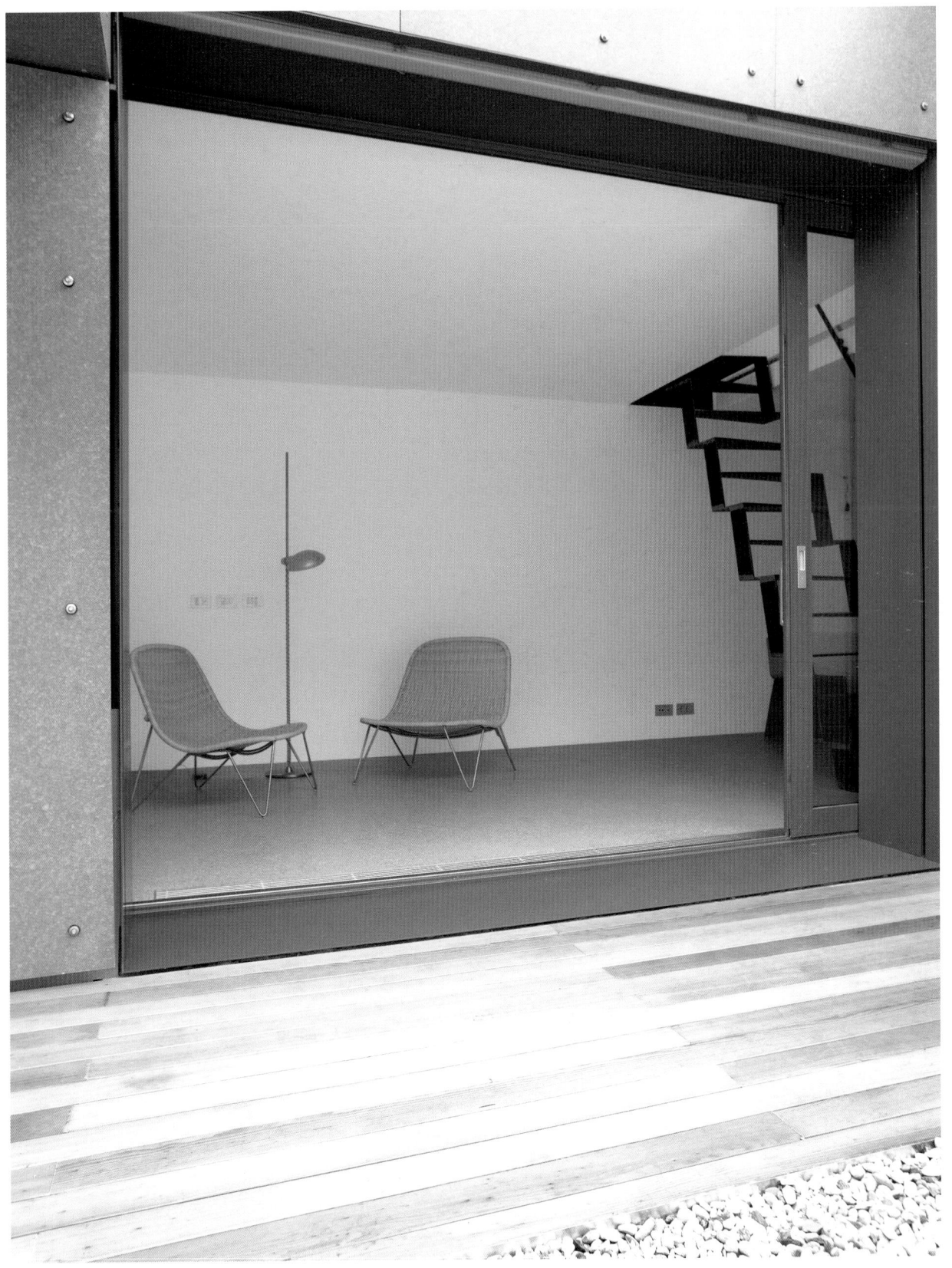

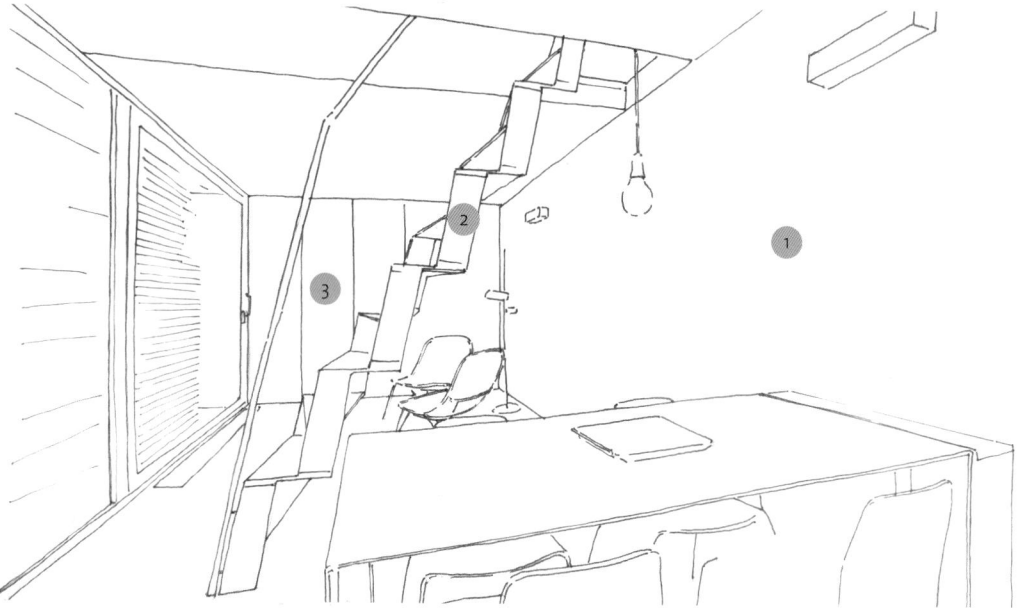

1_ The use of materials and furnishing is limited to avoid the feeling of a cluttered space.

2_ The folded steel stairs to the attic occupy a minimal space and stand out as a sculptural element.

3_ In spite of the reduced space, abundant integrated closets provide space for utilities and storage.

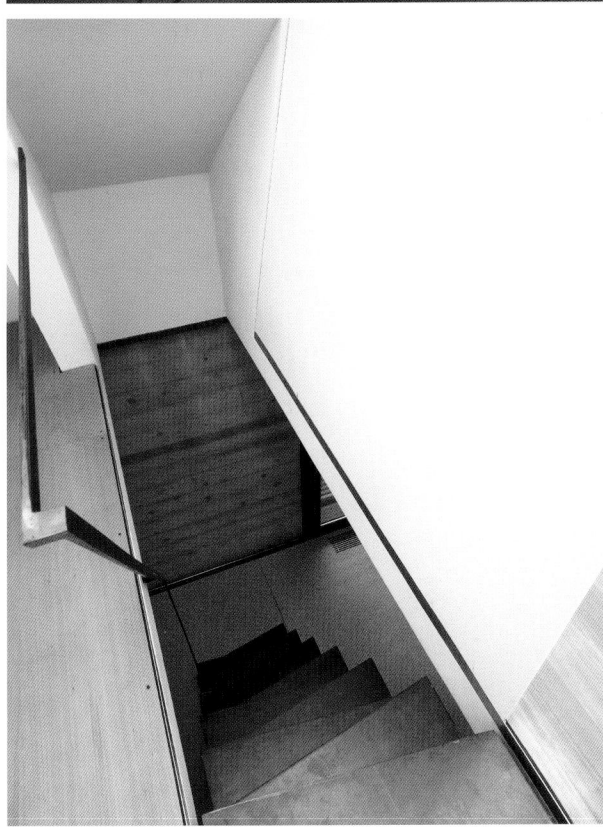
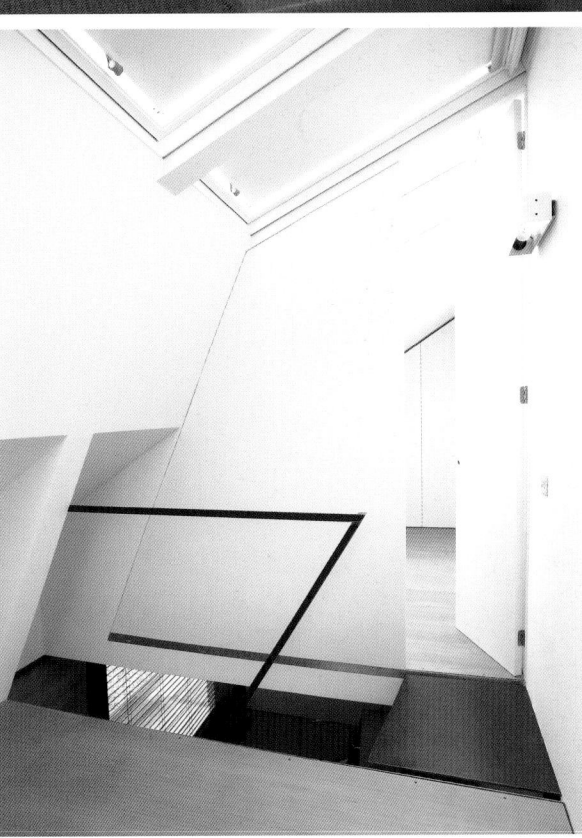

Paludo Apartment

484 sq. ft.

The apartment occupies a section of a pre-existing industrial building, originally built in the early thirties, which was used for fabricating Venetian chandeliers. The particular space was used to assemble the small parts.

The whole interior was refinished in oak paneling. This was a common practice between the fifteenth and seventeenth centuries when naval workers from the Arsenale (naval yard) were hired by the Serenísima—as the Republic of Venice was called at the time—to finish the interiors of administrative offices.

The widespread use of this technique was due to the good thermal insulation properties of the wood and also for its ease of installation.

Architect: Leo de Carlo, Roberta Angelini

Location: Venice, Italy

Completion date: 2003

Photographer: © Oliver Hass

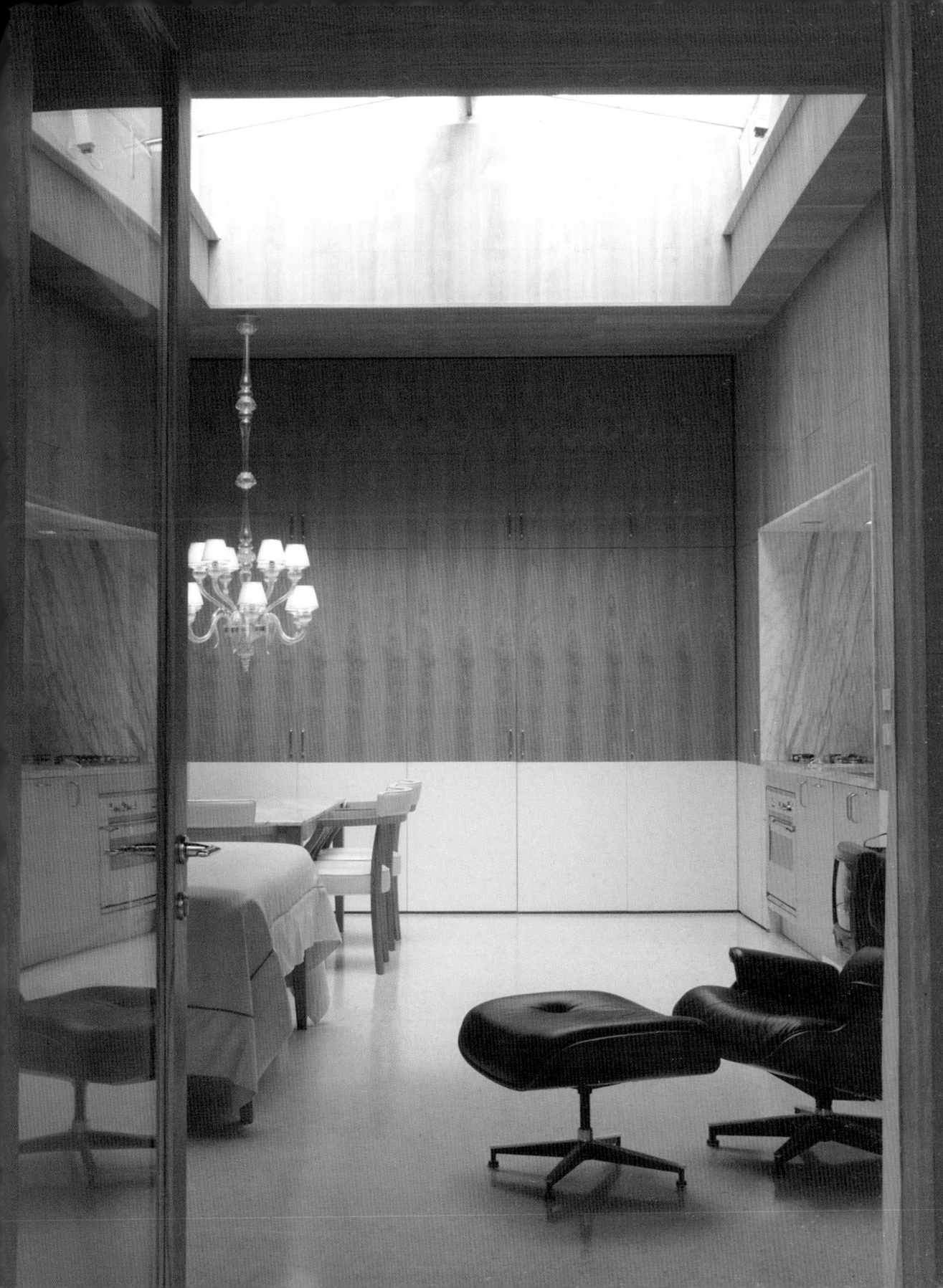

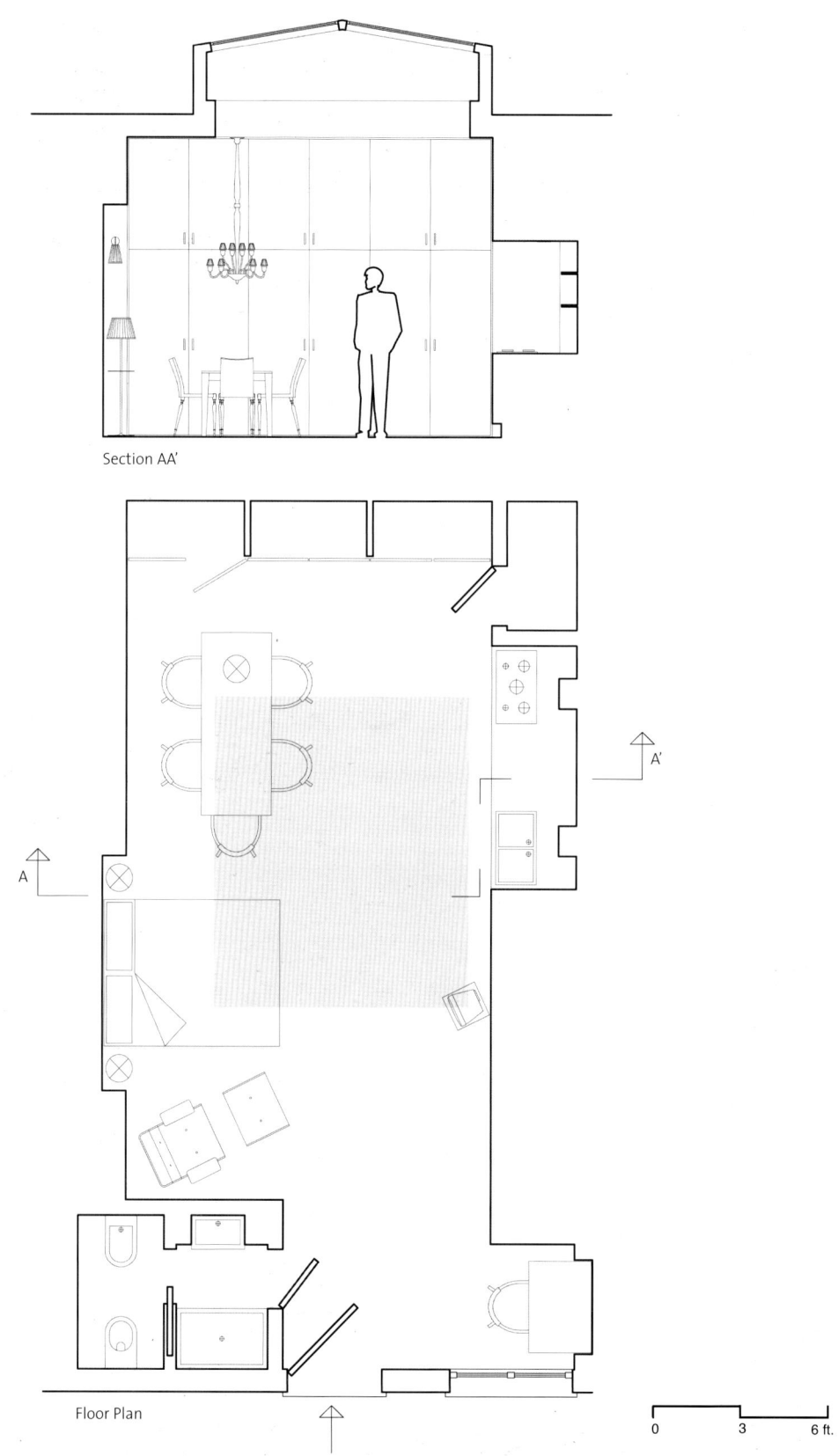

Section AA'

Floor Plan

0 3 6 ft.

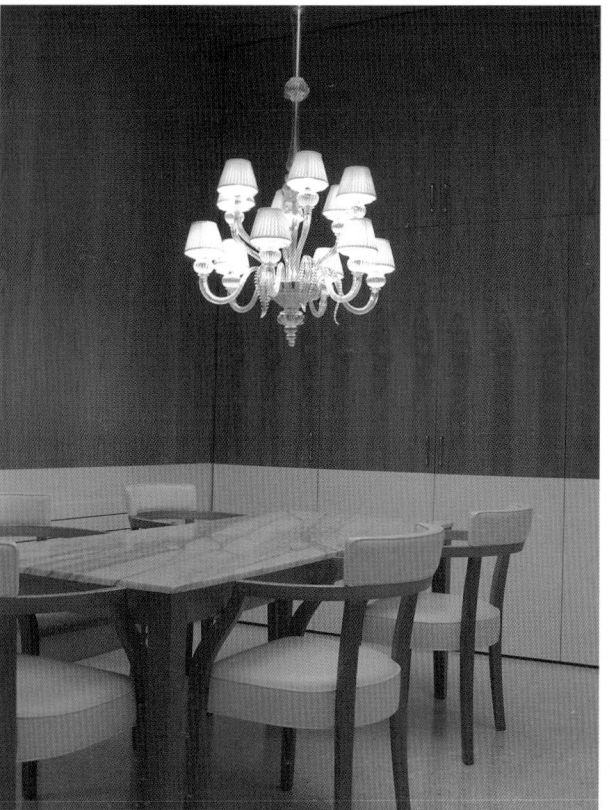

1_ The single space incorporates a dining room area, a sleeping area and an office. The kitchen is tucked into the wall to clear up the reduced floor space and to avoid obstructing the geometry of the room.

2_ The absence of partitions allows for flexibility in organizing the space. The room can be reorganized to adapt with ease to any function, whether an intimate and personal "pad," or a place to entertain a small group of friends.

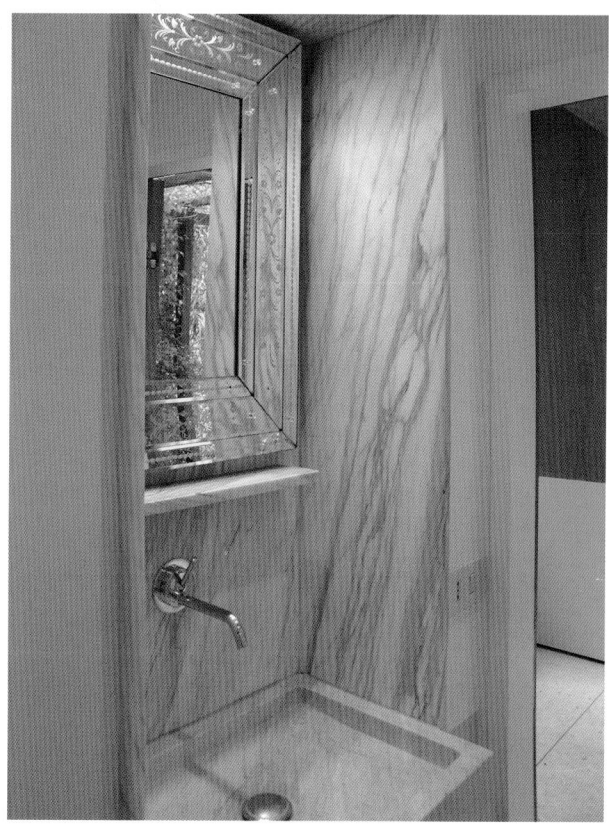

The bathroom surfaces are clad in white marble, a cooler reinterpretation of the wood paneling in the adjacent room, which already incorporates this treatment in the surfaces of the kitchen.

Mini Loft

484 sq. ft.

This project is part of a larger intervention consisting of the remodeling of an existing ground floor space. Once the interior was gutted, it was divided into three independent areas. From the outside, each loft can be differentiated by a color at mezzanine level while at street level all three spaces share the same perforated metal grill façade to unify the elevation. At the ground floor, an open space accommodates the daylight activities which include a living room, a kitchen and a toilet. Up on the mezzanine floor is the bedroom and the bathroom. Across the catwalk from the bedroom and slightly higher is a second bedroom. Every detail is thought through to optimize the use of the space: to allow for headroom over the narrow stair, the floor of the bedroom platform is raised to become a desk.

Architect: James& Mau

Location: Madrid, Spain

Completion date: 2006

Photographer: © Antonio Corcuera

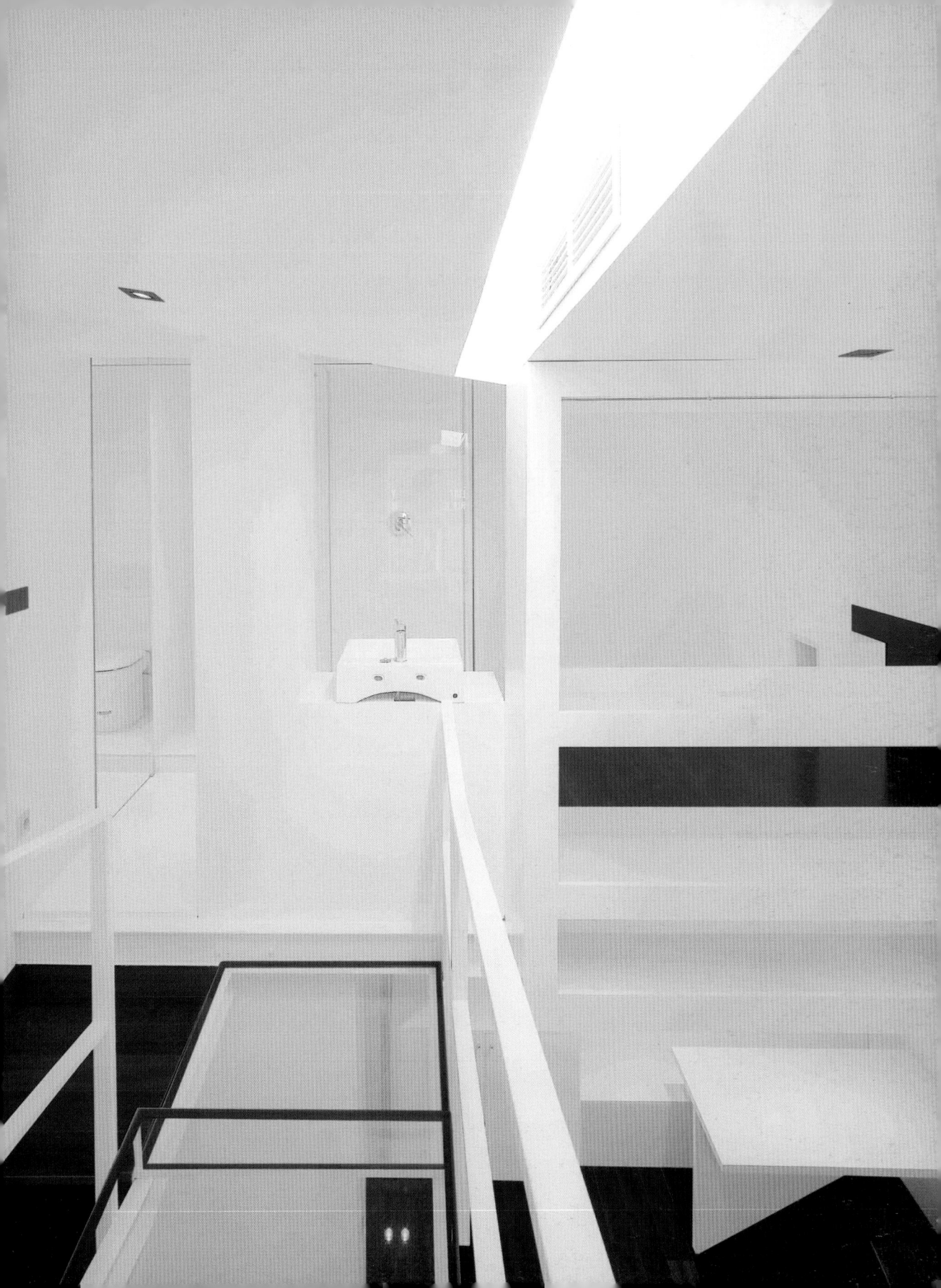

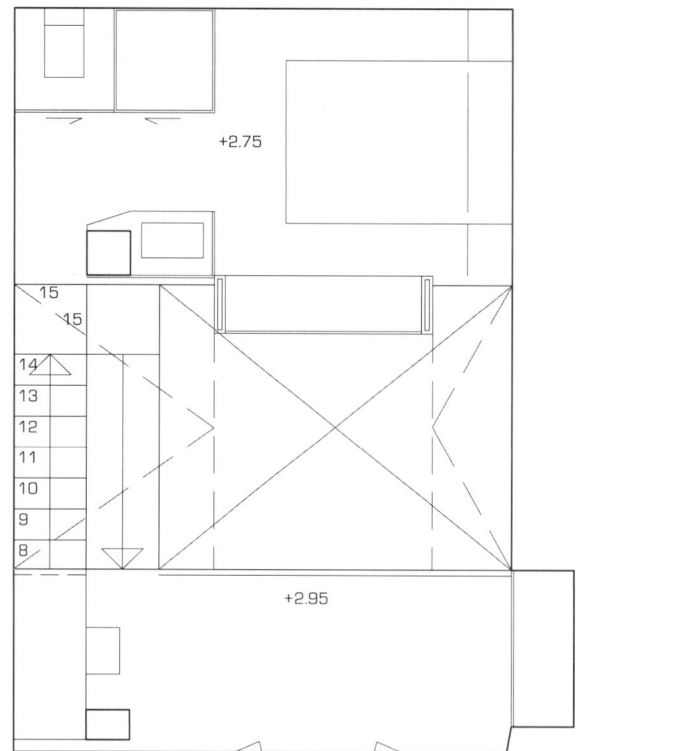

Upper Floor Plan

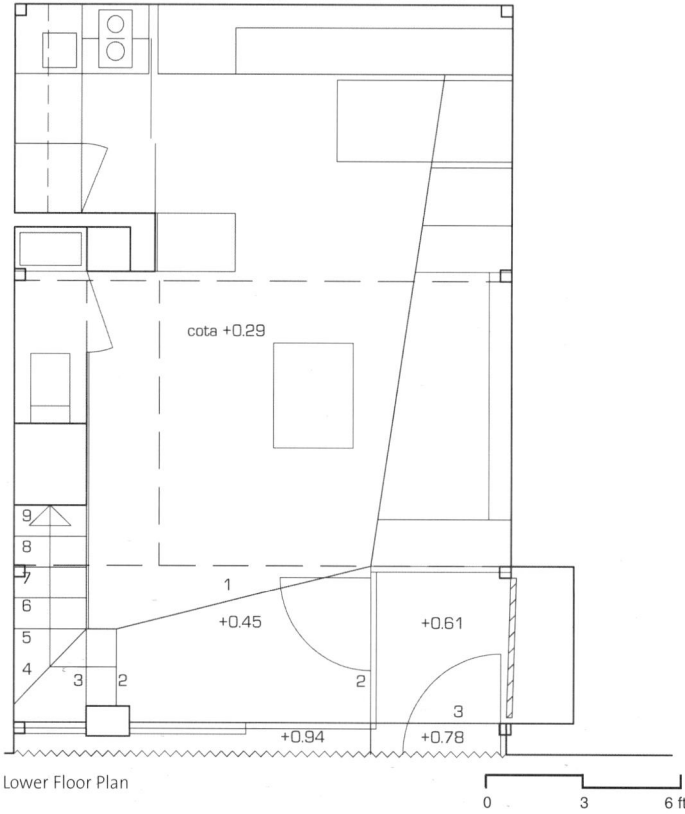

cota +0.29

Lower Floor Plan

0 3 6 ft.

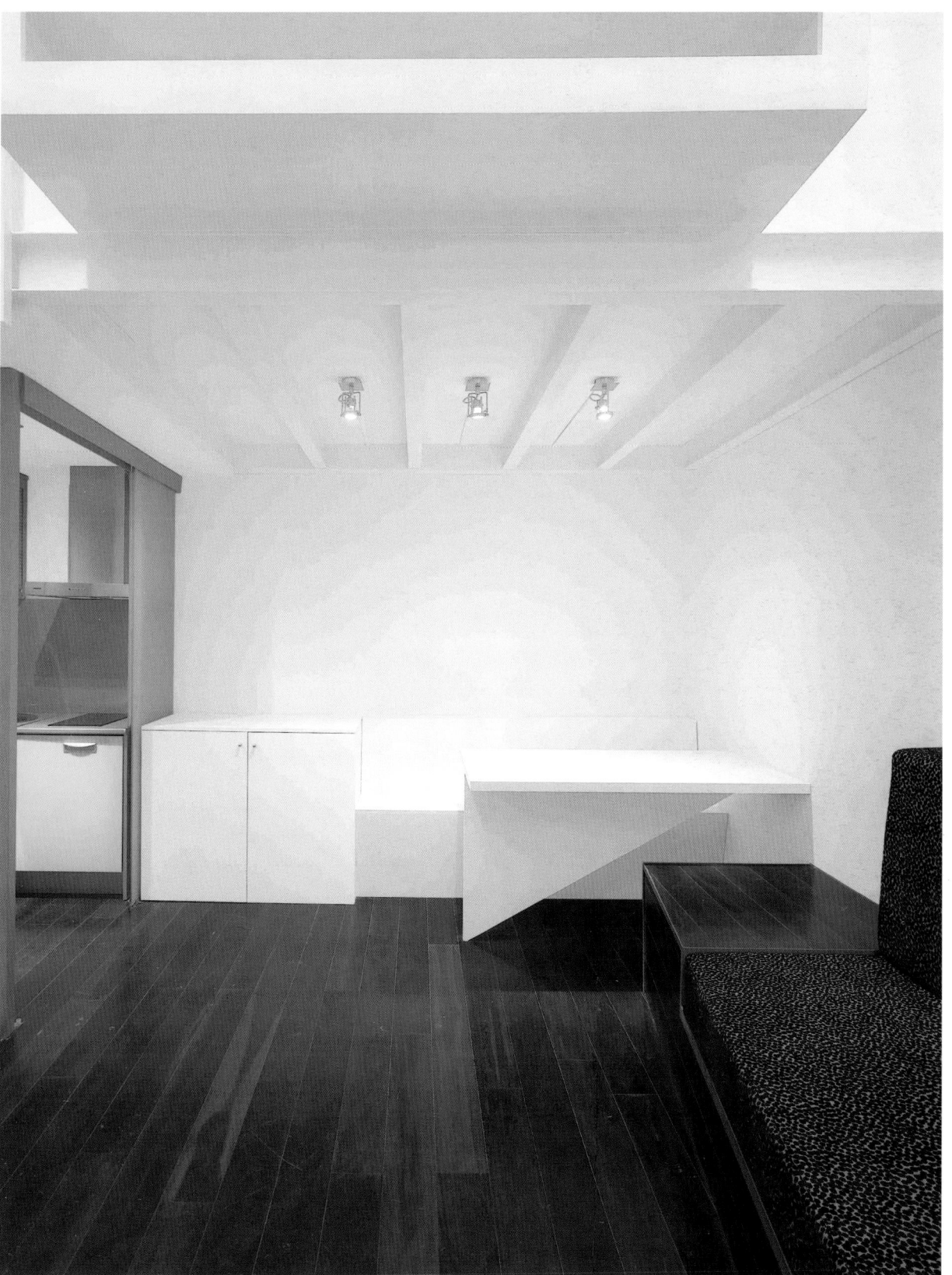

1_ The height of the spaces became an interesting asset to be exploited. From street level, three steps down give way to the living area, thus gaining some height.

2_ Built-in furniture makes best use of the limited space: a sofa that extends to become seating for the dining table.

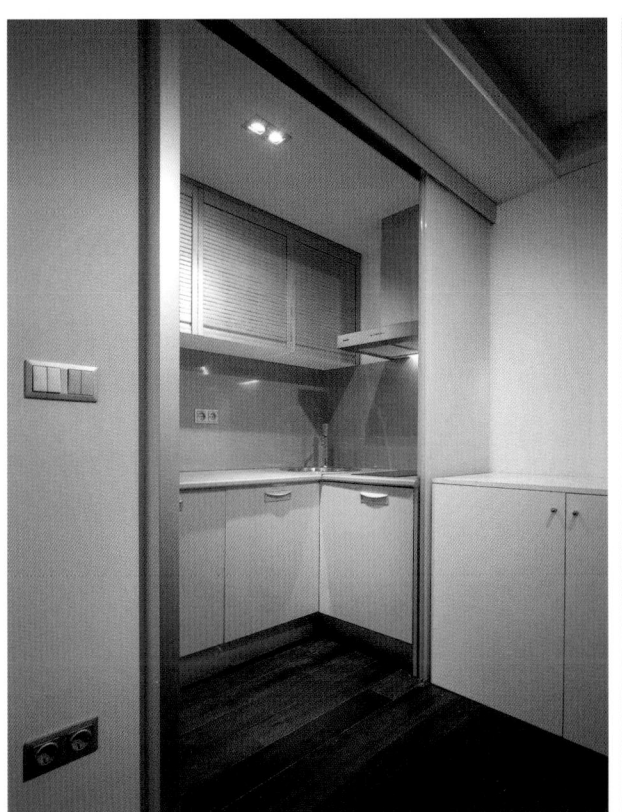
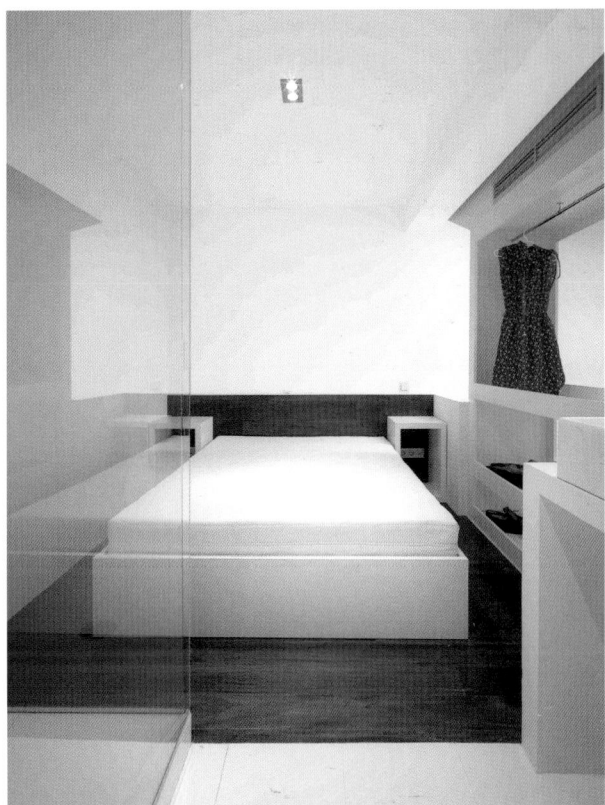

The space being so small, it was important to avoid any unnecessary partition. To achieve this, the designer resorts to a thin metal floor system, pocket glass doors, glass partitions, and even a glass floor at the "bridge." The railing at the sleeping loft does double duty as storage shelving and the bathroom space is integrated with the bedroom.

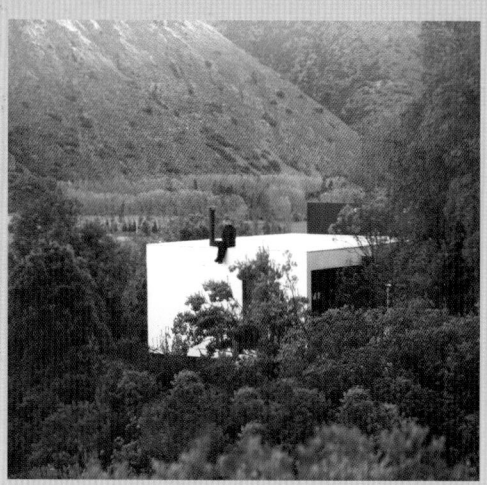

House R
484 sq. ft.

The client, a friend of the designer, had purchased a plot of land in the region of the "Cajón del Maipo." Excited about its location and its landscape, he thought of the location as a perfect refuge from the city. The site itself had elongated proportions (200 x 25 ft.) and a considerable slope.

Built manually with off-the-shelf materials, the goal was to make best use of the buildable area. The project was conceived as a primary act of man to occupy the land and so the structure would simply serve the basic needs of its occupants. From the roof, which serves as a terrace, one gains a dominant view of the valley. A white envelope wraps the single space structure. This simple geometry contrasts with the landscape and is a reference that is easy to spot from a distance.

Architect: Abel Erazo, Nicolas Norero, Andres Cavieres (renderings)

Construction: Rene Reyes

Location: San Jose de Maipo, Chile

Completion date: 2007

Photographer: © Francisca Pinochet

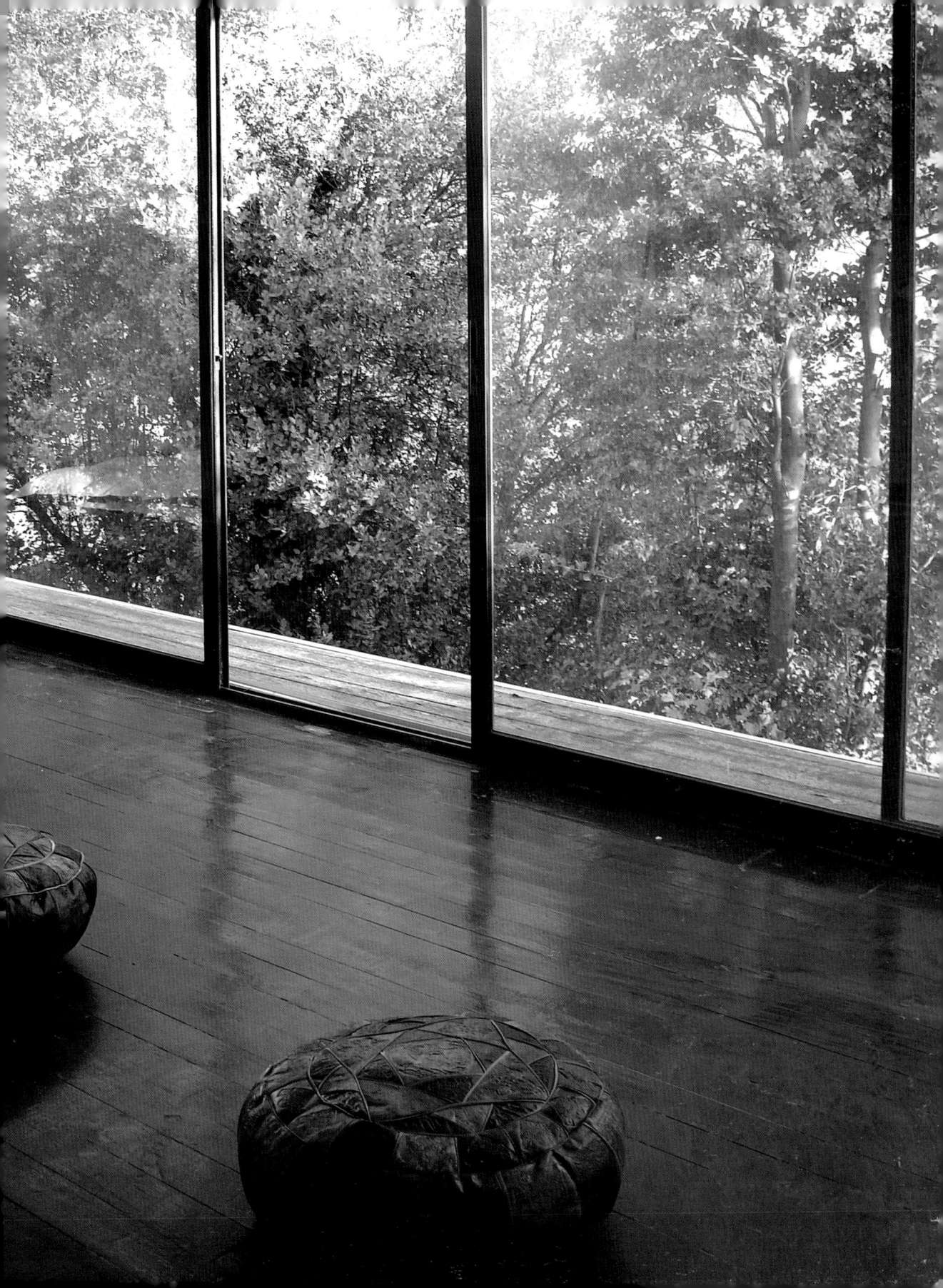

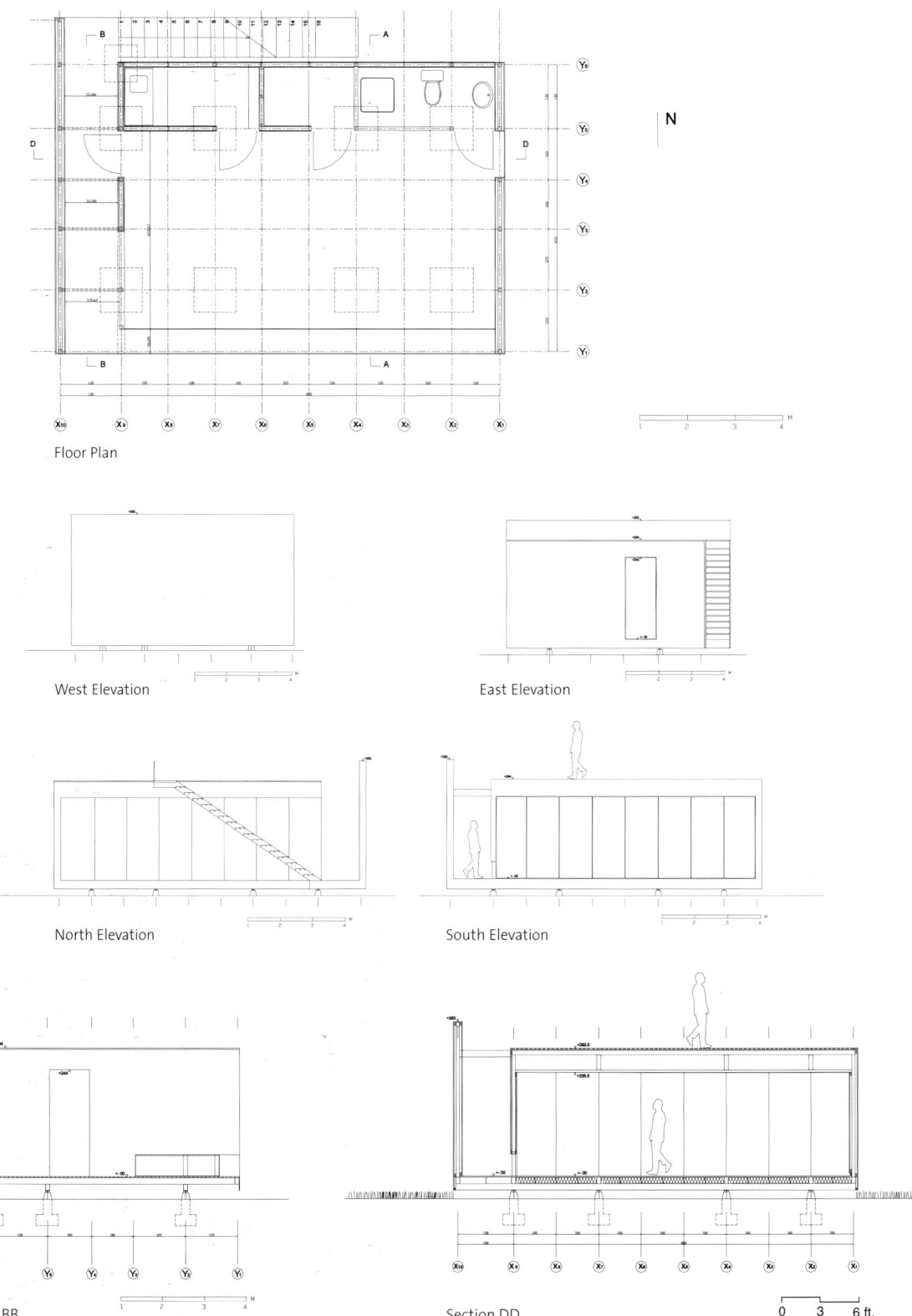

Floor Plan

N

West Elevation

East Elevation

North Elevation

South Elevation

Section BB

Section DD

0 3 6 ft.

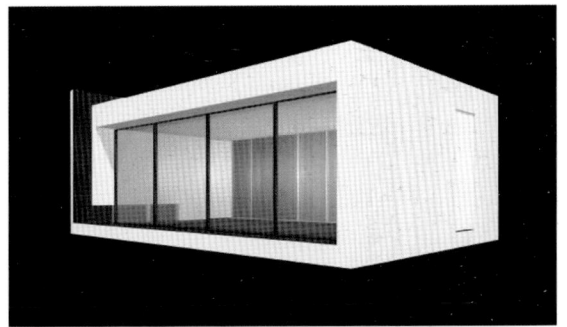

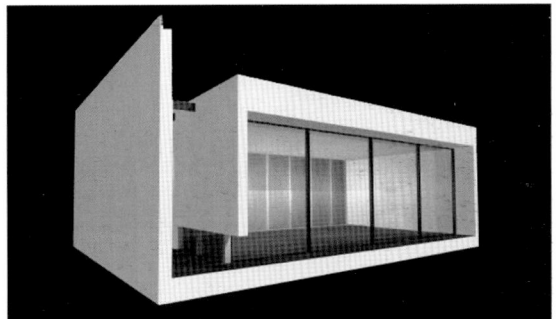

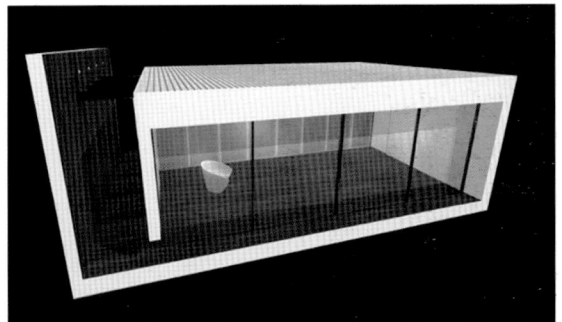

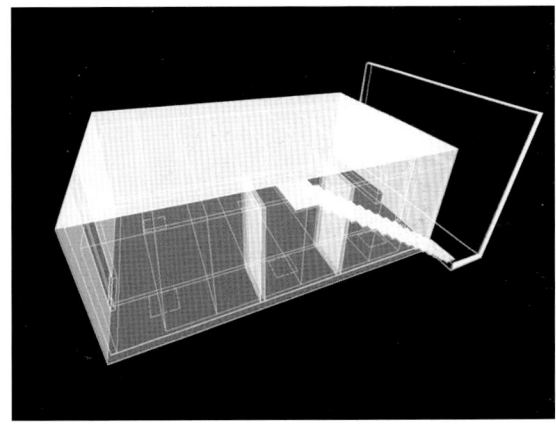

Site Plan

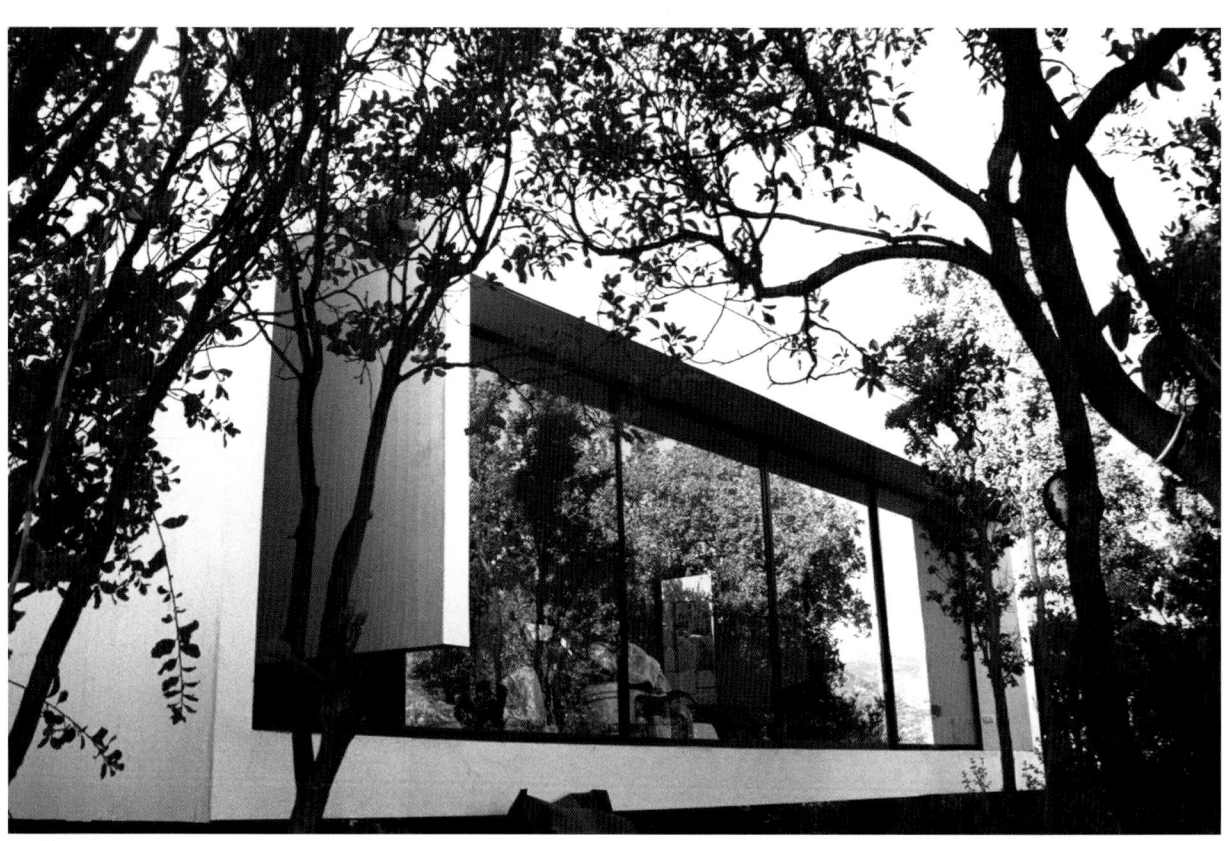

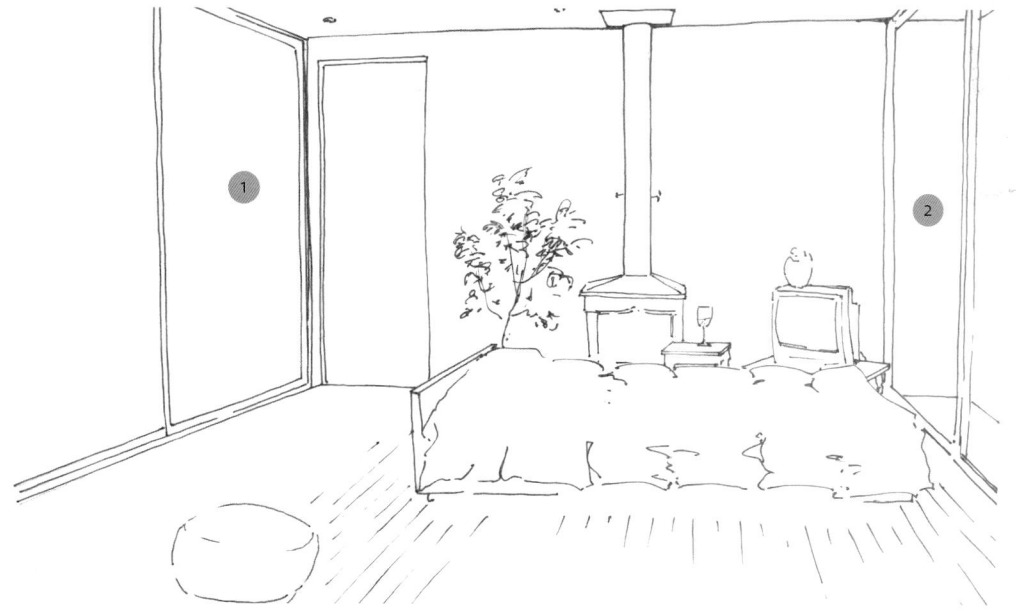

1_ The bathroom and the kitchen are organized along the north wall, screened off from the main room, while the glass south wall faces the lush valley.

2_ Basic materials such as steel, concrete, wood and glass were chosen to satisfy a tight budget and a clear intention to simply "camp out" and enjoy the opportunity to explore the magnificent landscape.

Greenwich Village Condominium

500 sq. ft.

Architect: CCS Architecture

Location: New York, U.S.

Completion date: 2003

Photographer: © Javier Haddad Conde

This former studio apartment was renovated to create a much more space efficient and flexible dwelling. The scope of work includes a bedroom, abundant storage space and a large room for daily activities. The bedroom with a queen size bed and storage underneath was inserted in what used to be a walk-in closet. This bedroom nook is provided with beside shelves, just enough to be filled with a few books and a reading lamp. The enclosure that partially conceals the bedroom is a few inches short from the ceiling and adopts the qualities of a freestanding element or a screen. The main space, which was used as a studio room where all the day and night activities were concentrated, was refurbished and its walls lined with shelves and cabinets. In the center of the room, a large table is used both for eating and for working.

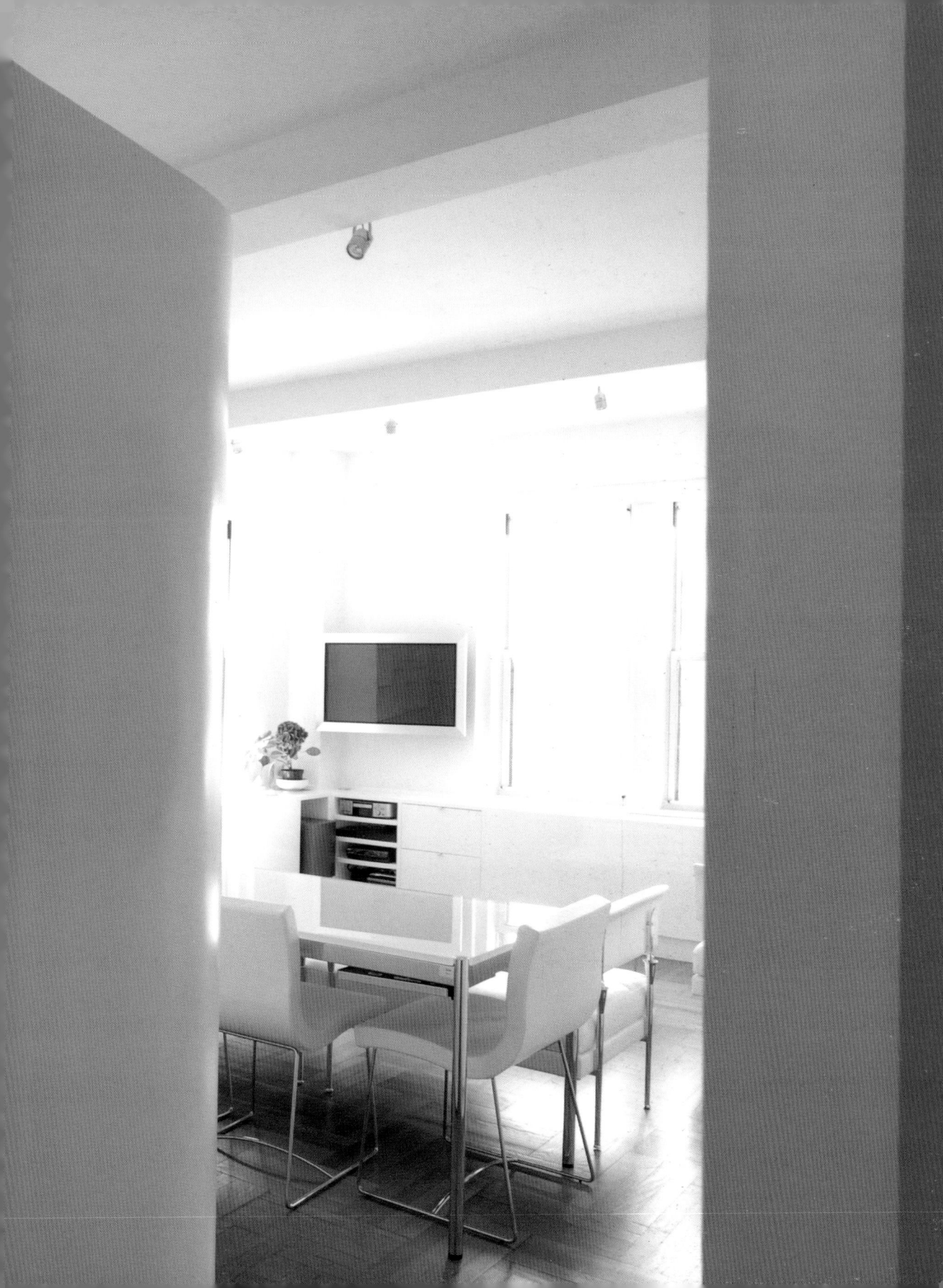

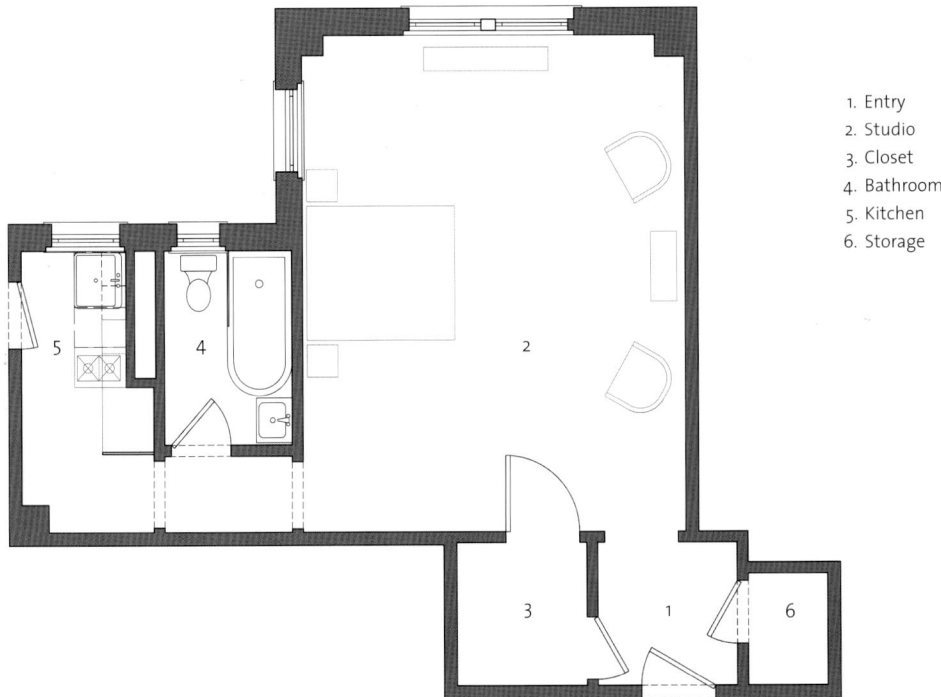

1. Entry
2. Studio
3. Closet
4. Bathroom
5. Kitchen
6. Storage

Existing Floor Plan

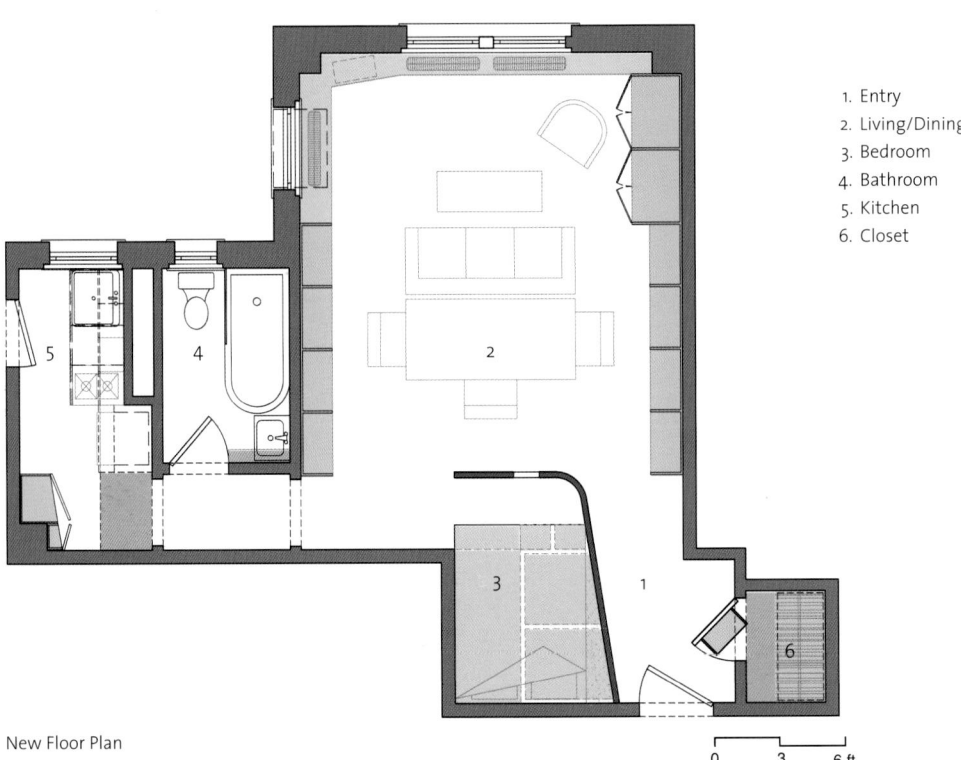

1. Entry
2. Living/Dining
3. Bedroom
4. Bathroom
5. Kitchen
6. Closet

New Floor Plan

0 3 6 ft.

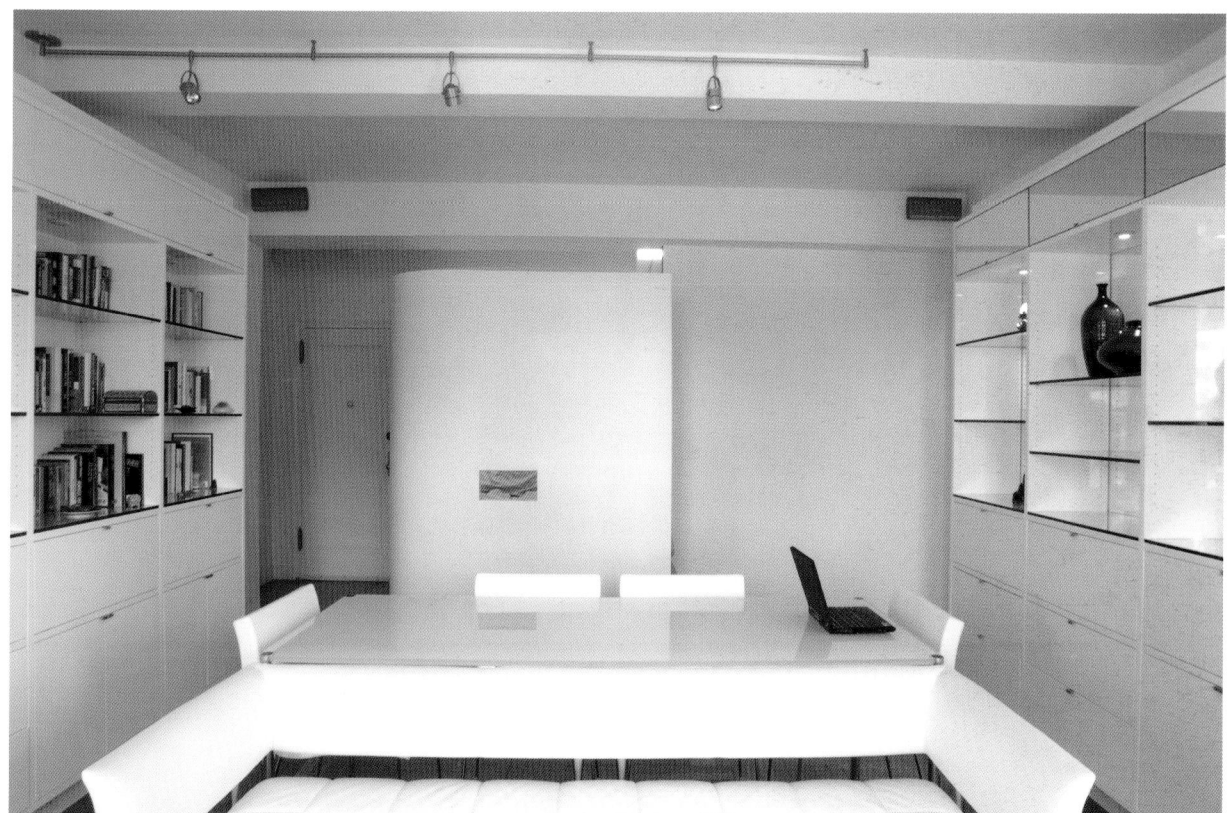

Short from the ceiling and with a rounded corner, the "L" shape bedroom wall seems, viewed from the main room, a piece of freestanding cabinetry or a screen. The warm light from the bedroom emanates from behind the screen. A small opening in the wall visually connects the bedroom with the living room and adds an element of surprise to the design of this interior.

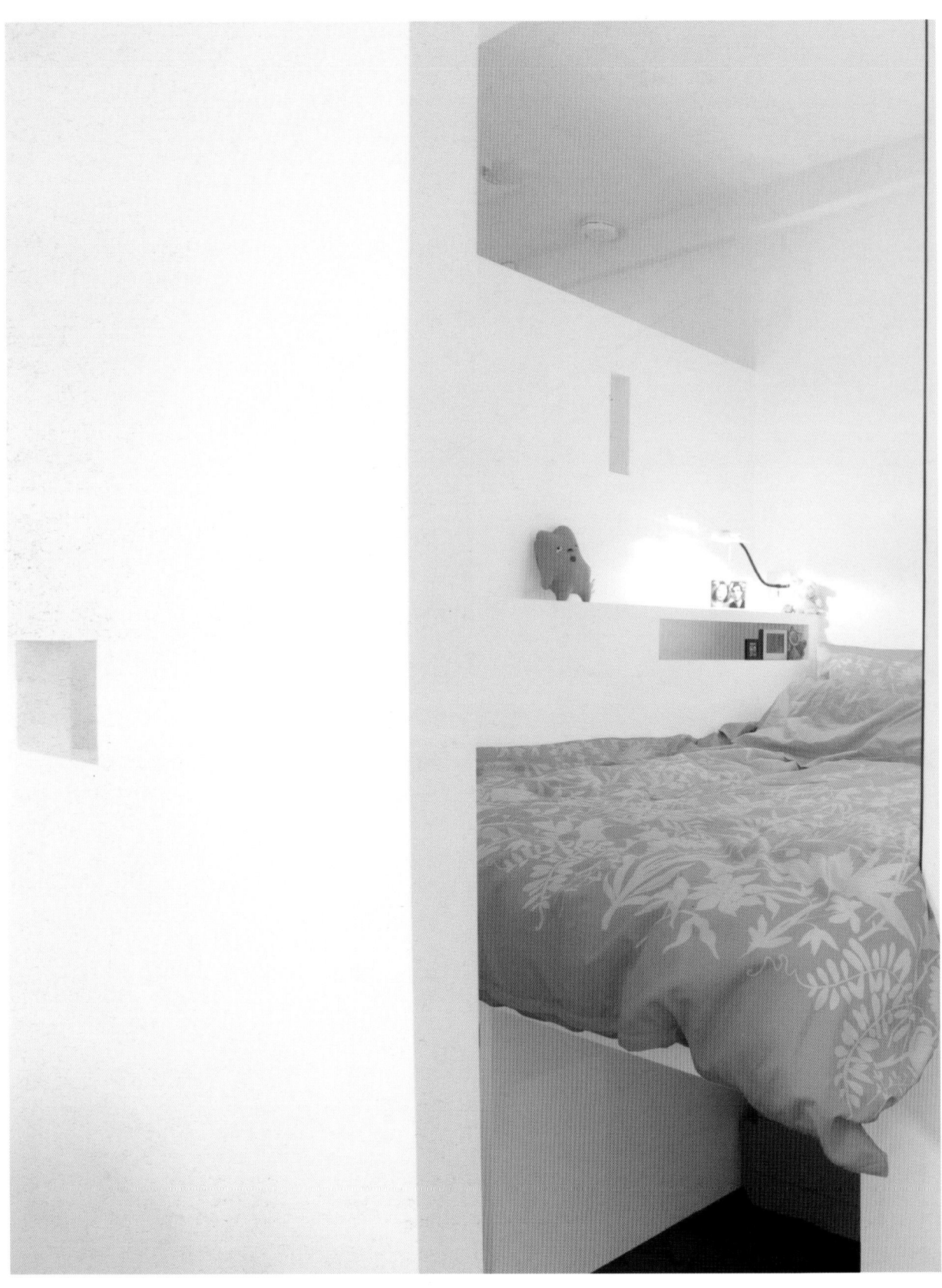

1_ Deep drawers under the bed and accessible from the entry hall provide maximum storage possibilities.

2_ The soft curvature of the bedroom enclosure softens the rigid grid of the structure visible in the ceiling.

3_ By lining the walls with storage space, the center of the space is left unobstructed, allowing for better circulation.

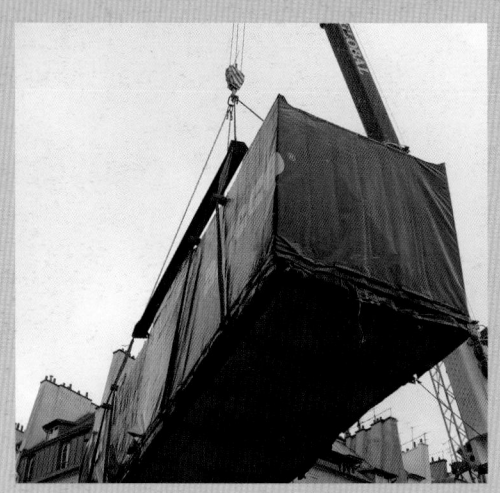

Drop House

538 sq. ft.

Entirely fabricated following the standards of industrial prefabrication, the Drop House rests on top of a concrete bed, the only part of the project that was built onsite. It serves as foundation and as a way to connect to the different systems (water, gas, electricity, sewage).

Being all one module, the project can be transported by truck all at once. Any additional parts are built separately and therefore transported and installed later. The Drop House proposes an alternative to conventional living. The idea that originated the project aims to combine dimensional restrictions and the need for a comfortable habitat. The different functions of the Drop House are grouped in small units that branch off the main volume. Large openings allow for a visual expansion of the space over the exterior surroundings.

Architect: Armel Néouze

Location: Paris, France

Completion date: 2005

Photographer: © Armel Néouze

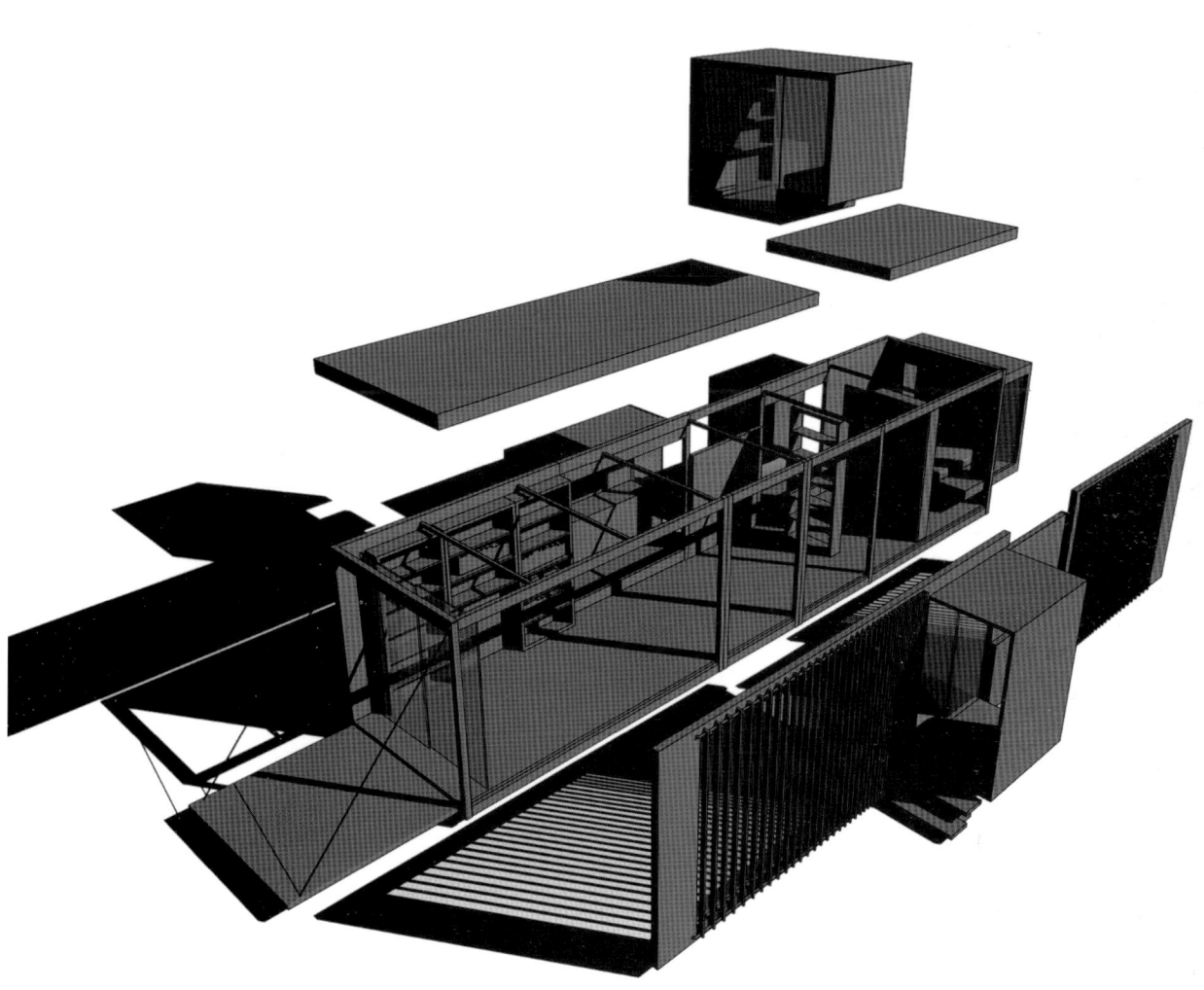

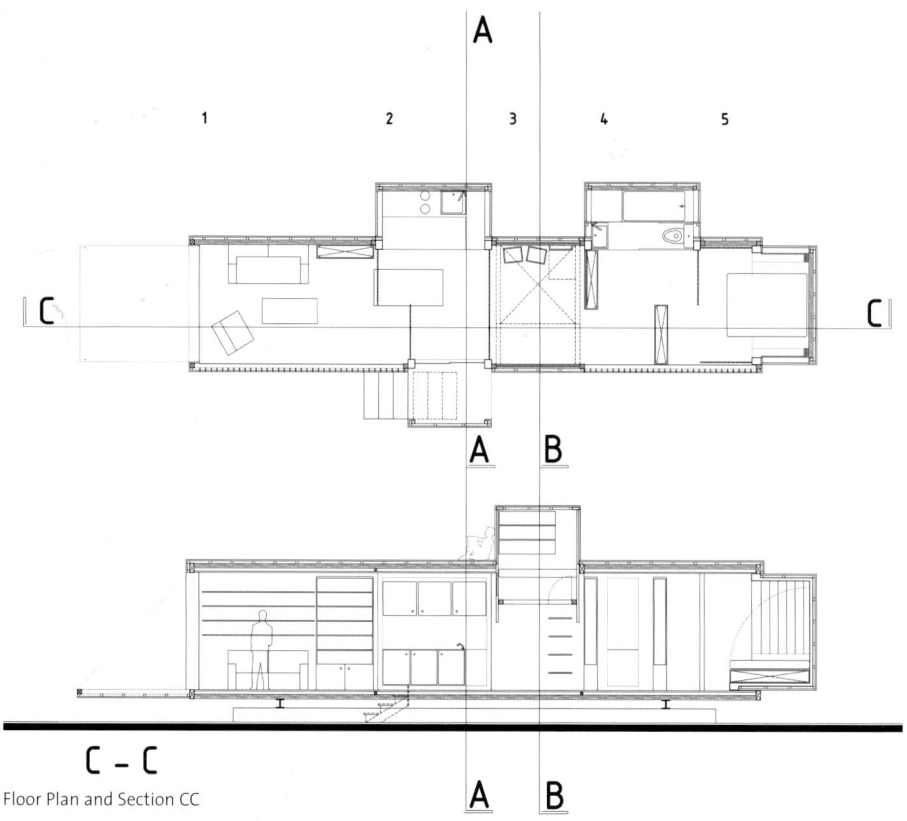

C – C

Floor Plan and Section CC

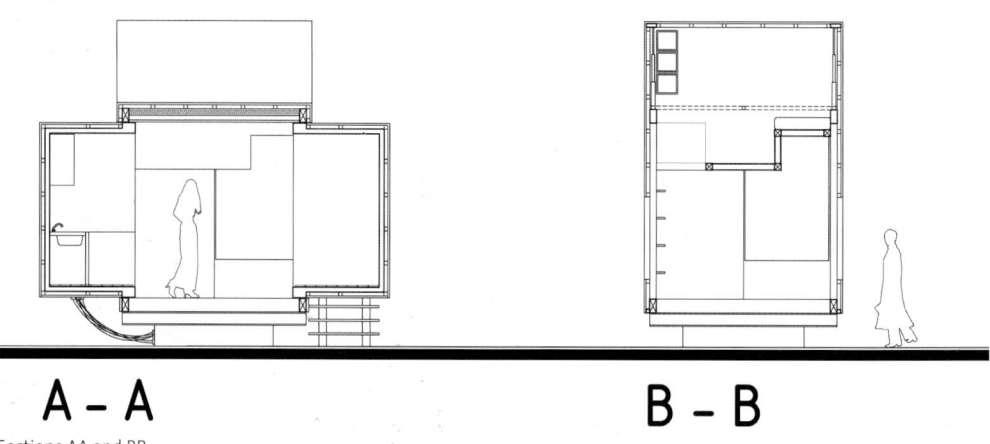

A – A B – B

Sections AA and BB

0 6 ft.

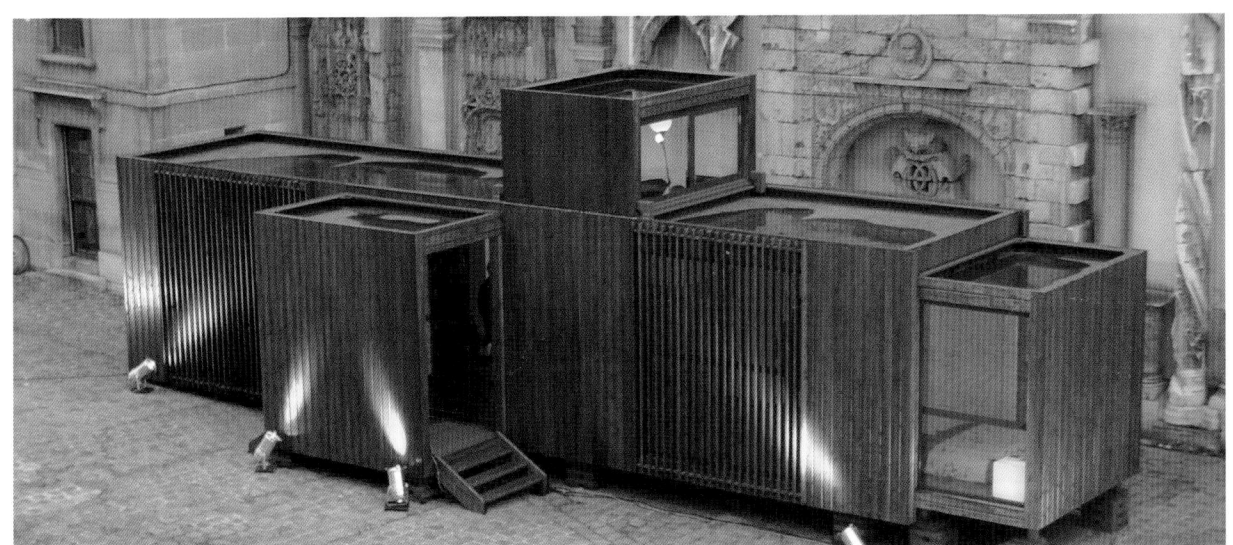

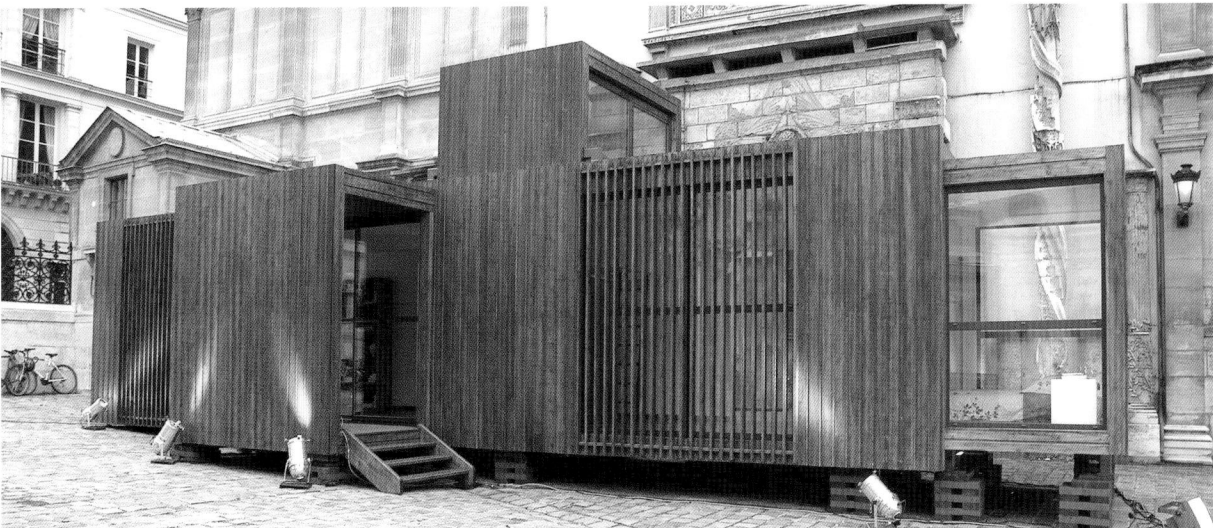

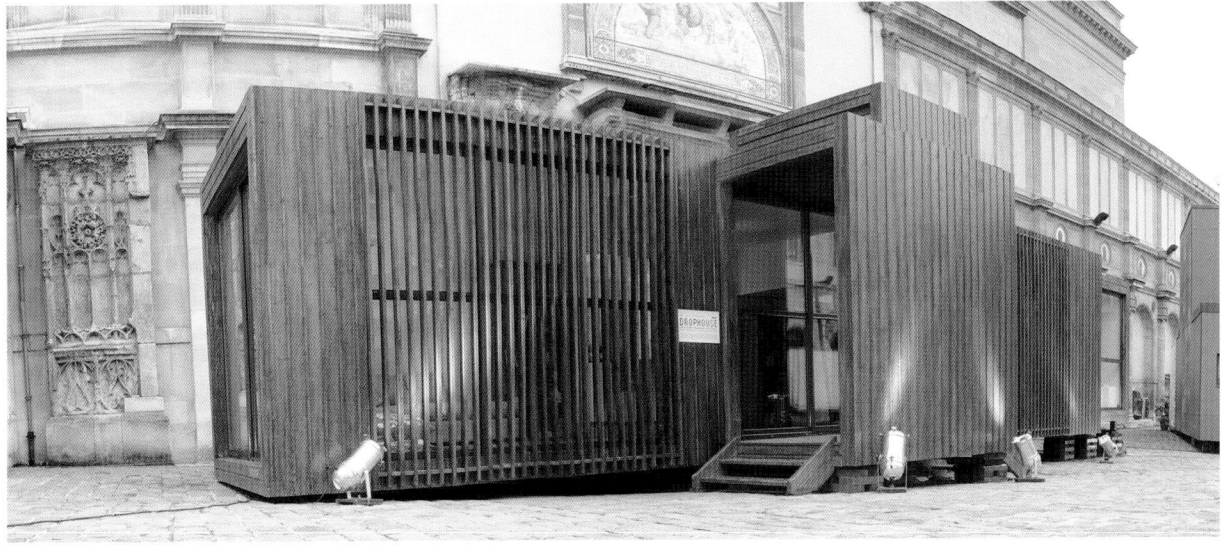

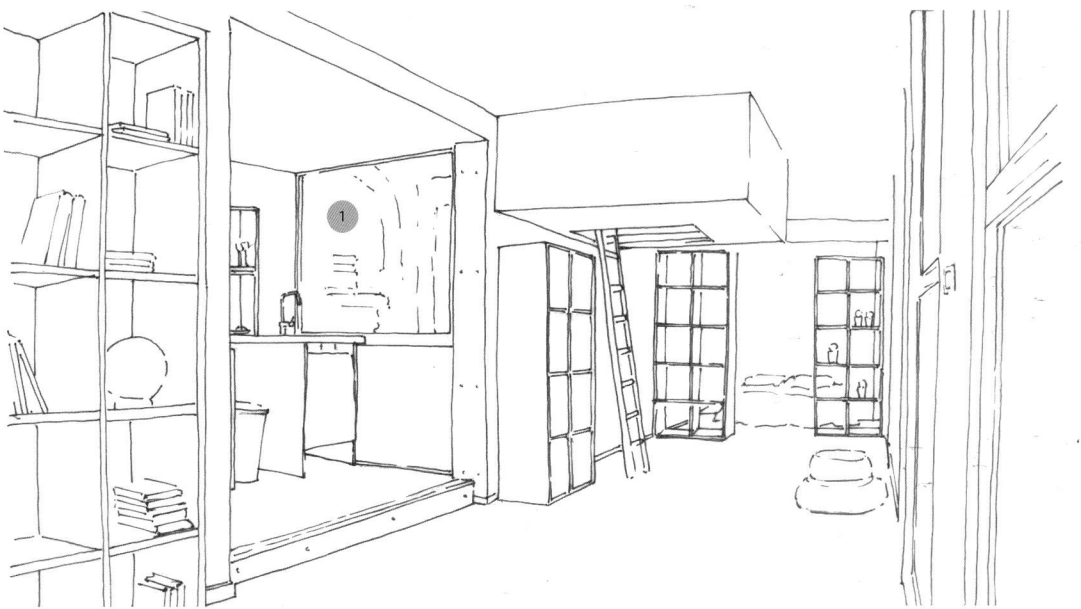

1_ The different functions of the home such as the kitchen, the bedrooms and the bathroom are built as satellite modules attached to the main volume which serves as living area.

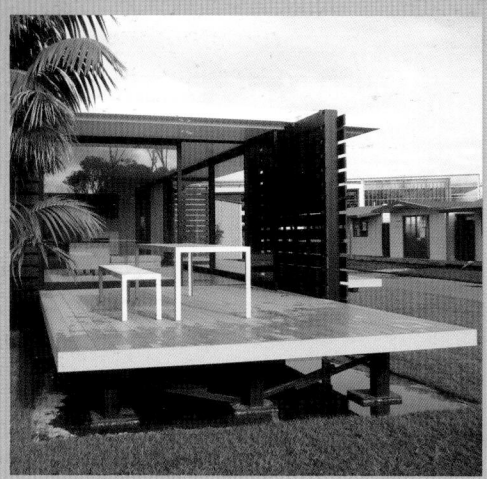

iPAD
538 sq. ft.

After experiencing a great success with "Bachkit" a few years earlier, the architecture office of André Hodgskin in New Zealand makes a comeback with iPAD. The iPAD is a kitset designed to offer a wide range of possibilities. A single iPAD totals 540 square feet with just as much deck area. It can be grouped as a series of pavilions arranged in a variety of ways to form larger accommodation if required. Various external cladding and color options are available to suit individual taste and the contextual environment. It is important to mention that the iPAD can either be manufactured offsite and easily transported to its final destination or shipped as a kitset and erected onsite by a licensed contractor. The iPAD is the ultimate designer pad, affordable yet versatile.

Architect: André Hodgskin Architects

Location: New Zealand

Completion date: 2007

Photographer: © Andre Hodgskin Architects

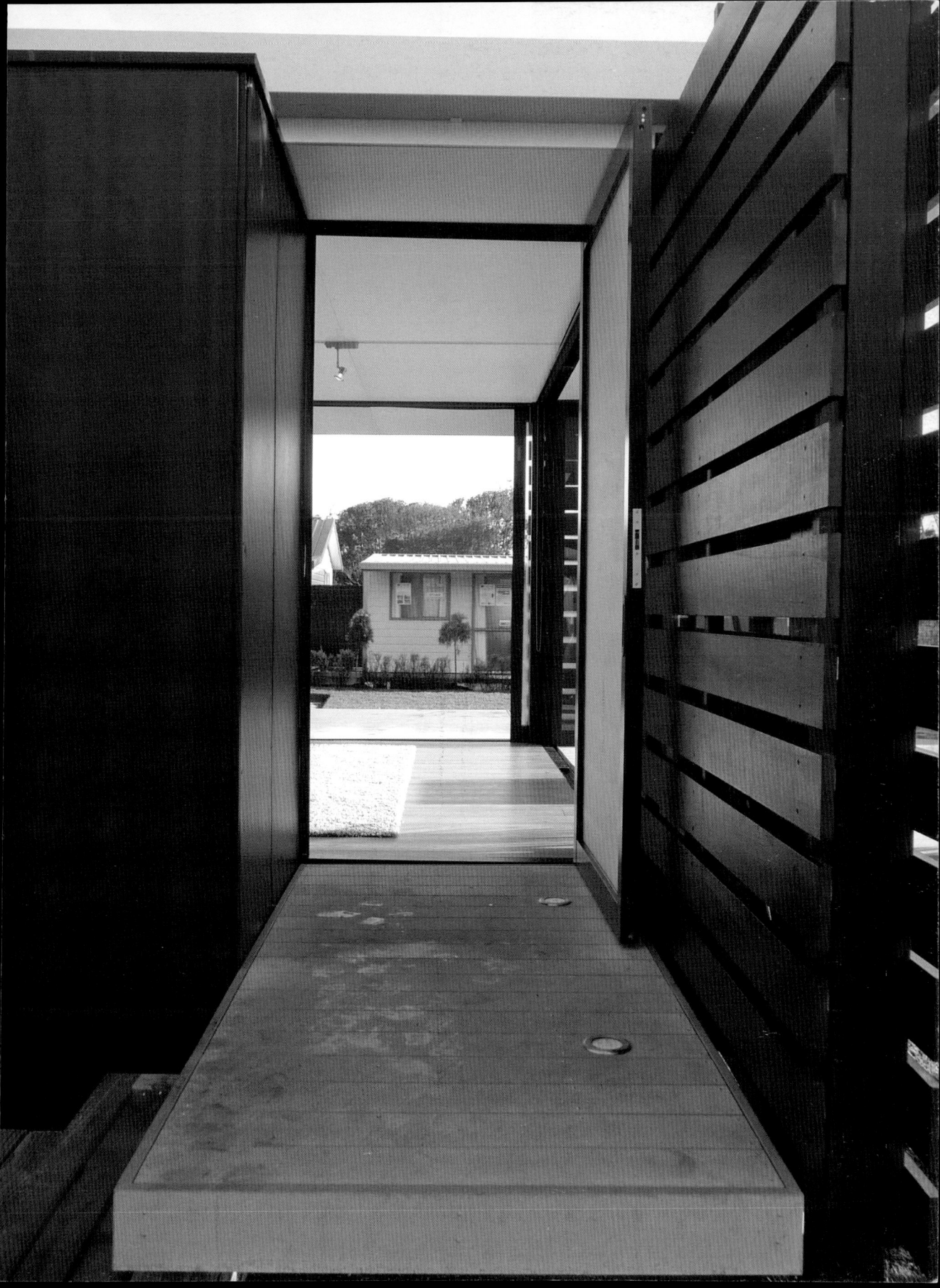

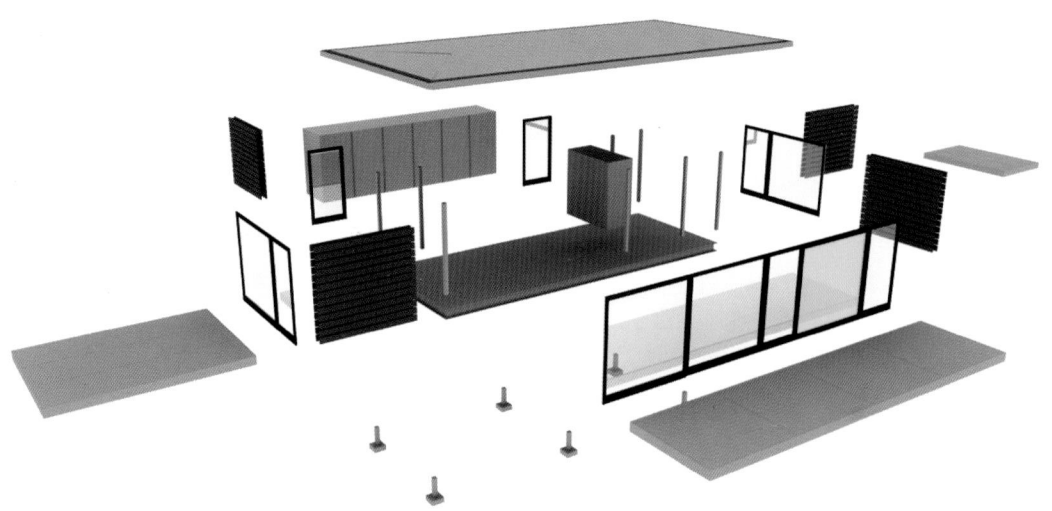

Exploded Axonometry

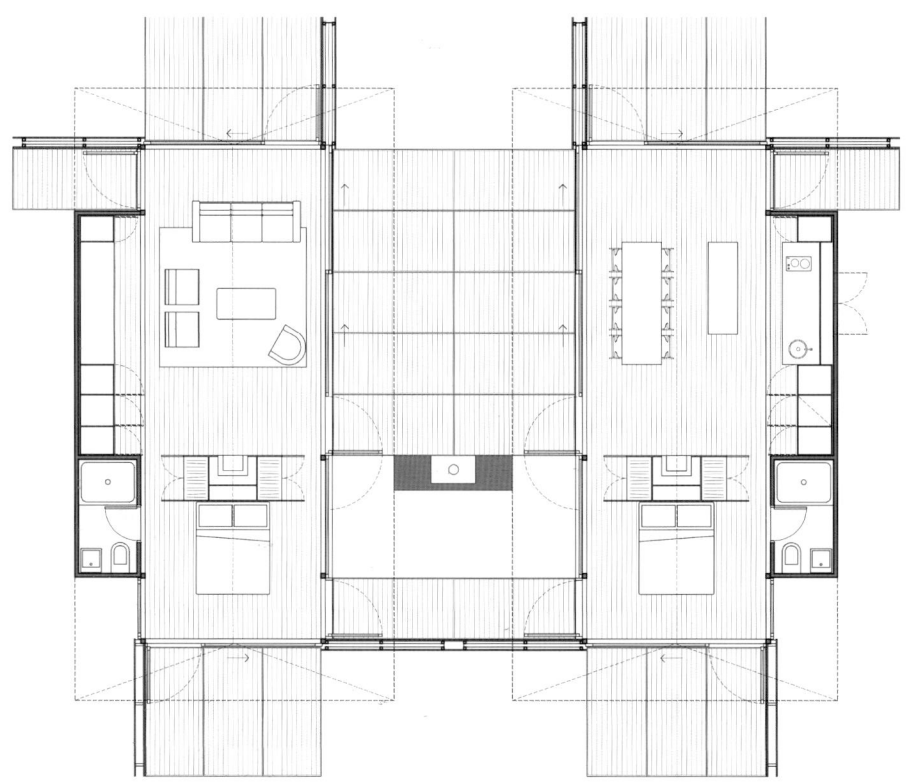

Floor Plan

0 5 10 ft.

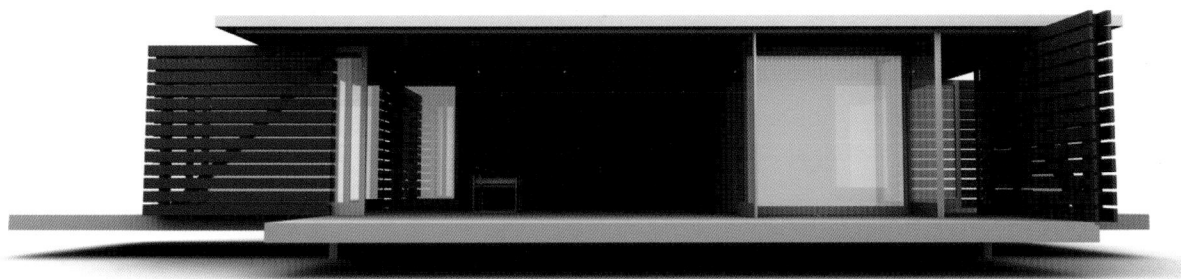

Front Elevation

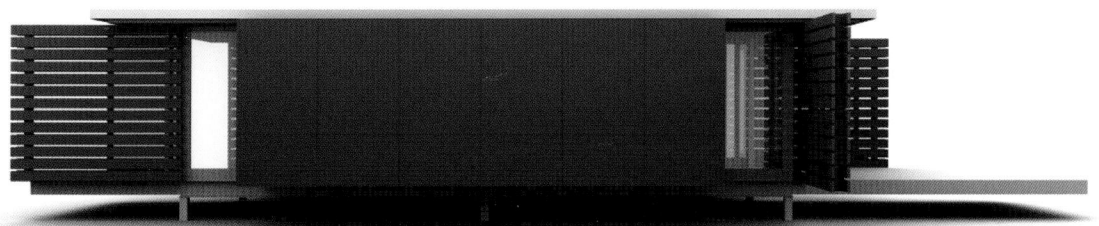

Back Elevation

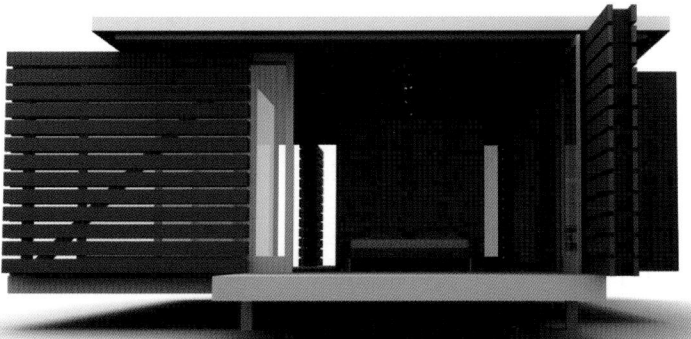

Side Elevation

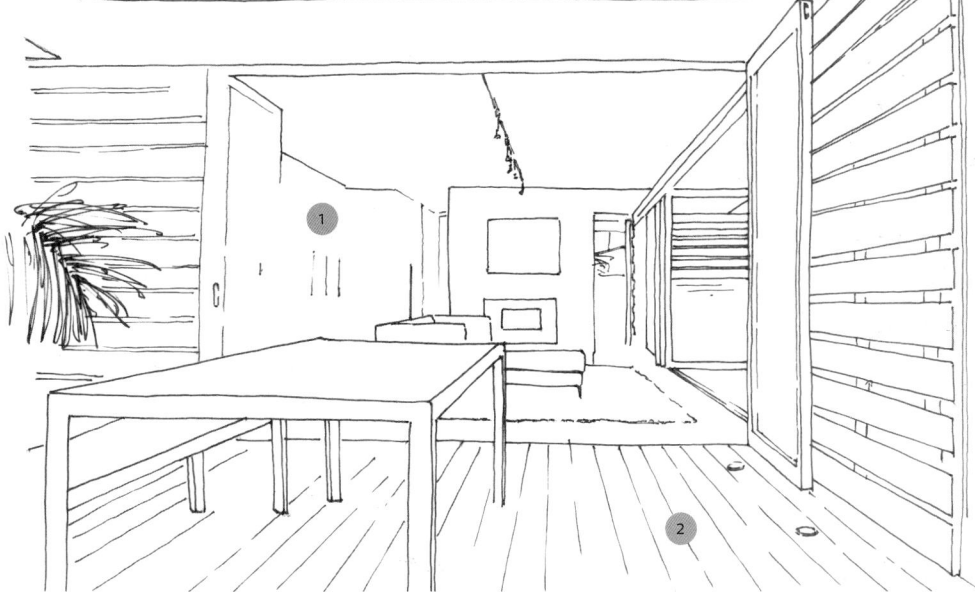

1_ Many options of configuration permit iPAD to adapt to the needs of the occupants. The iPAD comes in several versions: single, single with guest suite, or double.

2_ With as much floor area as the living module, the deck is an extension to be taken full advantage of during pleasant days.

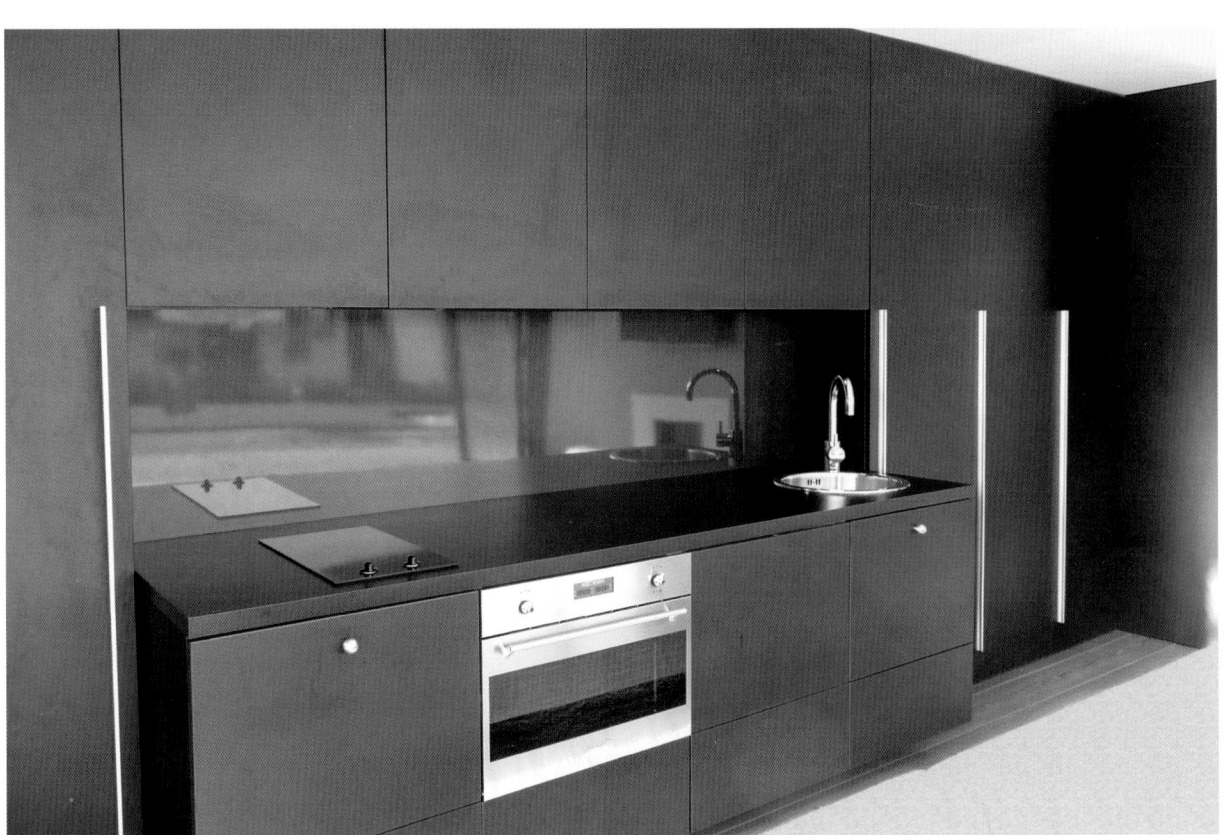

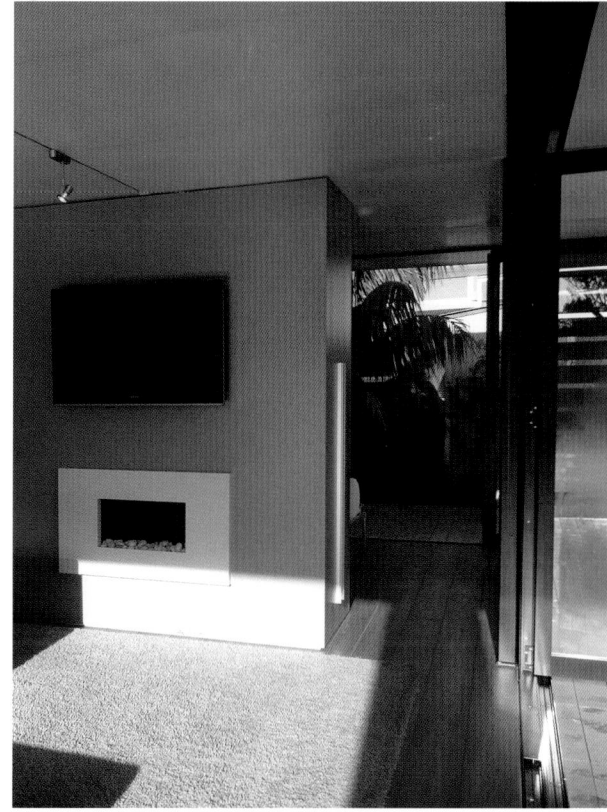

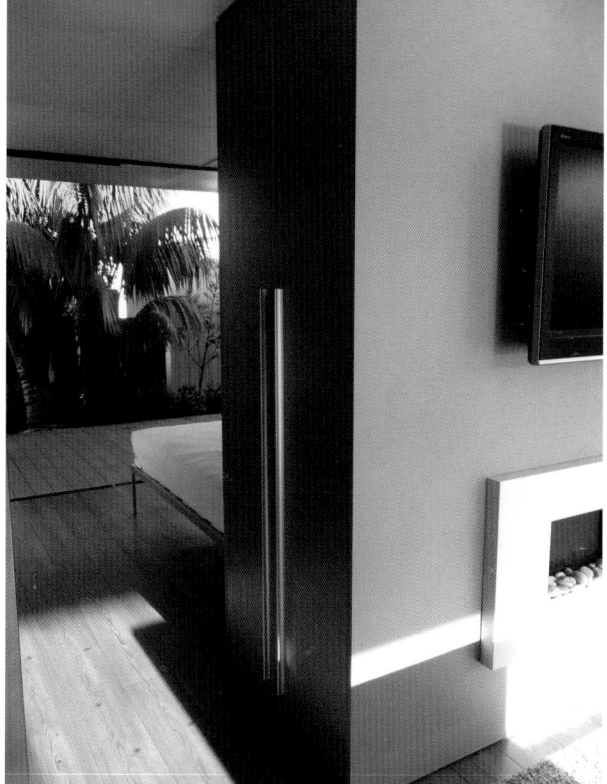

All utility rooms are concentrated along one wall. A central element that incorporates a gas fireplace and closet space acts as separator between the living room and the bedroom. The iPAD floor layout is free of partitions and its perimeter is built of sliding glass doors that open the interior to the outside, increasing the floor area.

Tower House

550 sq. ft.

The tower was built during the second half of the nineteenth century. It is located in the historic center of the small town called Béè, in the Piemontese hills, in Northern Italy. The building, which originally contained three rooms distributed on three levels, was very deteriorated and unsuitably organized. This lead to a thorough and complete reconstruction of the parts affected: the roof was replaced entirely and the existing wood joists were replaced with thin steel assemblies which ultimately would increase head clearance. The entire void is treated as a unique space. The dining area and the kitchen are located on the ground floor, the bedroom on the first and the living area on the top floor. A tall built-in cabinet or "totem" of bleached birch contains the various utilities of the house.

Architect: Piero Camoletto & Luca Rolla

Location: Bée, Italy

Completion date: 2006

Photographer: © Andrea Martiradonna

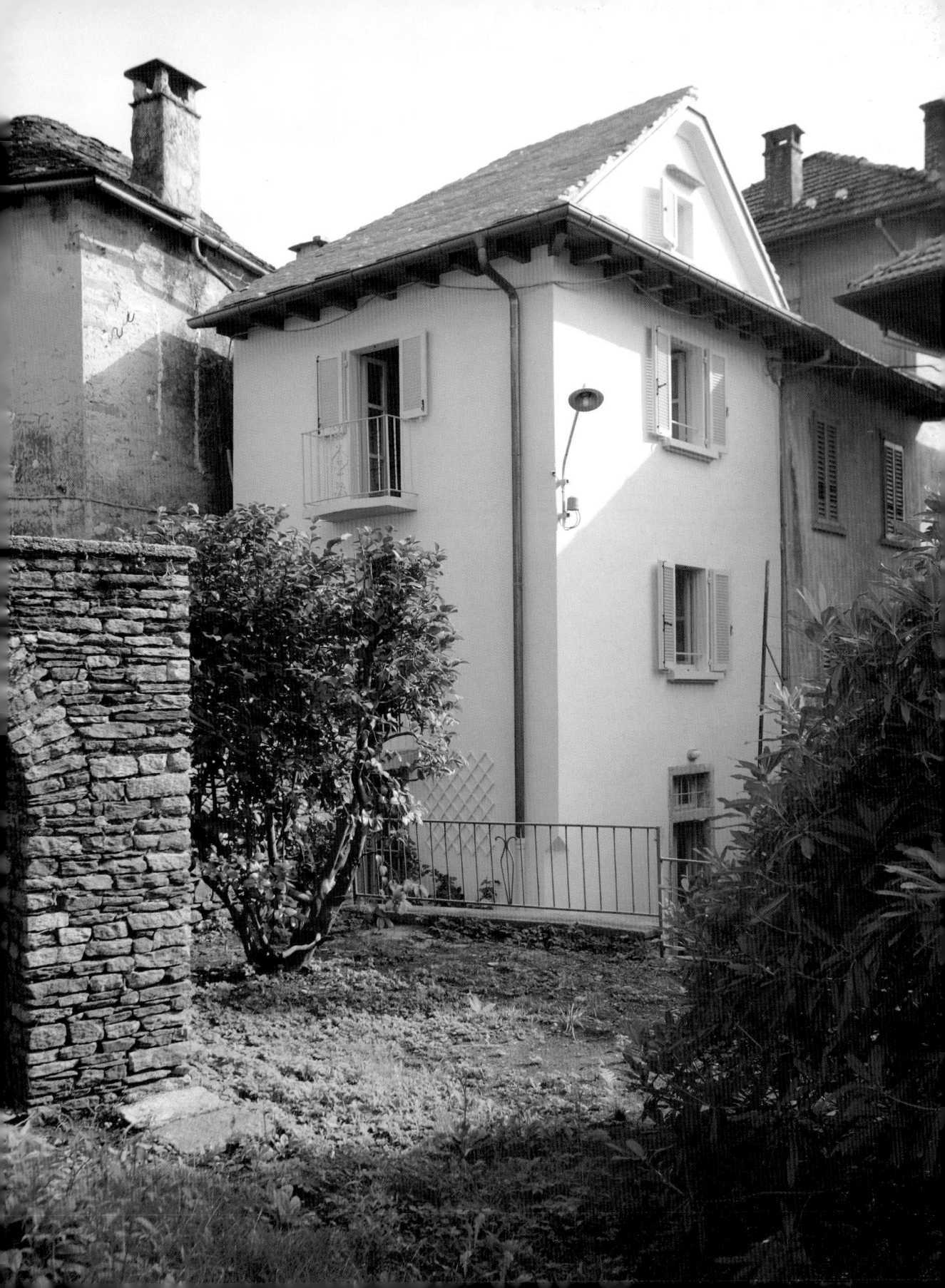

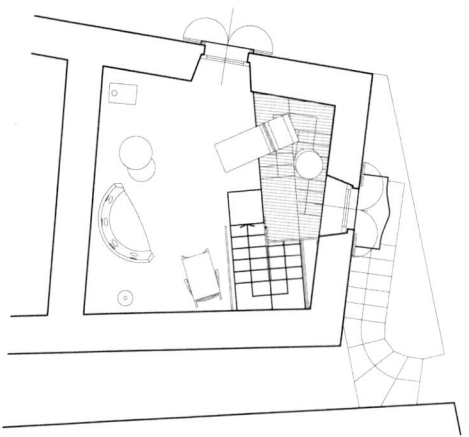

Third Floor Plan

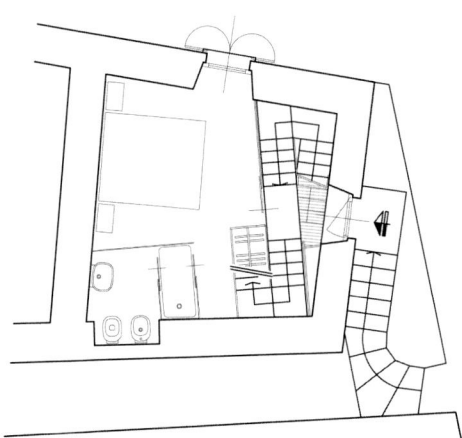

Second Floor Plan

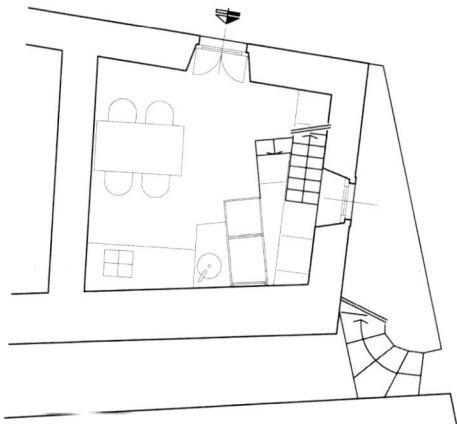

Ground Floor Plan

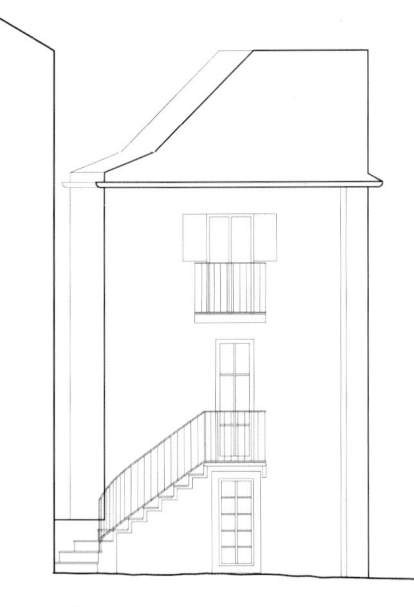

Elevations

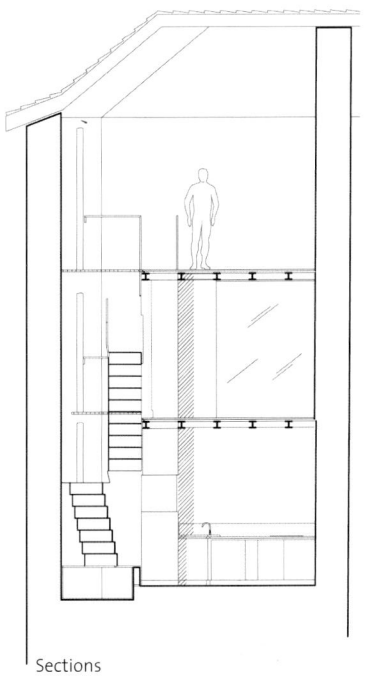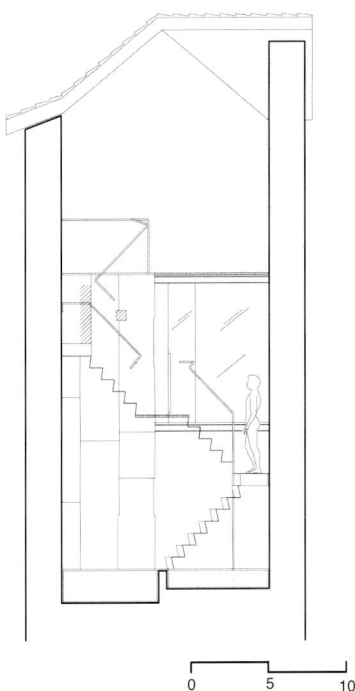

Sections

0 5 10 ft.

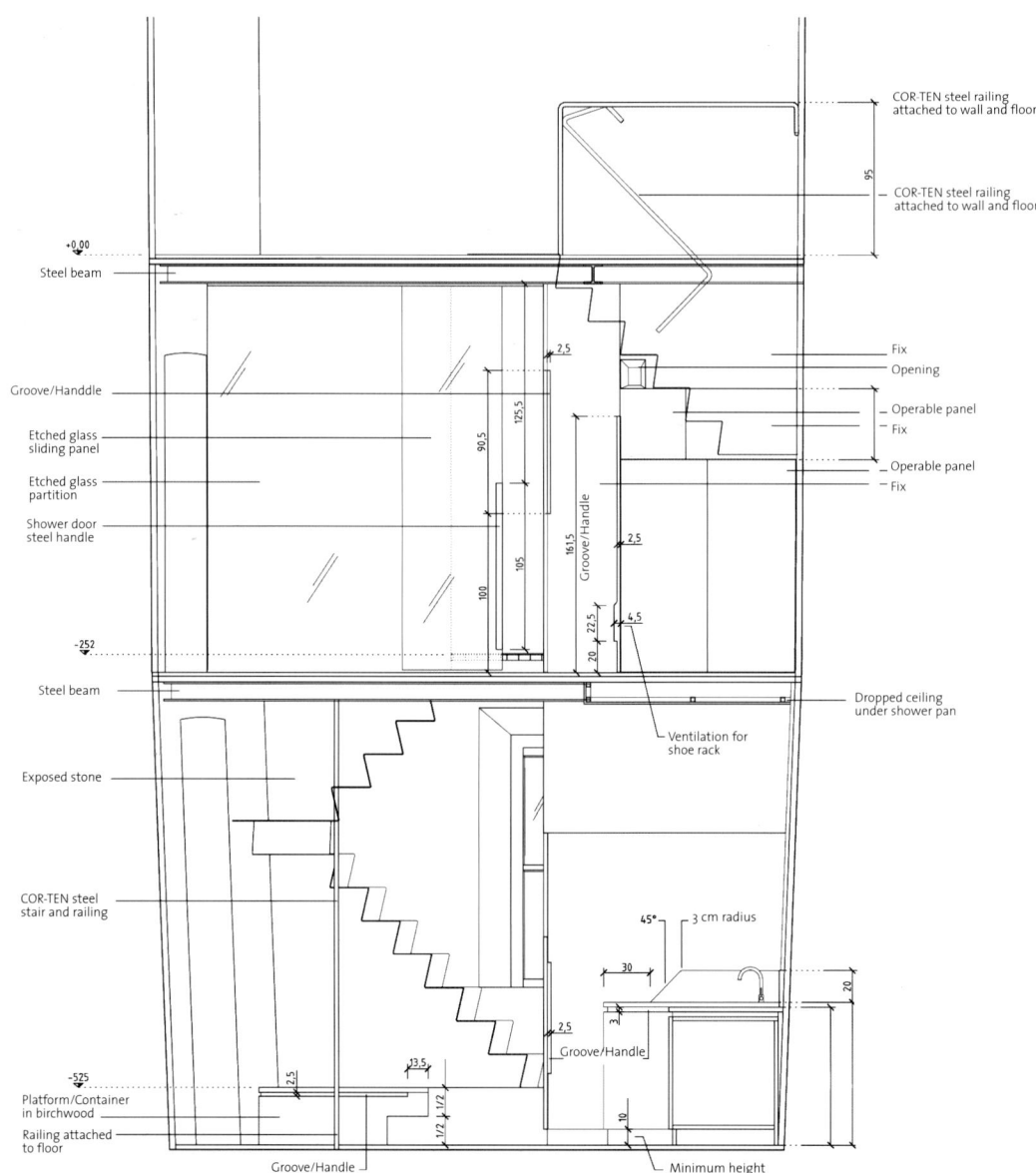

COR-TEN steel railing
attached to wall and floor

COR-TEN steel railing
attached to wall and floor

95

+0.00

Steel beam

Fix

Opening

Operable panel

Fix

Operable panel

Fix

Groove/Handdle

2,5

125,5

90,5

Etched glass
sliding panel

Etched glass
partition

105

161,5

Shower door
steel handle

Groove/Handle

2,5

100

20 22,5 4,5

−252

Steel beam

Dropped ceiling
under shower pan

Ventilation for
shoe rack

Exposed stone

45° 3 cm radius

COR-TEN steel
stair and railing

30

3

20

2,5

Groove/Handle

10

−525

2,5

13,5

Platform/Container
in birchwood

Railing attached
to floor

1/2 1/2

Groove/Handle

Minimum height

Enlarged Section

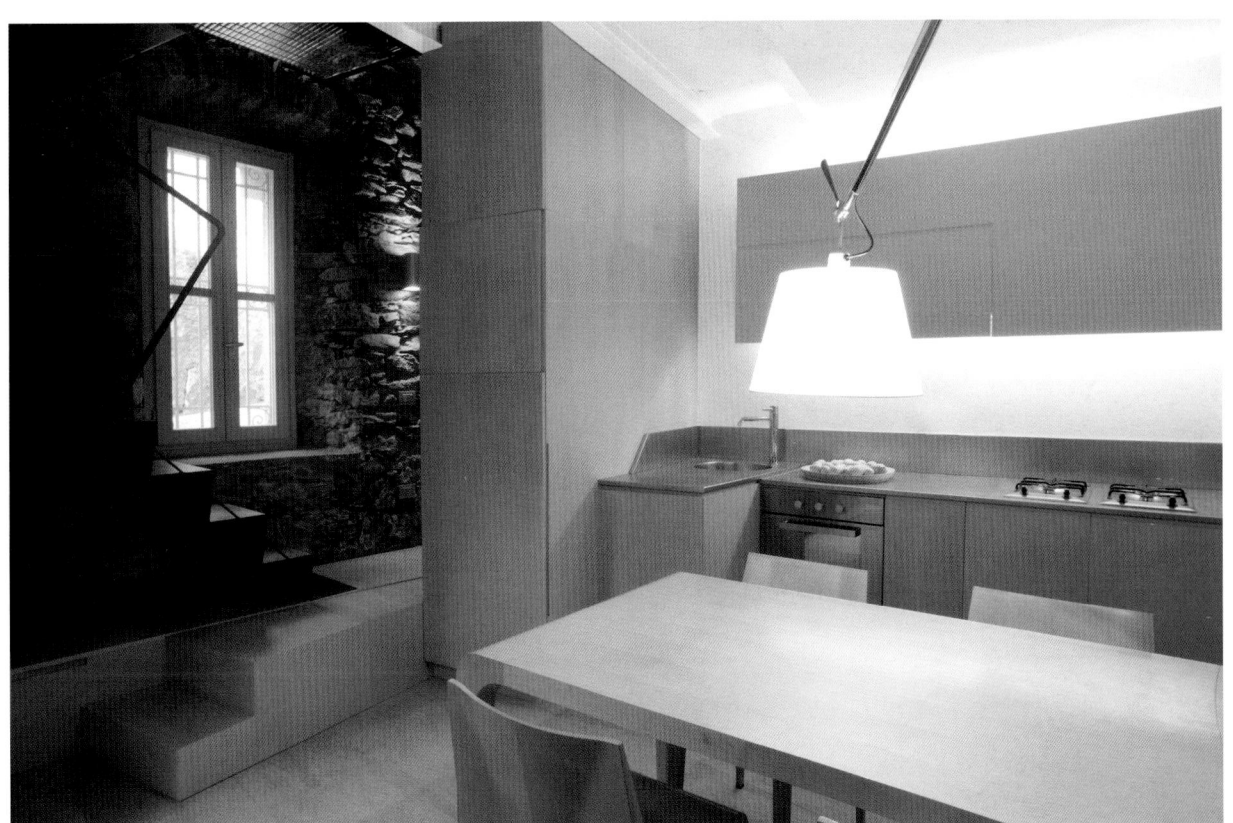

At the base of the stairs, a wooden platform serves as a pantry. The "totem" that separates the entry from the kitchen and living area contains the main appliances of the house. This element acts as an organizer and puts in juxtaposition the verticality of the stairs on one side and the platforms with different functions on the other side.

1_ The metal sheet stairs underline the vertical continuity of the house interiors while the stone flooring on the ground floor ensures a greater resistance to wear.

2_ Some portions of the floors were built with metal grating to enhance the visual connection between the different levels and to permit the passage of natural light.

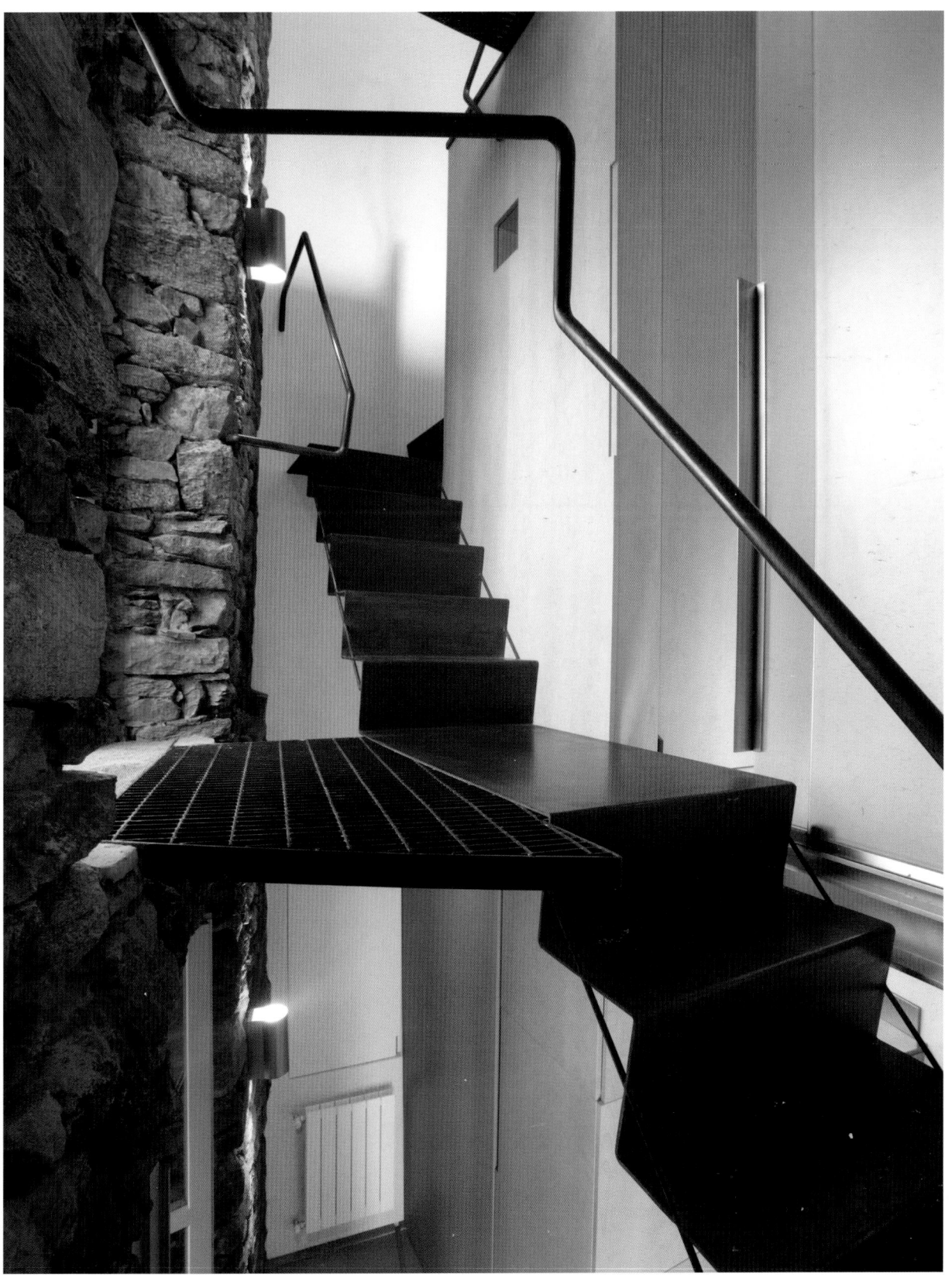

DT Loft

590 sq. ft.

The DT Loft is located in a singular office building in downtown Los Angeles. Tag Front moved into the 3,000-square-foot office space soon to realize that the spatial needs of the business were not quite so big. This situation generated the opportunity to create a place to live contiguous to the work place. First step was to seal the loft off from the office space.

The project includes a fully functional kitchen, a dining area, living room, bedroom and a bathroom with bathtub. All needed to be squeezed into just 500 square feet. The living room has ample proportions suitable for entertaining. The kitchen, open to the living area, is made simple with a combination of built-in cabinets and off-the-shelf products. The idea to keep the entire space as one single volume brought the design team to create a series of sliding panels to close off parts of the loft when needed for privacy.

Architect: Mandy Rafaty/Tag Front

Location: Los Angeles, U.S.

Completion date: 2005

Photographer: © Dean Pappas/Tag Front

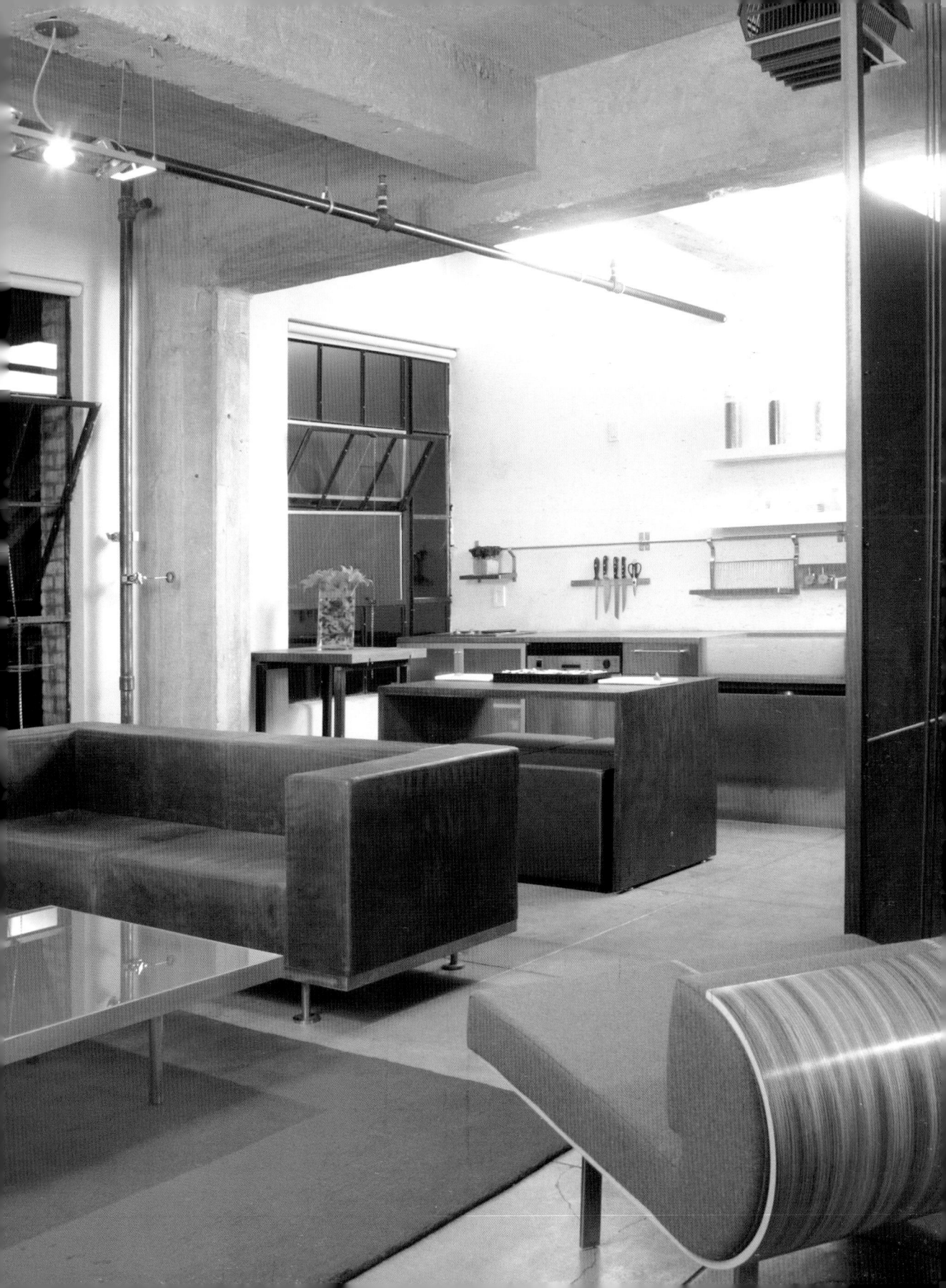

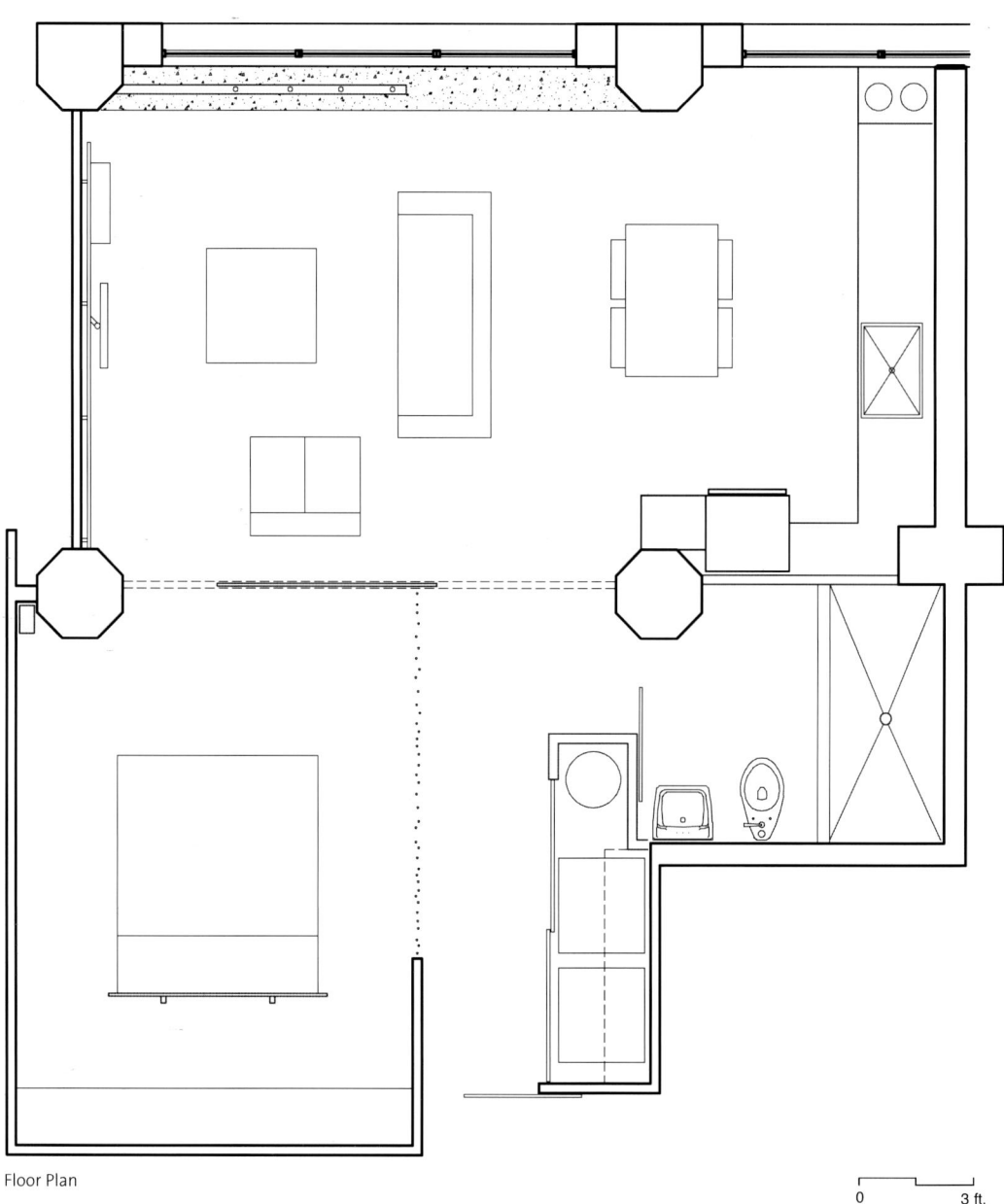

Floor Plan

0 3 ft.

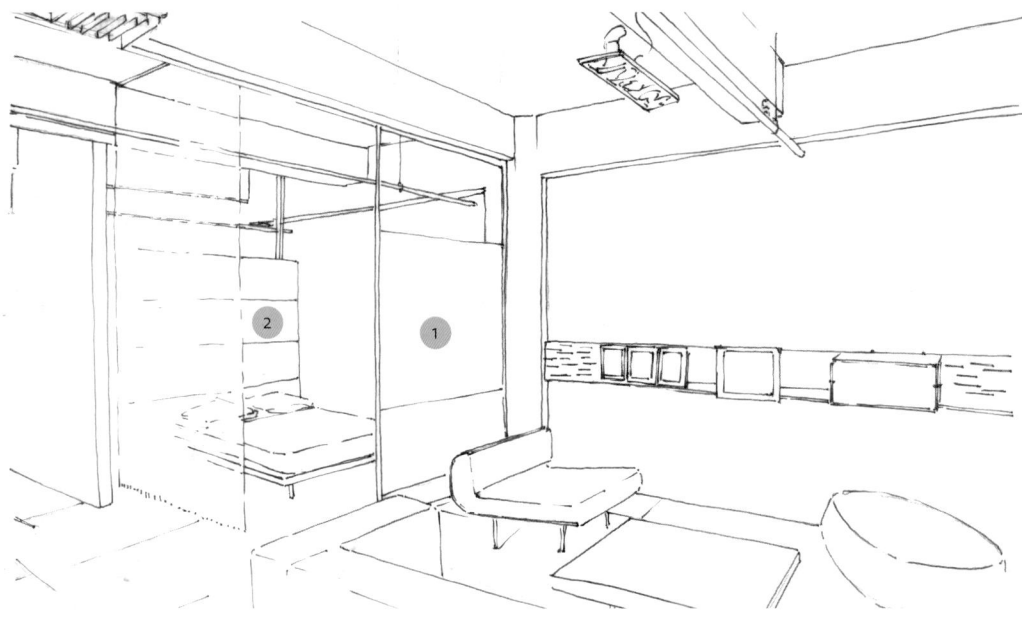

1_ The low height sliding panel conceals the bedroom or adds some extra square footage to the living area.

2_ A second panel serves as headboard and separates the bed from the closet. Every groove and corner in the existing shelf is used as an opportunity for storage in order to avoid furniture.

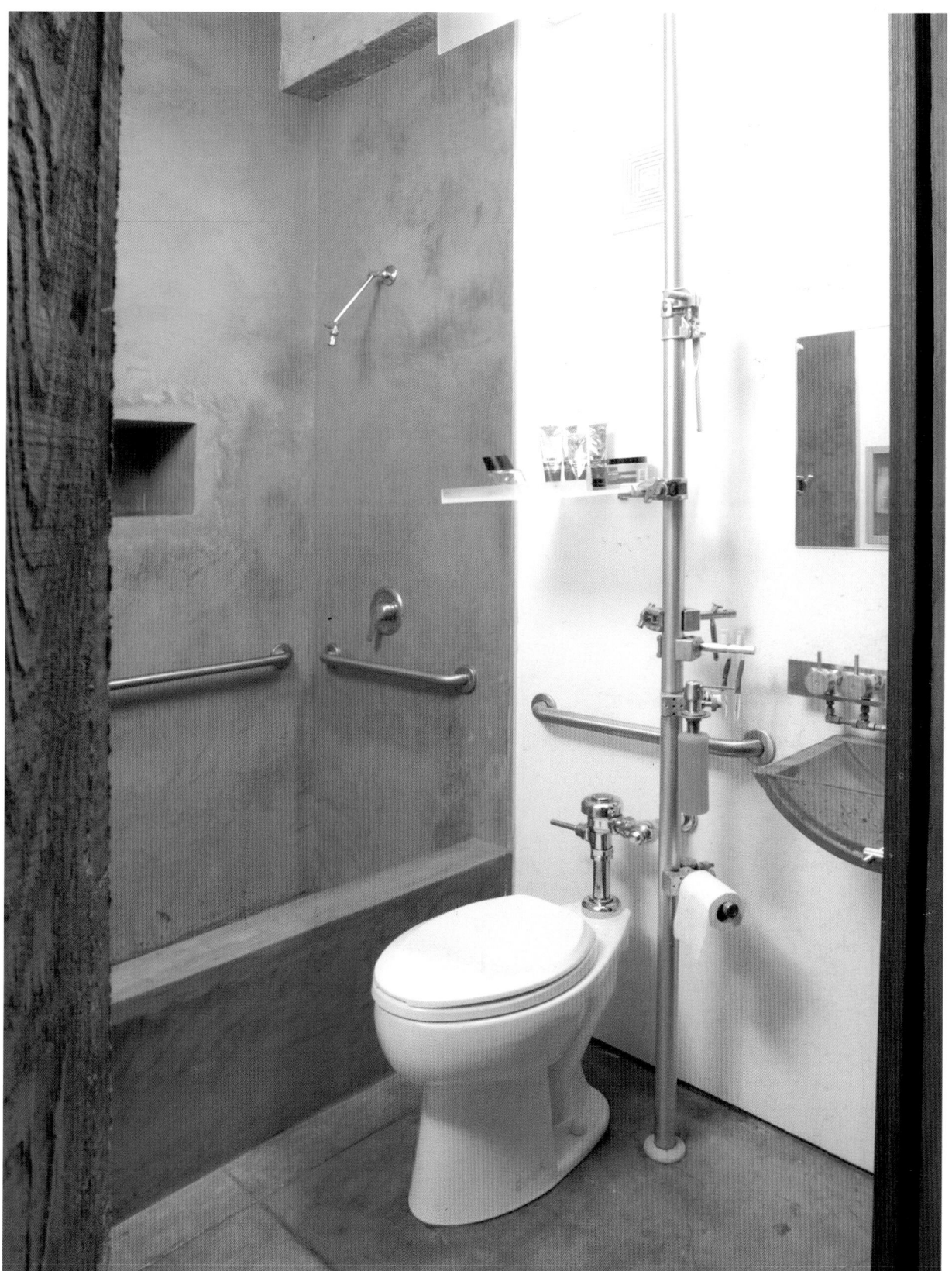

Yoga Studio/Guest House
600 sq. ft.

The limited size of an existing house created the necessity for more space for friends and family and the privacy needed to meditate and enjoy yoga in a natural setting. The studio rests behind a craggy stone ridge, a hundred feet away from the existing house. It allows for some independence while staying connected enough to the main house for shared functions. Inside the studio, an open plan features yoga space, in-floor bunks to sleep up to nine, a bathroom and a small kitchen. The simplicity of the structure required more attention to detail and materials to maximize the use of the limited space. This was achieved by means of the customization of most elements in the project. The clients' dedication to energy efficiency and minimal waste inspired a sustainable project.

Architect: Carter & Burton Architecture

Location: Clarke County, Virginia, U.S.

Completion date: 2007

Photographer: © Daniel Afzal

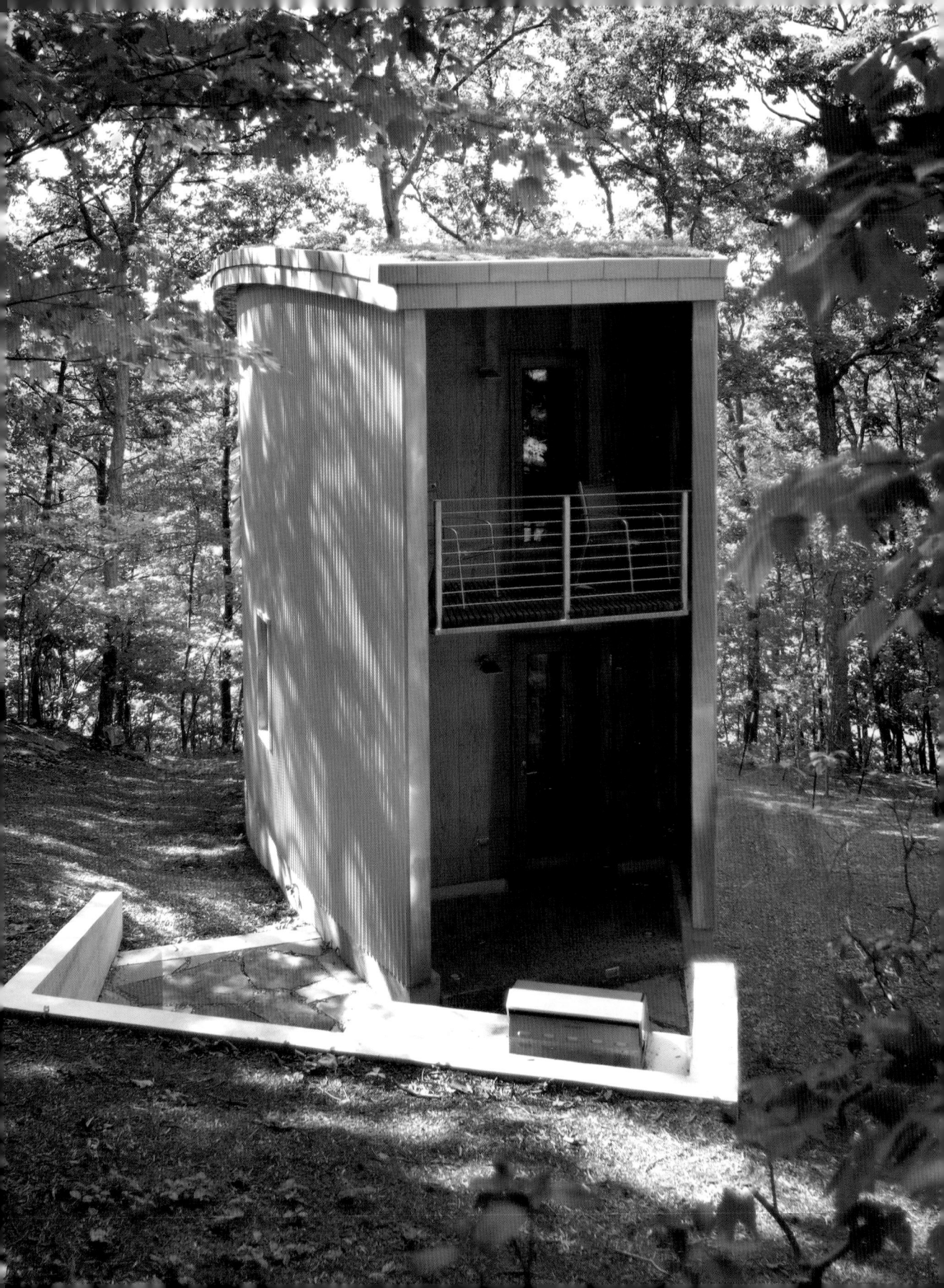

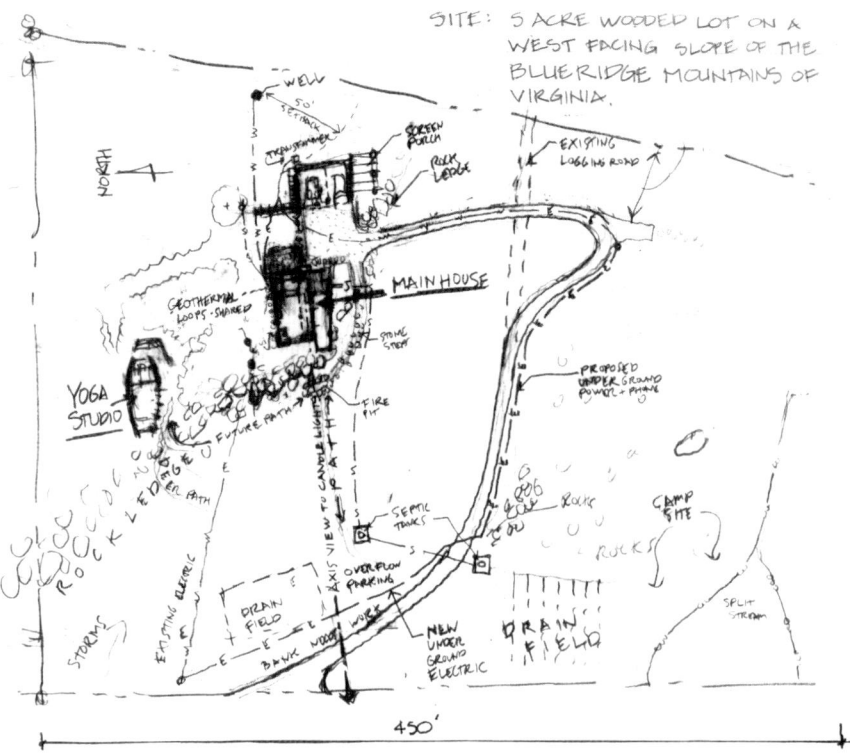

SITE: 5 ACRE WOODED LOT ON A WEST FACING SLOPE OF THE BLUE RIDGE MOUNTAINS OF VIRGINIA.

Site Plan - Preliminary Sketch

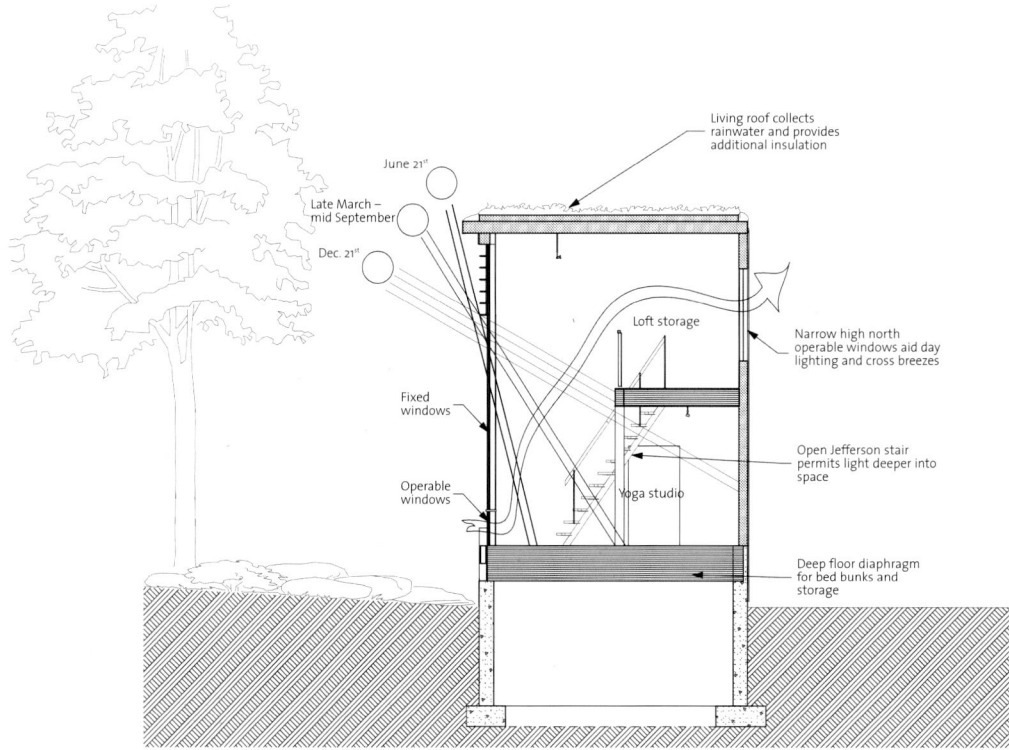

Living roof collects rainwater and provides additional insulation

June 21st

Late March – mid September

Dec. 21st

Loft storage

Narrow high north operable windows aid day lighting and cross breezes

Fixed windows

Open Jefferson stair permits light deeper into space

Operable windows

Yoga studio

Deep floor diaphragm for bed bunks and storage

Section

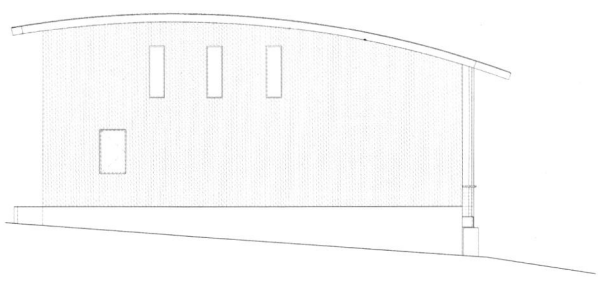

North Elevation

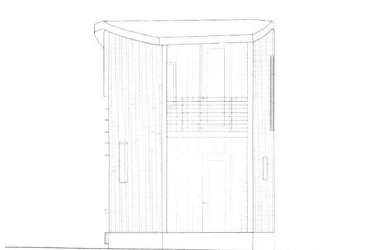

East Elevation

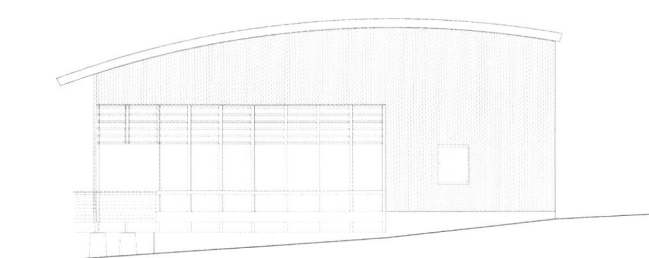

South Elevation

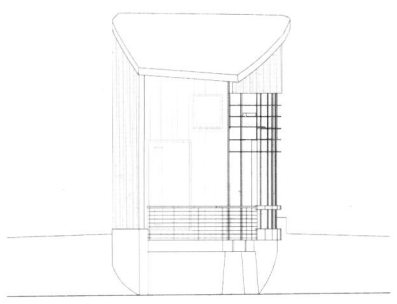

West Elevation

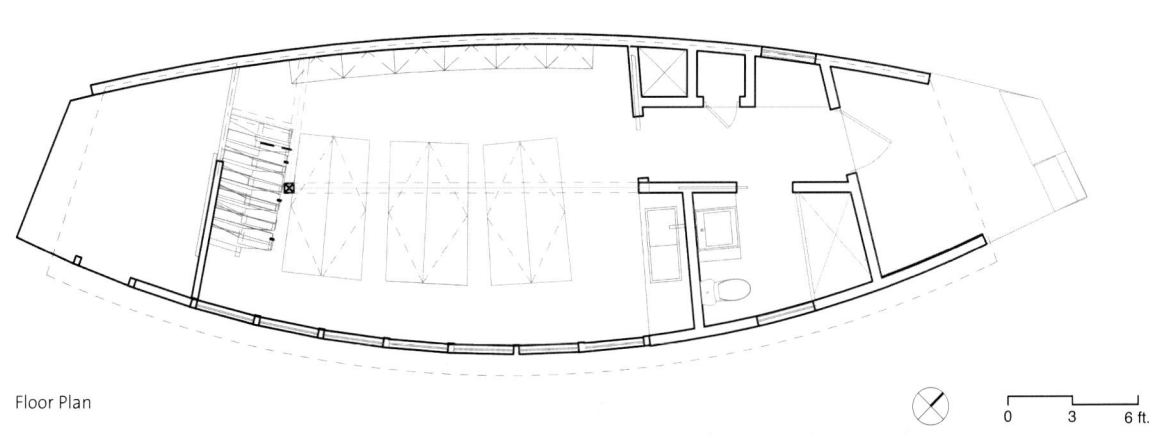

Floor Plan

0 3 6 ft.

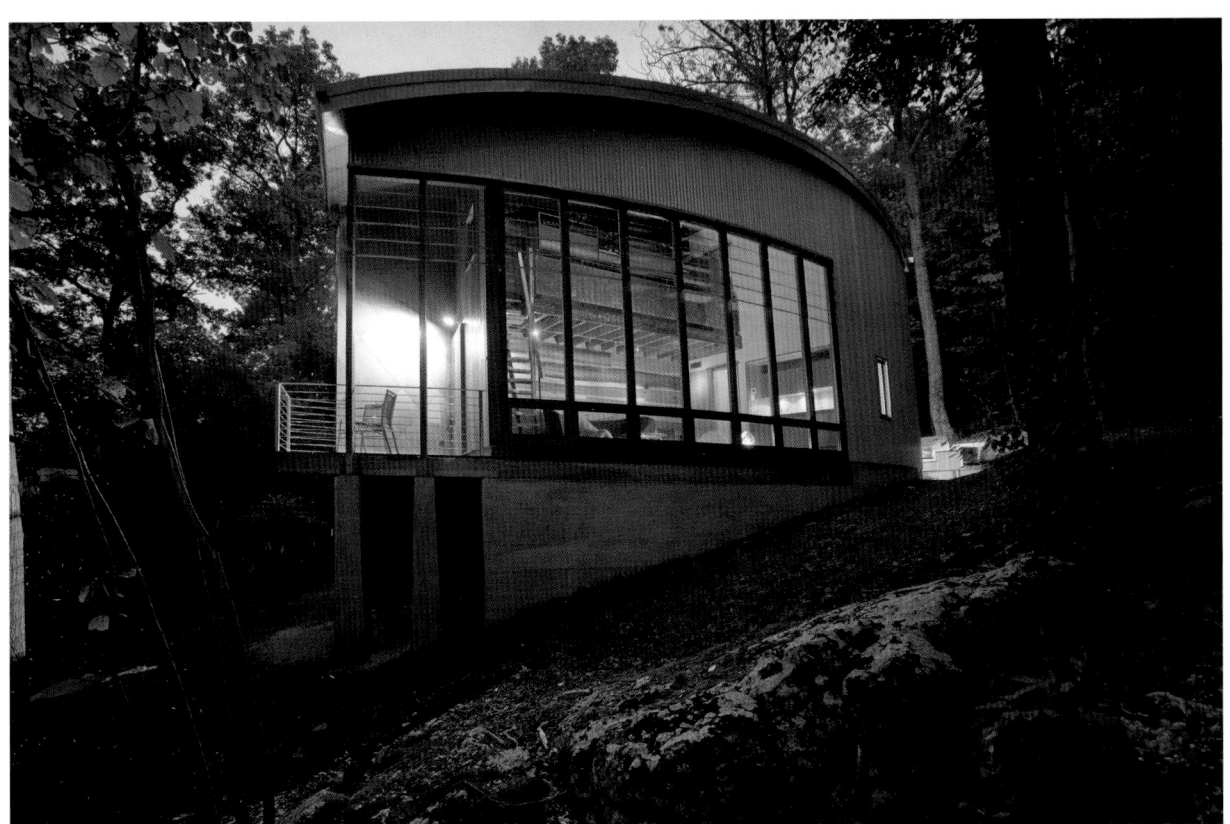

This outbuilding fits with the site while maintaining
a modern purity of form and space rarely seen in
a rural setting. The charge to build a private yoga
studio afforded the opportunity to experiment
with construction in a different expression from
the main house.

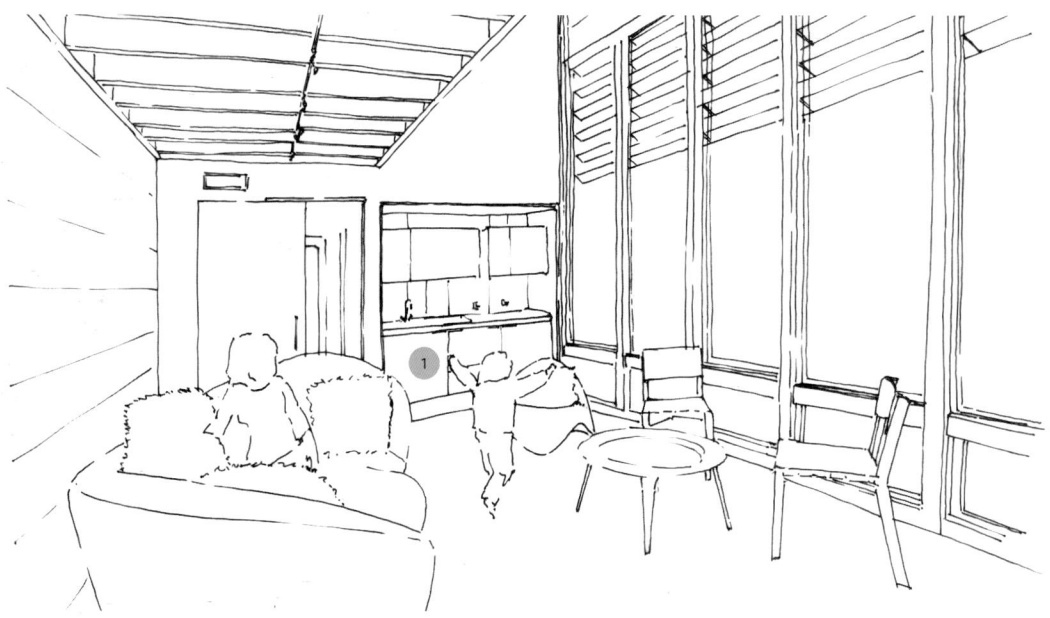

1_ The team of client and architect agreed on the importance of local craftsmanship in nurturing local culture. All the cabinetry in the studio, including a bathroom, a shoe storage bench by the front door, a bathroom sink cabinet and the kitchen cabinets were built by local craftspeople.

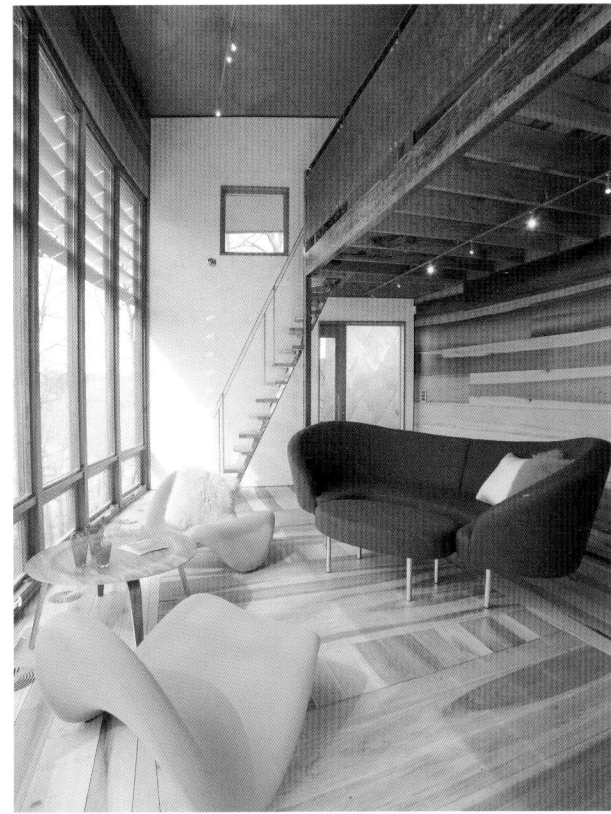

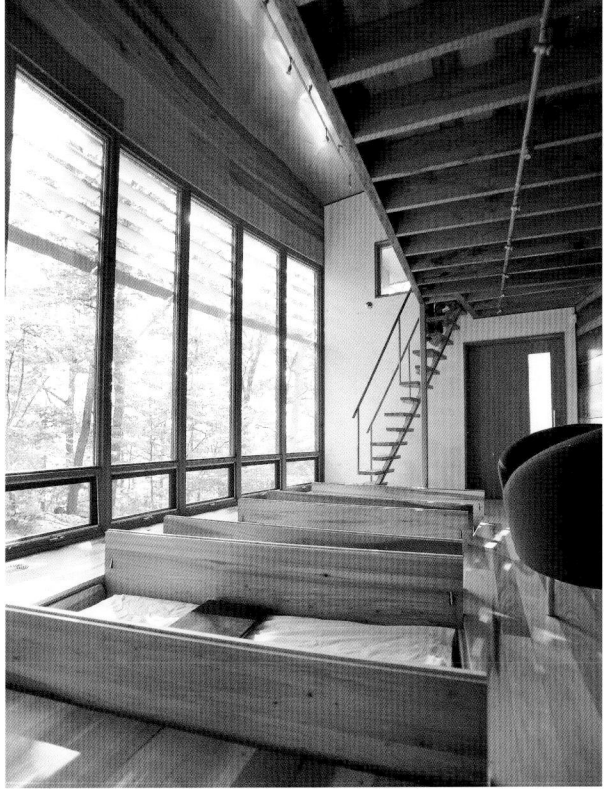

A key feature of the studio is that it doubles as a bunkhouse. There are beds built into the floor with trap doors hiding them during the day. Bunk beds built out of steel frame are located on the mezzanine. With all the beds in use, the studio can sleep up to nine people in a minimal space during special occasions.

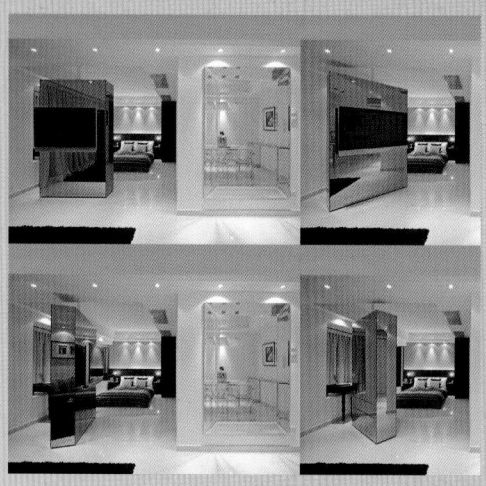

Angler's Bay
630 sq. ft.

An elegant interior dominated by a white color scheme mixes fine and comfortable pieces of furniture with plastic and glass items to play a game of transparencies and reflections.

The original two bedroom apartment was transformed into a comfortable one bedroom separated from the living area by a bright orange reflective rotating cabinet. This element, centrally located, organizes the space and permits the large TV screen to be watched either sitting comfortably on the couch or lying in bed by simply turning the gyratory wall around. Color is therefore associated with movement while stillness or the space around the rotary wall is characterized by its muted, dark colors; a world of elegance and sophistication enhanced by the appropriate lighting is transformed when reflected on the bright orange wall.

Architect: PTang Studio
Location: Hong Kong, China
Completion date: 2006
Photographer: © Ulso Tang

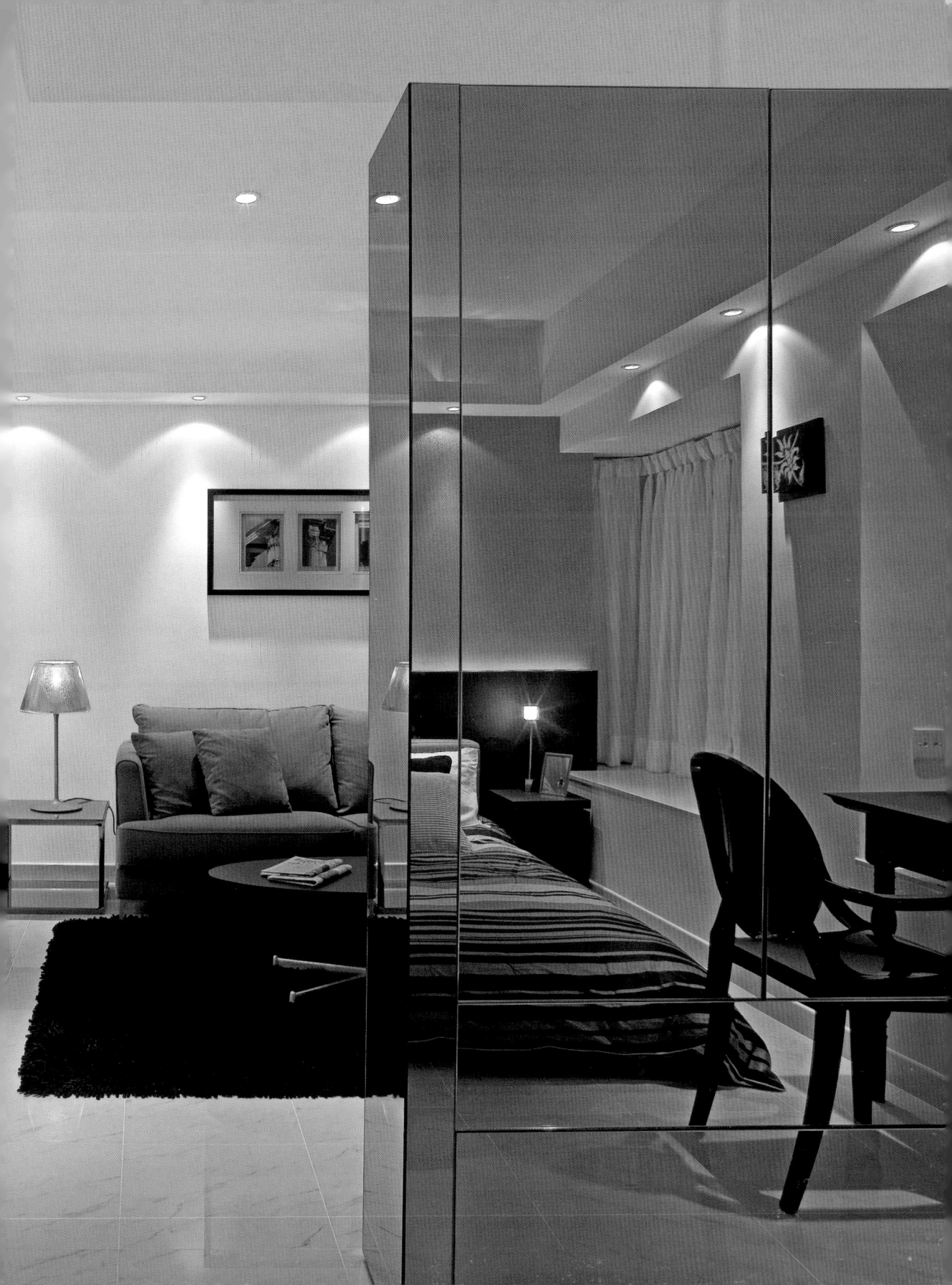

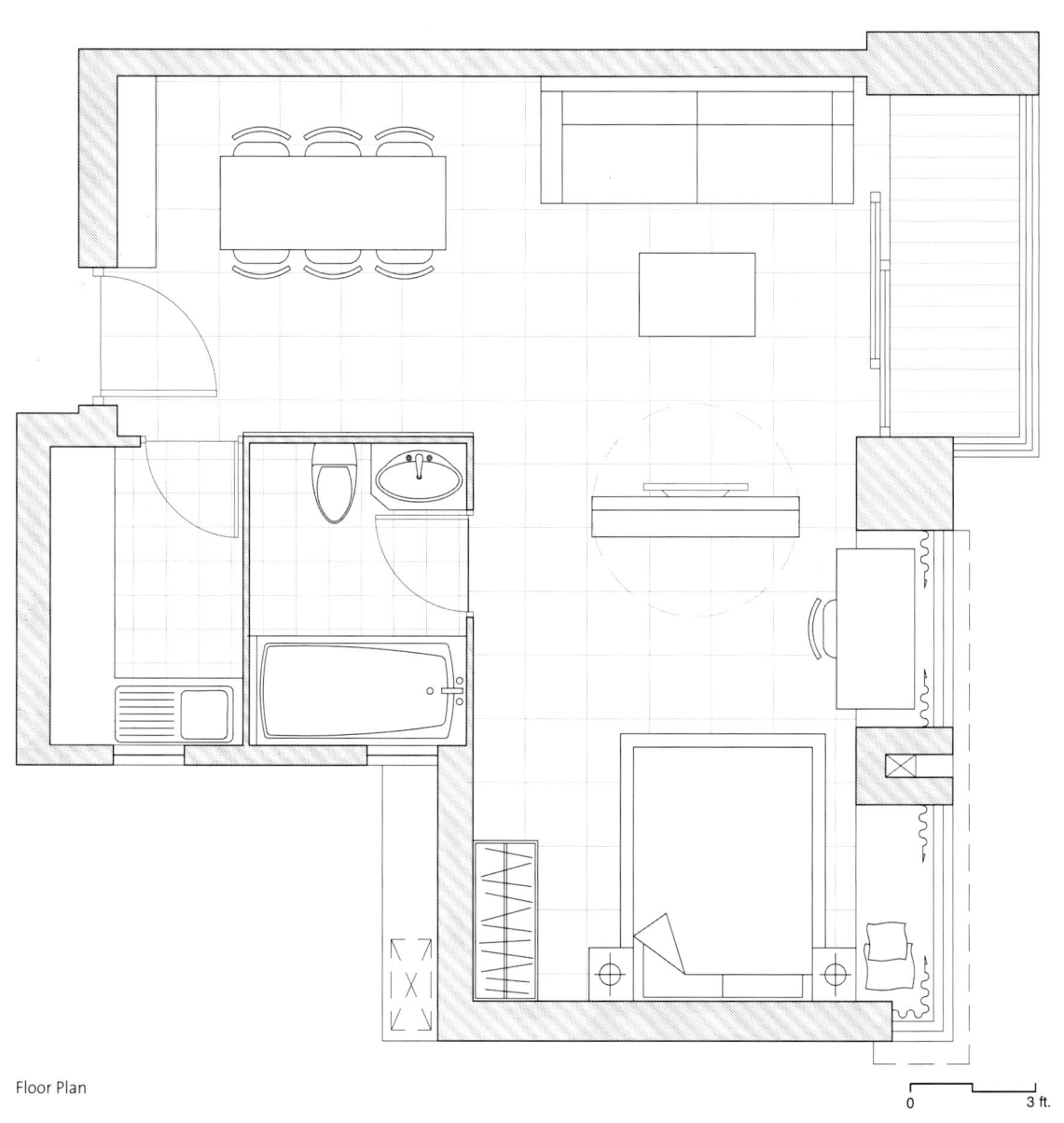

Floor Plan

0 3 ft.

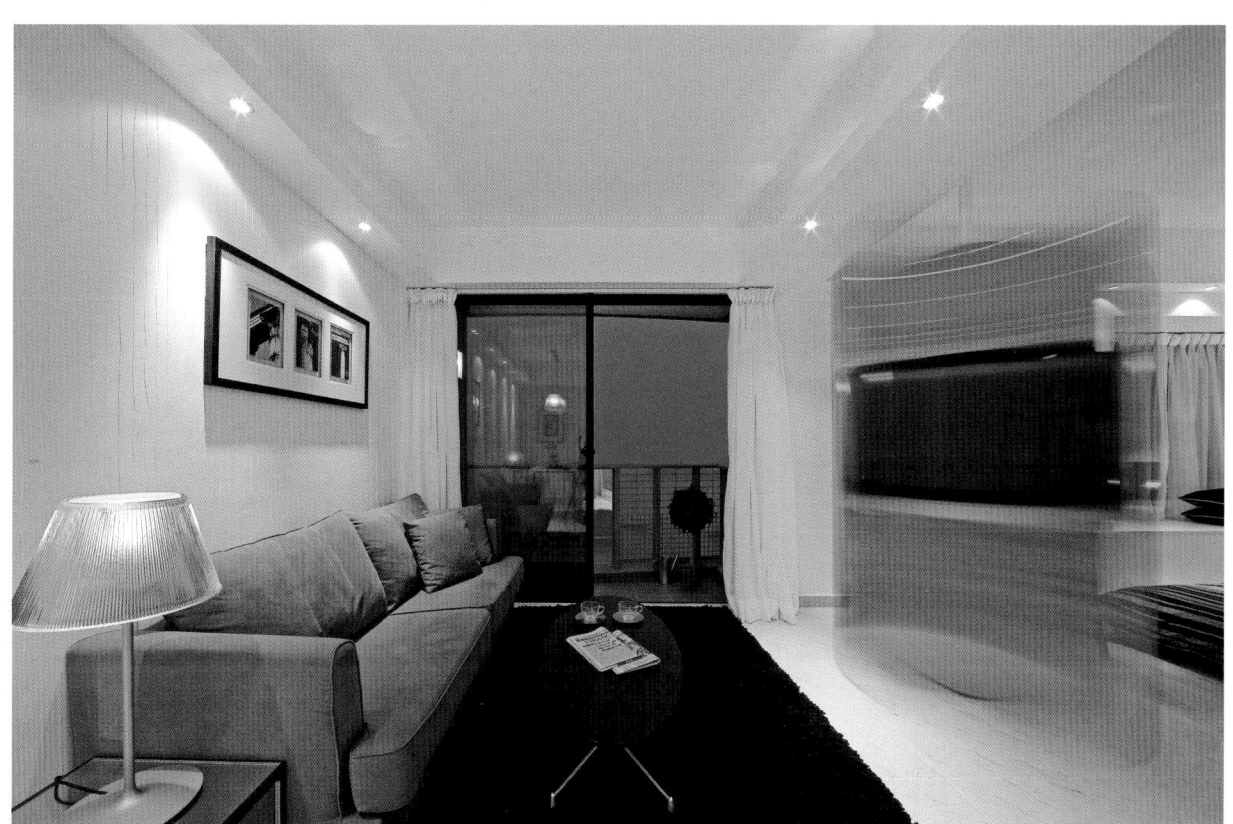

Reflection and transparency are the recurring themes of this project. Physically, the circulation is fluid with no obstruction except for the rotary wall which alters the perception of the whole space as it turns around. Conceptually, the wall offers perhaps another reality?

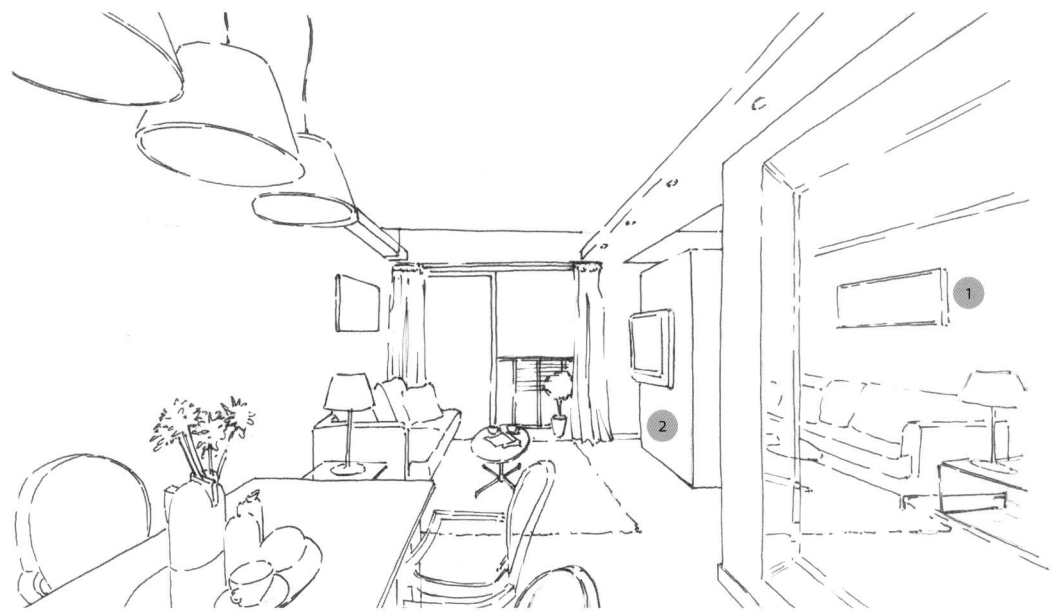

1_ A large mirror reflects an all-white space with glass and plastic items such as Philippe Starck's "Louis Ghost" polycarbonate chairs enhancing the sense of space.

2_ Centrally located, the gyratory wall divides the living area from the bedroom. It stands out for its color and gives the entire apartment an orange tinge as it is being reflected.

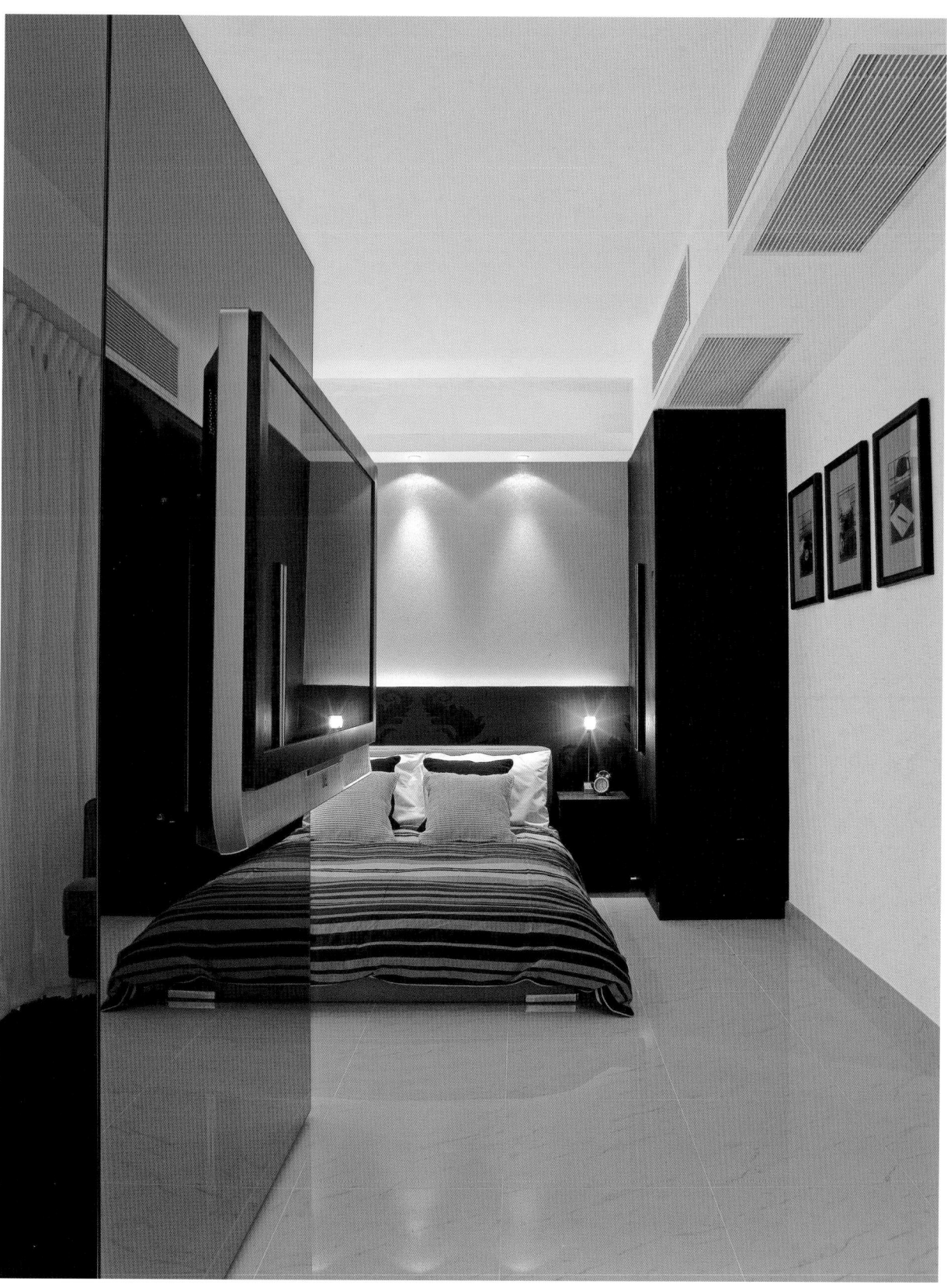

Attic in Donosti

645 sq. ft.

The remodel of this attic in San Sebastian (Donosti in Basque) was executed with a very limited budget but a lot of enthusiasm. One thing was certain: all the functions were to be centralized to free up as much space as possible.

The existing structure of wood beams and columns is maintained and large skylights are placed to facilitate the entry of light. The intervention transforms a dark and gloomy space in an open and luminous dwelling that reflects the personality of the young occupant.

The kitchen block separates the bathroom from the open living space. The sleeping loft as well as abundant storage space is suspended over the bathroom. Where the ceiling comes down to intersect the floor, a line of wood cases mounted on wheels add to the much-needed storage space while avoiding the construction of partitions.

Architect: Jabier Lekuona

Location: San Sebastian, Spain

Completion date: 2007

Photographer: © Gorgotza & Llorella Architecture Photography

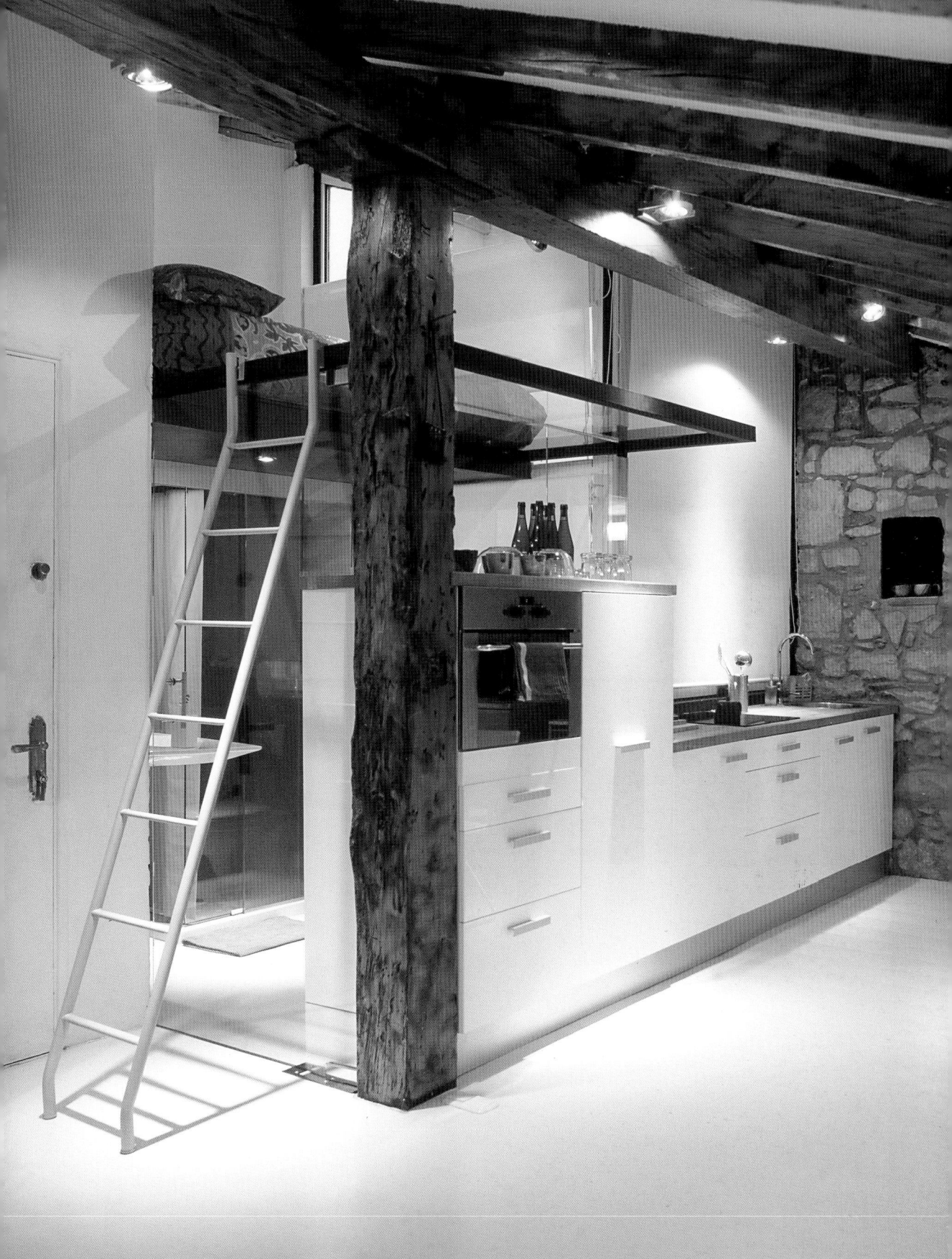

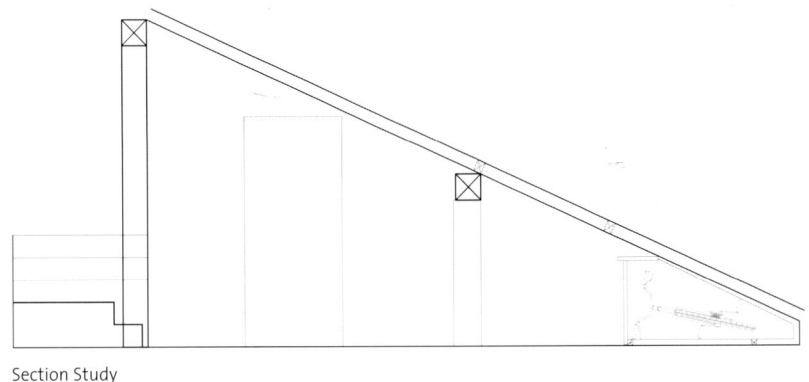

Section Study

Floor Plan

0　　　3　　　6 ft.

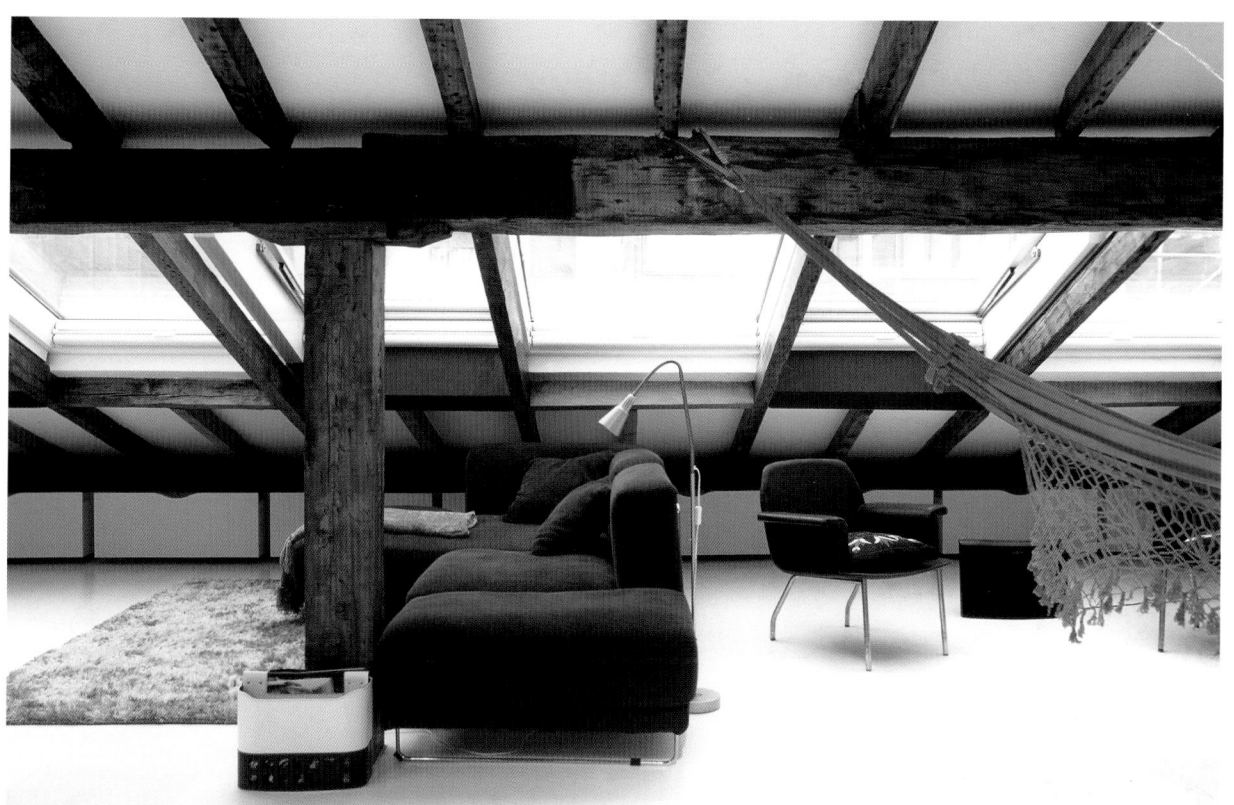

Several skylights are placed over the sitting area to illuminate the otherwise dark and gloomy attic. The white colored flooring reflects the light and enlivens the entire space. Few pieces of furniture and a clever use of color complete this attic remodel.

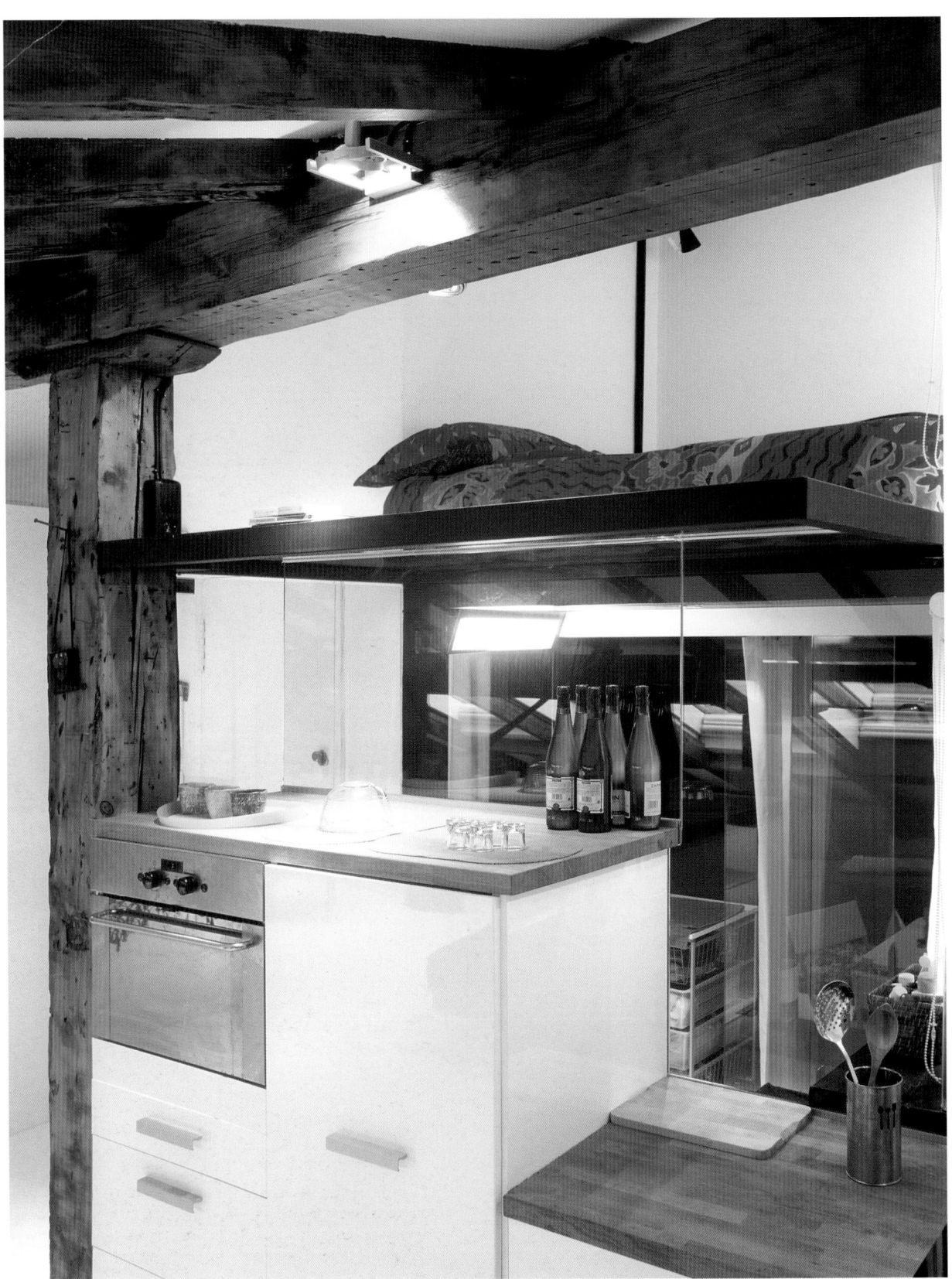

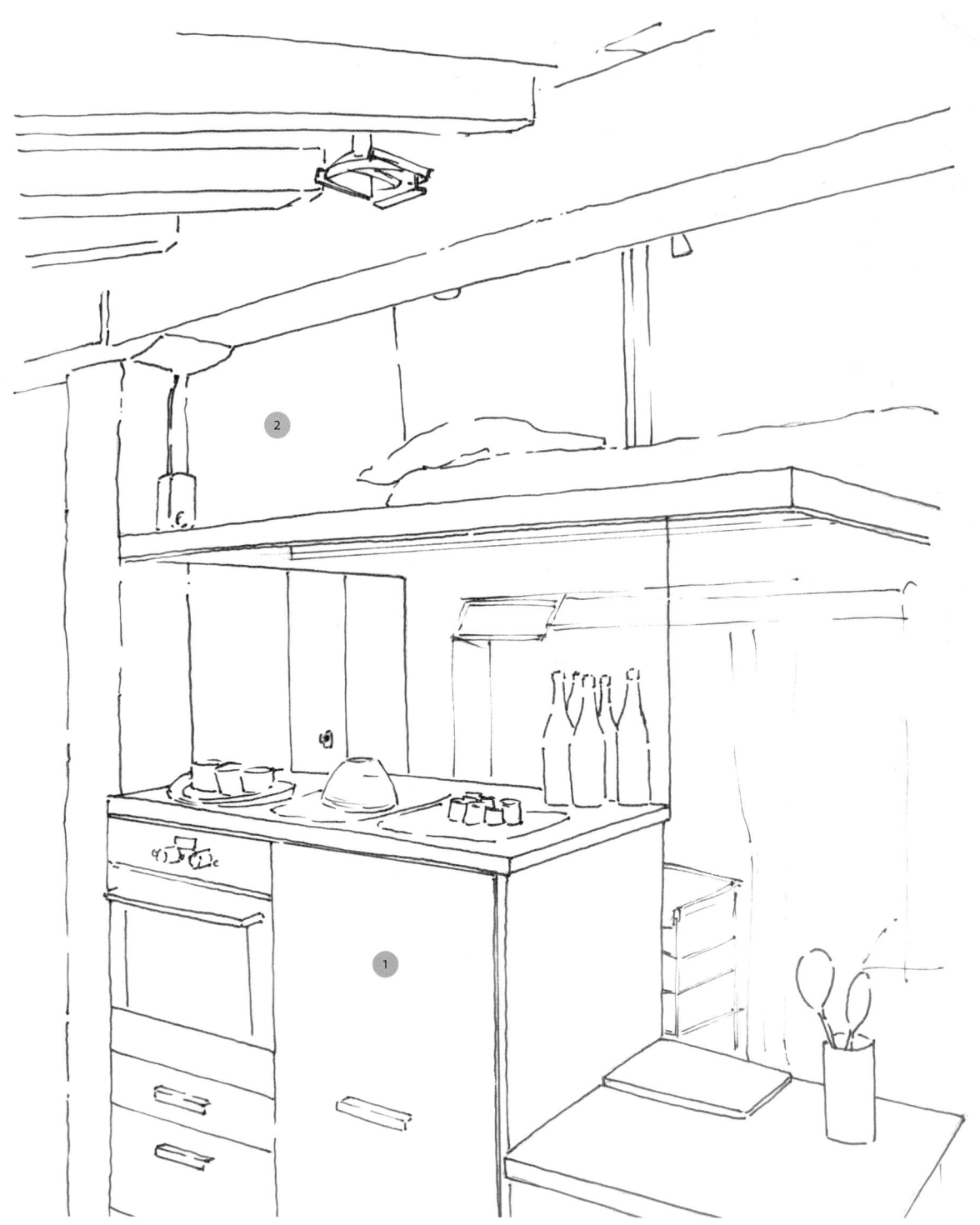

1_The kitchen block visually separates the living area from the bathroom, which is enclosed in a glass box.

2_The sleeping loft is placed over the bathroom and is accessible by means of a ladder. By doing so, the kitchen, the bathroom and the sleeping area occupy a minimal floor area, leaving the rest of the attic as open as possible.

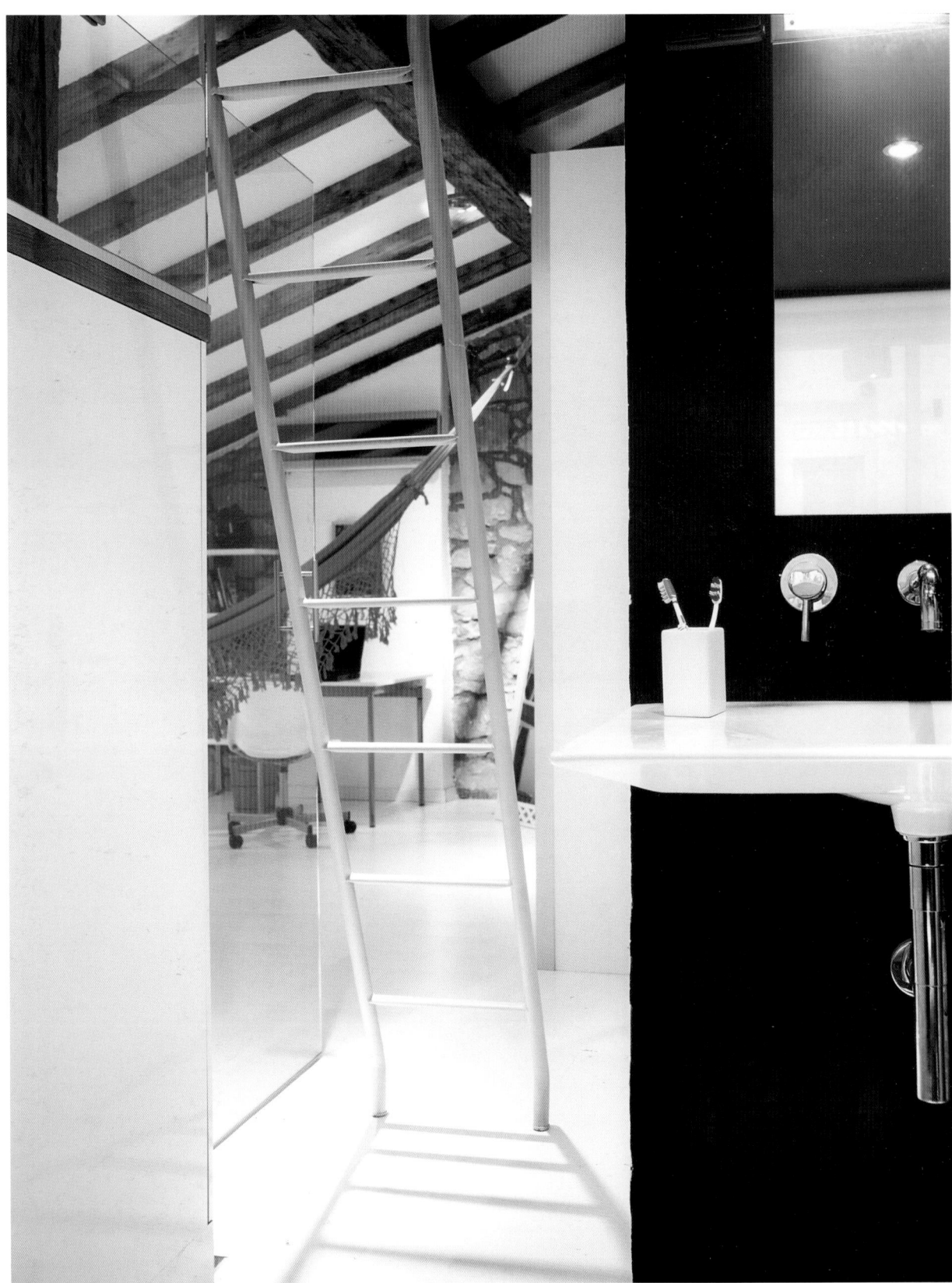

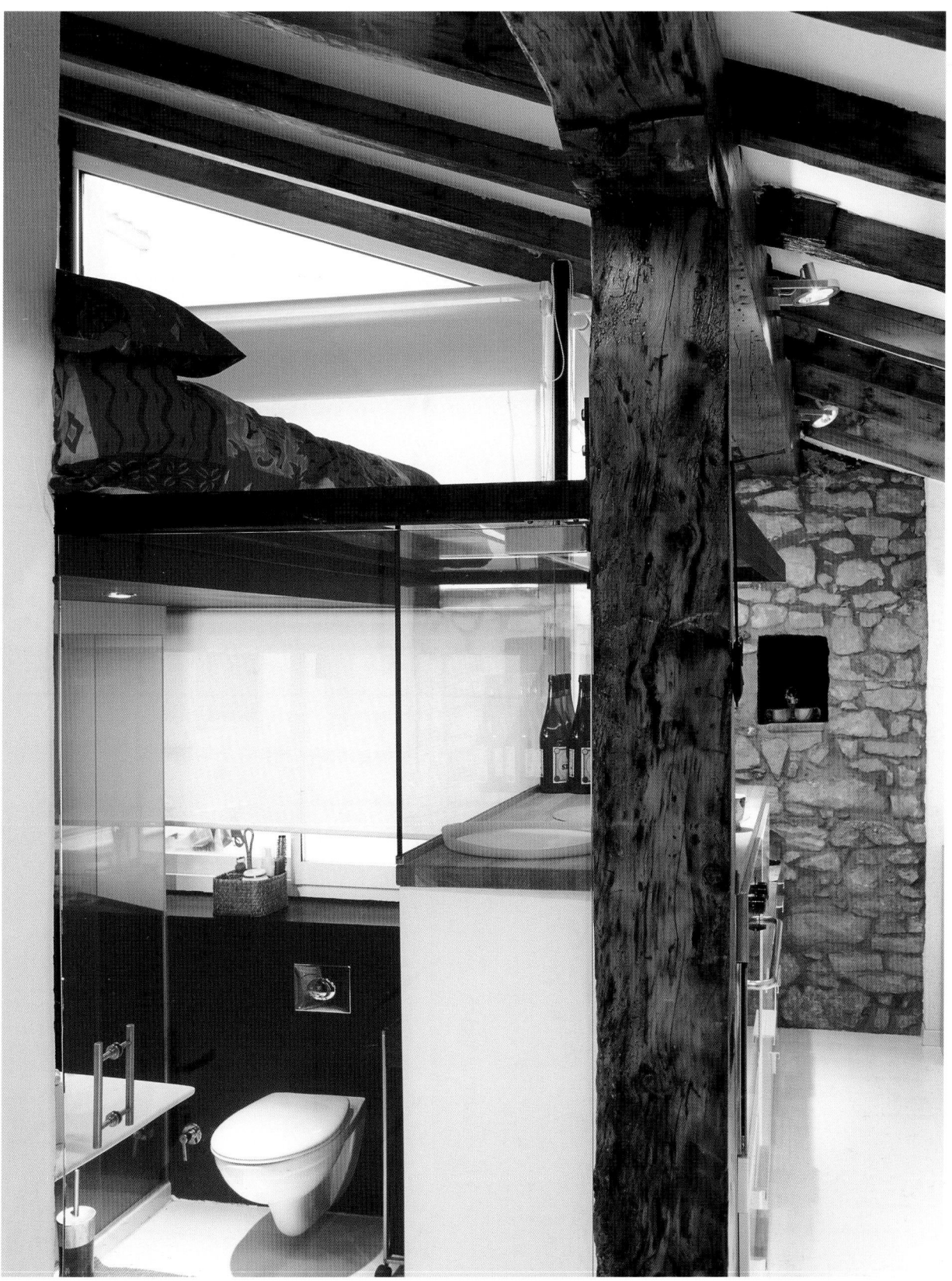

Narrow Apartment in Antwerp

646 sq. ft.

Four long, narrow floors squeezed in between the pre-existing side walls present an opportunity to explore new ways to accommodate the typical functions of a home. While the upper floors are reserved for living, the ground floor is used for office space. Both ends of the loft-like apartment are glassed-in. From the outside, each floor, framed in black, appears as an art installation. The striking illumination is a wink to the "red-light district" where the building is located. The available space, limited to 646 square feet, establishes new parameters that define the line between necessity and luxury. The surfaces of the existing shell are left intact as finishes are not in this case a requirement for comfortable living conditions.

Architect: Sculp(it) Architecten

Location: Antwerp, Belgium

Completion date: 2007

Photographer: © Luc Roymans

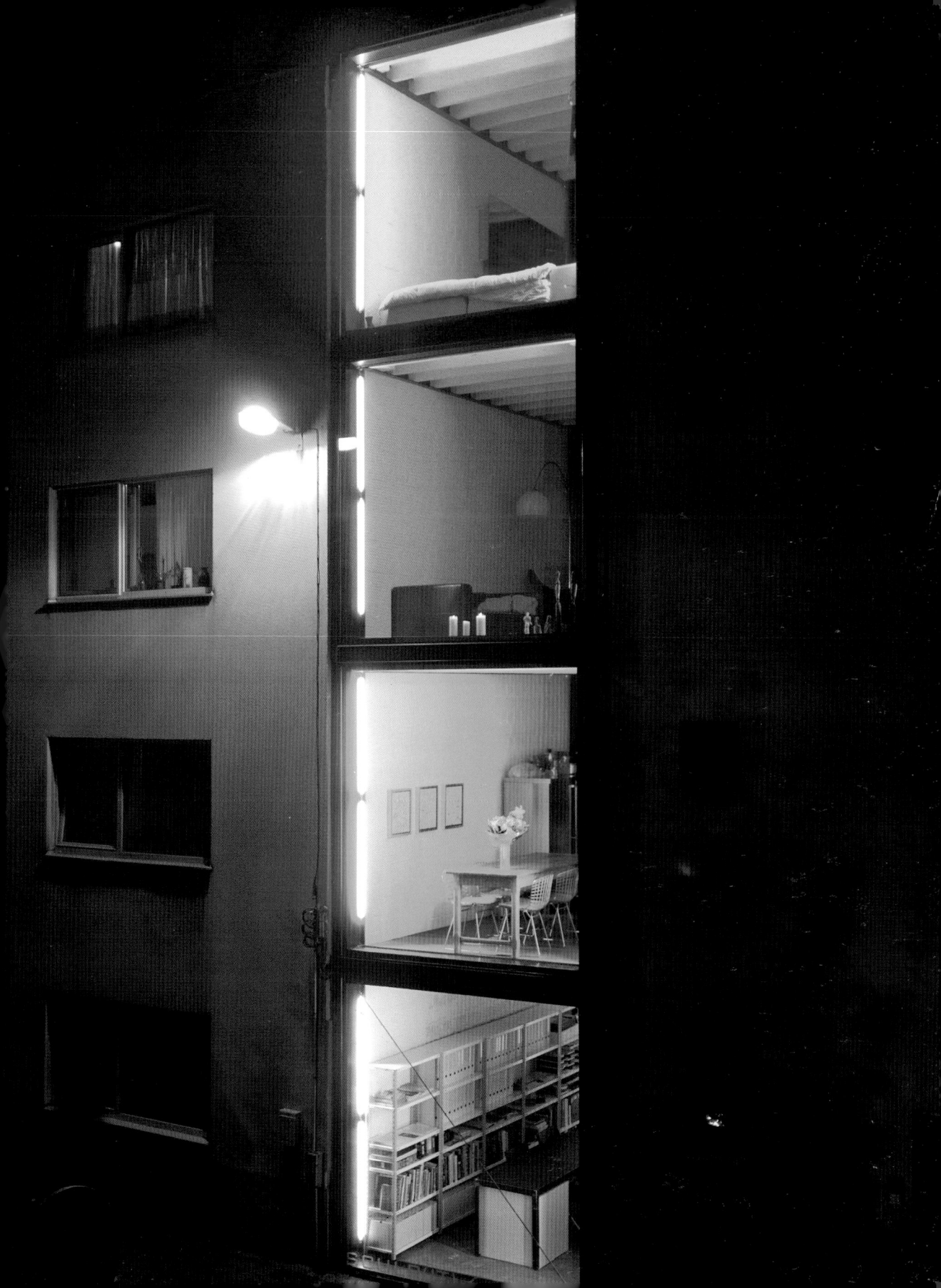

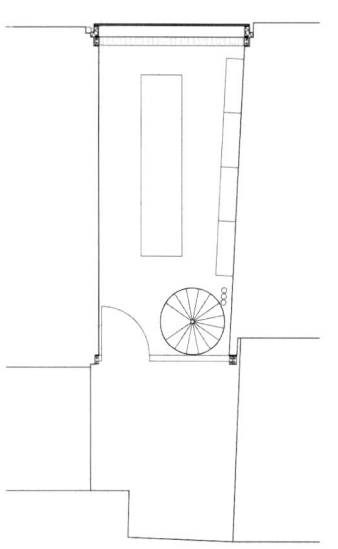

Location Map

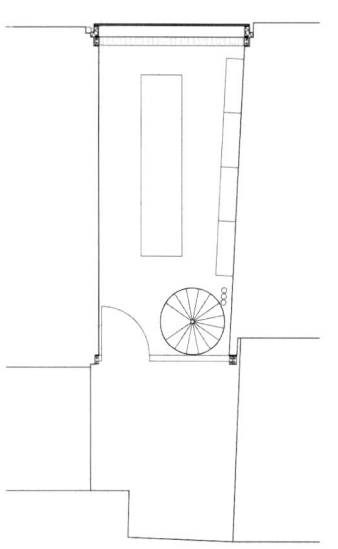

Ground Floor Plan

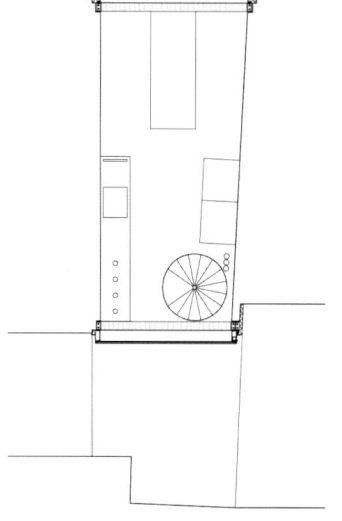

Second Floor Plan

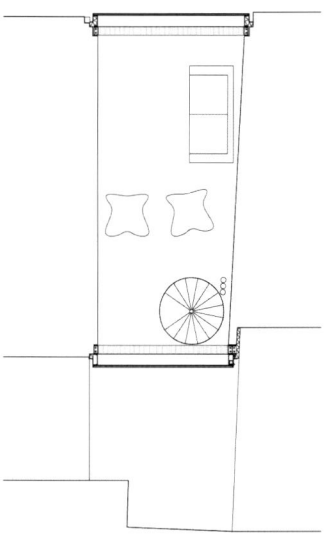

Third Floor Plan

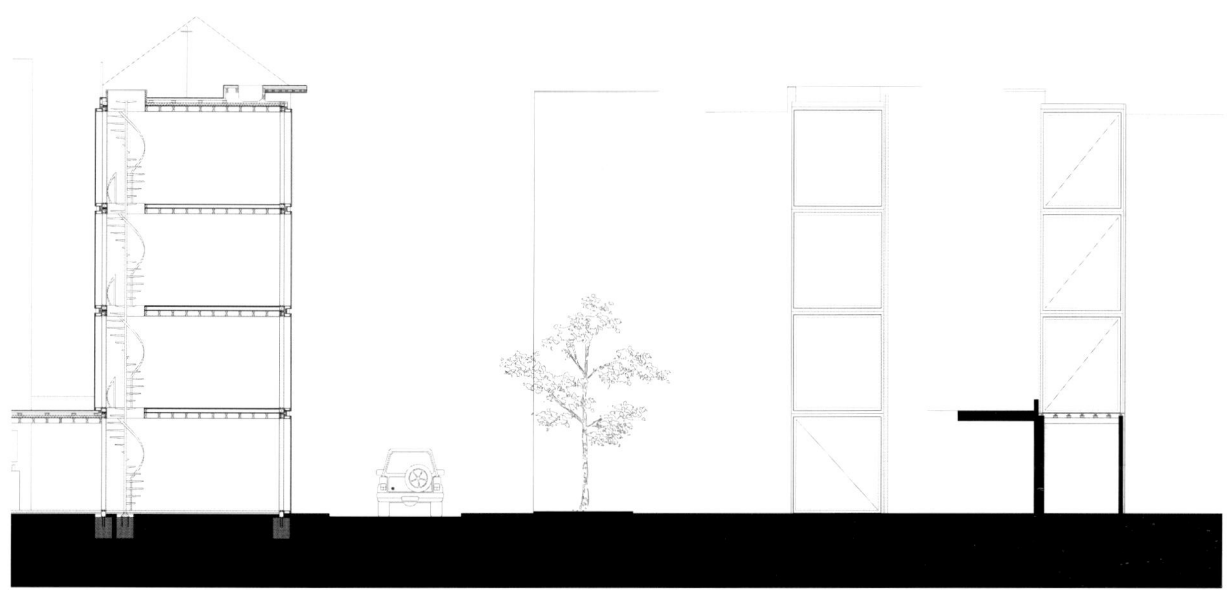

Section

Elevations

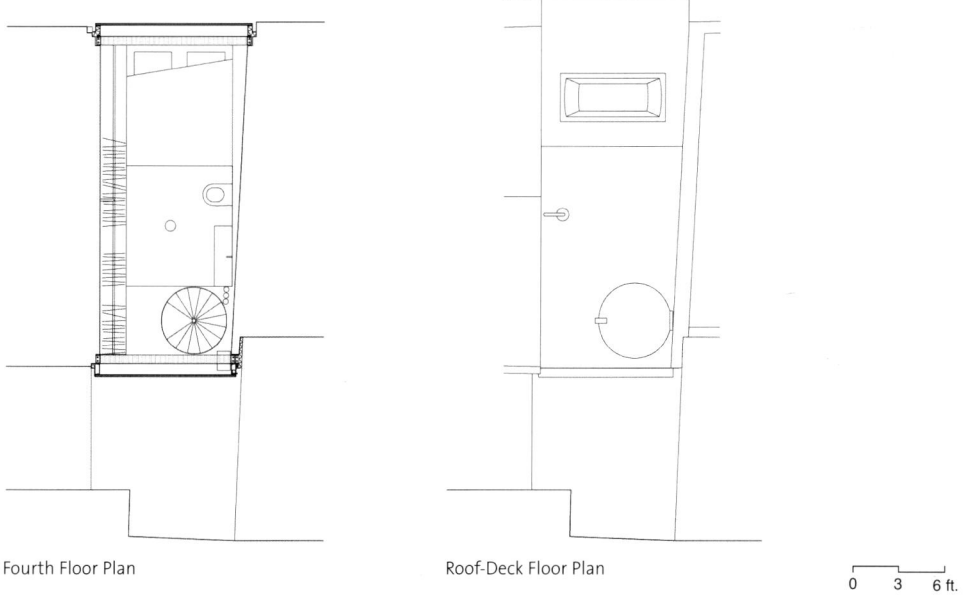

Fourth Floor Plan

Roof-Deck Floor Plan

0 3 6 ft.

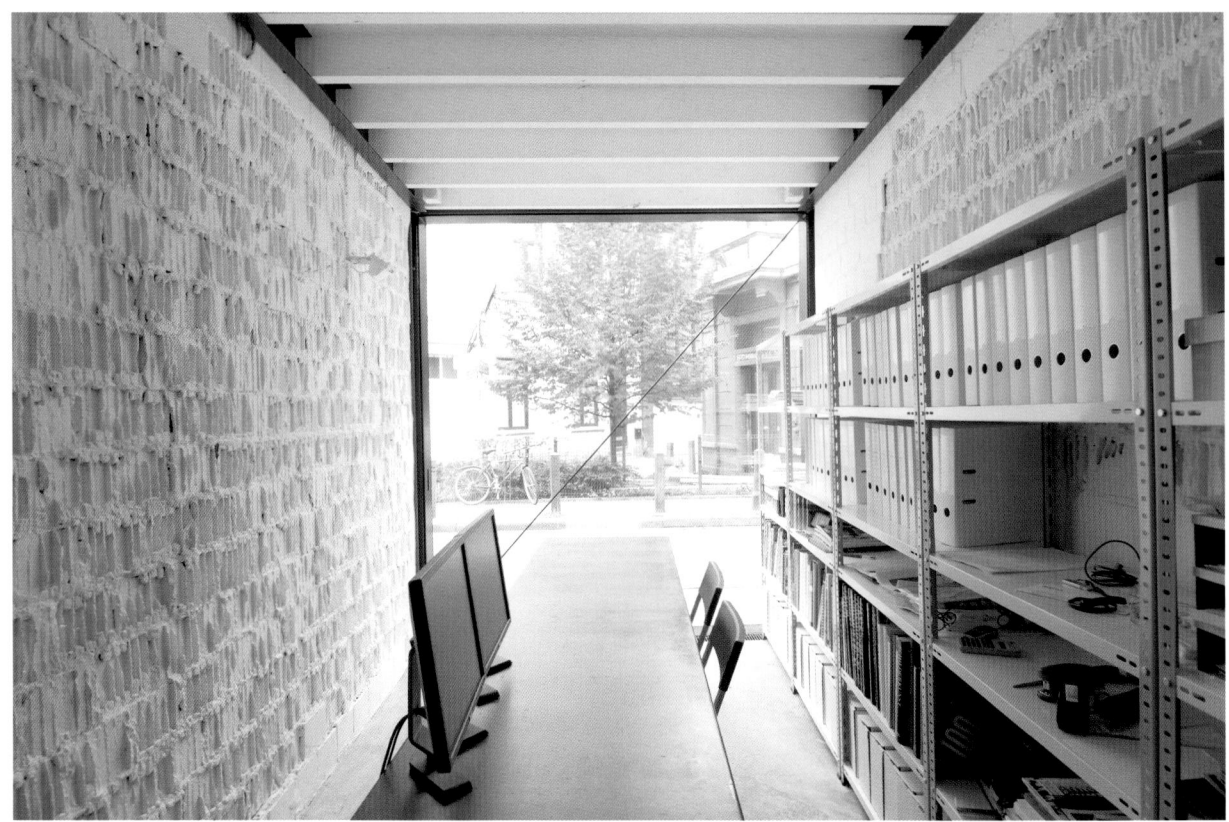

All four wood floor assemblies are supported by a steel structure placed in between the existing masonry side walls. The project includes an office space on the ground floor, kitchen and dining on the second floor, the living room on the third, and the bedroom and bathroom share the fourth floor. The rooftop is also accessible and made for enjoying the views.

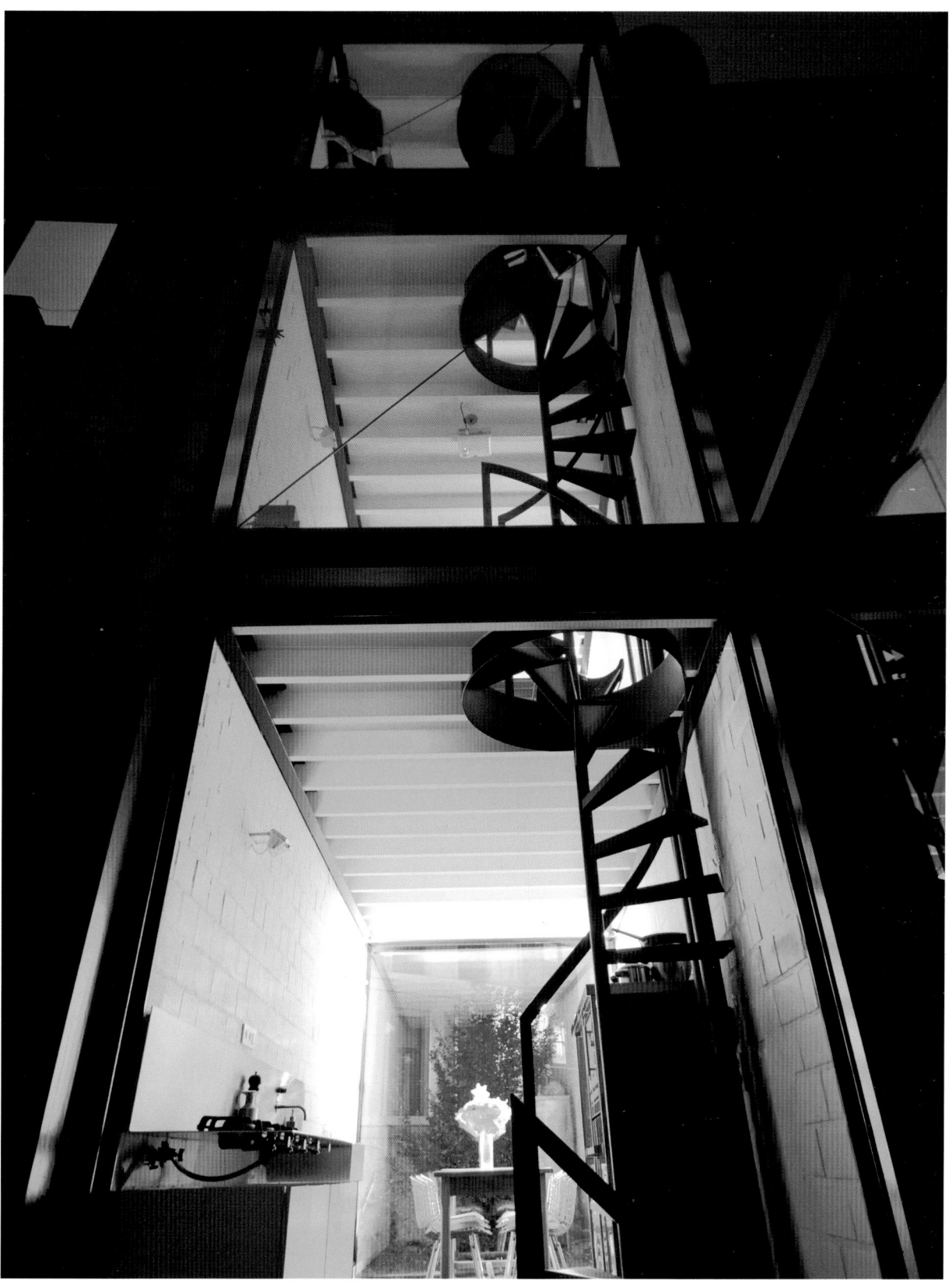

1_ The essential appliances and equipment, most of them in stainless steel, are planned to fit in the narrow spaces.

2_ Circulation is a critical factor that dictated the space layout and the placement of the spiral stair at one end of the volume.

3_ Both end walls are entirely glassed-in as the only option available to bring natural light into all the floors.

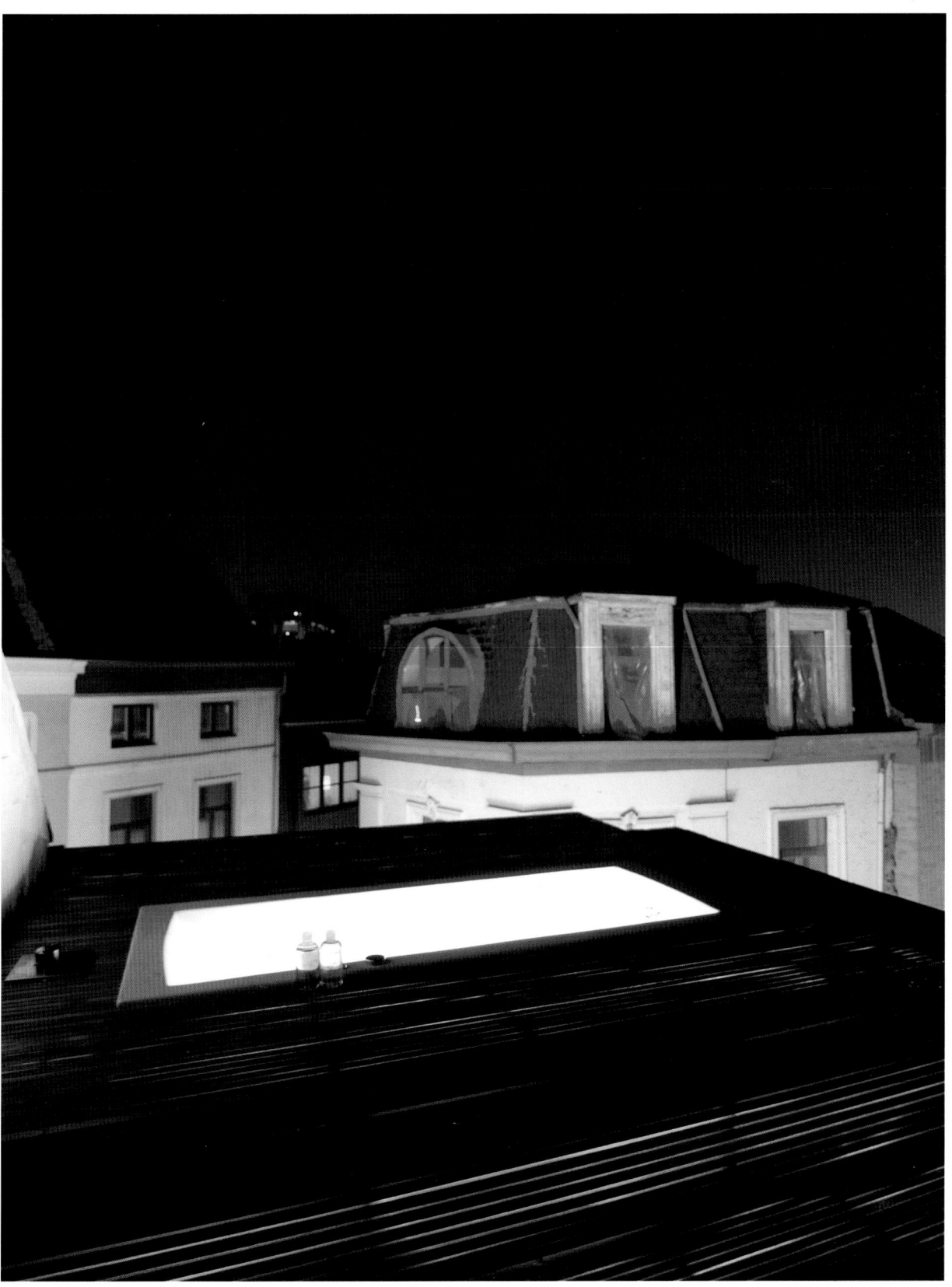

Atelier for a Calligrapher

150 sq. ft.

The site is on a hill at the foot of Mount Yatsugatake and there are rice fields around. It is a simple building that contains a workshop and residence for a calligrapher. The client requested an accessible rooftop with views to the rice fields. He also wanted a solution that would resolve the problem of the snow accumulating on the roof.

The building, leaning towards the view, was inspired by a ship's hull. At the same time, the parallelogram-shaped house acts as an awning over the entry. Inside, the experience is defined by the inclination of the walls and the openings which establish a relationship with the outside.

Both the structure and the wooden sandwiched insulated panels that form the skin of the building are prefabricated in the workshop and assembled onsite.

Architect: Koshi Architect's Studio

Location: Ymanashi, Japan

Completion date: 2004

Photographer: © Koshi Architect's Studio

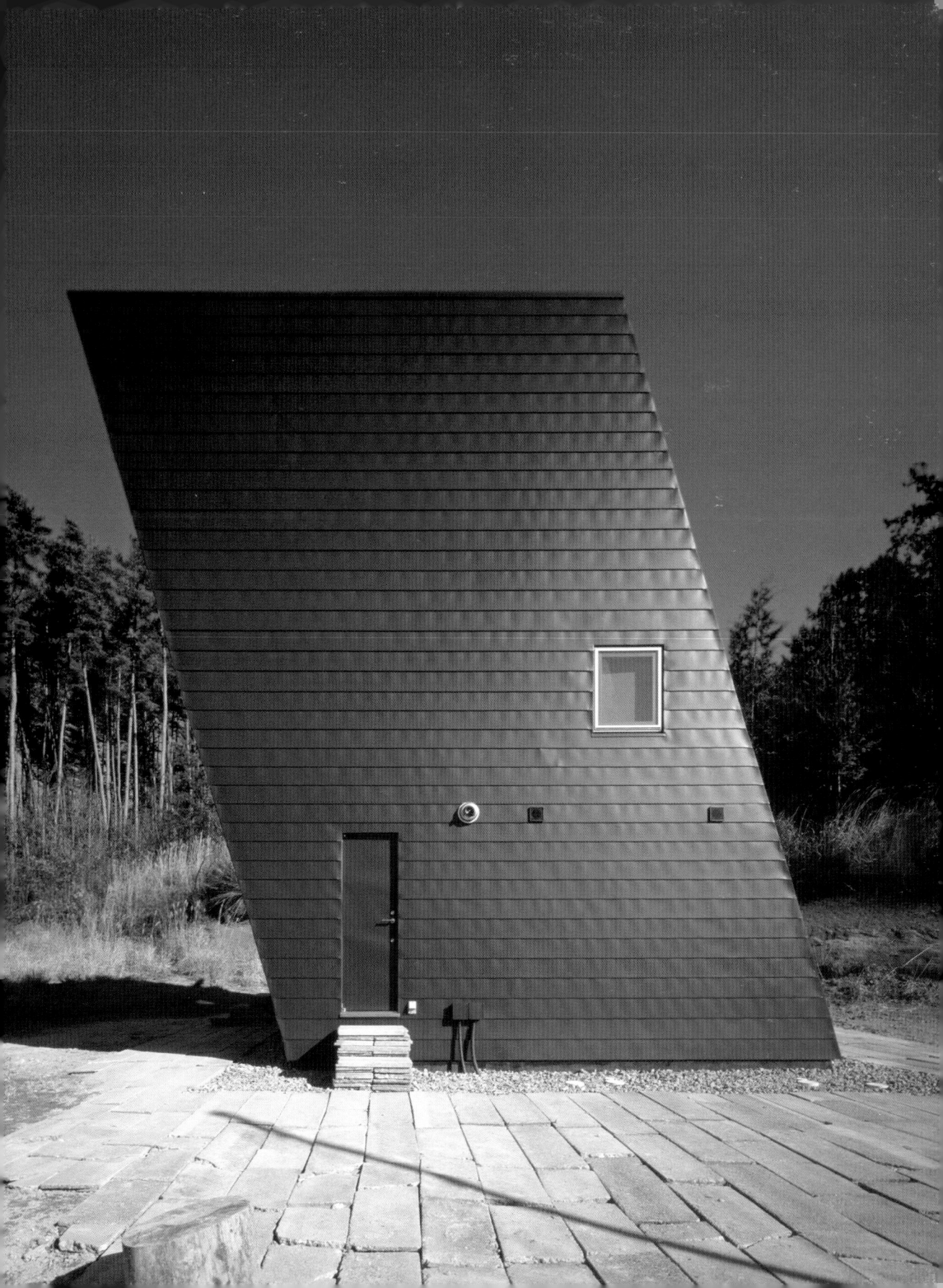

Site Plan

Roof Plan

Second Floor Plan

Ground Floor Plan

East Elevation

North Elevation

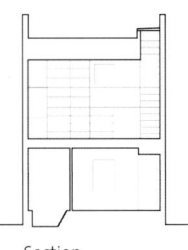

Section

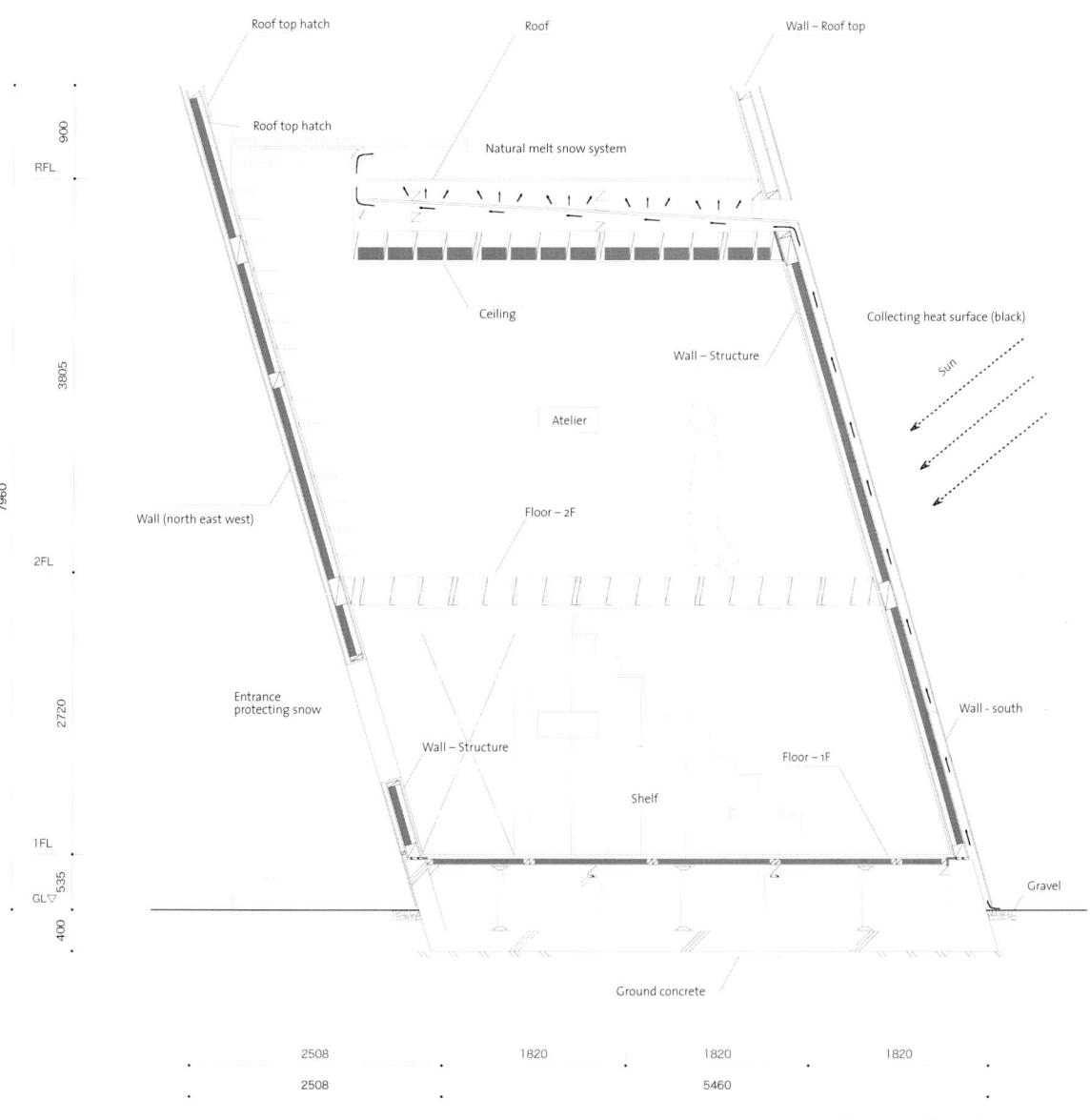

Roof top hatch

Roof

Wall – Roof top

Roof top hatch

Natural melt snow system

900

RFL

Ceiling

Collecting heat surface (black)

Wall – Structure

Sun

3805

Atelier

7960

Wall (north east west)

Floor – 2F

2FL

Entrance
protecting snow

2720

Wall – Structure

Wall - south

Floor – 1F

Shelf

1FL

GL▽ 535

Gravel

400

Ground concrete

2508 1820 1820 1820

2508 5460

Dimensions (in mm)

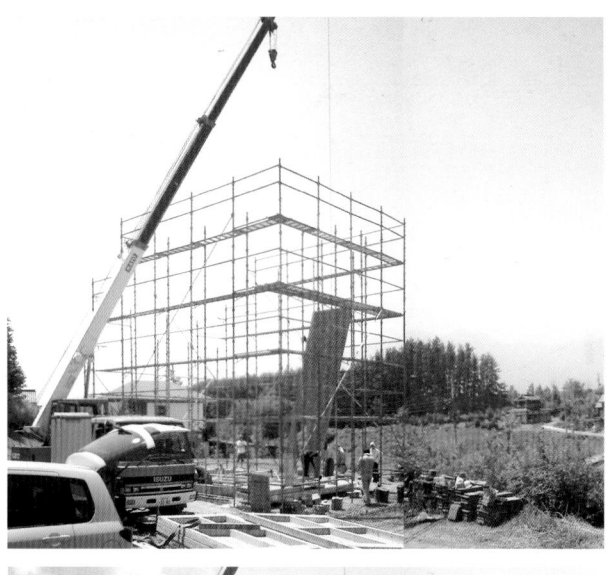
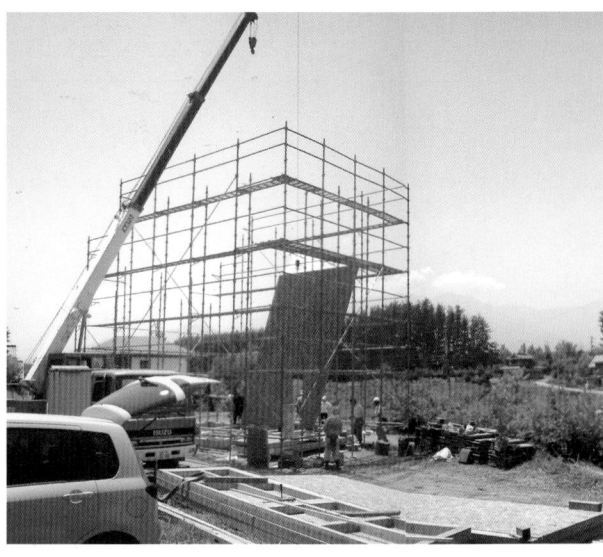
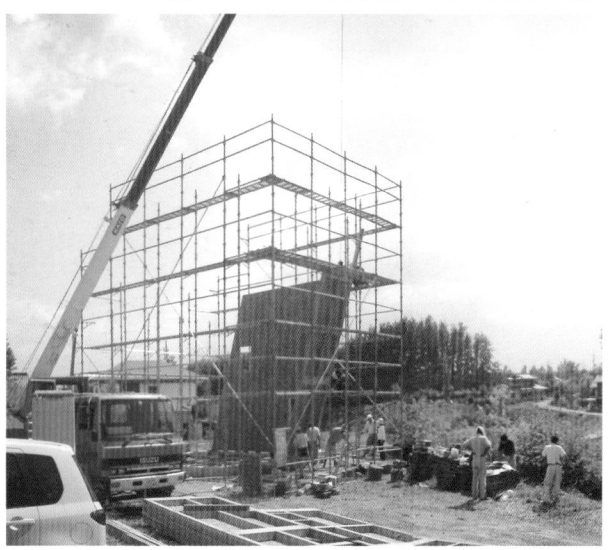
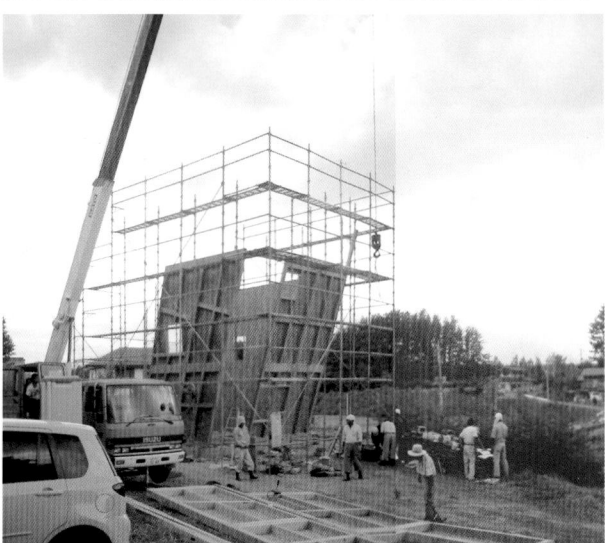
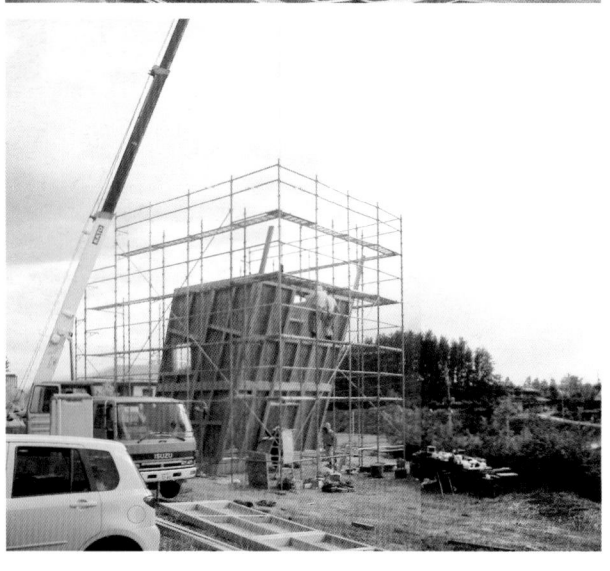
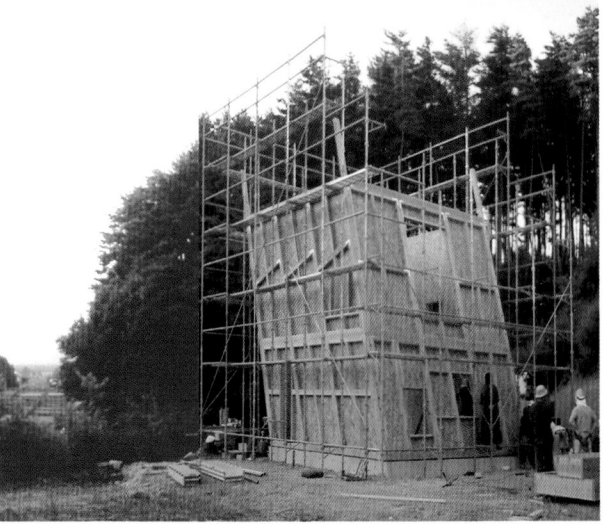

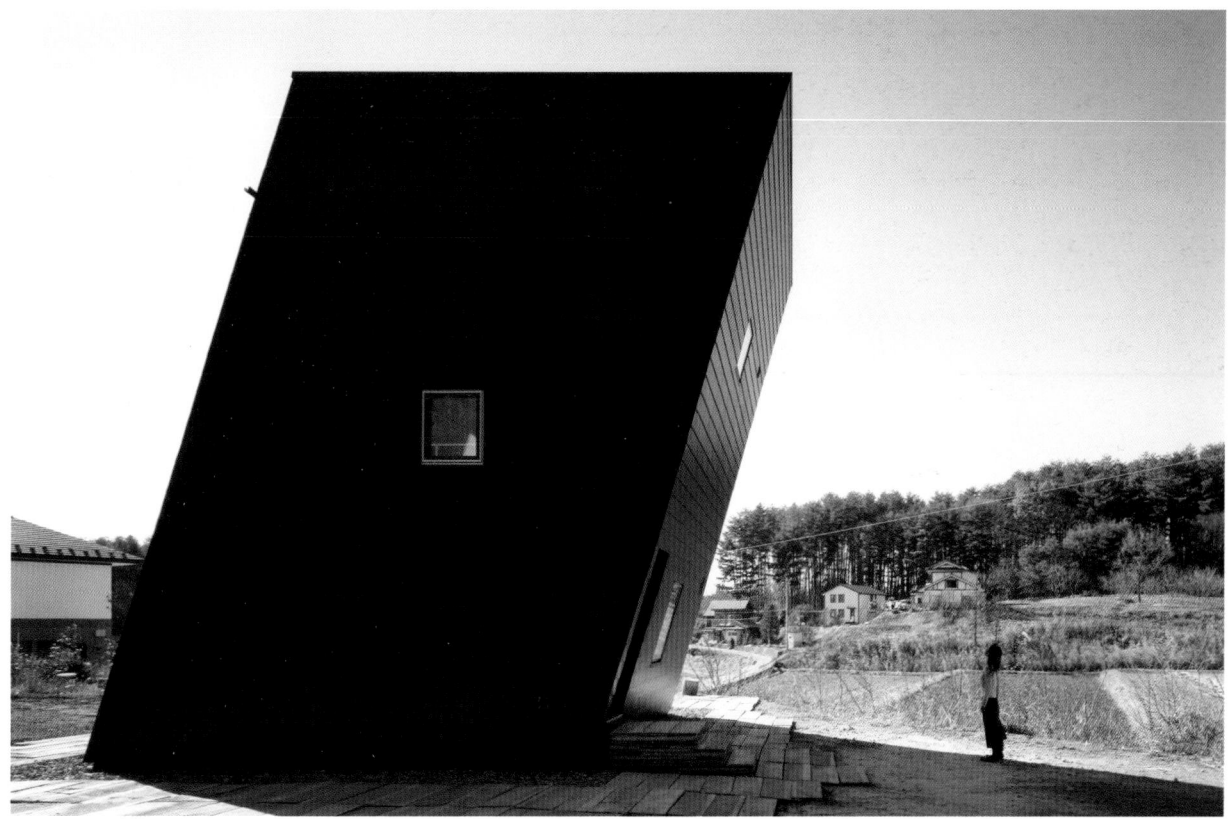

Snow in winter was an issue for the client who requested a building that would be maintenance-free. The design of the construction was therefore guided by this constraint. The building was tilted and its exterior surfaces were planned to accumulate the heat generated by sunlight, melting the snow and minimizing the maintenance during the snow season.

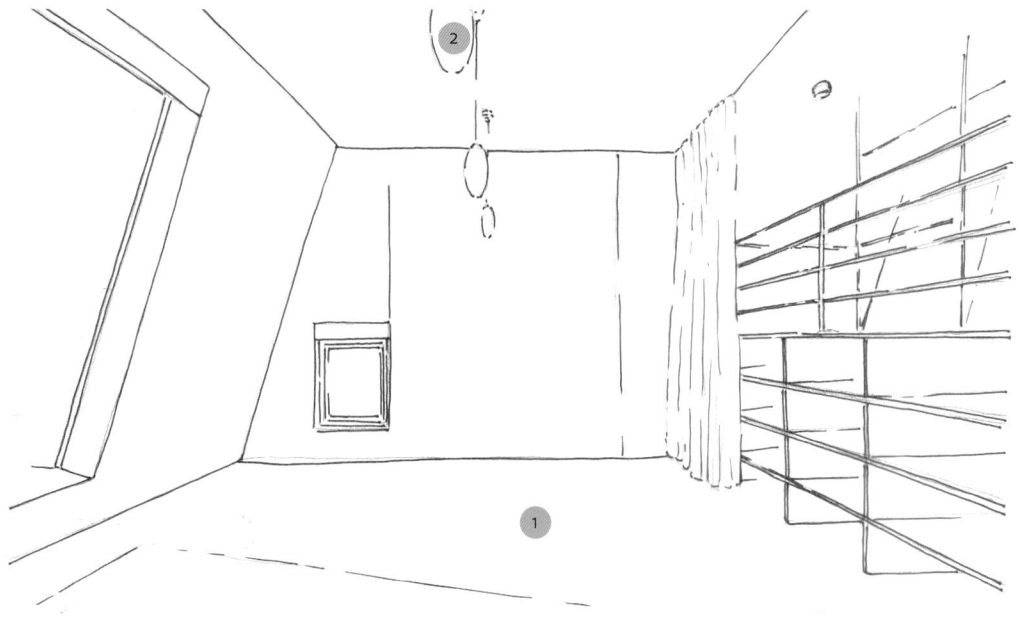

1_ The interior is bare and simple. The living area is located on the ground floor and the atelier on the first floor with a large window and a generous storage space.

2_ Light is an important element of the design to create a well-lit work place reinforced by several light fixtures hanging over the center of the atelier.

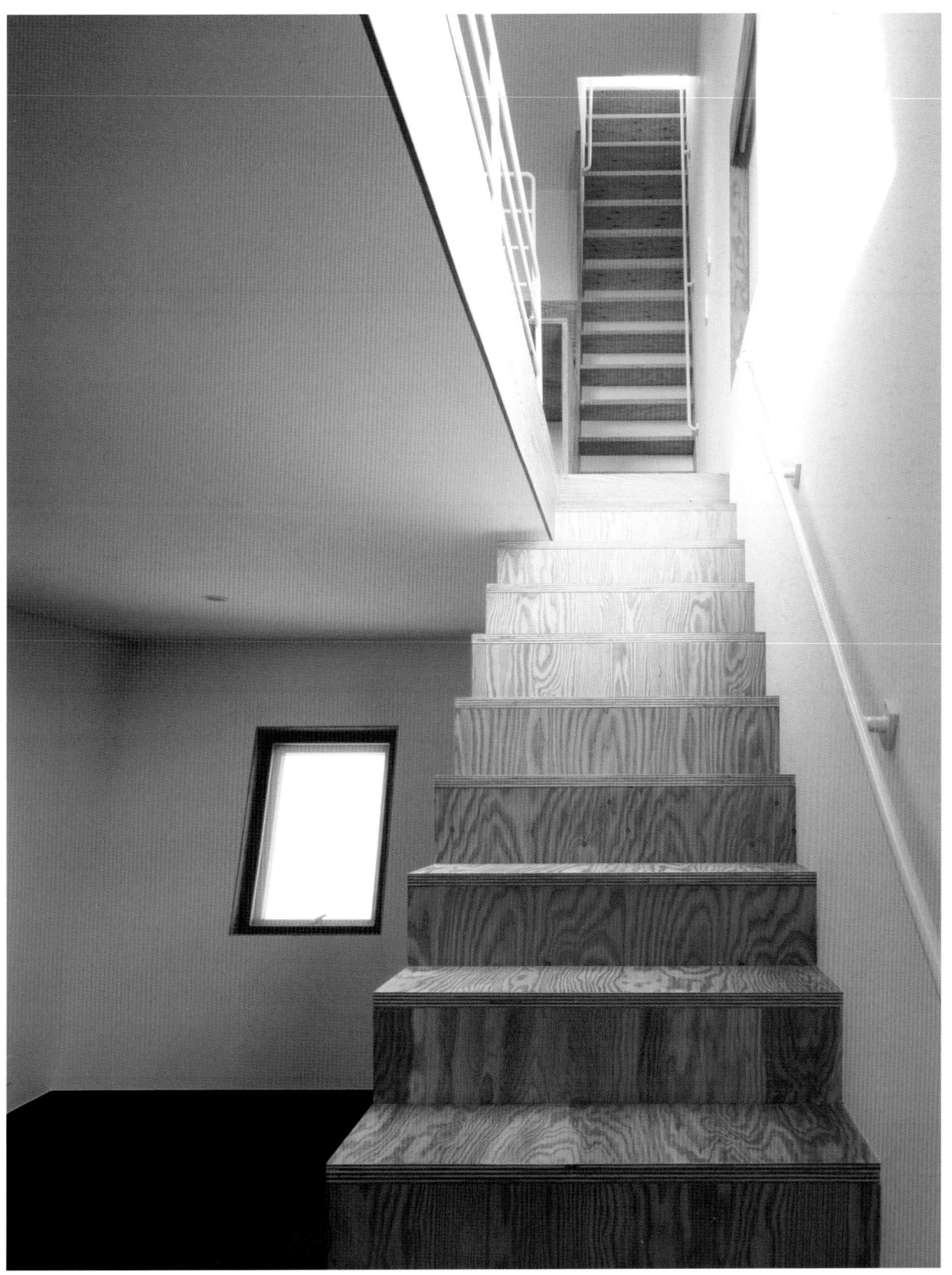

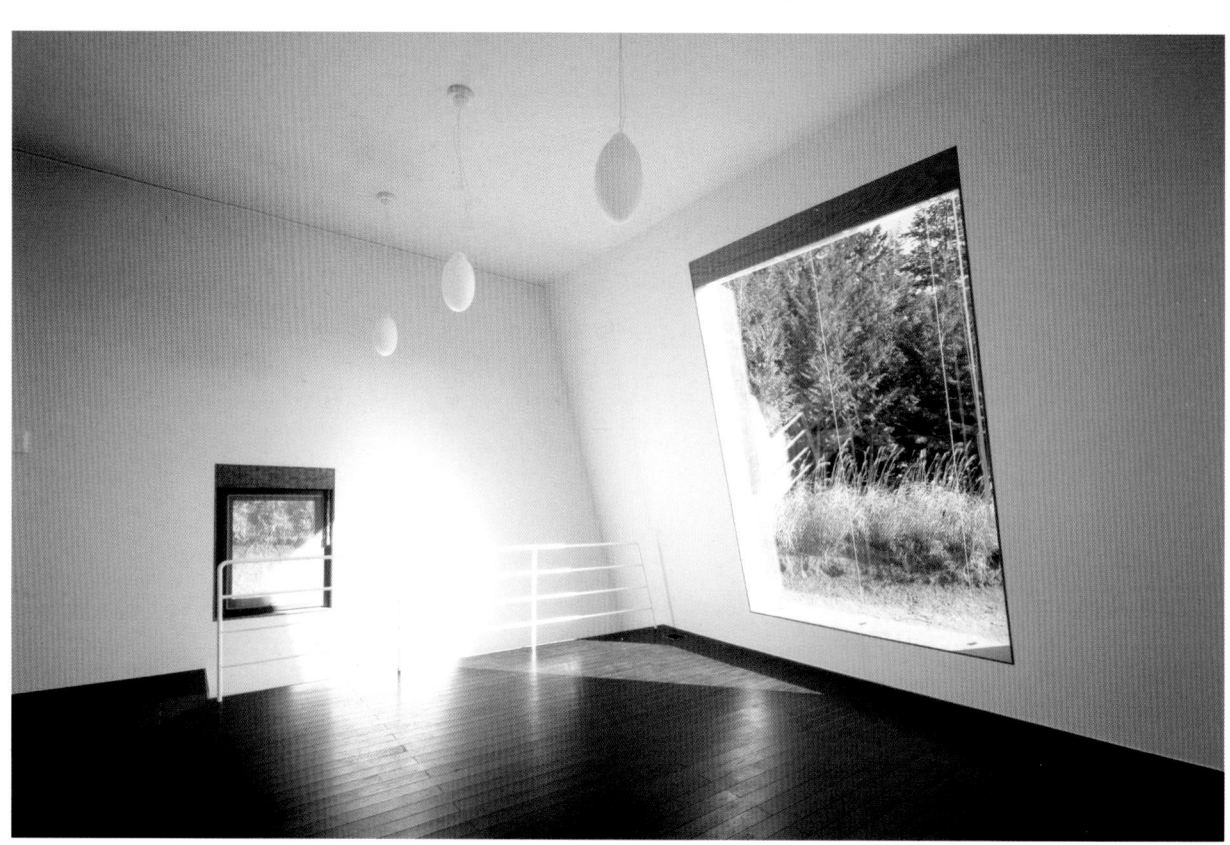

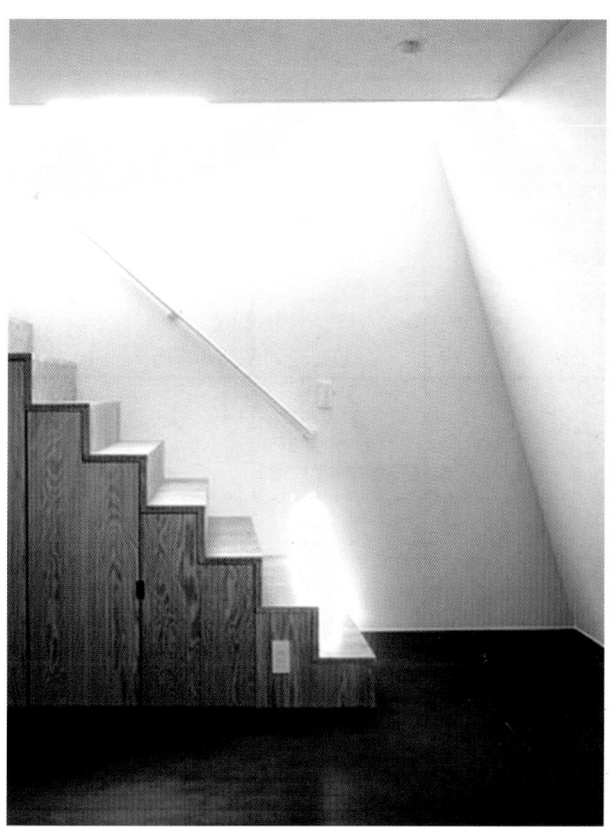

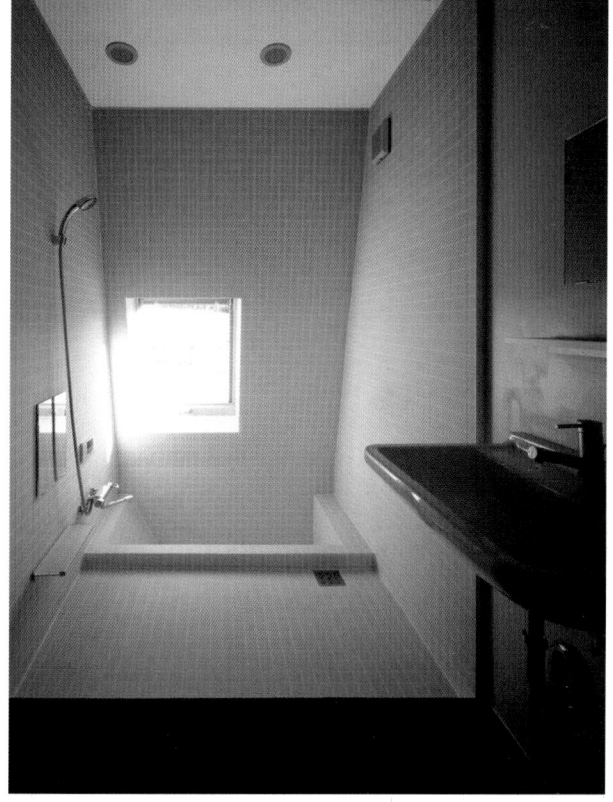

mkLotus

672 sq. ft.

This compact yet stunning home, with landscaping included, is built with the most high-tech green materials and sustainable systems available, including flyash concrete, FSC-certified wood, no-VOC paint, EcoResin on the green roof, LED lighting systems, EnergyStar appliances, photovoltaic energy systems, and rainwater/gray water collectors. MkLotus allows for flexibility and for customization.

Architect: Michelle Kaufmann Designs, Inc.

Location: U.S.

Completion date: 2007

Photographer: © Michelle Kaufmann Designs, Inc.

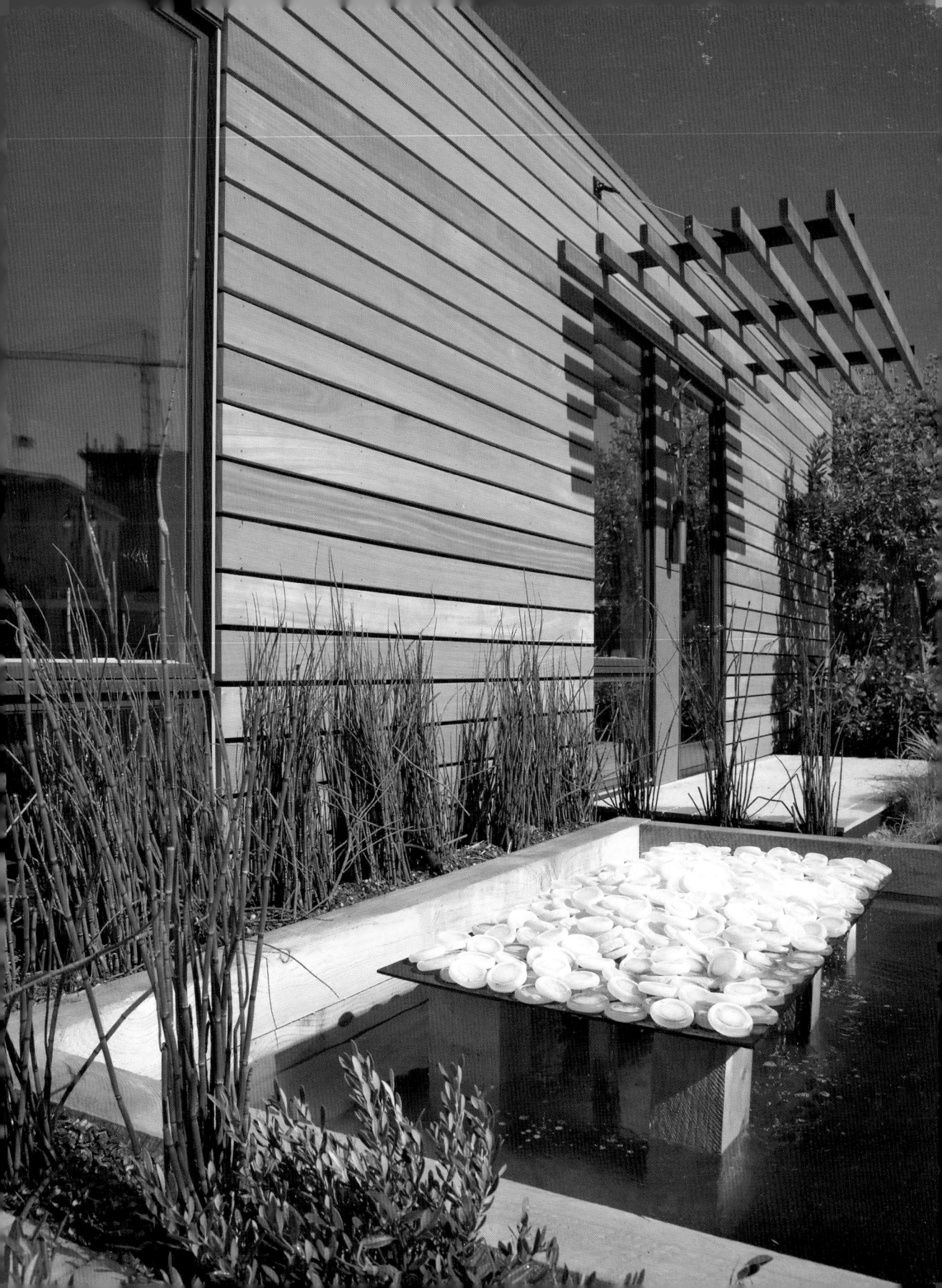

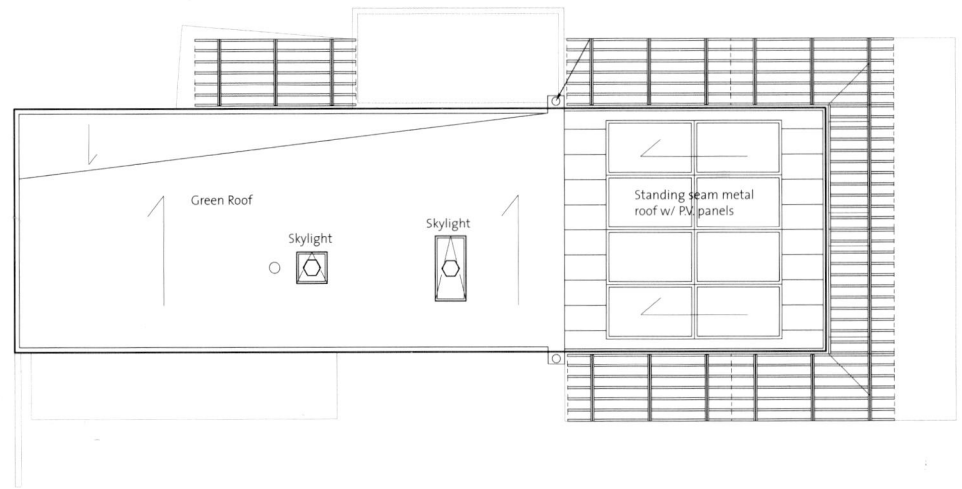

Green Roof

Skylight

Skylight

Standing seam metal roof w/ P.V. panels

Roof Plan

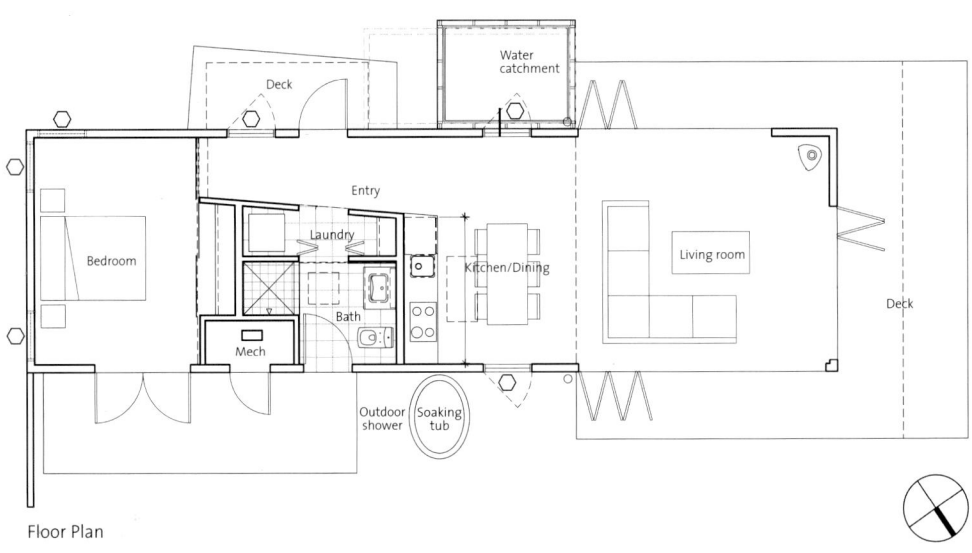

Deck

Water catchment

Entry

Laundry

Bedroom

Kitchen/Dining

Living room

Bath

Deck

Mech

Outdoor shower

Soaking tub

Floor Plan

East Elevation

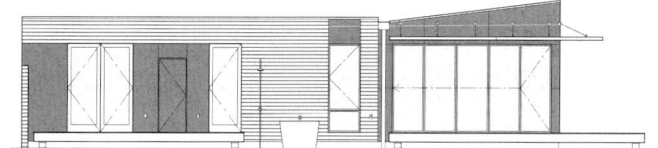

North Elevation

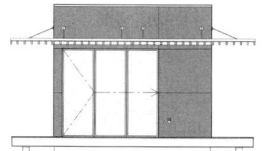

West Elevation

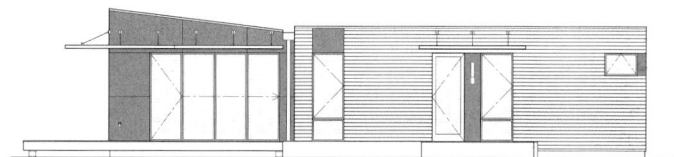

South Elevation

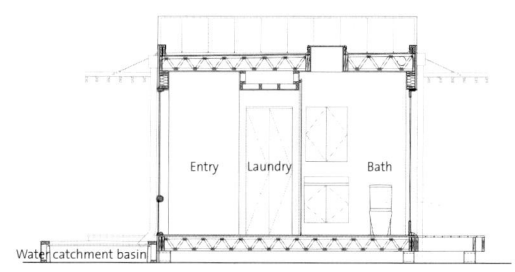

North-South Building Section

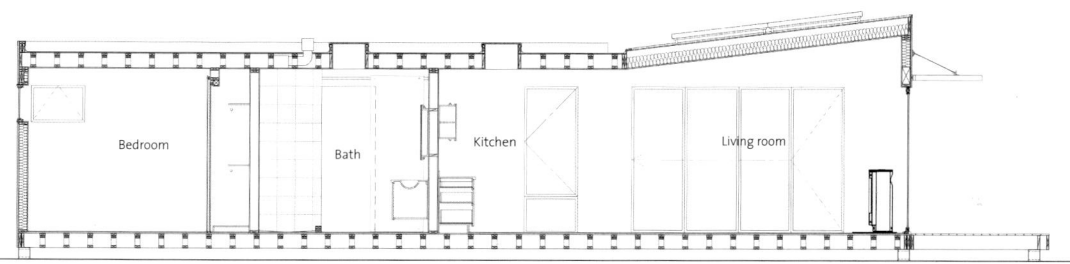

East-West Building Section

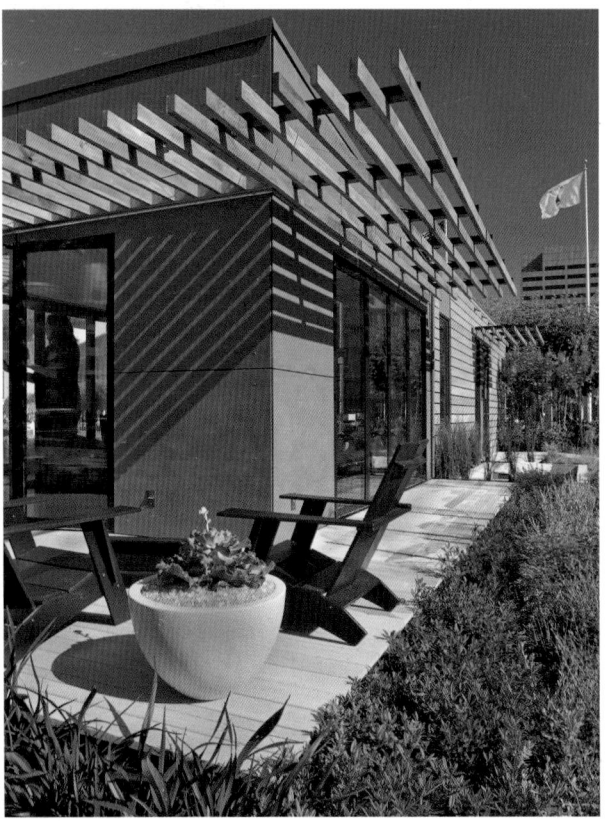
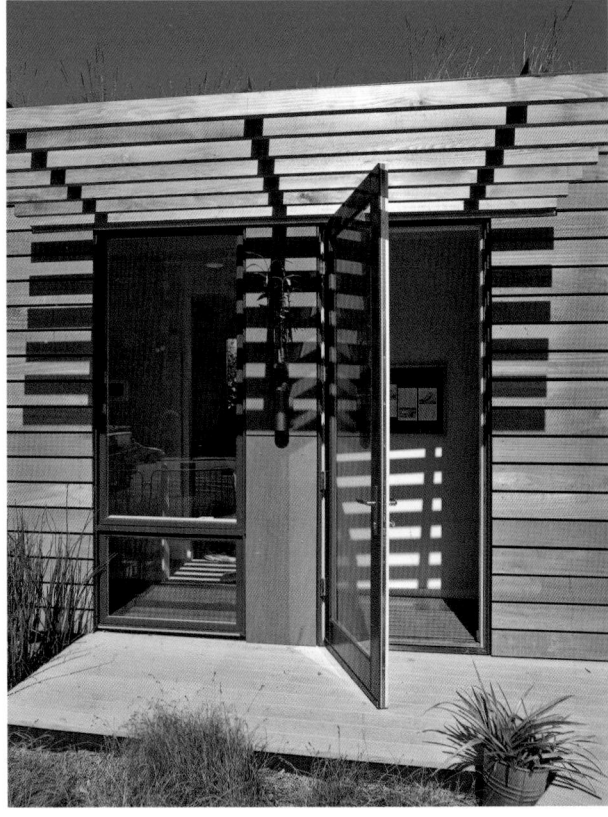

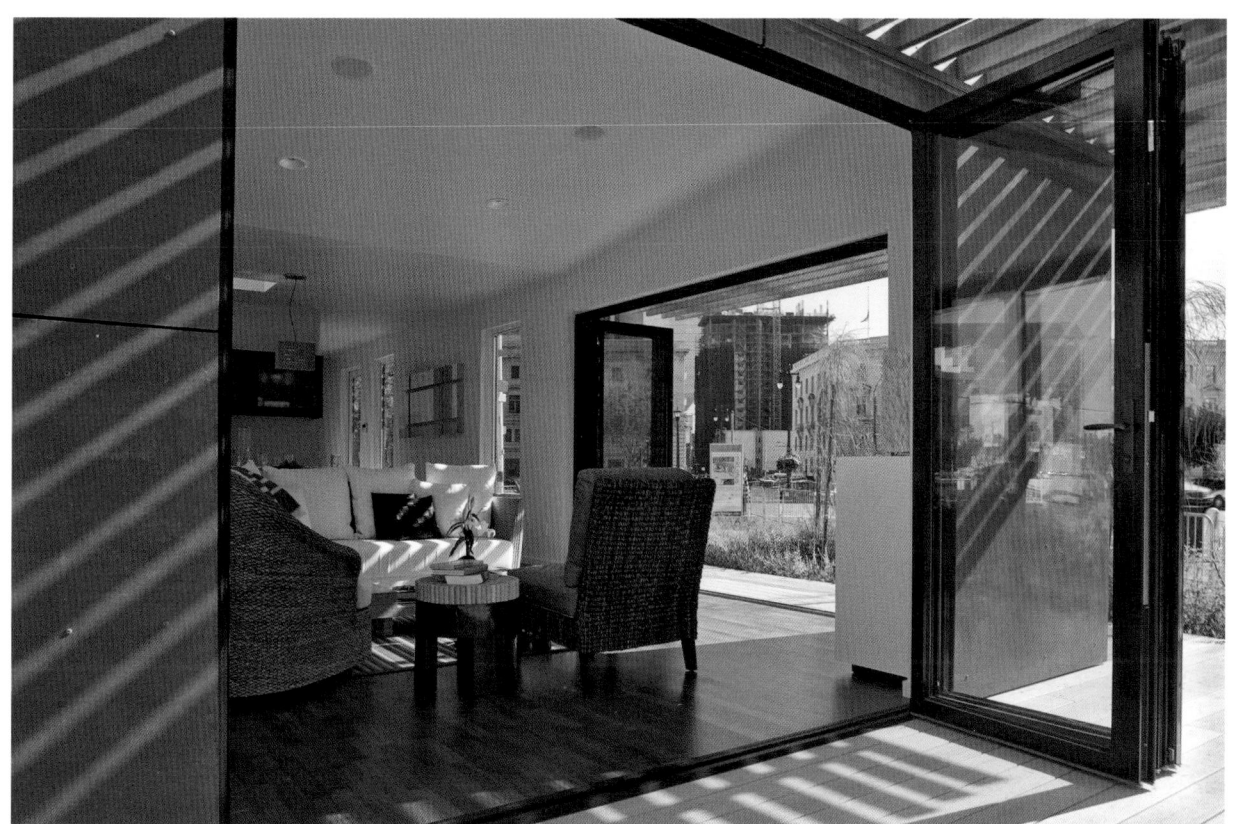

Occupying one end of the house, the living room can be totally opened to the exterior by means of folding glass doors, therefore extending the interior area and emphasizing the sense of amplitude. The high ceilings, skylights, gently angled walls, floor-to-ceiling glass and copious daylight all work to make the 700-square-foot house feel a lot bigger and more spacious then it actually is.

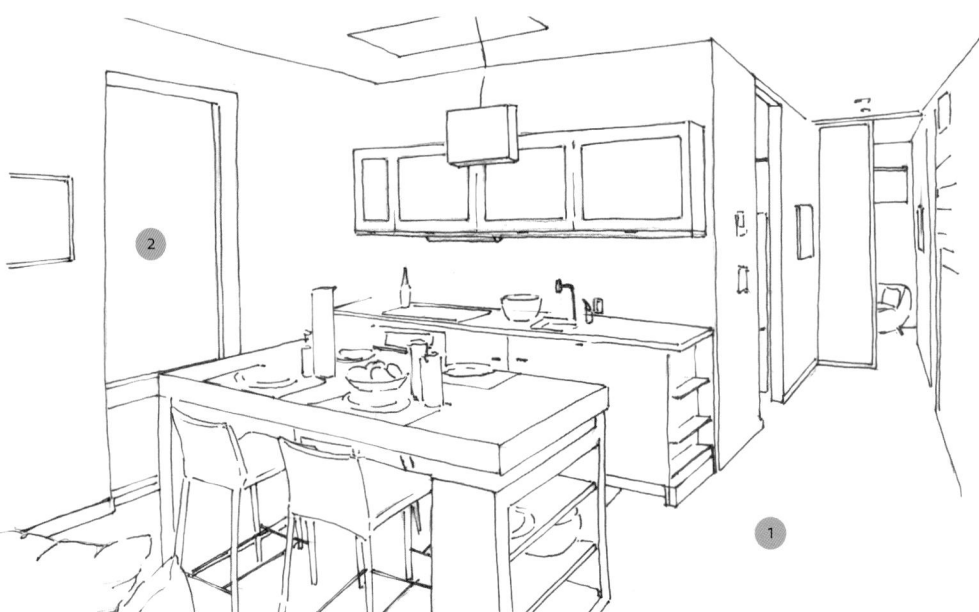

1_ Little difference exists between this prefabricated house and a
site- built home, such as utilities, installations and finishes. Neither
comfort nor design have been sacrificed to prioritize prefabrication.

2_ The high ceilings, skylights, floor-to-ceiling windows and abundant
daylight make this 700-square-foot house feel much bigger.

This prefabricated home is provided with all the comforts and utilities common in a site-built house. Every material, system and design choice appears to be thoughtful and purposeful.

House on Vermont Street

672 sq. ft.

The traditional zoning of communal and private space within this typical Edwardian house is inverted to reflect contemporary preoccupations. In the backyard, a simple volume replaces previous ramshackle additions. It combines the living, dining and kitchen areas into one ample room with carefully "tuned" door, window and skylight openings. In this way, the home now has strong relationships to the garden and sky (as well as views of the city) where previously there were none. Conversely, at the front of the structure, within the existing compartmentalized spaces (formerly the living, dining and parlor rooms), the bedrooms and refurbished bathrooms are now accommodated.

Architect: Macy Architecture

Location: San Francisco, U.S.

Completion date: 2003

Photographer: © Deco Group, Wesley Rose

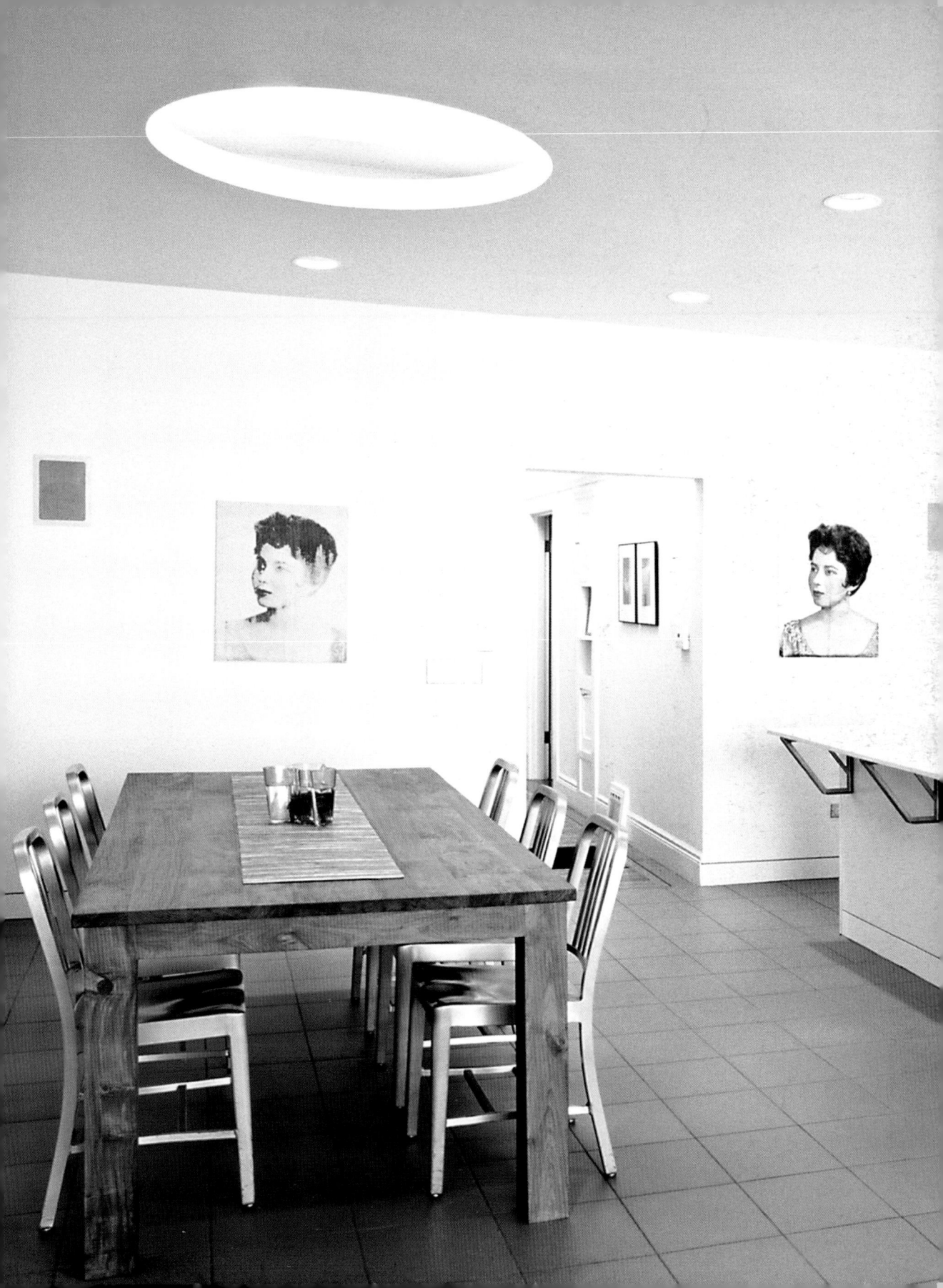

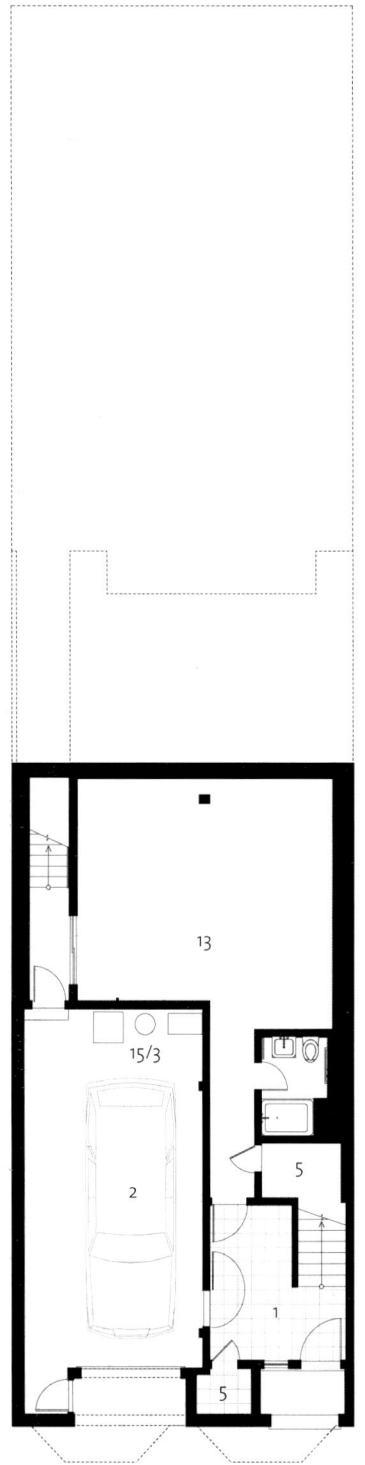

Lower Floor Plan

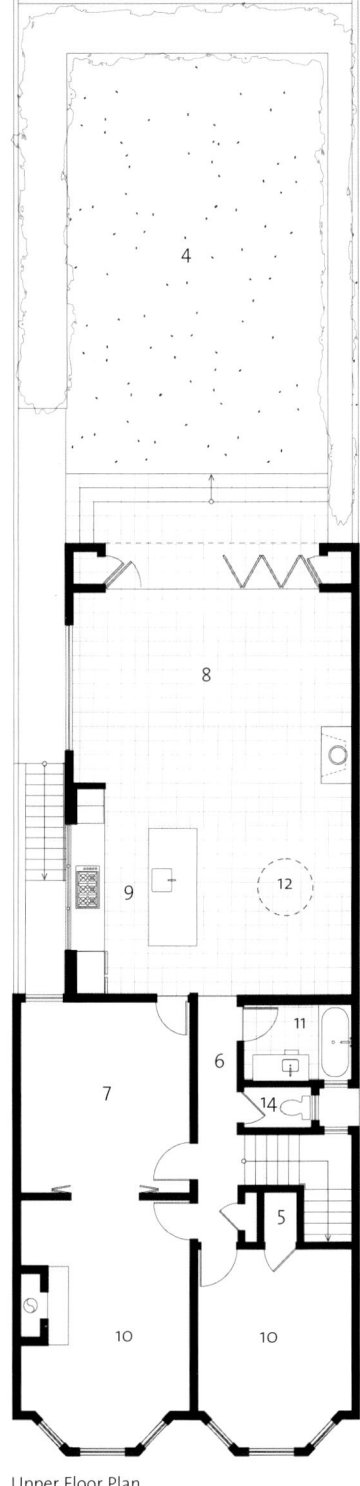

Upper Floor Plan

1. Entry
2. Garage
3. Utility
4. Garden
5. Storage/Closet
6. Hall
7. Study/Bedroom
8. Living area
9. Kitchen
10. Bedroom
11. Bathroom
12. Dining area/
 Skylight above
13. Recreation/Guest bed
14. Toilet
15. Laundry

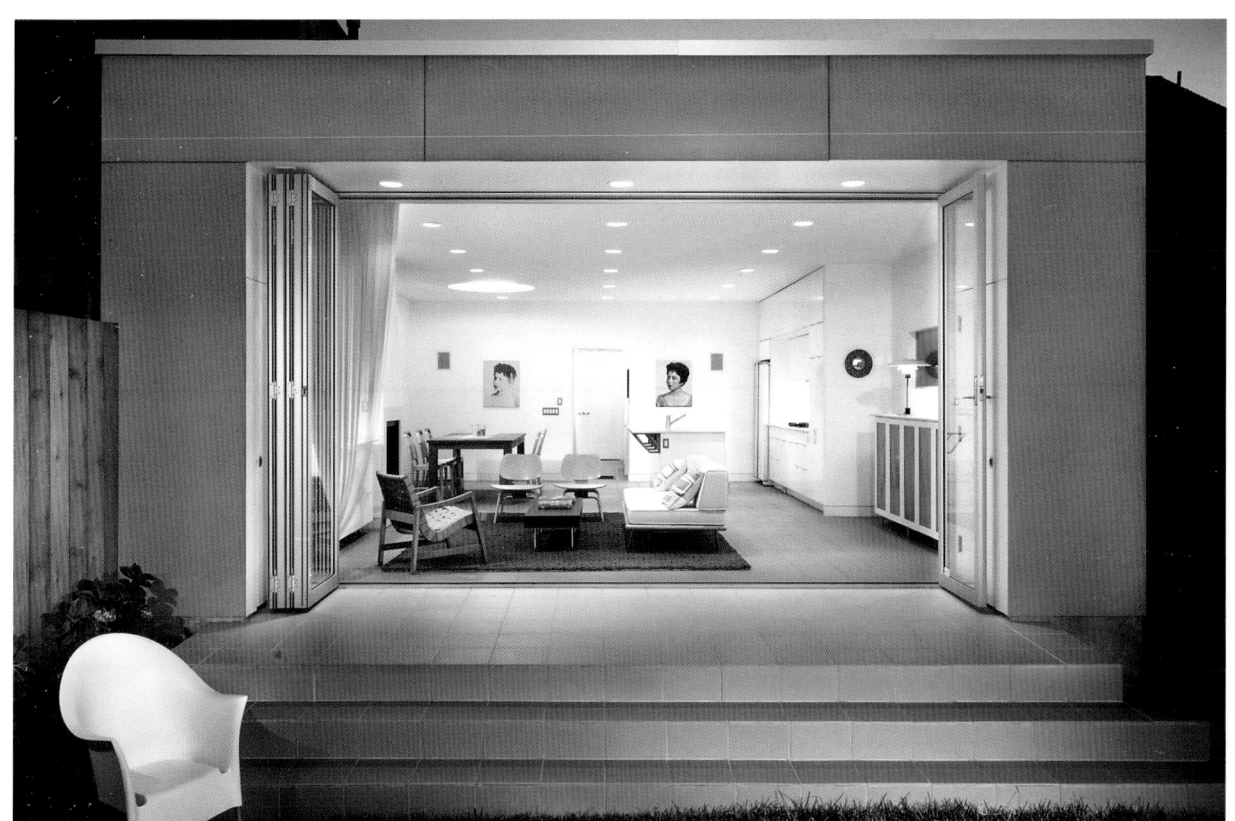

The most public spaces in the small house face
the backyard, inverting the traditional plan.
Accordion- fold doors stack up all to one side
to allow the wide opening to the garden to be
unobstructed. The wide side walls and thickness
of the roof form a sort of monumental portal
that addresses the garden.

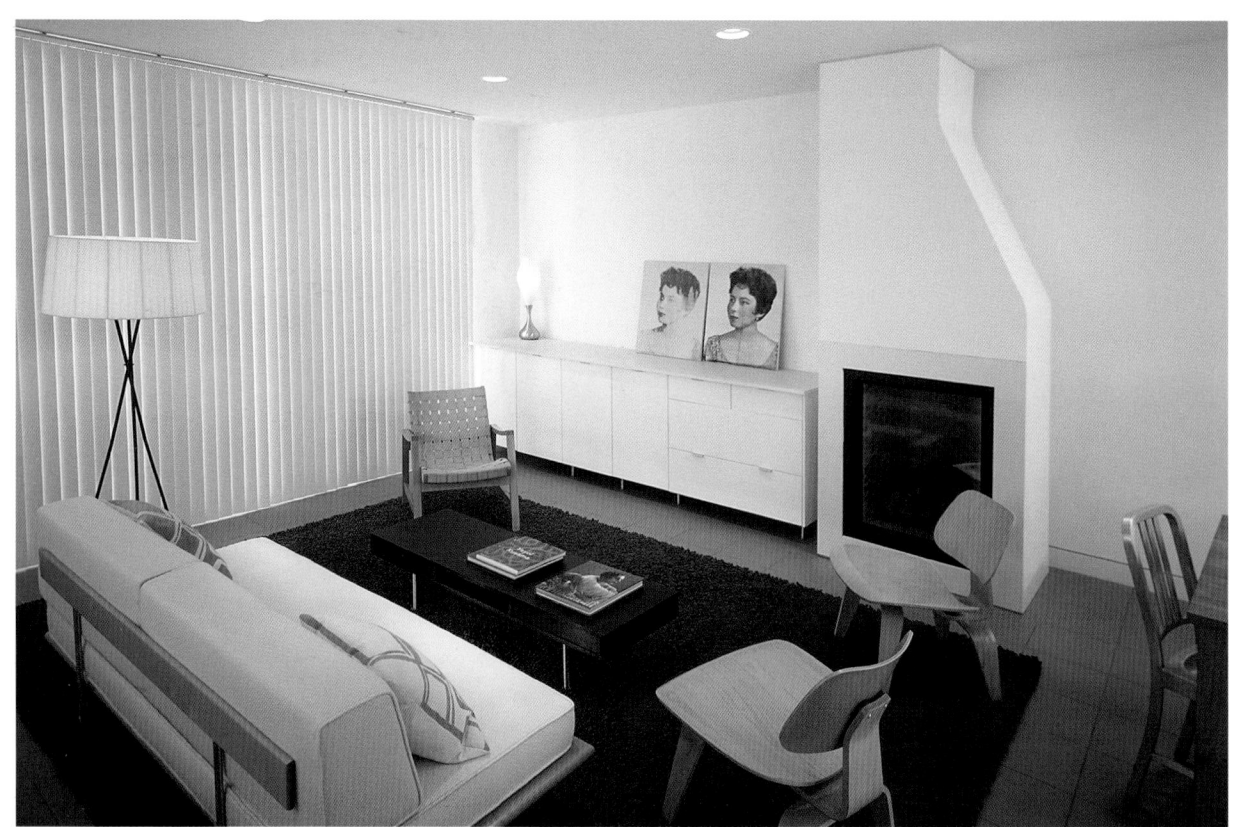

The living area, with the curtains closed, is a straight forward, comfortable arrangement of seating focused around a small fireplace, under a simple grid of recessed lights. No simpler pallet of materials could be possible.

1_ The gridded kitchen cabinets form a post and lintel "portal" that echoes the shape of the rear elevation at the garden. The highest overhead cabinets are full depth, providing more storage space.

2_ The galley-type kitchen plan uses little space and adapts well to an open plan with all its full-height cabinetry stacked against the wall, leaving the main volume open.

Flat
600 sq. ft.

The chef Fréderick E. Grasser Hermé gave the French designer Matali Crasset *carte blanche* for the design of his home in the centre of Paris. Measuring 600 square feet, the home is laid out on one level and the rooms are distributed around the kitchen which opens out onto the dining area and living room without the use of any doors. Because of a limited budget, the kitchen is from IKEA, but it is distinguished as the main space through the use of unusual colors, such as blue and lime green. A bookshelf made of birch wood and designed exclusively by crasset sits in one of the corners of the kitchen. In the other space, a door leads to the studio and bedroom, with an adjoining toilet and small bathroom separated by glass. All the rooms reflect the French designer's signature style with lively colors and vinyls on the walls, which play with the visual element of the interiors.

Architect: Matali Crasset/Matali Crasset Productions, in collaboration with Marco Salgado and Francis Fichot

Location: Paris, France

Date of completion: 2007

Photographer: © Patrick Gries

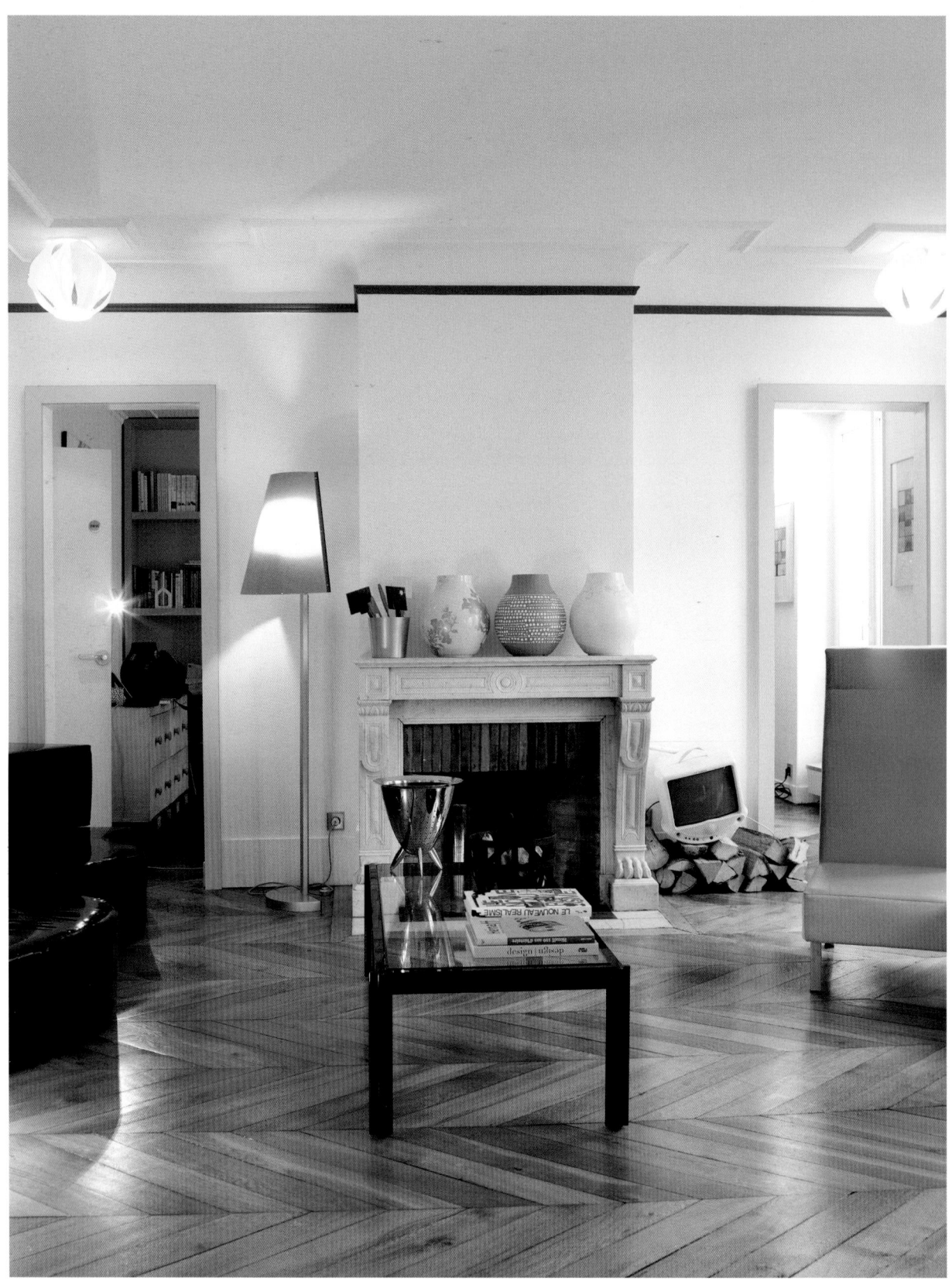

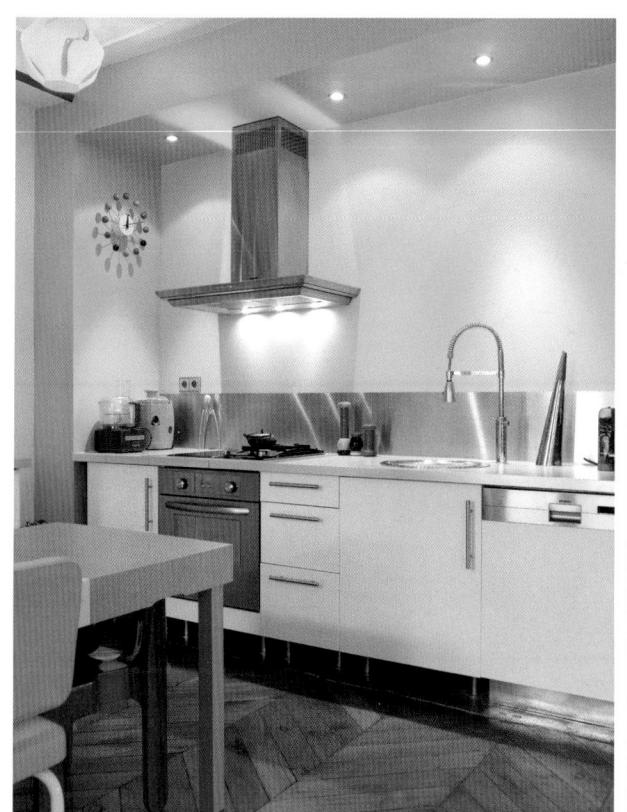
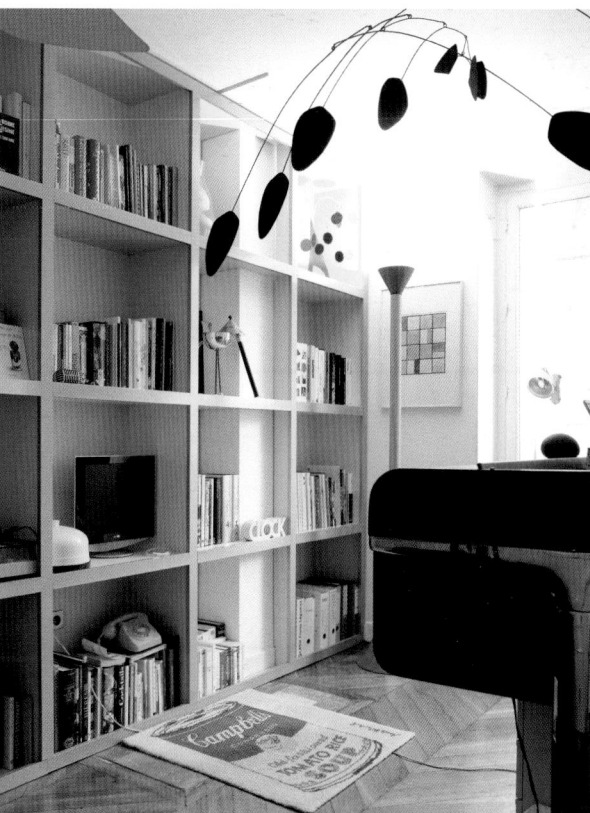

1.- A birch wood book shelf inspired by a tree, an exclusive design by matali crasset, sits in one of the corners of the dining area. The design is an adaptation of one of her works used in museums and temporary exhibitions.

2.- The kitchen and dining area are laid out in a few limited square meters. The table made of different colored pieces and the chairs around it are also part of crasset's collection.

3.- The IKEA kitchen, which opens out on to the dining area, stands out for its lively colors which contrast with the stainless steel oven and extractor hood, and the white furniture.

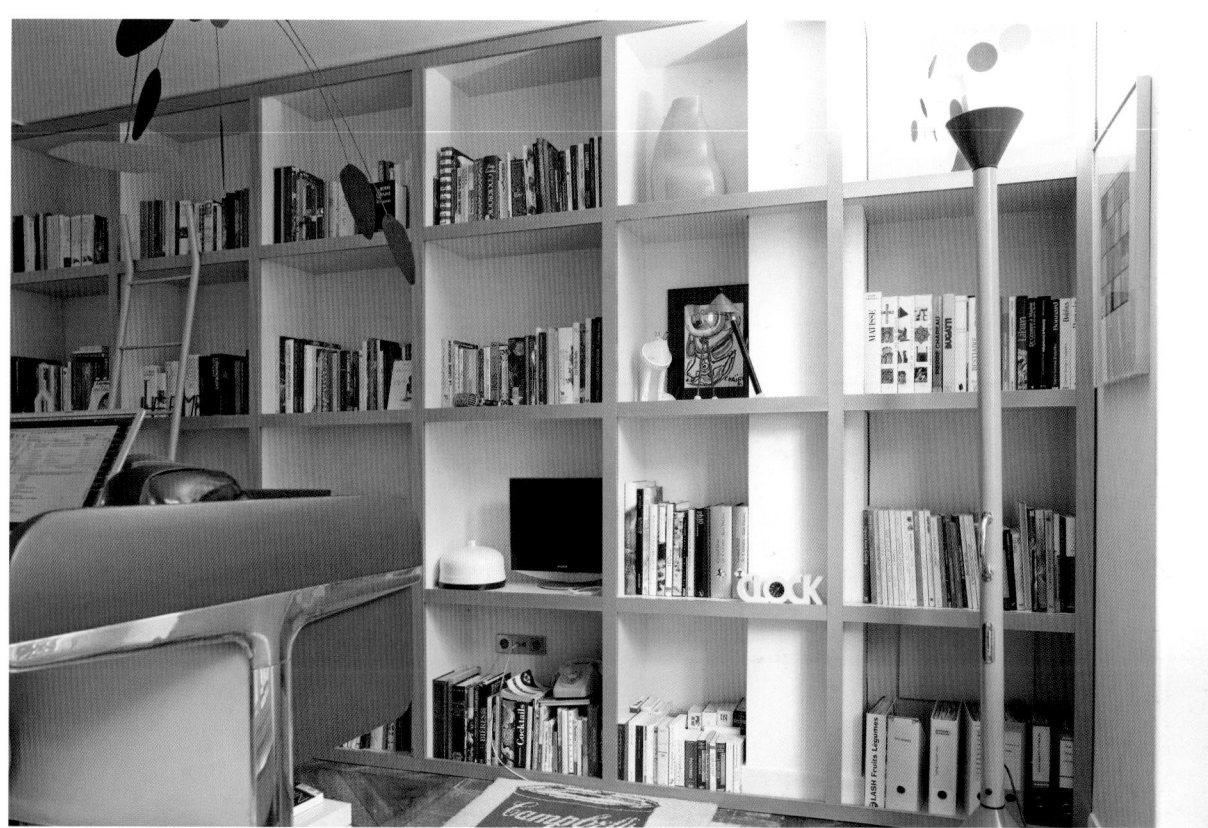

A series of shelves takes up the length of the
studio's wall. Some elements, such as the desk,
characterized by laminated wood in which the work
space is hidden, lend a certain style to the space.
Drawers and a filing cabinet underneath the table
make the work area more flexible.

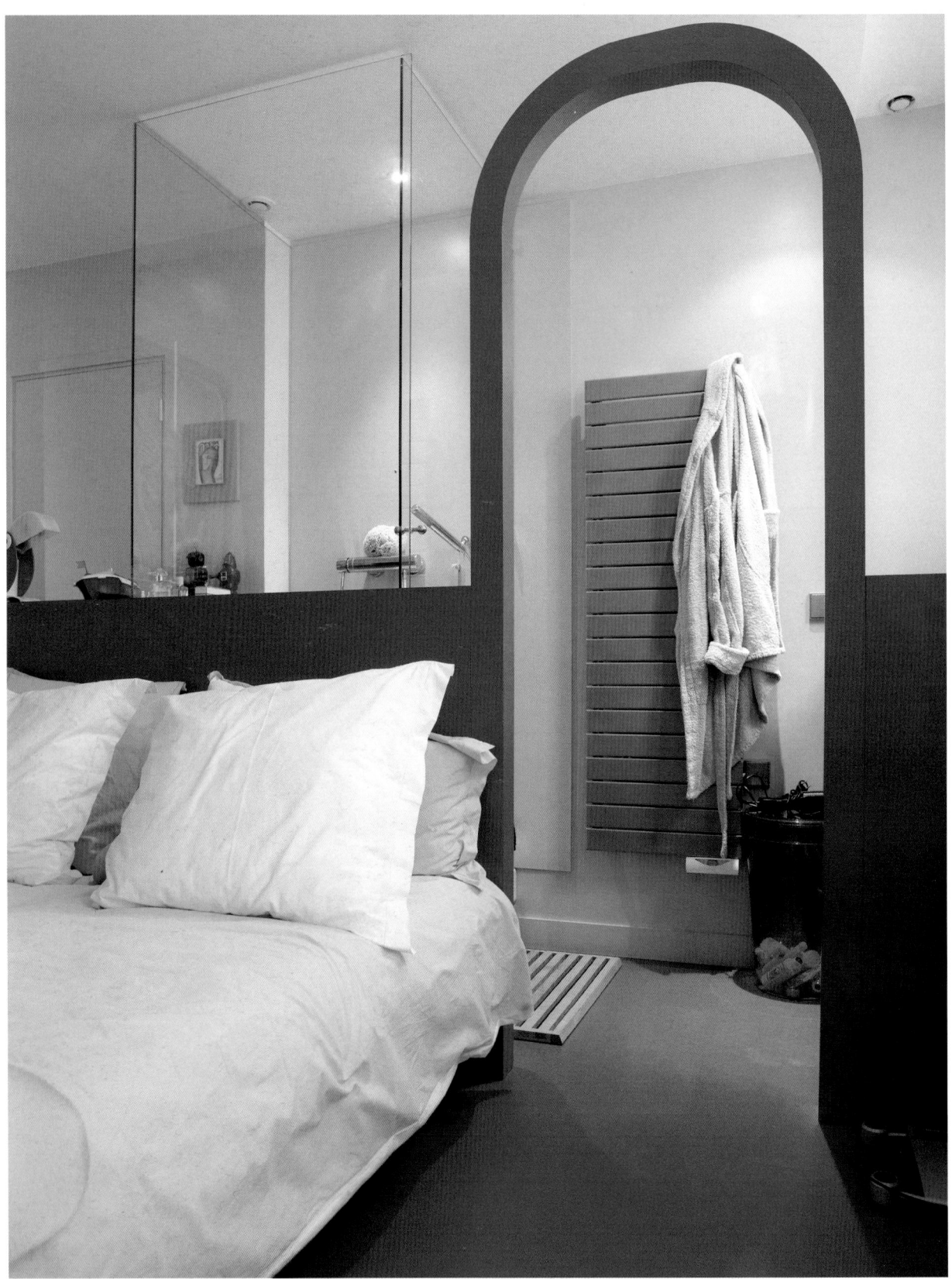

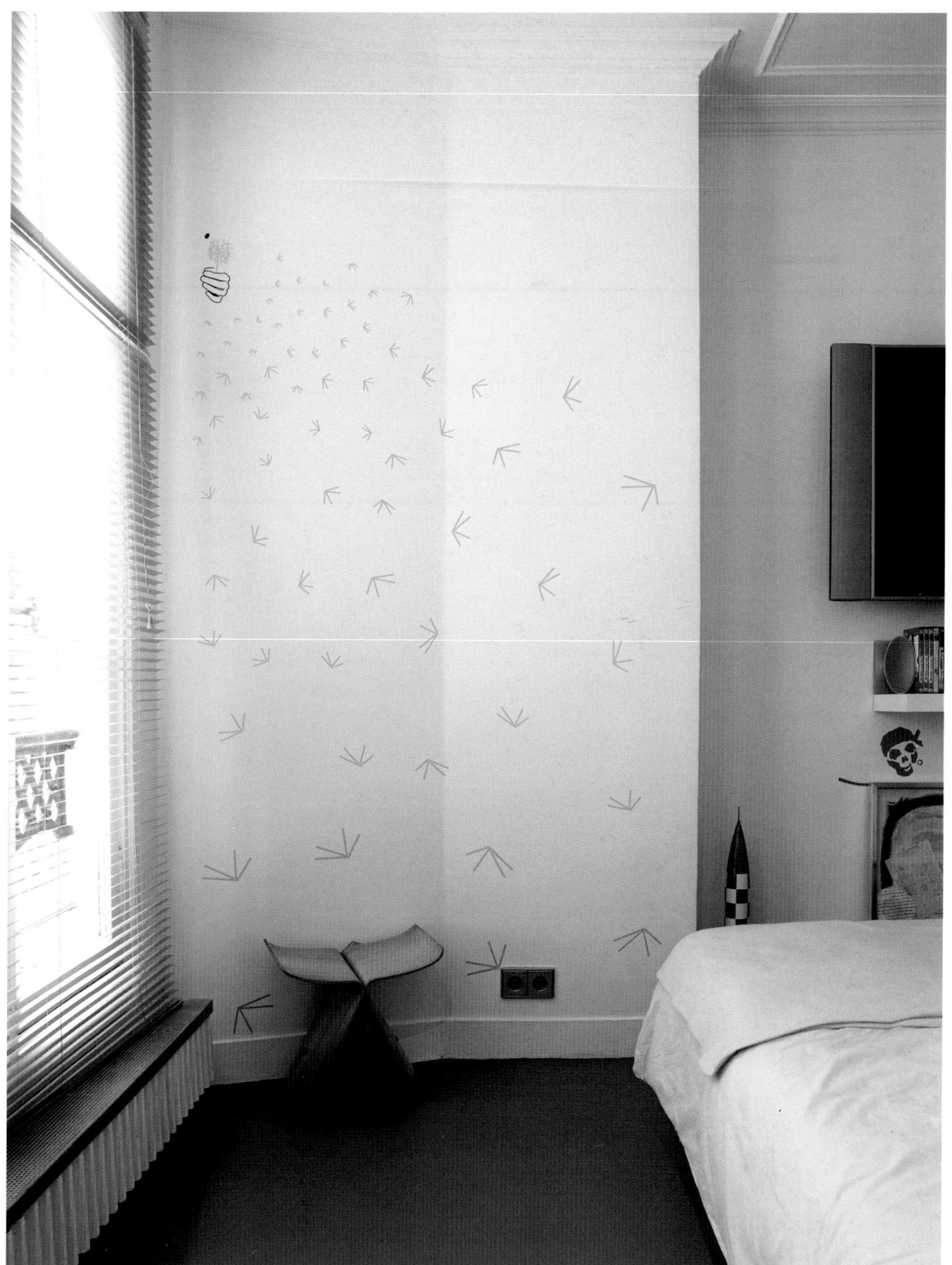

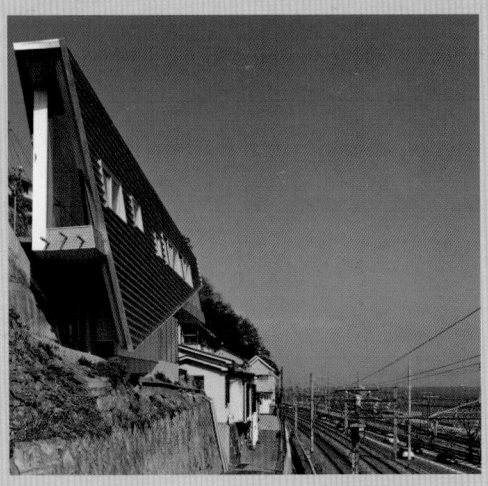

Rooftecture S

707 sq. ft.

The house sits almost dangerously on a coastal hillside. The site presents all indications that even the most daring developer would not consider investing in this plot of ill-favored terrain.

The building with a usable area of 707 square feet tapers from thirteen feet at one end to a dramatic point barely 5 feet wide at the opposite end. The triangular-shaped plan is also reflected on elevation; this accentuates the perspective as one approaches the building from the road down below.

The living room is oriented towards a secluded terrace between the house and the retaining wall rather than towards the long views of the ocean. These views are reserved for the lower floor where the doma is. This room, where traditional work activities take place, opens up to a covered courtyard.

Architect: Shuhei Endo Architect Institute

Location: Kobe-City, Hyogo prf., Japan

Completion date: 2005

Photographer: © Yoshiharu Matsumura

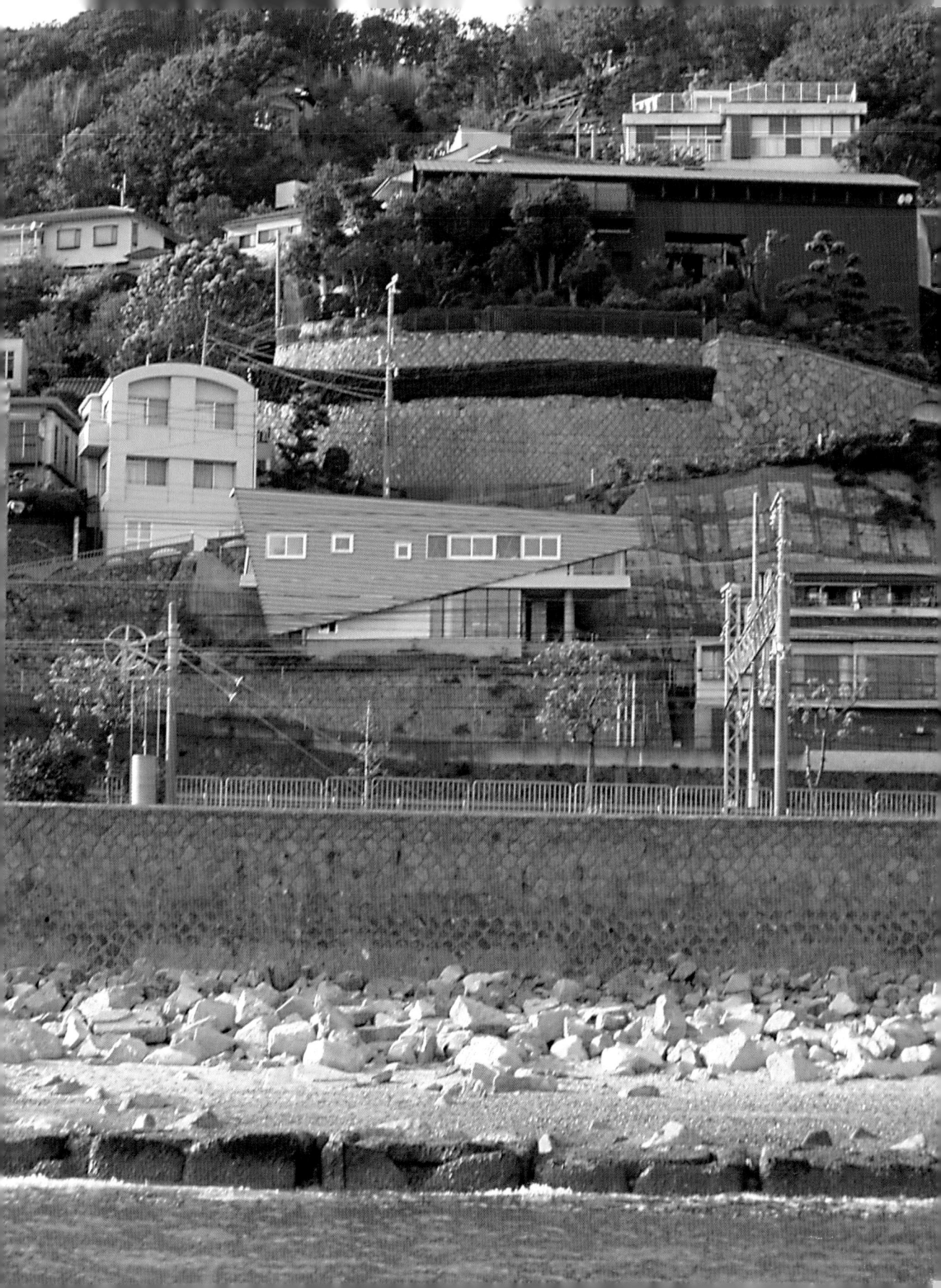

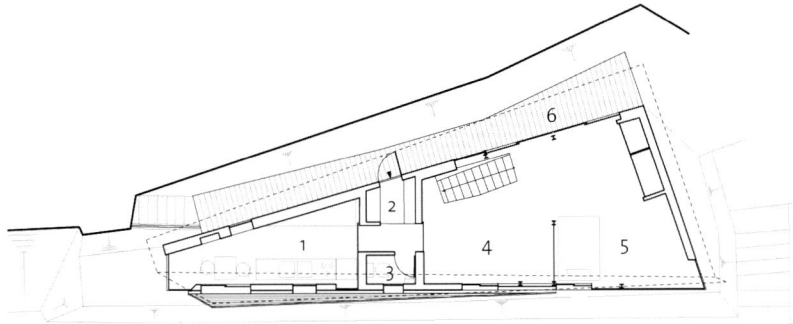

Upper Floor Plan

1. Dining Kitchen
2. Entrance
3. W.C.
4. Living room
5. Bed room
6. Terrace
7. Bathroom
8. Doma
9. Court

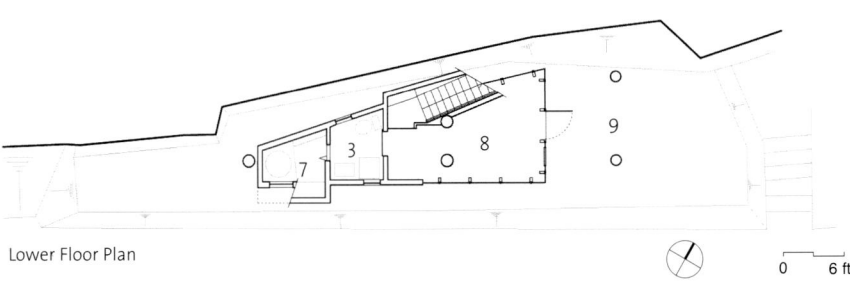

Lower Floor Plan

0 6 ft.

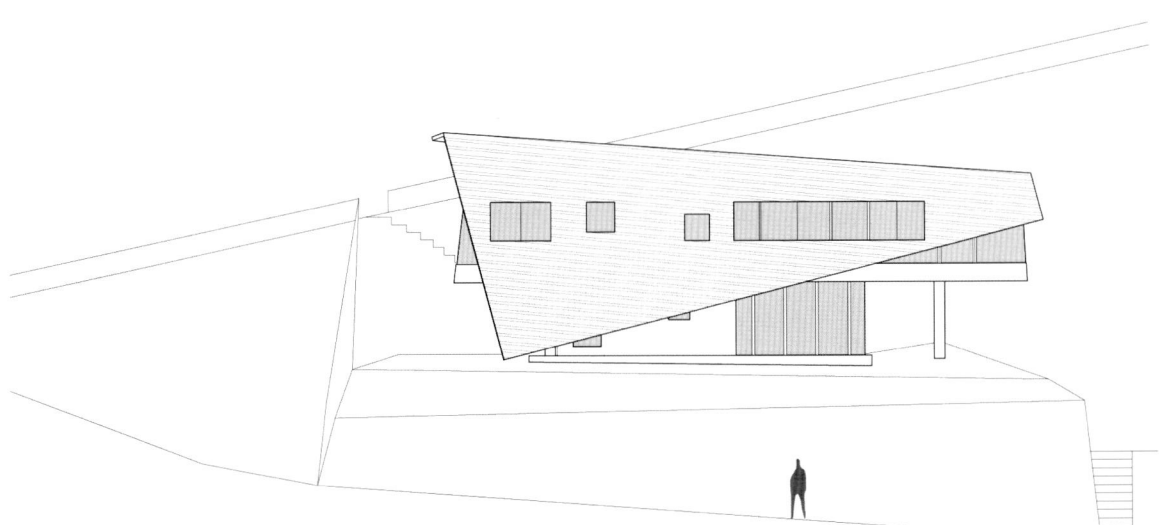

South Elevation

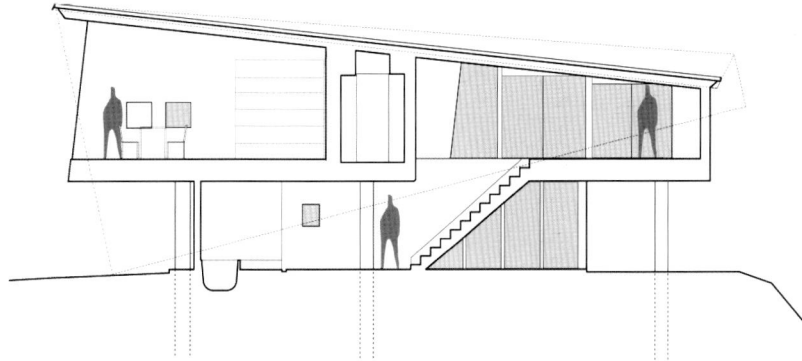

Longitudinal Section

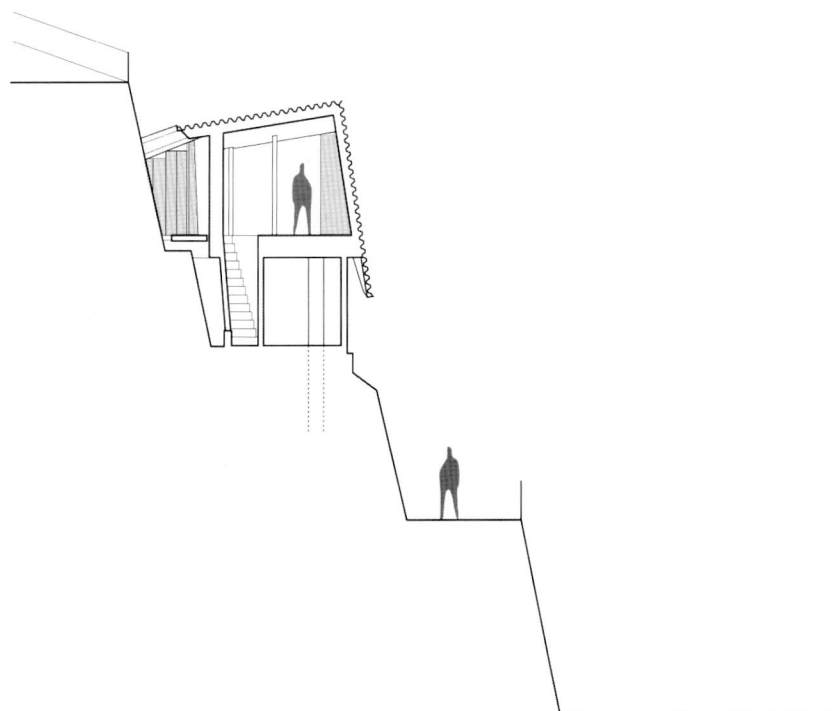

Cross Section

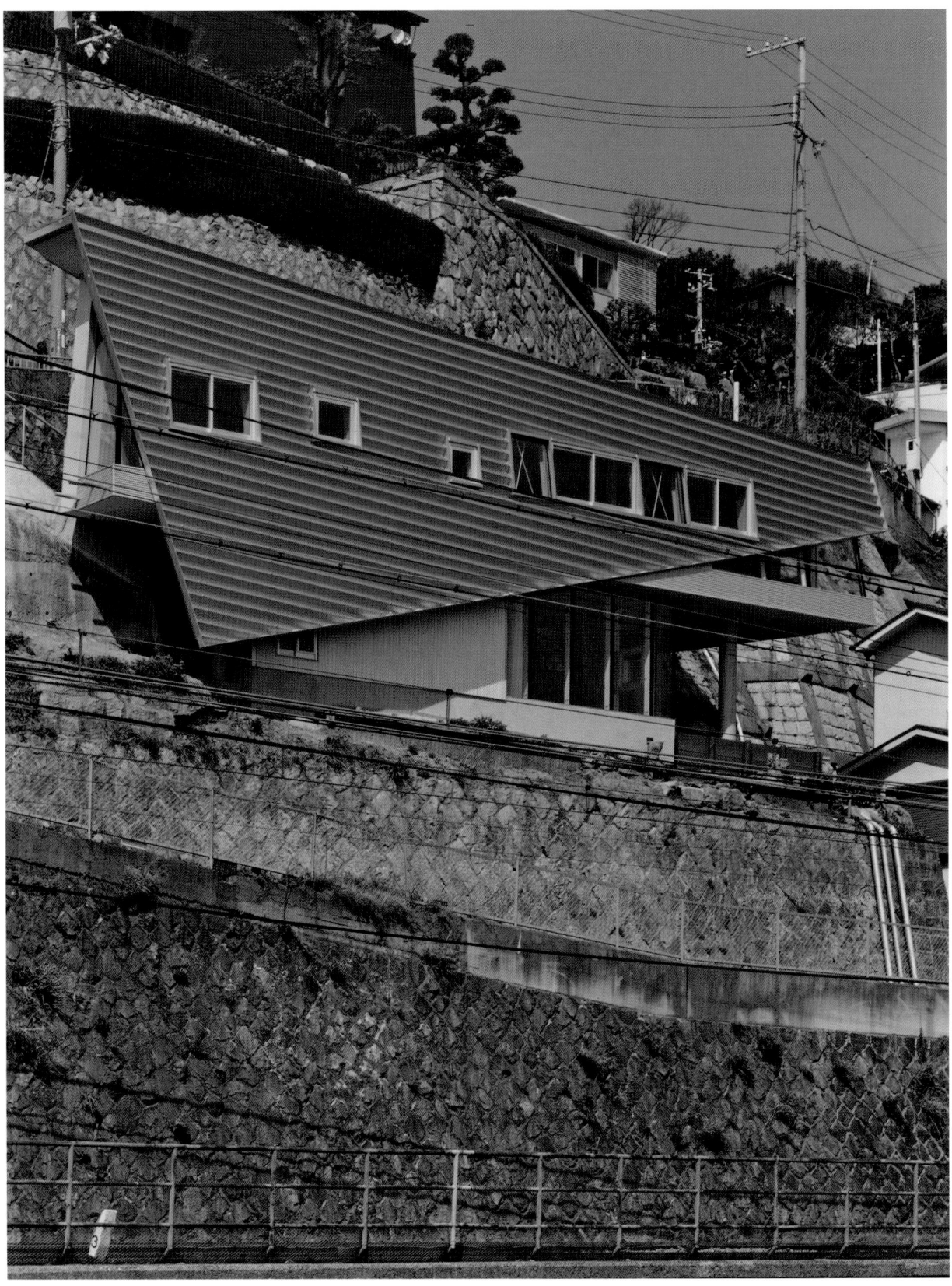

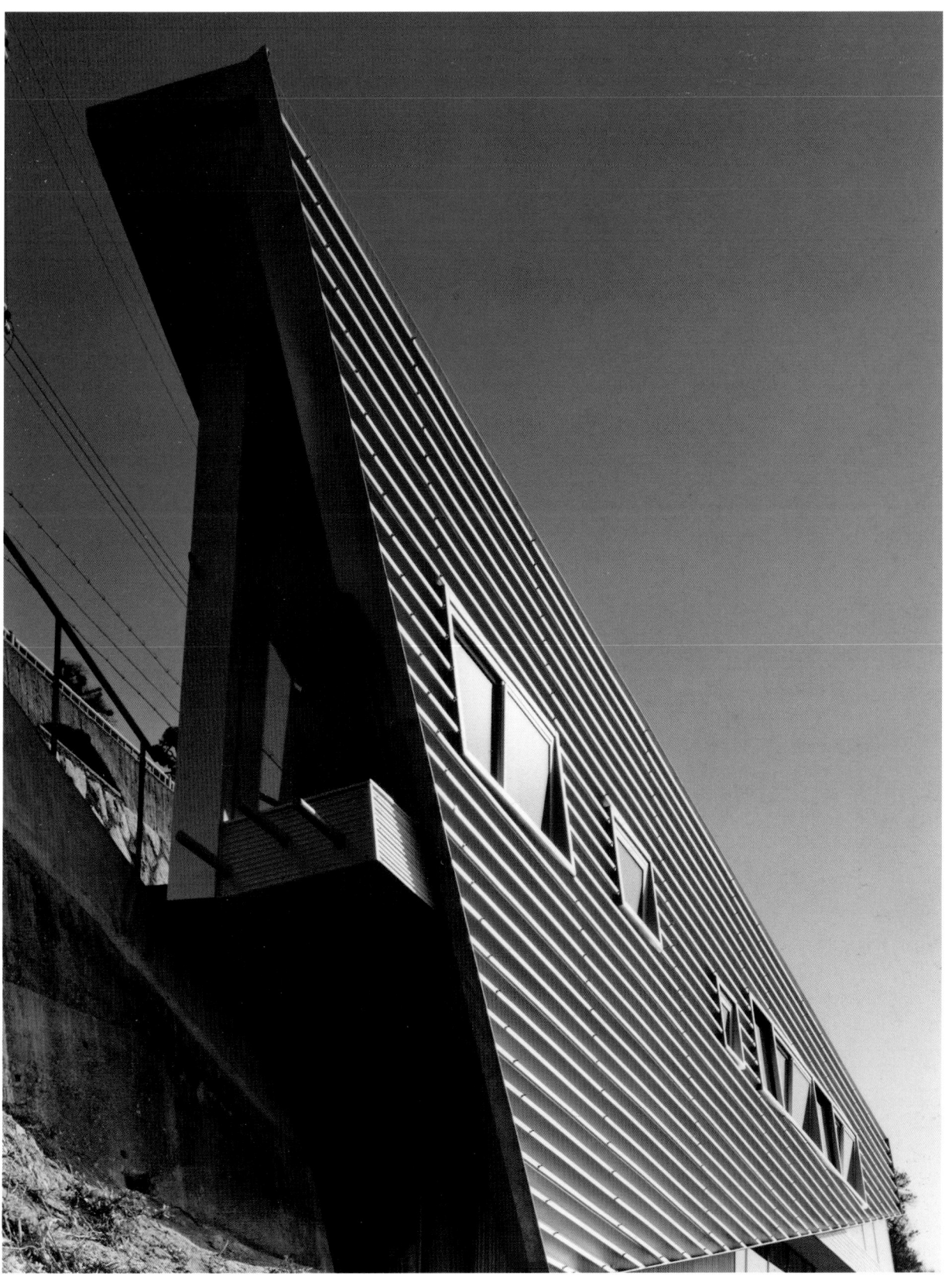

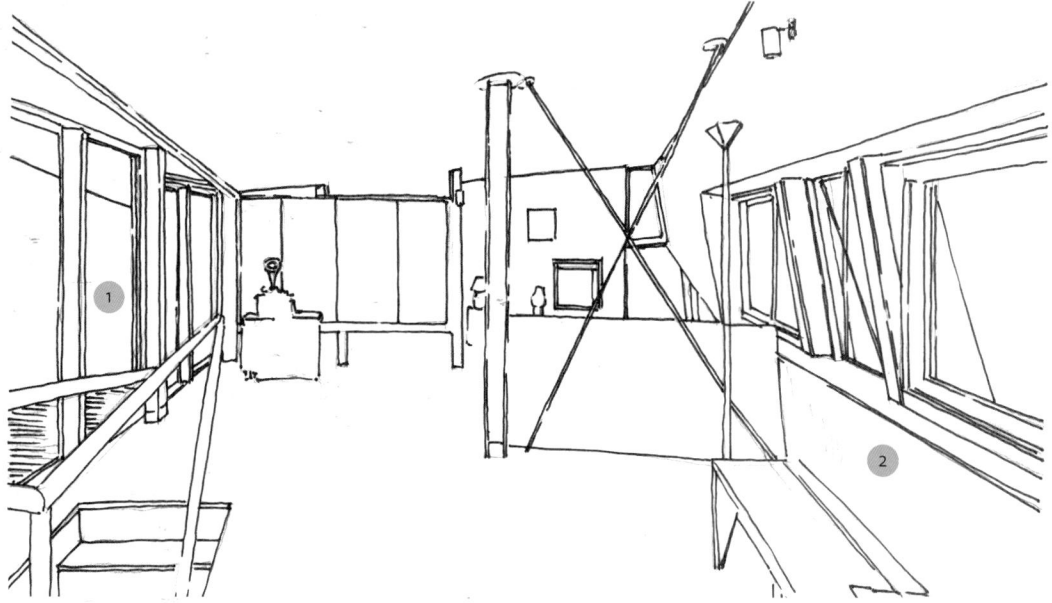

1_ The entry to the house is via the terrace facing the retaining wall. It is a secluded transitional space that connects interior and exterior.

2_ The long band of windows facing the ocean permit the passage of the south light into the living area while leaving the wall below the windows available for low pieces of furniture.

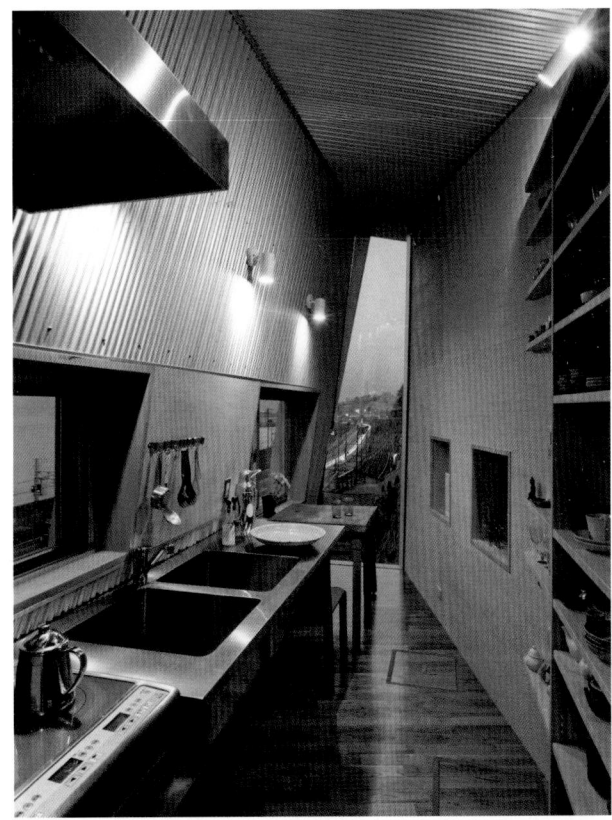

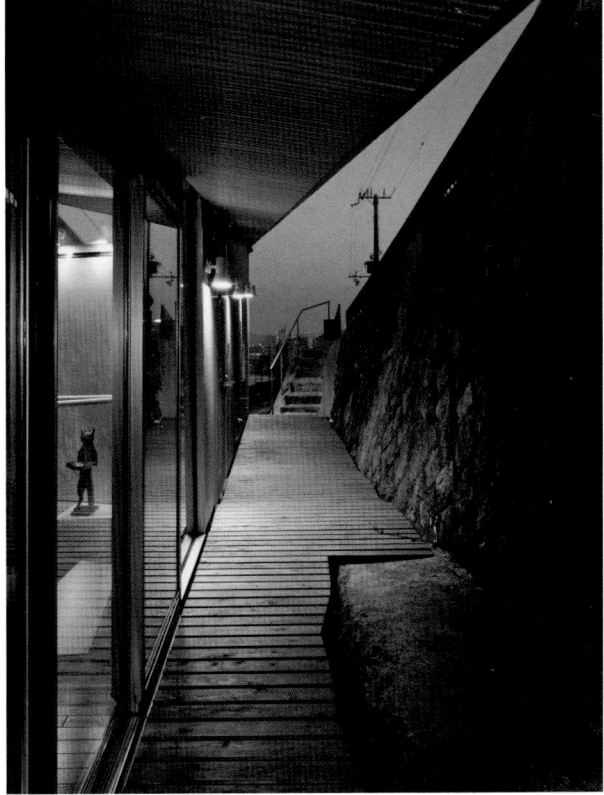

The terrace on the upper floor acts as intermediate space between the house and the wall and serves as the entryway. Inside, the functions are organized so that the wider part of the floor is occupied by the living room with a sleeping area discreetly hidden behind a screen. The kitchen takes up the narrow part of the upper floor with a work bench on one side and storage along the opposite side.

Metropolitan Chic

797 sq. ft.

This apartment is actually a demonstration project built within a larger space. It is a proposal for a typical compact apartment on a high floor of a building in any modern city. The spaces are clearly separated. The hallway divides the space into two areas: the living room facing the kitchen and the bedroom facing the study that doubles as guest room. The frequent use of mirrors throughout (at the entry closet, living room shelf, and behind the bed in the master bedroom, among other places) expand the otherwise small apartment. In combination with the brown colors they make the space simple, elegant and chic. Dramatic lighting effects and an emphasis on horizontal lines plays up this simple, elegant aesthetic.

Architect: Mohen Design International

Location: Changhai, China

Completion date: 2006

Photographer: © Mohen Design International

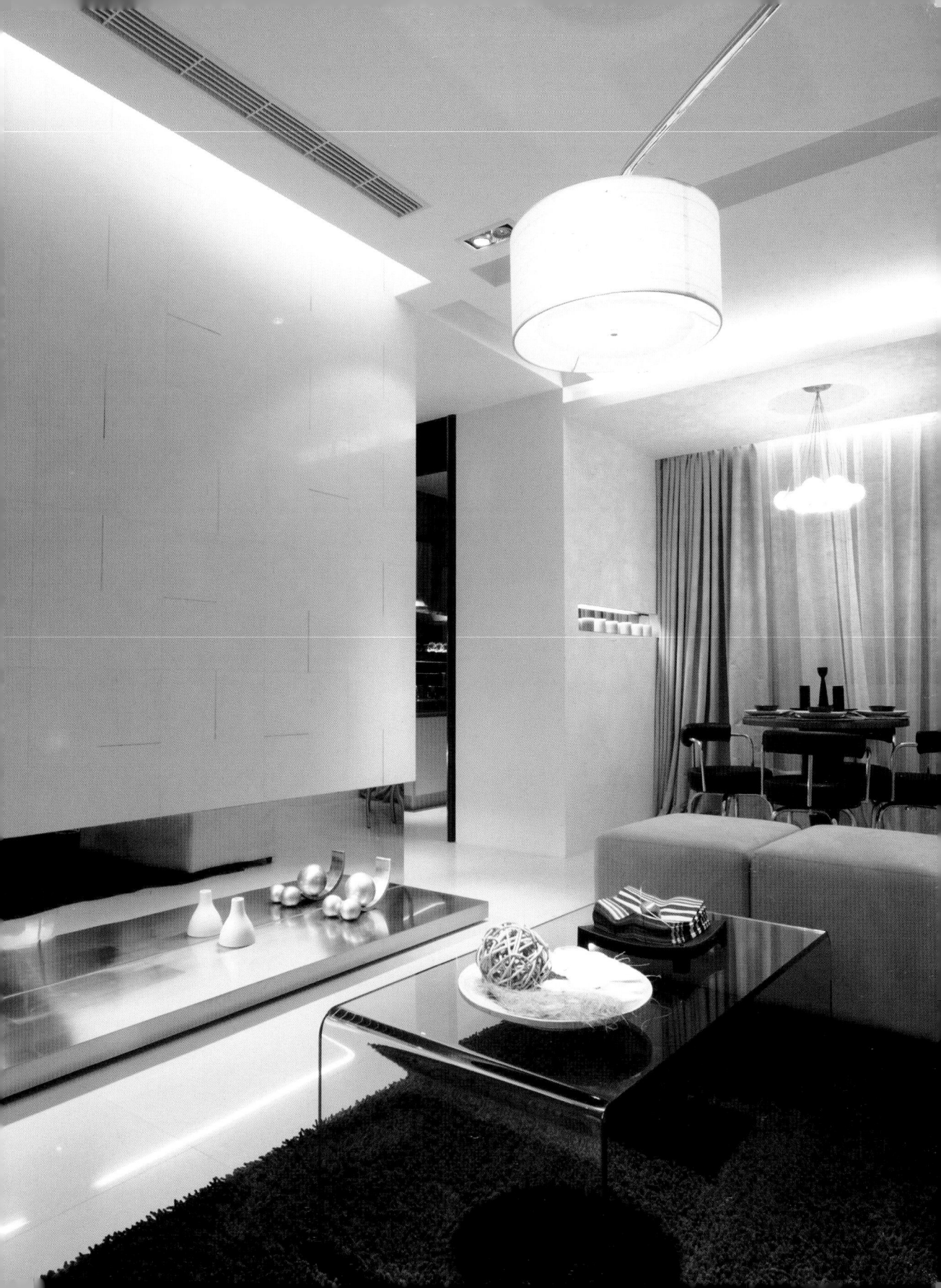

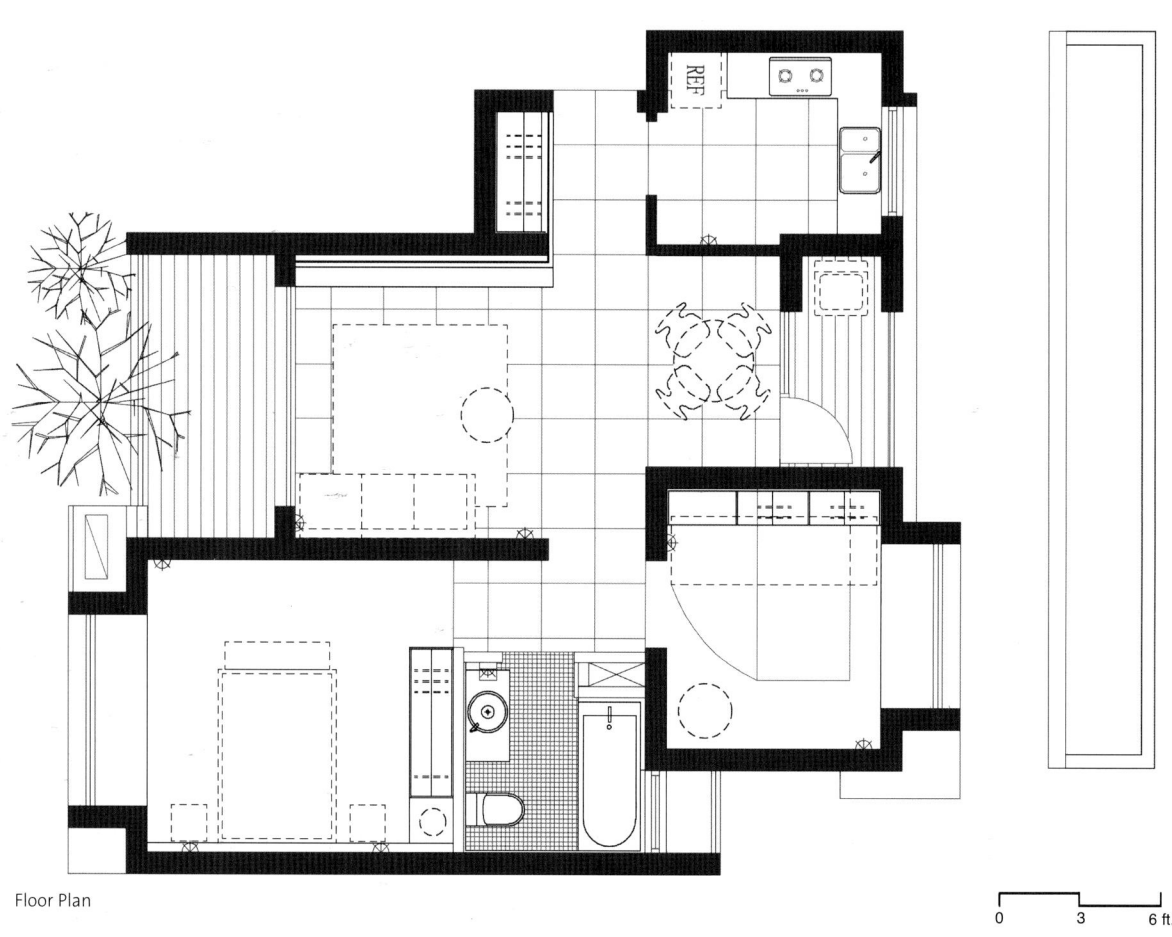

Floor Plan

0 3 6 ft.

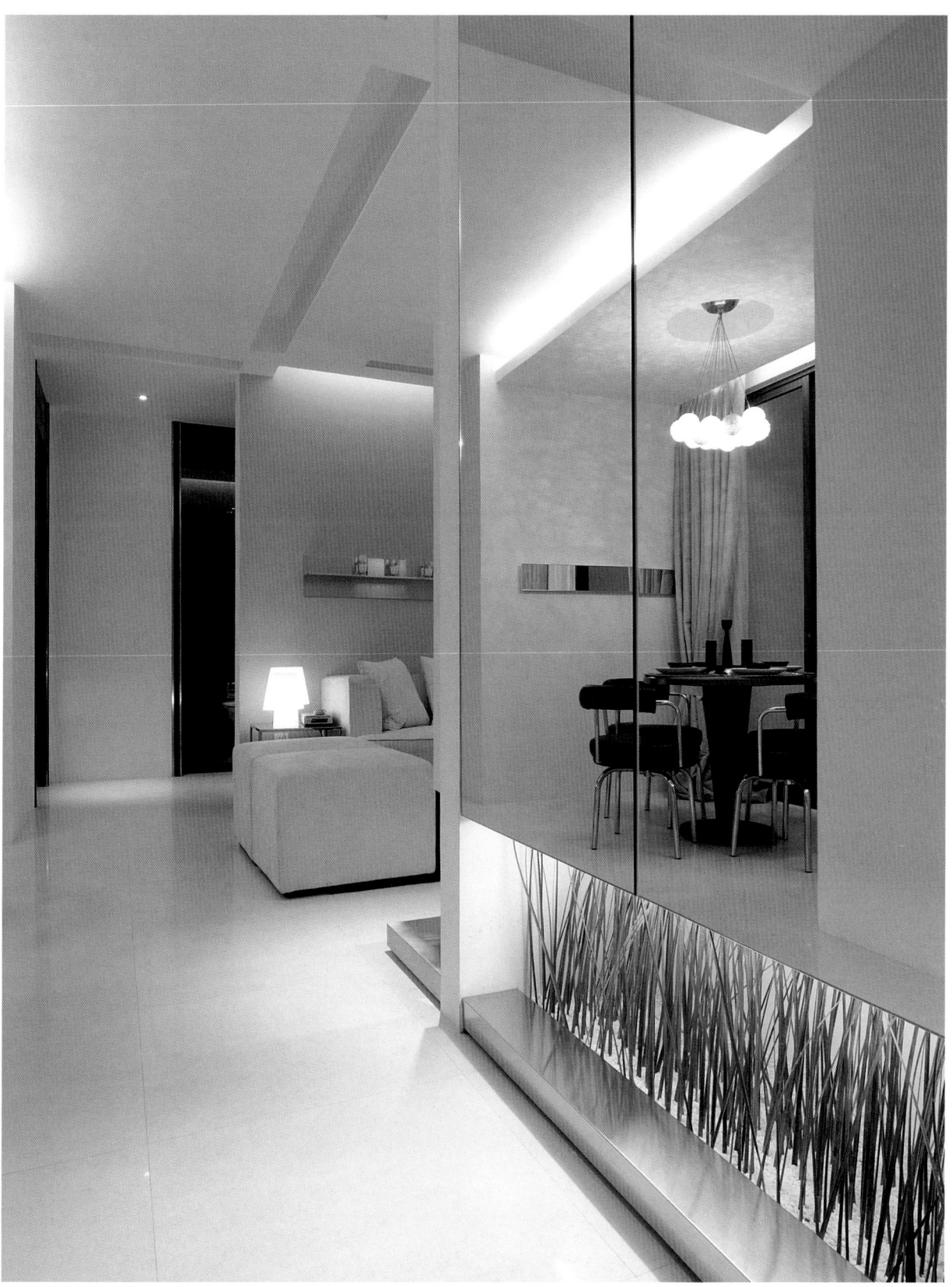

1_ A mirror used in conjunction with a low stainless steel shelf makes the wall above it appear to float, and doubles the visual depth of the shelf, emphasizing the horizontal.

2_ Dramatic lighting placed in light troughs at the junctures of walls and ceiling makes these planes look disjointed and hints at the idea of space extending well beyond the confines of the walls.

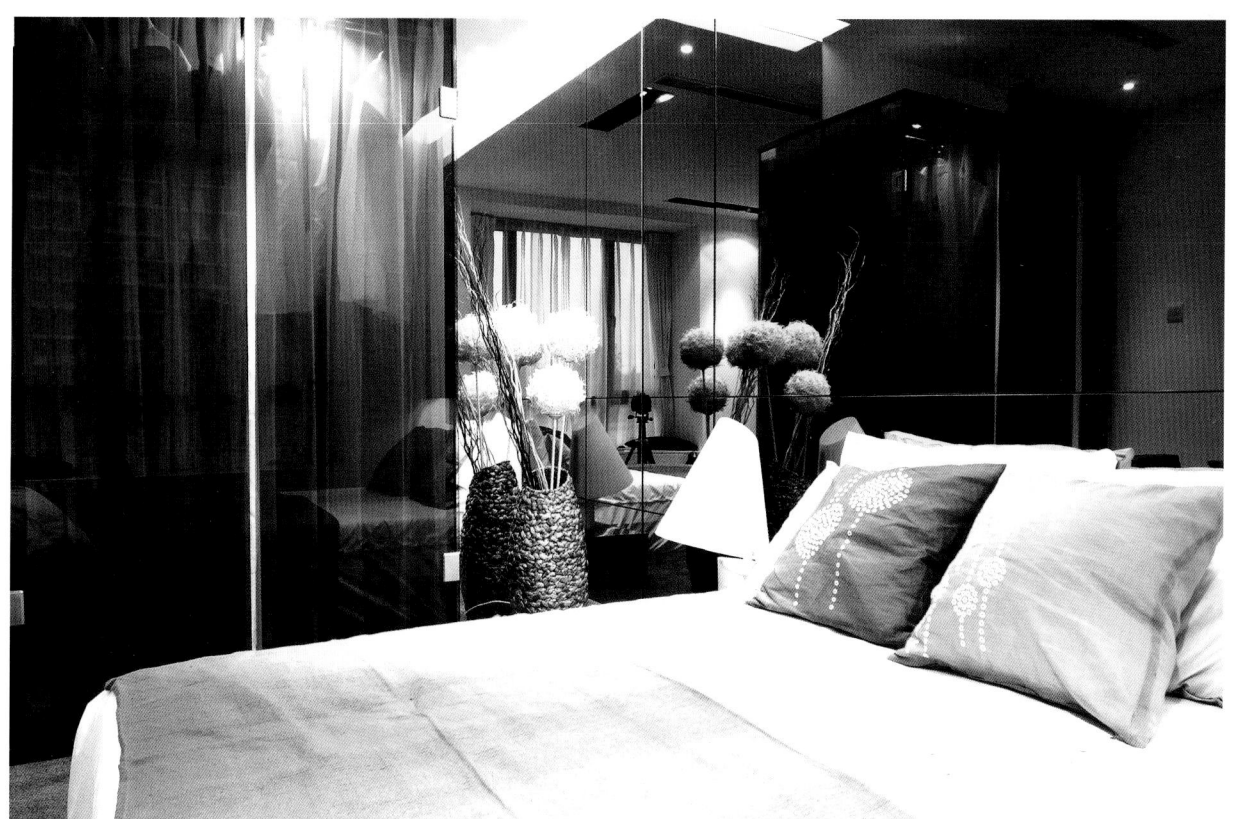

A full wall of mirror behind the bed doubles the visual size of the room while also reflecting light that emanates from a light trough at the top of the wall. A set of closet doors to the side are also glass, but tinted glass with a backdrop of fabric curtains.

Softbox Apartment

797 sq. ft.

The architecture studio of Centrala was commissioned the remodel of a 797-square-foot bachelor apartment in Warsaw's downtown for a young finance analyst who inherited the flat from his grandmother. The potential of the flat was obscured by the fact that all the windows lined along one wall faced a deep courtyard providing little to no natural light. Nonetheless, the lighting issue is effectively resolved and becomes a central element of the design. Semi-transparent curtains encompass the perimeter of the flat and divide the space in various sections according to the different functions: storage, workplace, media and bedroom. To preserve the open character of the apartment, all the utilitarian functions are centralized in one single block. This block contains a small kitchen, a toilet room, a shower, and a bathtub.

Architect: Jakub Szczesny, Malgorzata Kuciewicz/CENTRALA Designers Task Force

Location: Warsaw, Poland

Completion date: 2008

Photographer: © Nicolas Grospierre

Elevation at Built-in Cabinet

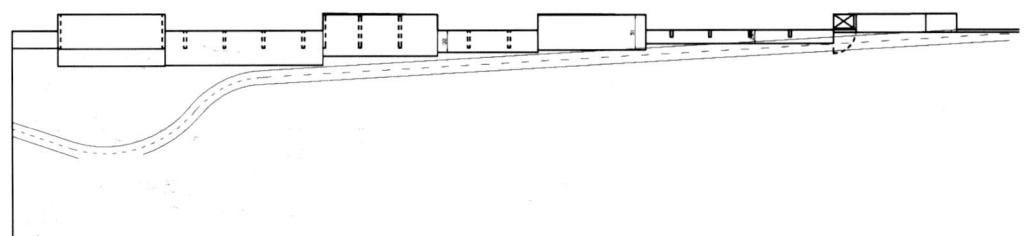

Plan at Built-in Cabinet

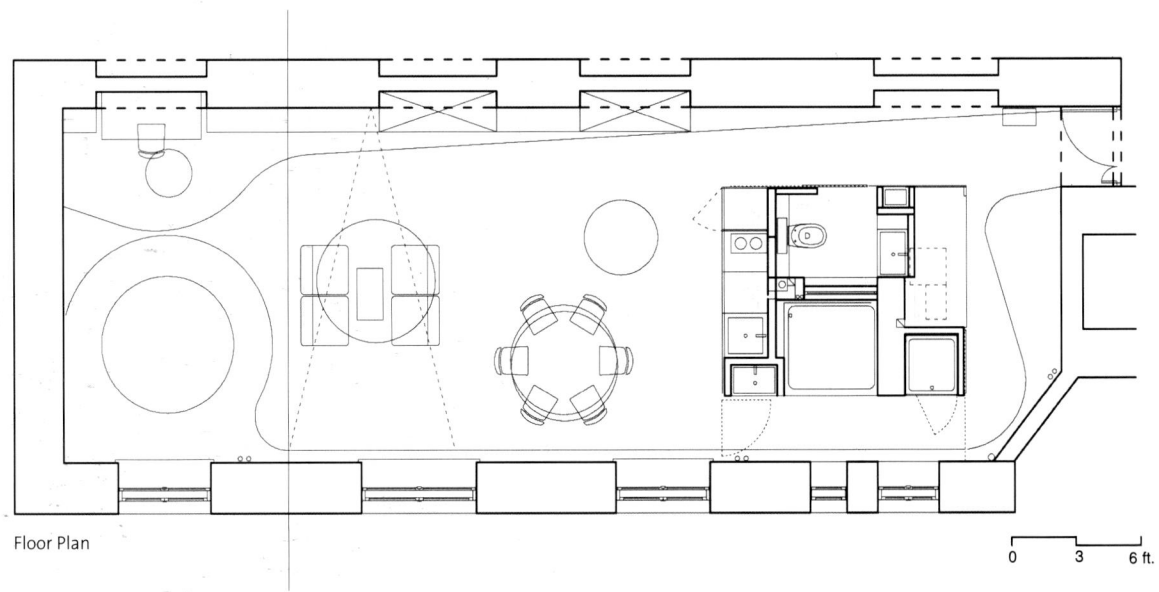

Floor Plan

0 3 6 ft.

Softbox Apartment **245**

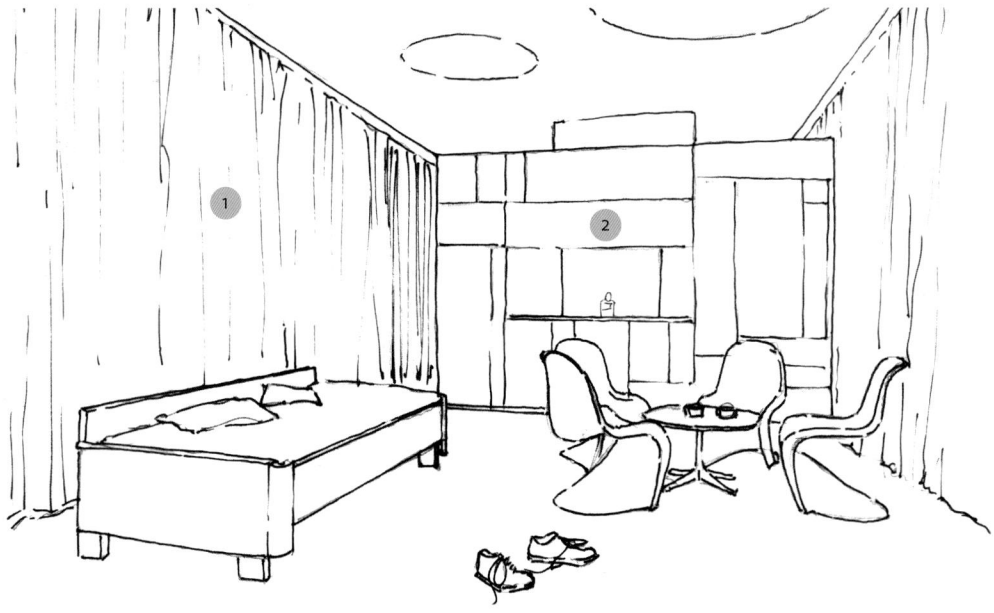

1_ The curtains, made of a polyester fabric used for car airbags, divide the space into smaller modules and line the walls to hide the open shelves and work desk.

2_ The different grains of wood contrast with the stark white envelope that forms the space.

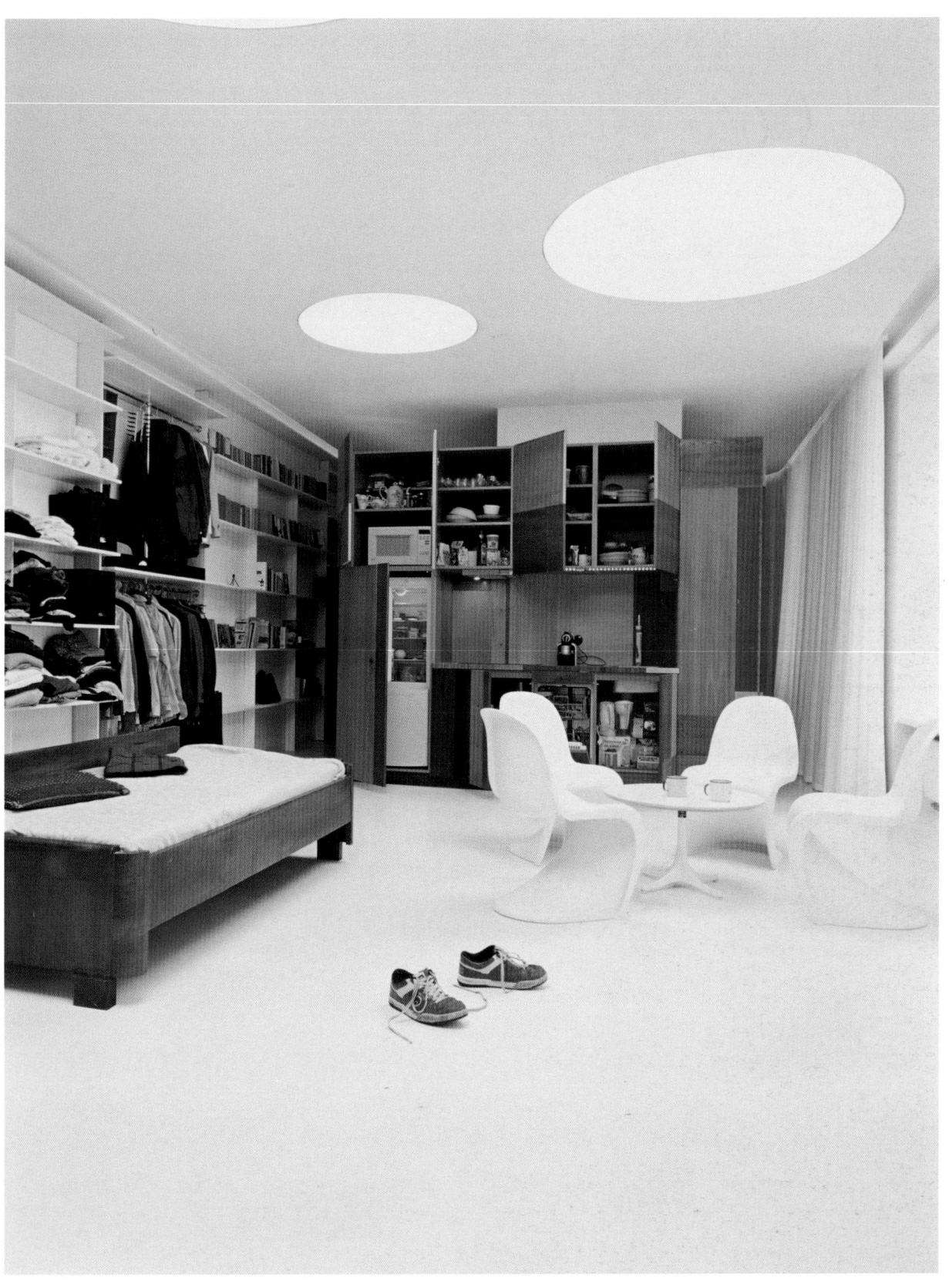

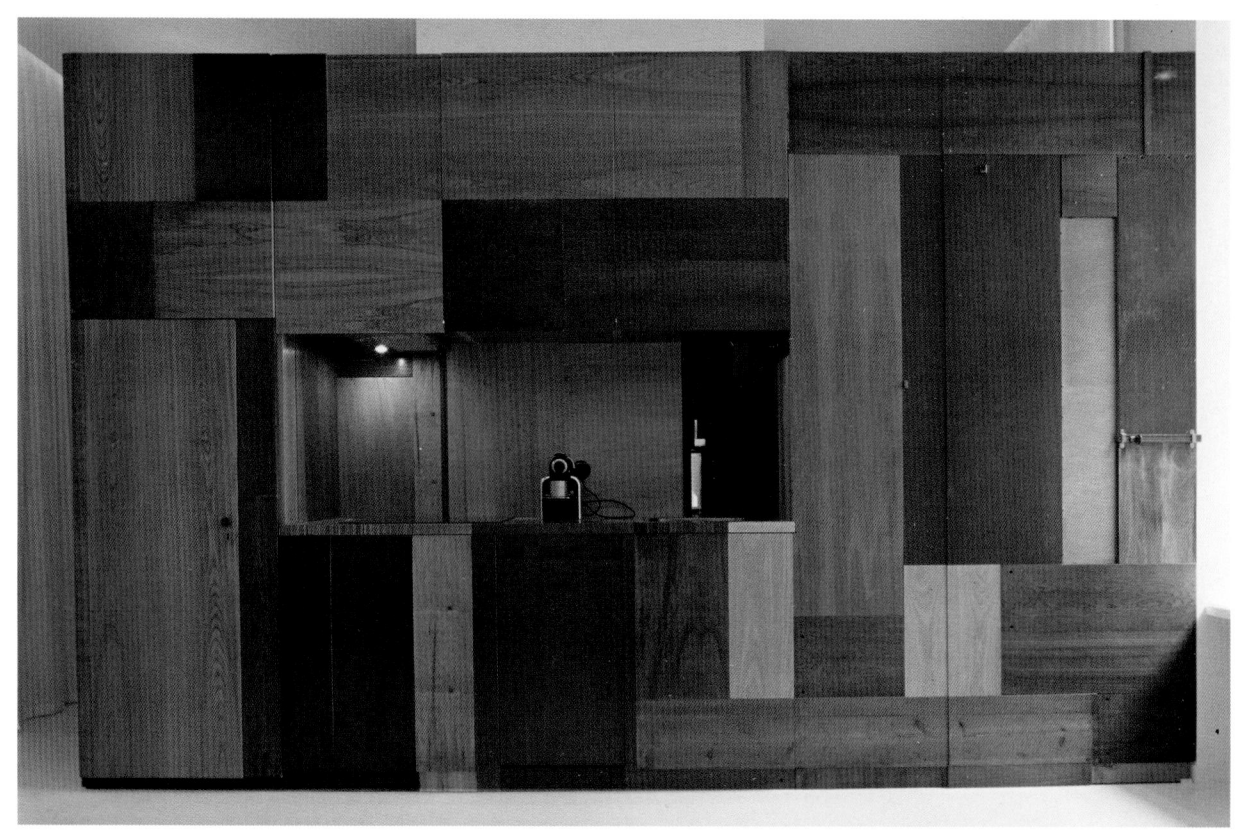

To create the utilitarian block, all remaining furniture and all doorframes (including one where the new occupant's grandmother used to note his heights as a growing child with a pencil line and a date) were cut down into small pieces.

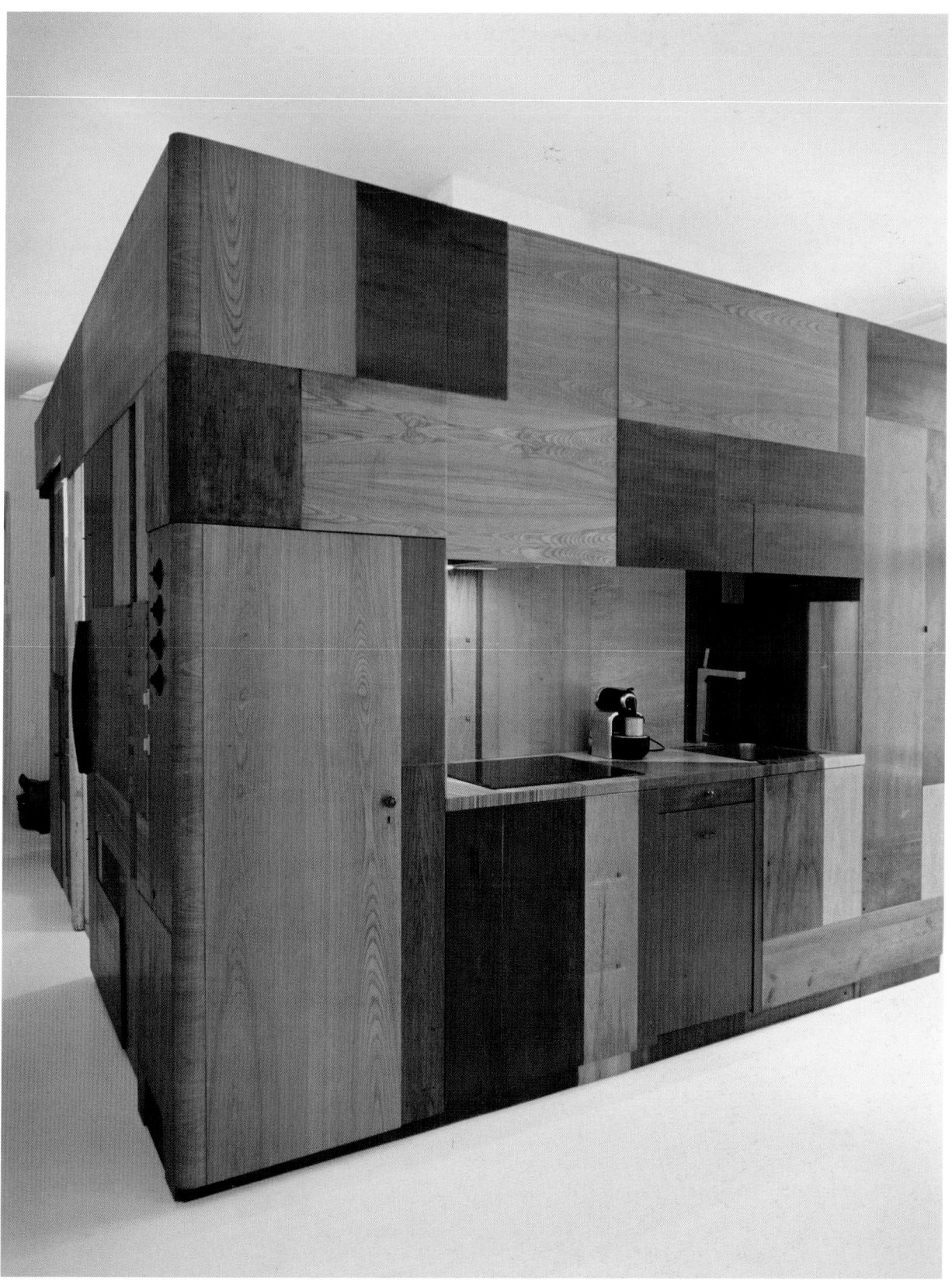

Apartment K
807 sq. ft.

The apartment is located in a 1950s multi-story building. The project accommodates the functional needs for five people in an area of 807 square feet. The space feels surprisingly spacious. The aim to make the entire space one single volume contributes to this feeling of amplitude. A large piece of cabinetry occupies the center of the space and is accessible from all sides. Besides the diverse functions that this element offers, it serves as an organizer of the space. Additional built-in cabinets conceal various pieces of furniture that can be pulled out or folded away as needed.

Another peculiar aspect of the apartment is the treatment of its surfaces. Artist Rainer Fuereder was responsible for the finish touch that covers all the surfaces that envelop the interior volume and blurs the geometry of the space.

Architect: Peter Ebner & Franziska Ullmann Architects

Location: Attersee, Austria

Completion date: 2005

Photographer: © Peter Ebner

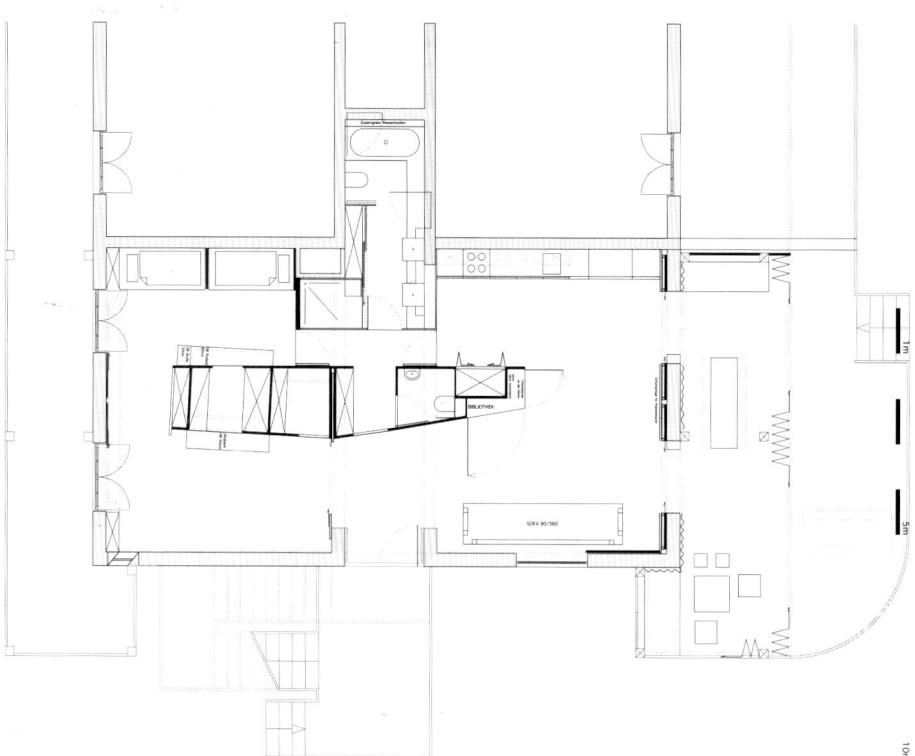

Floor Plan

All sketches courtesy of Peter Ebner, Franziska Ullmann Architects

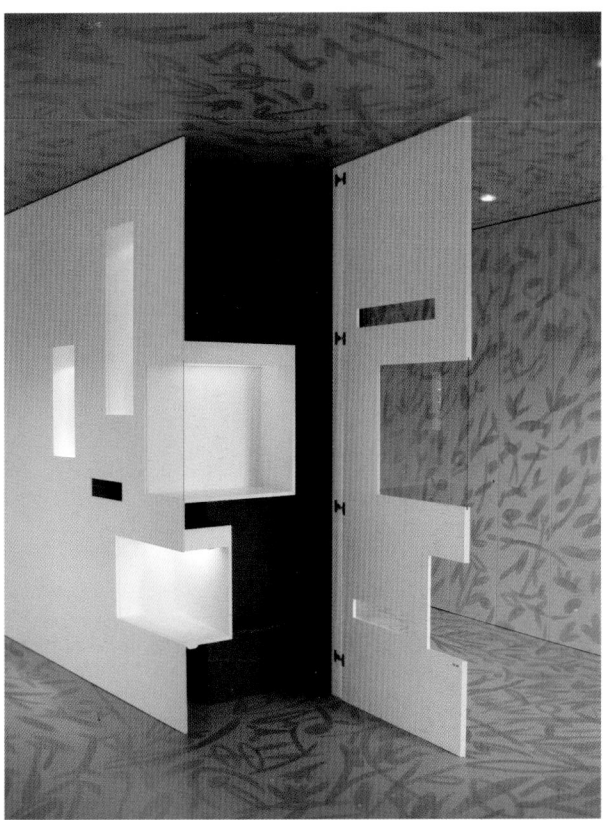

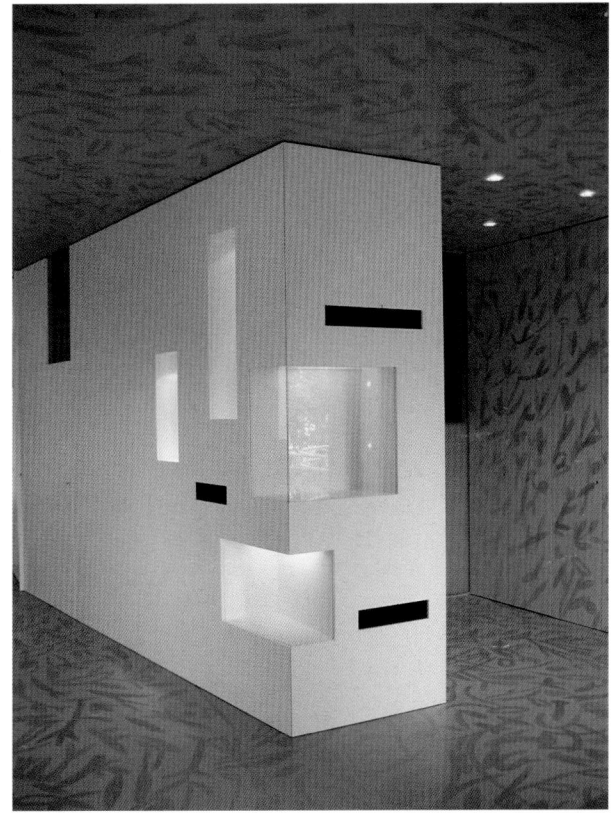

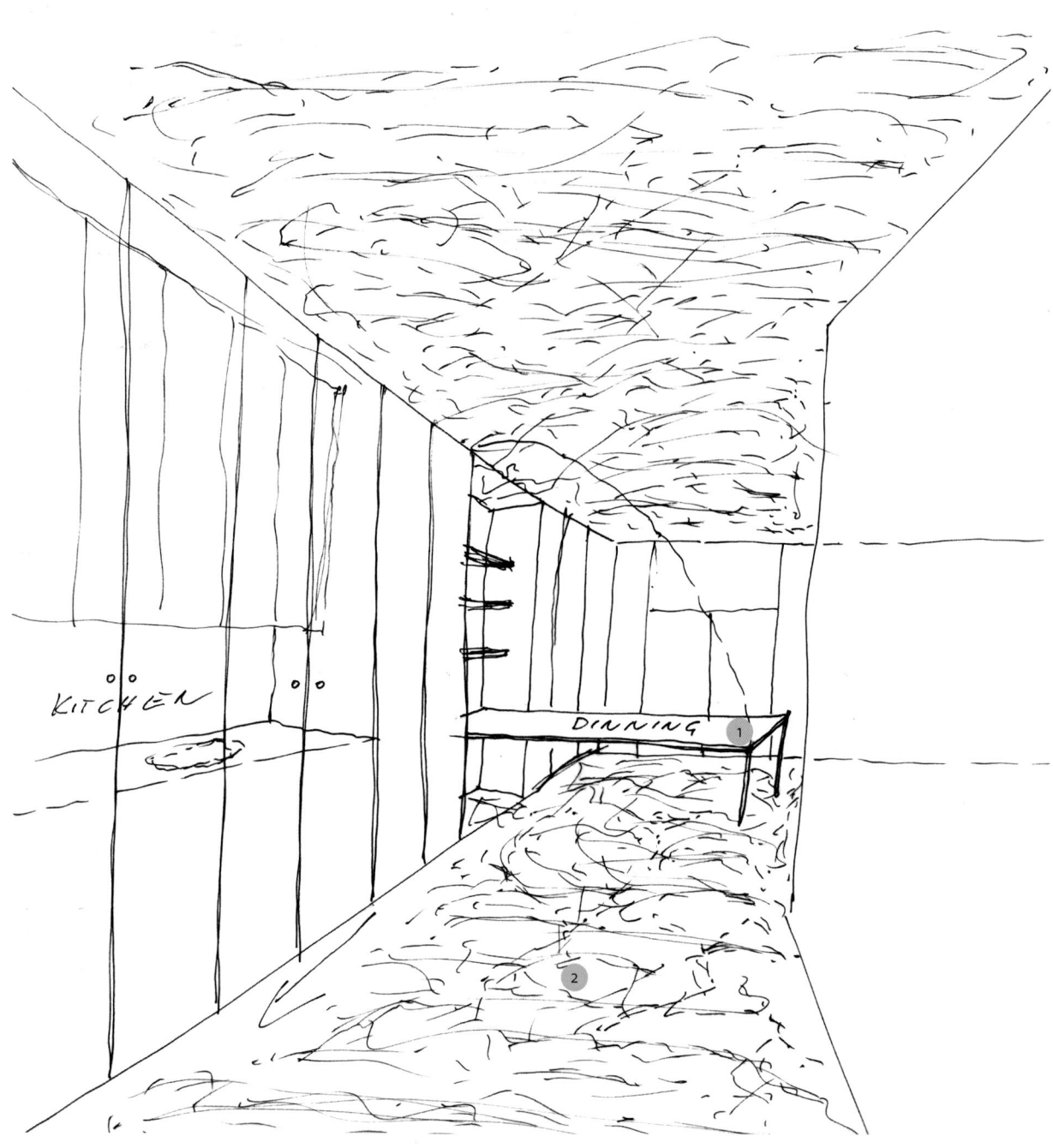

KITCHEN

DINNING

1_ From the built-in cabinet, the dining table folds down and the desk expands. The same stratagem is used to pull a bed out of the central cabinet.

2_ The floor, the walls and the ceiling are painted with monochromatic motifs that represent leaves and branches.

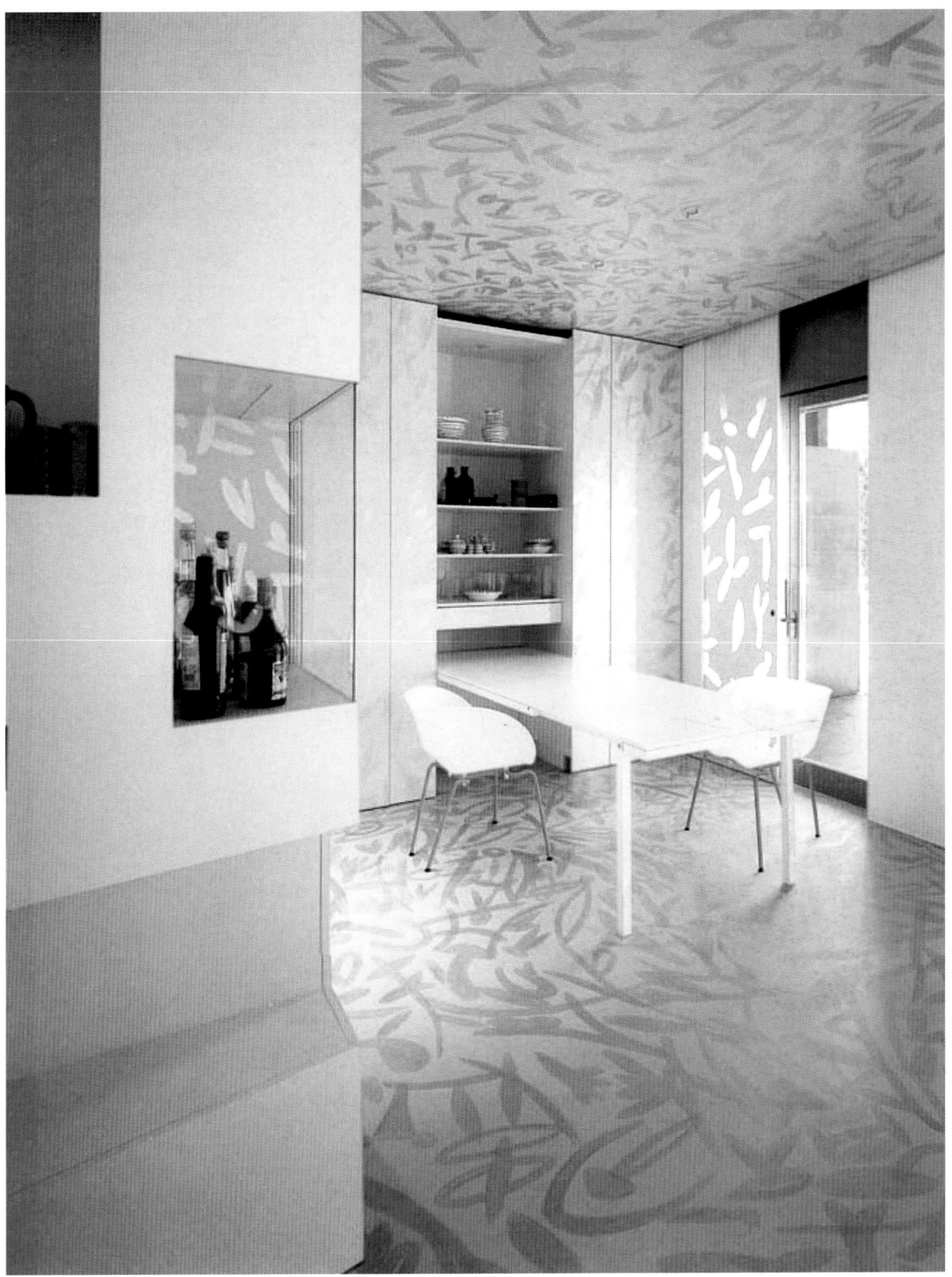

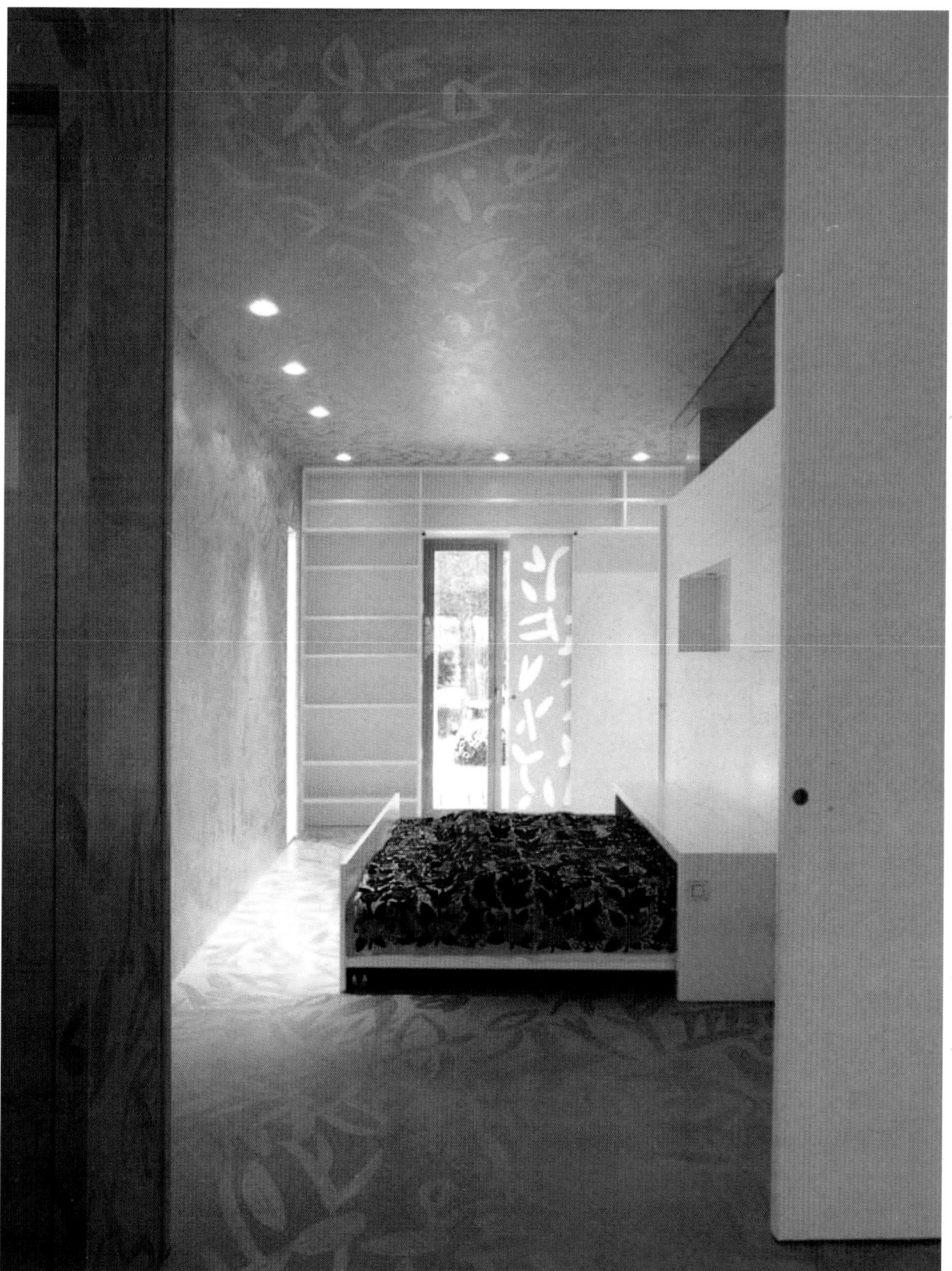

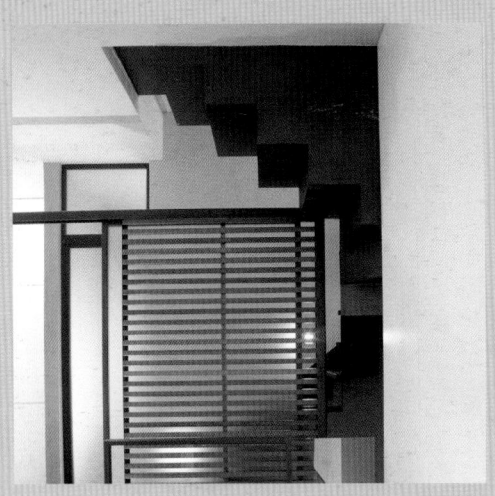

Porto Ercole

818 sq. ft.

This small seaside house on the Argentario (Tuscany) is characterized by the sliding panels that divide the various spaces. This design decision was originated by the client's request that natural light should flood the living areas. As a result, the design team came up with a solution to let generous amounts of light into the apartment and, at the same time, resolve the necessity of dividing the floor area into separate sections. These sliding panels, made of obscure glass and wooden slats, filter the bright light of the hot season. They also divide the kitchen and bathroom from the living space. On the upper level, the bedroom can be closed off for more privacy. The variety of materials used is in harmony with the different levels of separation desired.

Architect: Fabrizio Miccò

Location: Porto Ercole, Italy

Completion date: 2007

Photographer: © Beatrice Pediconi

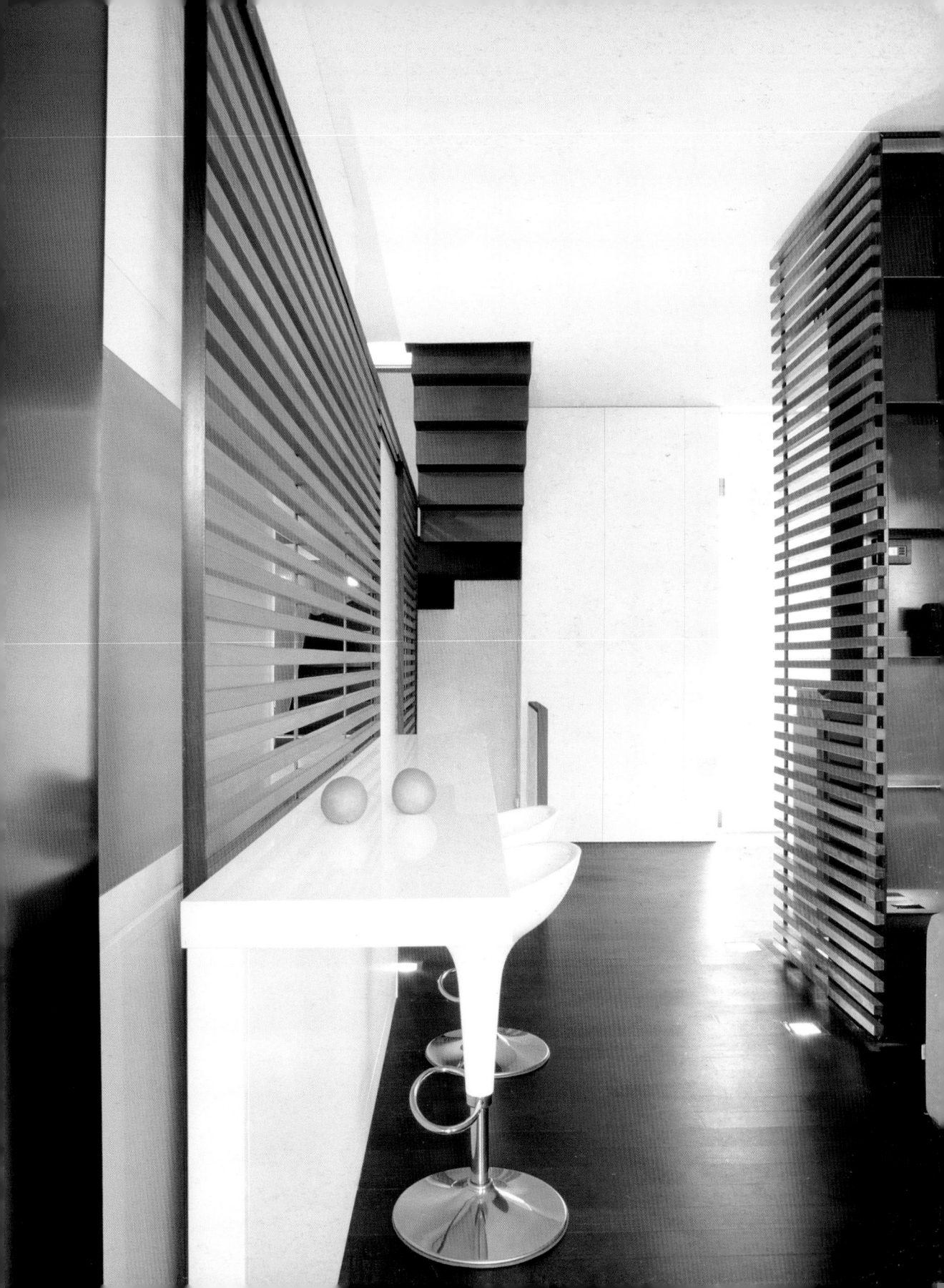

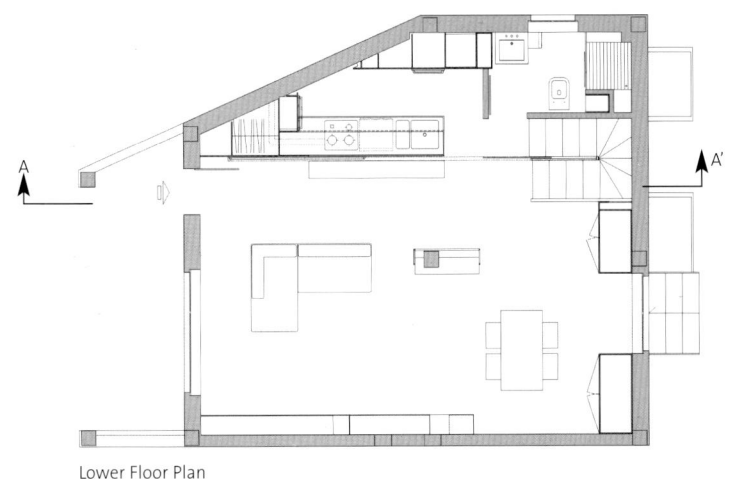

Lower Floor Plan

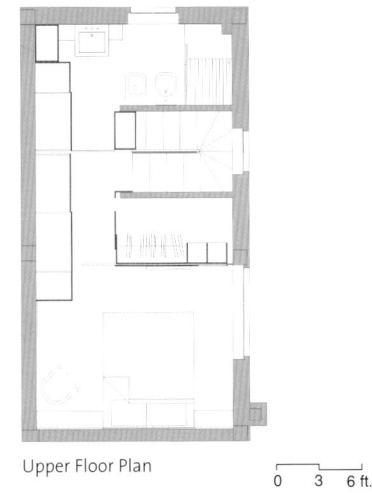

Upper Floor Plan

0 3 6 ft.

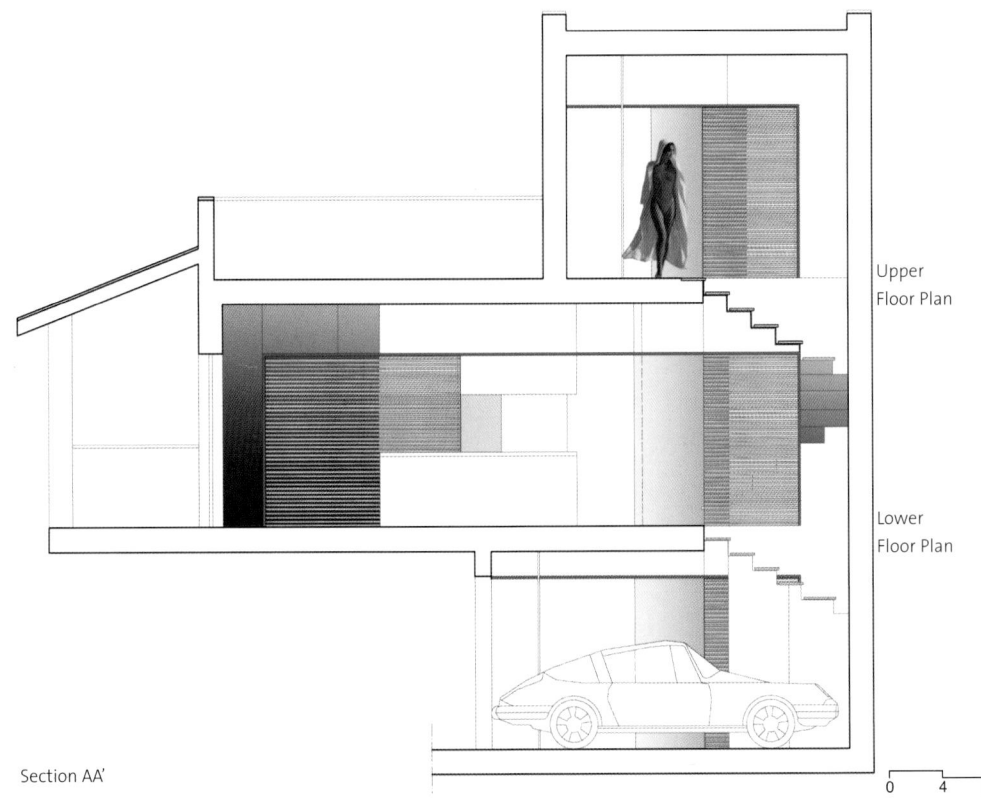

Upper
Floor Plan

Lower
Floor Plan

Section AA'

0 4 8 ft.

Delightful plays of light and shadow emphasize
the geometry of this interior. One sliding screen of
horizontal wood slats slices through the kitchen
counter, while another stationary one clads an
existing structural column and forms a room divider
and built-in shelving.

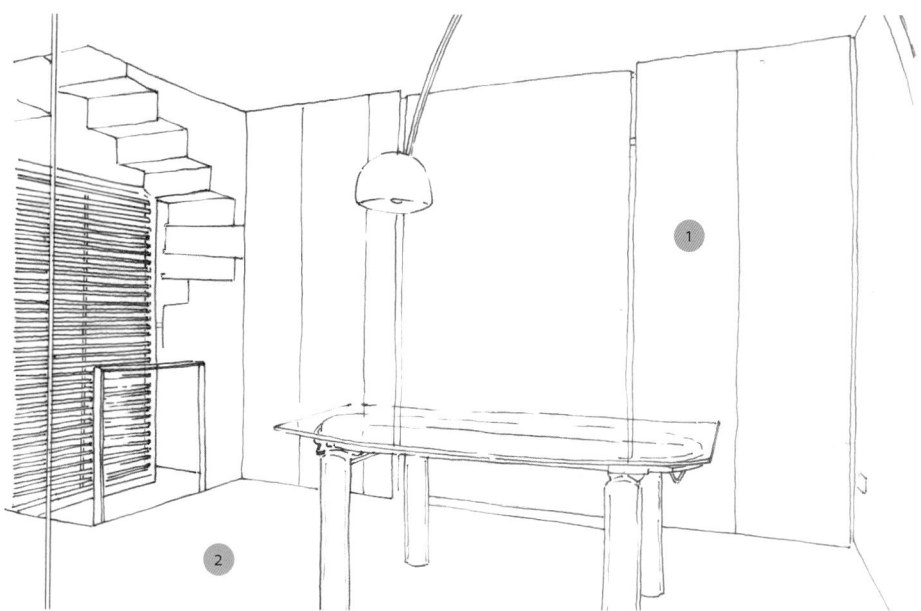

1_ Storage cabinets, built-in on either side of the window, create a recess for the window and allow space for modulating the impact of the strong natural light.

2_ The dark wood floor and dark steel staircase make a striking contrast with the stark white of the furniture and walls.

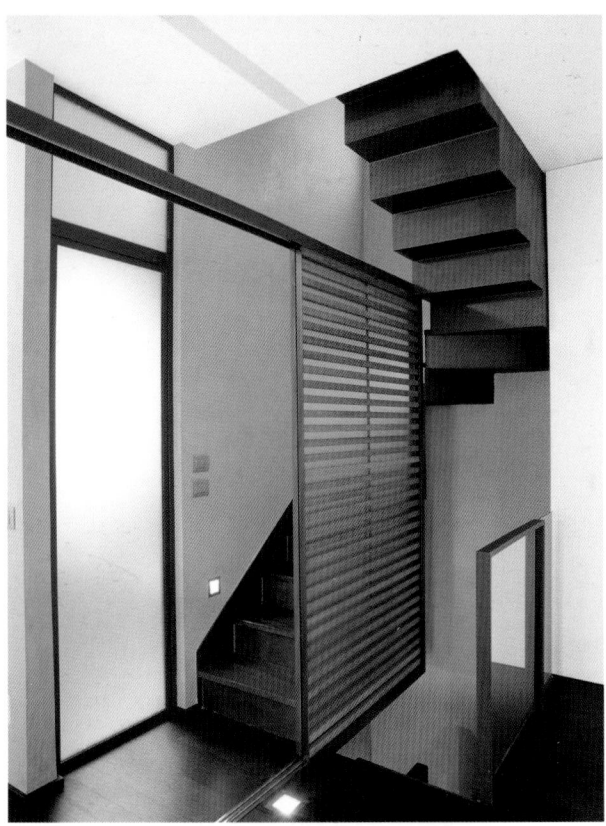

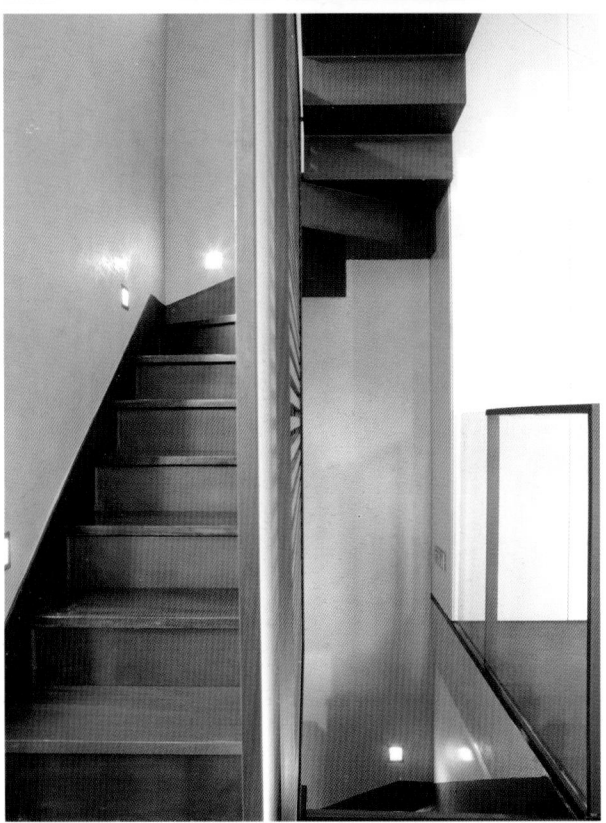

Crisply detailed guard rails and a stair structure in black steel take up much less space than heavier constructions. One sliding panel tucks into the slot between the two runs of the stair, making the most of the space. The door to the bathroom is cased in the same steel details that make the sliding panel and glass guard rail.

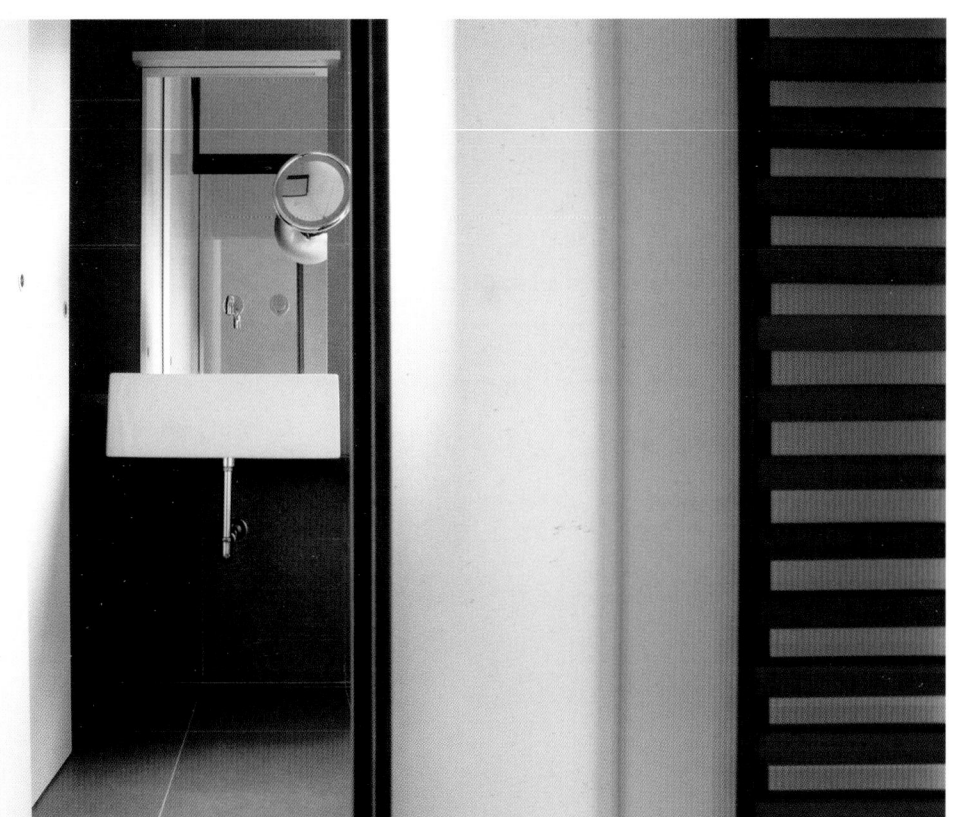

The upstairs bathroom is glimpsed between more
built-in cabinetry, with its own sliding panel to close
it off if need be.

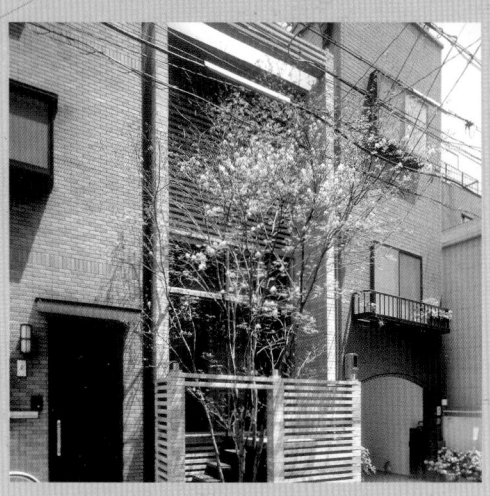

Layer House

822 sq. ft.

This house, squeezed between two existing masonry buildings, consists of a shell made of stacked precast concrete beams. Except for its street-side elevation and a skylight that allows in natural light through the roof, the house does not present any openings. The house is in fact bathed, from top to bottom, in a light that enlivens the horizontal layers of concrete with thin beams also expressed in the interior.

The 822-square-foot house is distributed in three levels. In an attempt to increase the sense of privacy, the architect placed all floors below and above street level.

A study and the only bathroom occupy the lowest level while the middle level is dedicated to the entrance and the bedroom. The top floor, the brightest, is occupied by the kitchen and the living room.

Architect: Hiroaki Ohtani

Location: Kobe, Japan

Completion date: 2005

Photographer: © Kouji Okamoto

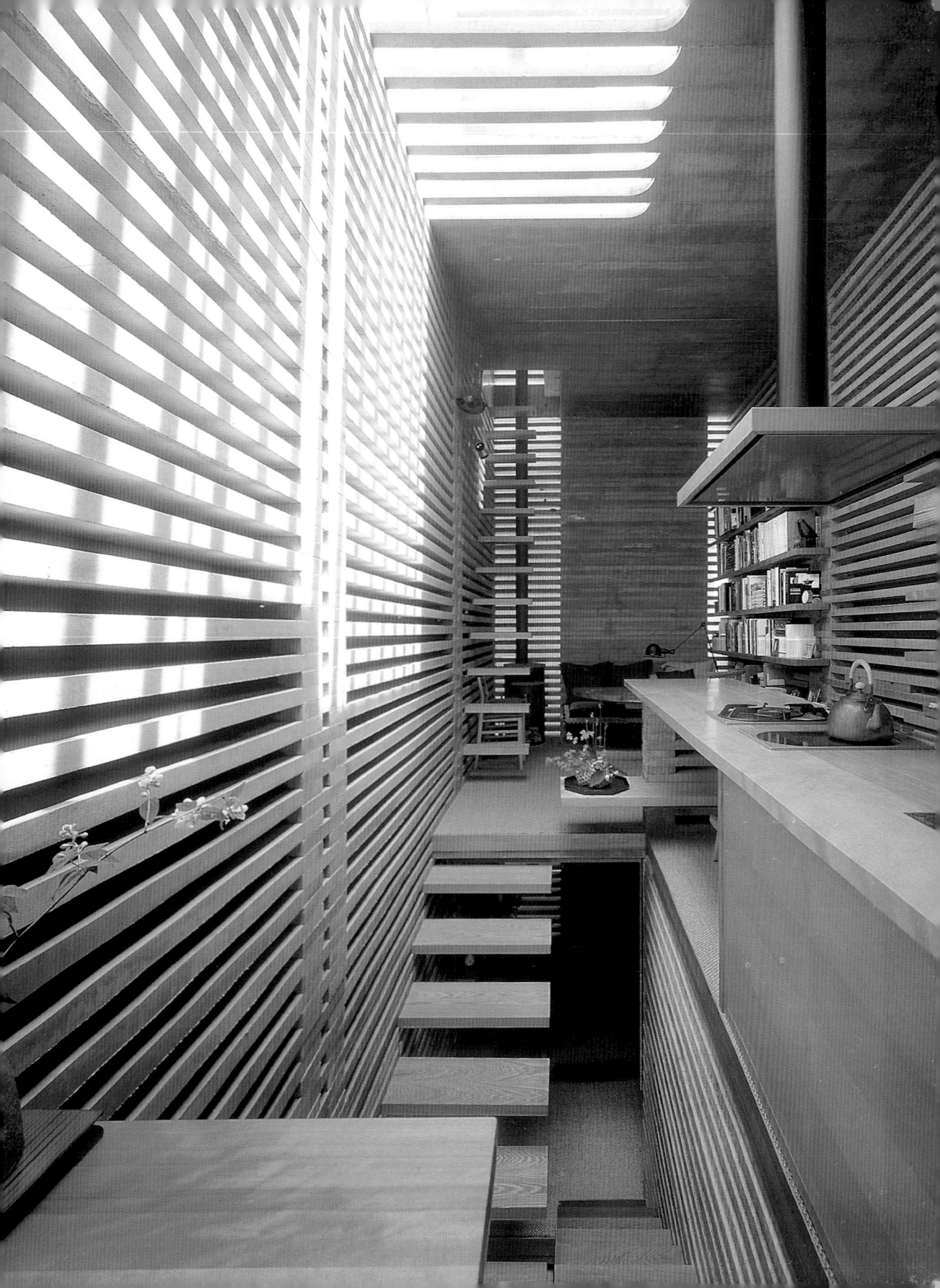

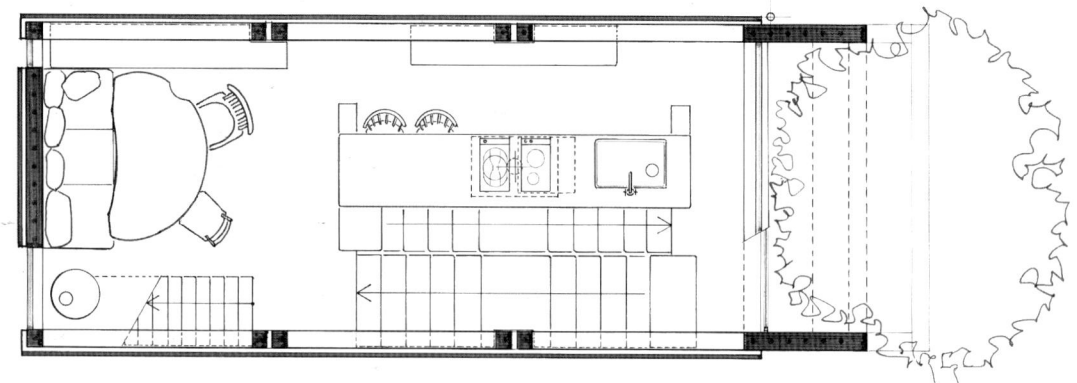

Access Floor Plan

Street Elevation

Section

0 3 6 ft.

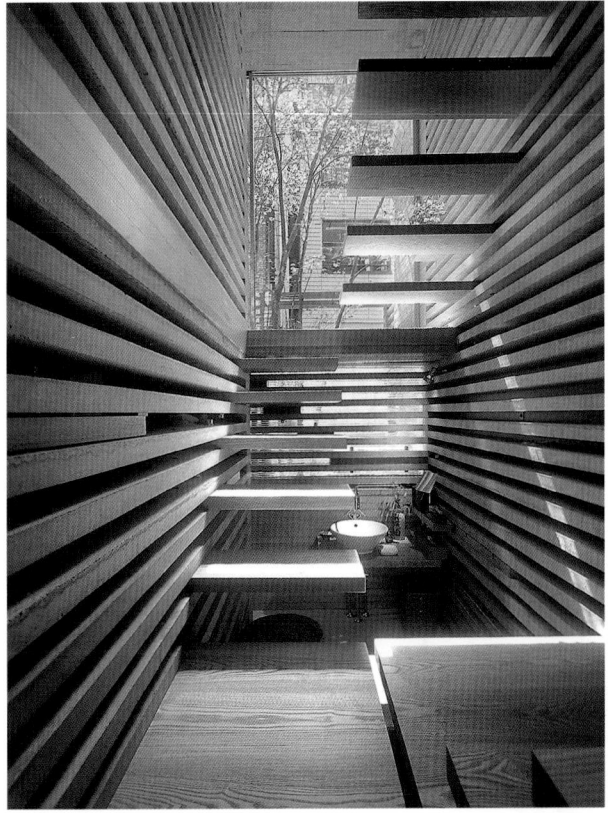

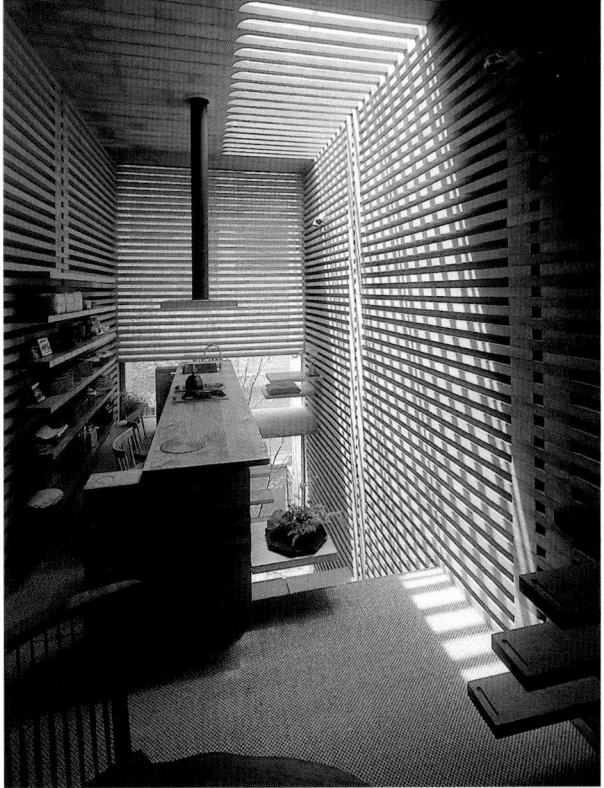

Staggered slabs of wood fit in the slots between concrete beams to form the staircase. Throughout the house, the architect fitted out the slots with plug-in furnishings: ash wood shelves, desk and drawers, towel hangers and light fixtures that the owner can rearrange.

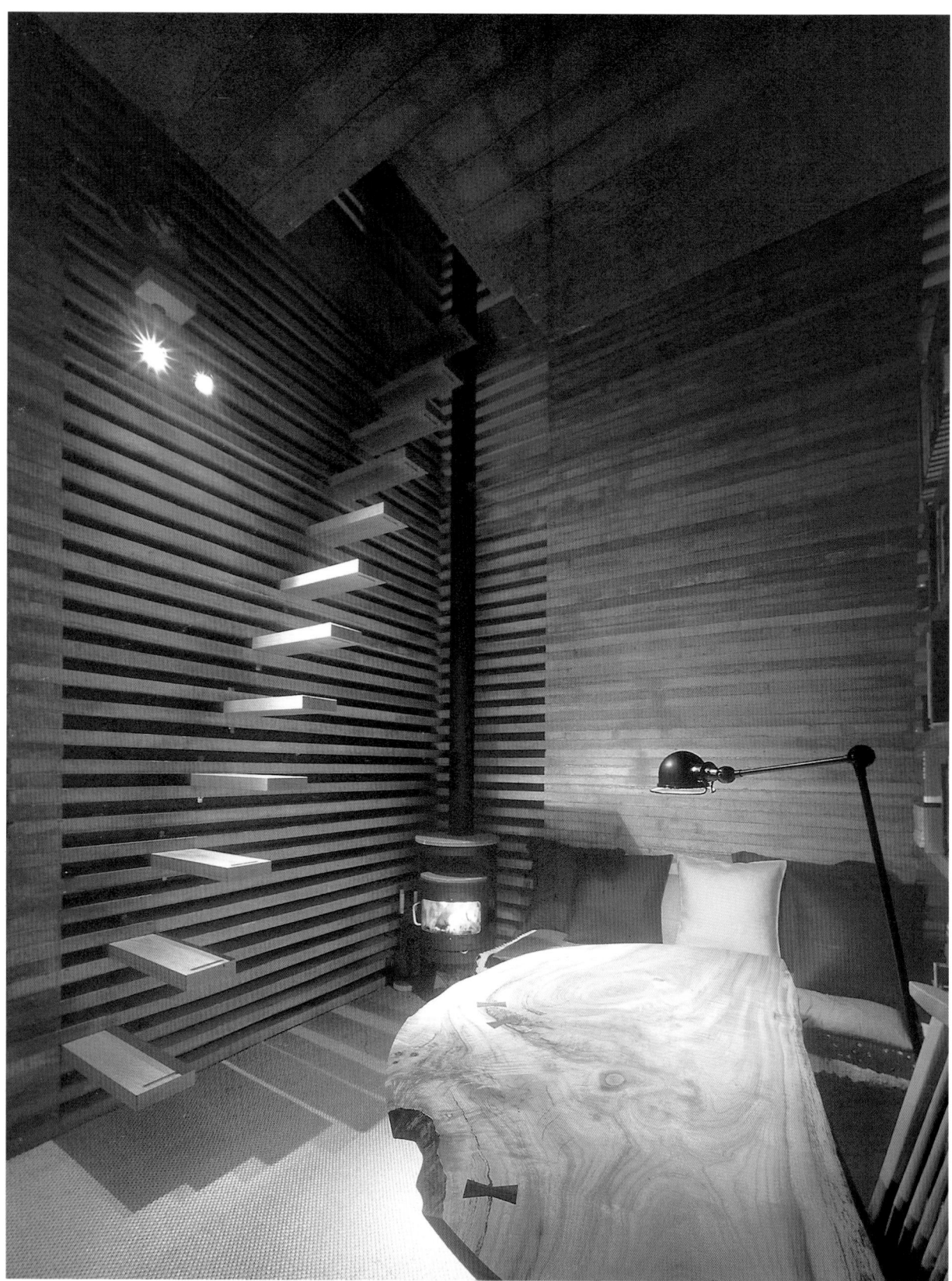

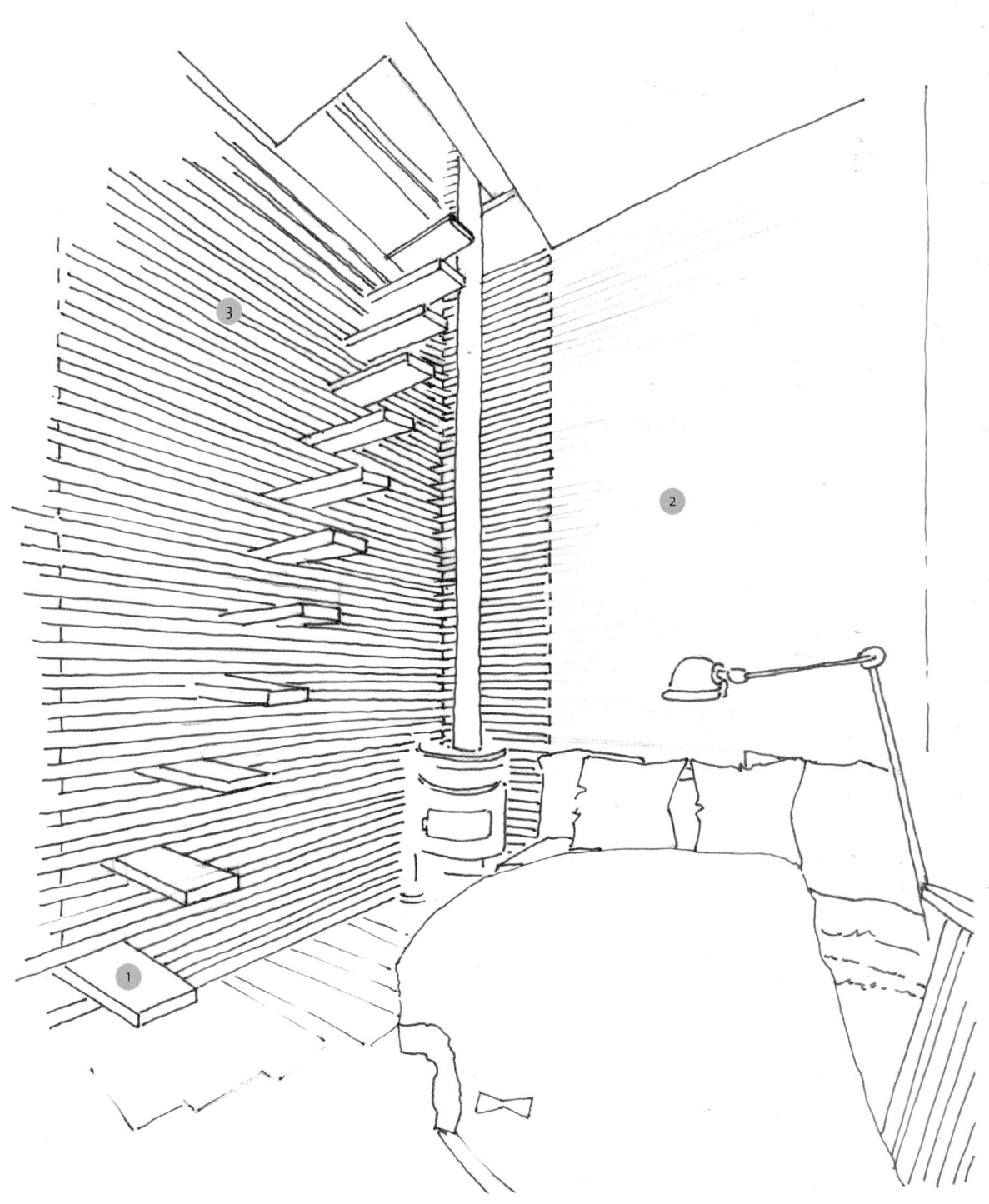

1_ The stairway, in addition to providing its functional utility as a stair, is an element with strong sculptural qualities.

2_ While the stack of concrete beams presents a rhythmic pattern of solid and void, other vertical surfaces are completely solid.

3_ Besides the aesthetic character that the slots in the concrete walls impart, they add a utilitarian aspect by being used to receive plug-in furnishings.

Apartment near the Coliseum

861 sq. ft.

The view over the Coliseum constitutes a central element of discussion between a young couple, owners of the small apartment, and the architect. The result is a compromise between the desire to reflect in the design the incomparable sight of the monumental surroundings and the need expressed by the clients to make best use of the limited space. The entry, flanked by panels of translucent fabric, opens up to the living room where a rich selection of colors allude to the gray Roman stone and the green Celio gardens. The kitchen, tucked into a corner, is open to the living room through a bank of storage cabinets. Down the hallway, in the master bedroom, the bed fits under a small raised platform where the study is and from where one can enjoy the view of the Coliseum through a small window.

Architect: Filippo Bombace

Location: Rome, Italy

Completion date: 2006

Photographer: © Luigi Filetici

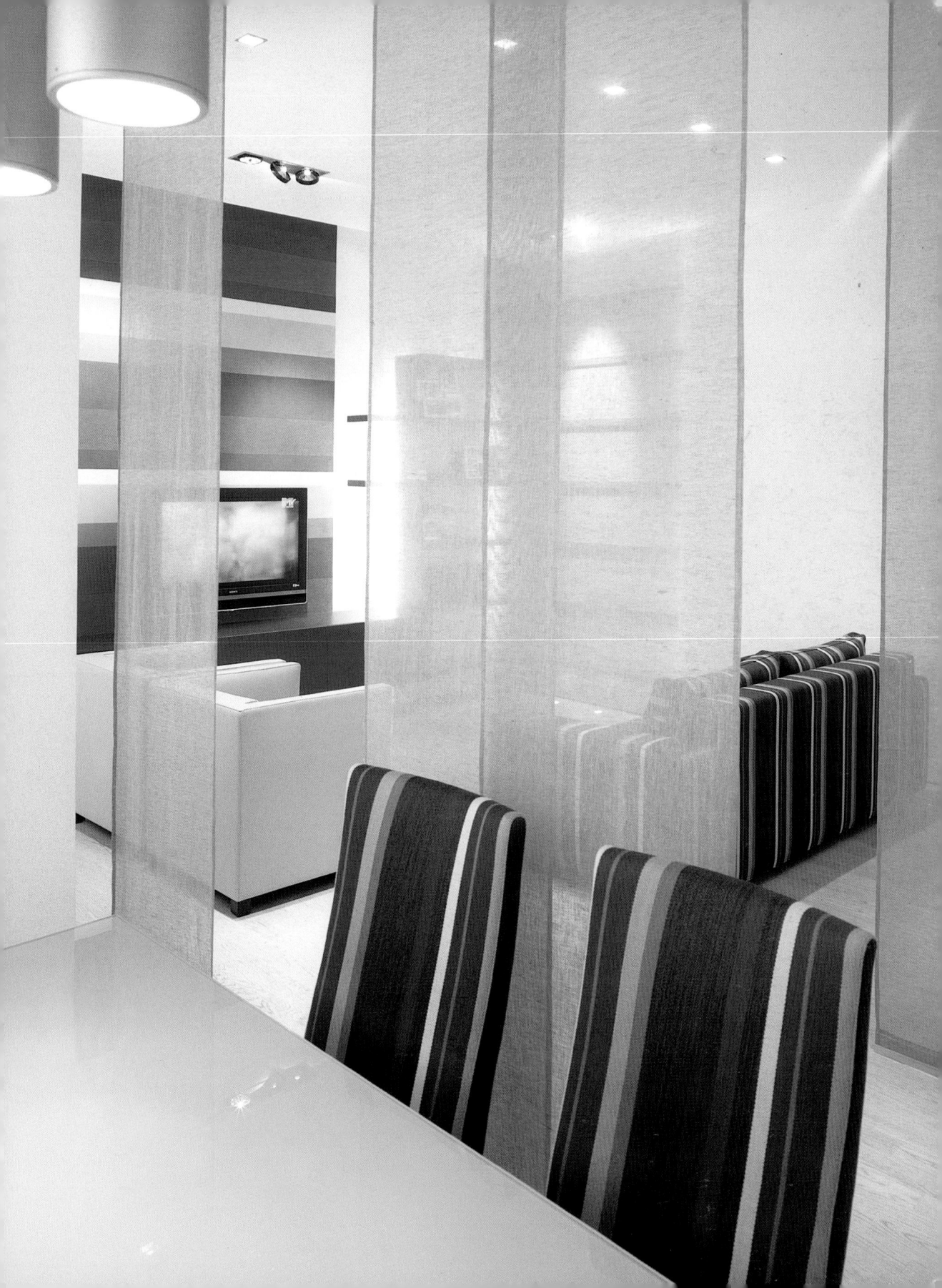

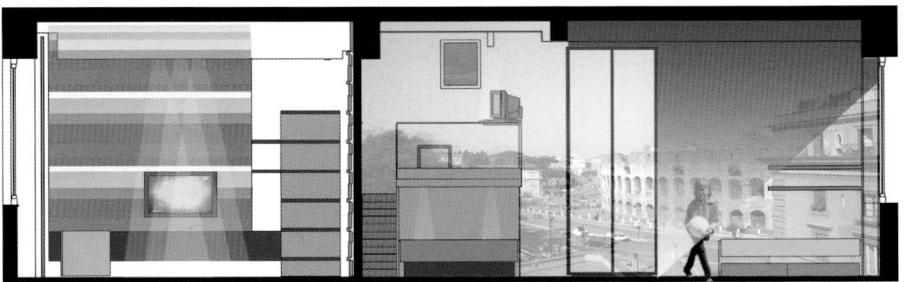

Section AA'

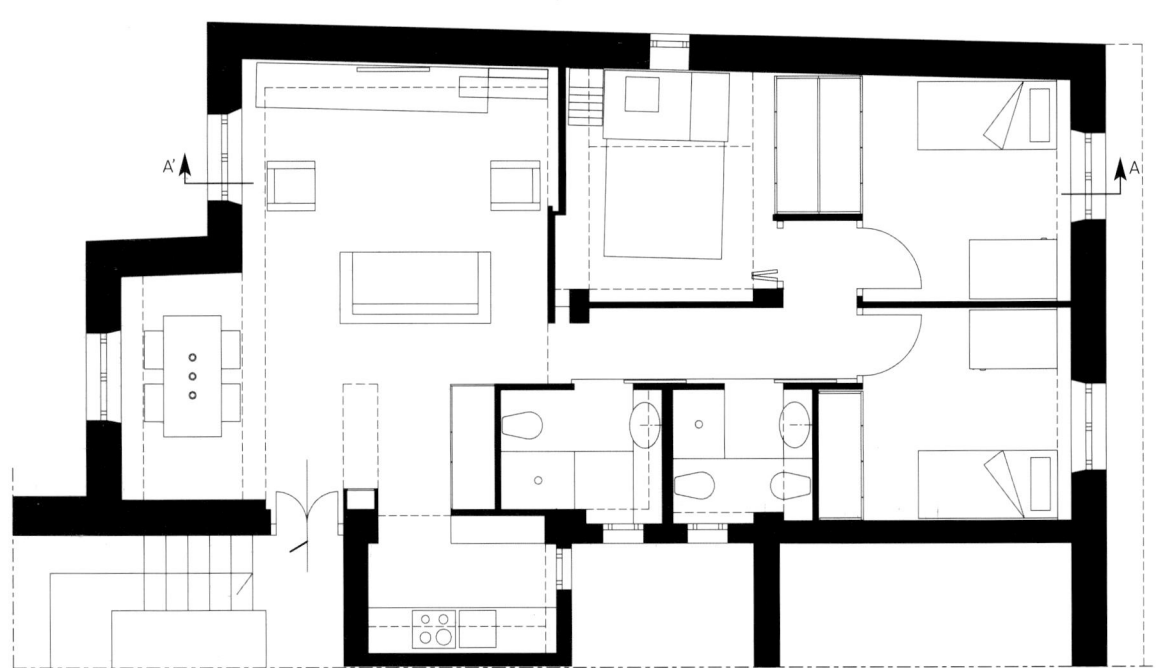

Floor Plan

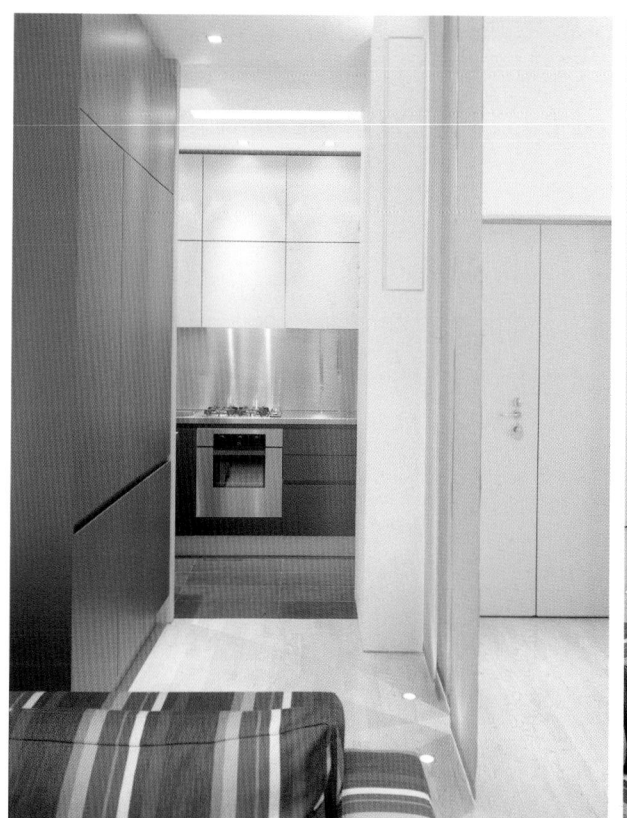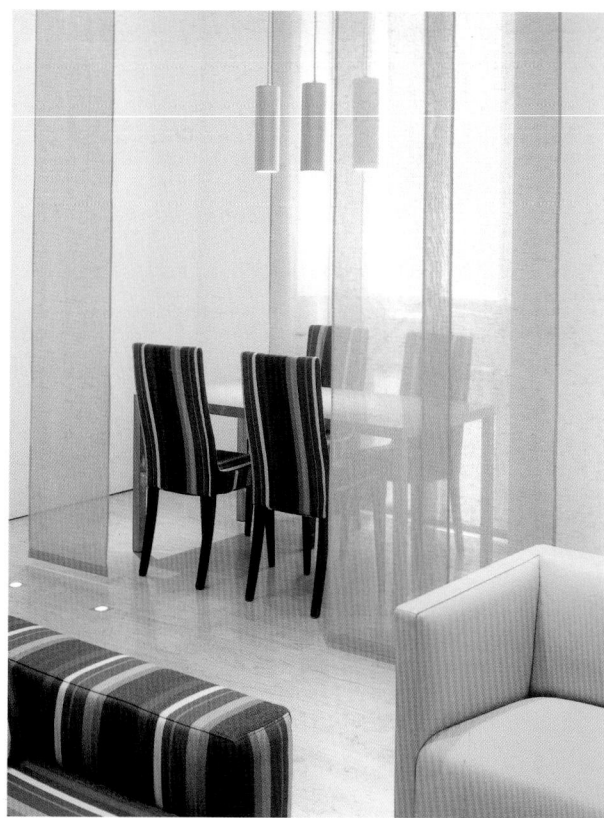

Sheer fabric panels hang from the ceiling to provide subtle differentiation between the entry area, the dining bay and the sitting area. Casework walls provide ample storage along a short passage to the kitchen, with its stainless appliances and counters. Colorful stripes are a theme repeated on the upholstery, dining chairs and walls, as is the spring-green of the arm chairs, dining table, and another wall.

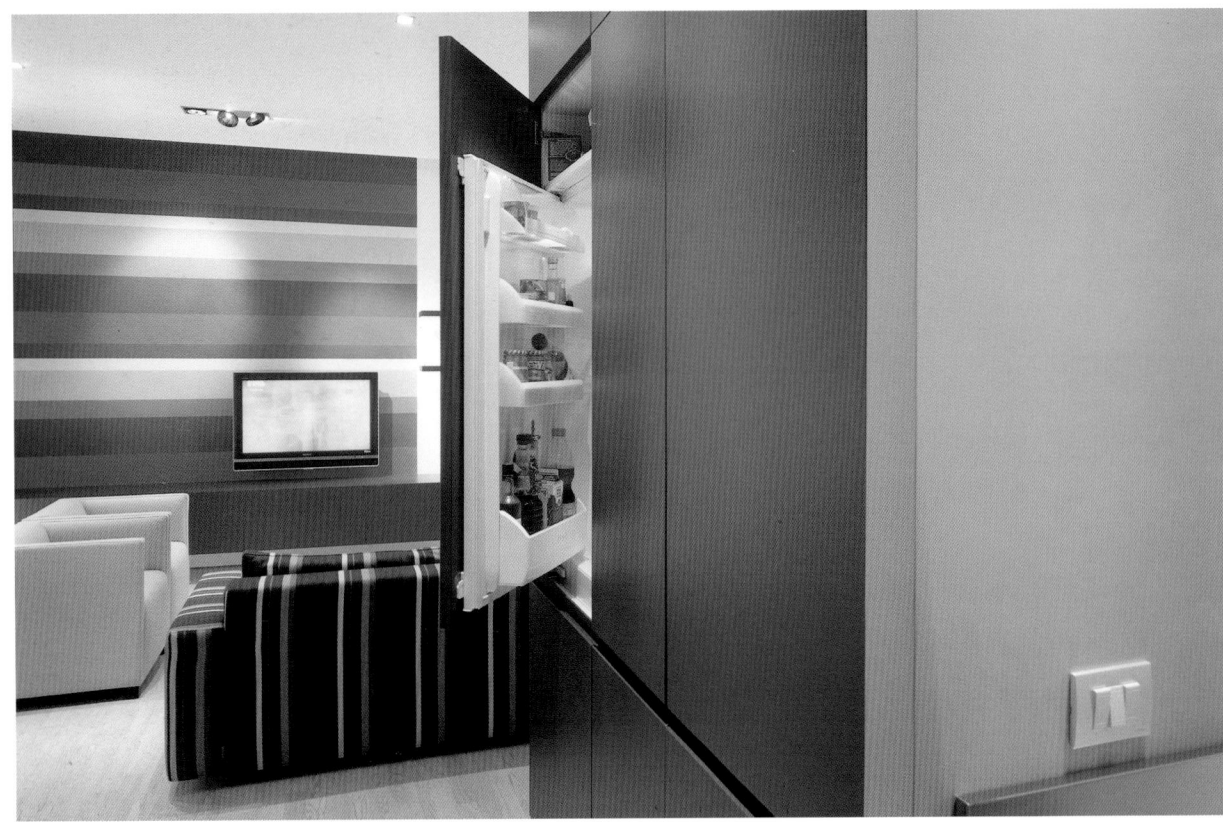

An existing small, high window captures the precious view of the Coliseum. In order to take advantage of the window, as well as to make the best use of limited space, a small loft has been installed over the head of the bed in the master bedroom. This space serves as an office area.

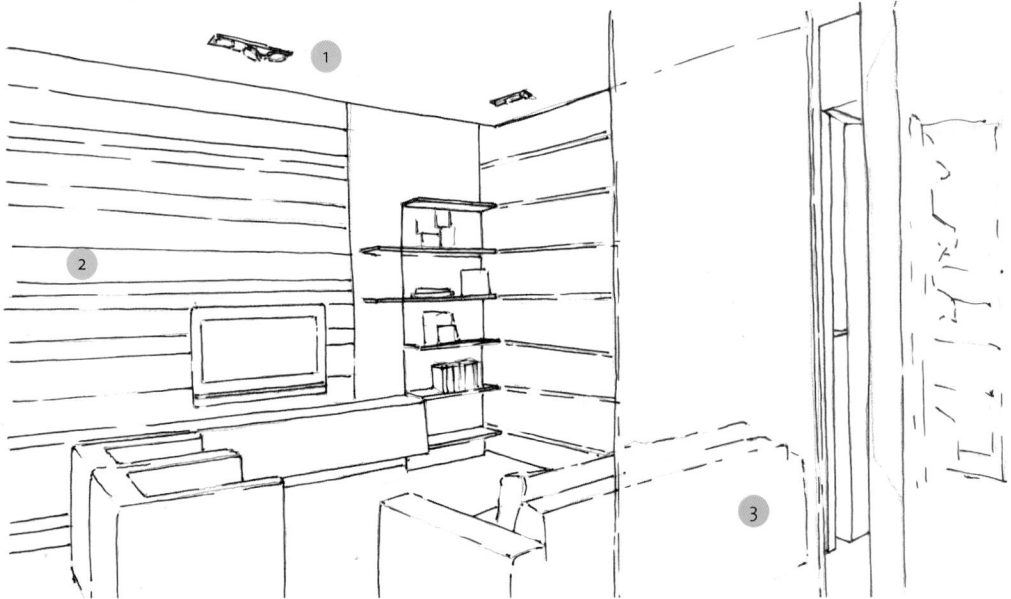

1_ Adjustable gimble-ring light fixtures mounted in slightly recessed troughs at the ceiling are pointed towards the striped wall and display shelving, providing indirect lighting.

2_ Repetition of elements and geometries ties the composition together. The horizontality of the shelving is repeated in the striped wall as well as in the low, cantilevered cabinet.

3_ Sheer fabric hanging panels provide just the right amount of separation and definition between spaces.

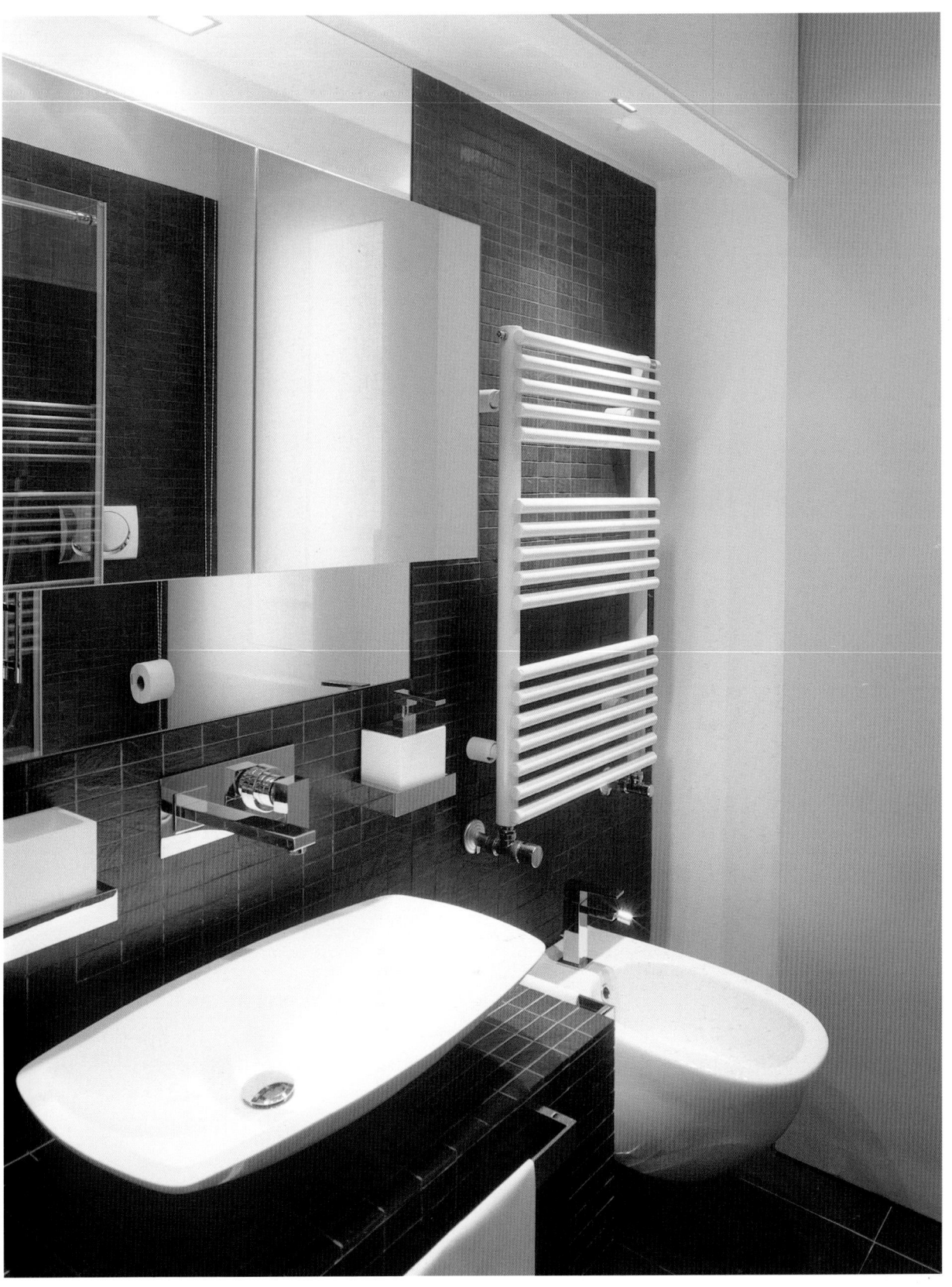

B House
875 sq. ft.

Architect: Atelier A5 Architecture and Planning

Location: Tokyo, Japan

Completion date: 2005

Photographer: © Sadahiro Shimizu/Atelier A5

The house is located in a densely populated residential area in Tokyo. The footprint of the house is small but the organization of the interior spaces is formed so as to accommodate two generations of a family.

With the exception of the concrete walls, the structure of the house is made of wood to simplify construction and reduce costs as well as to shorten the construction schedule. The project results in three floors. The two families occupy the lower and upper floors separately, while the middle floor, the living area, is used to enjoy common activities.

The project expresses the concept of a box within another box. The inner box encloses the more private areas. The other box wraps the entire building with a translucent metallic fabric, so as to visually separate the house from its neighbors. This outer shell is also composed of a metal grill floor which surrounds the living room on three sides and offers a possibility to expand the area.

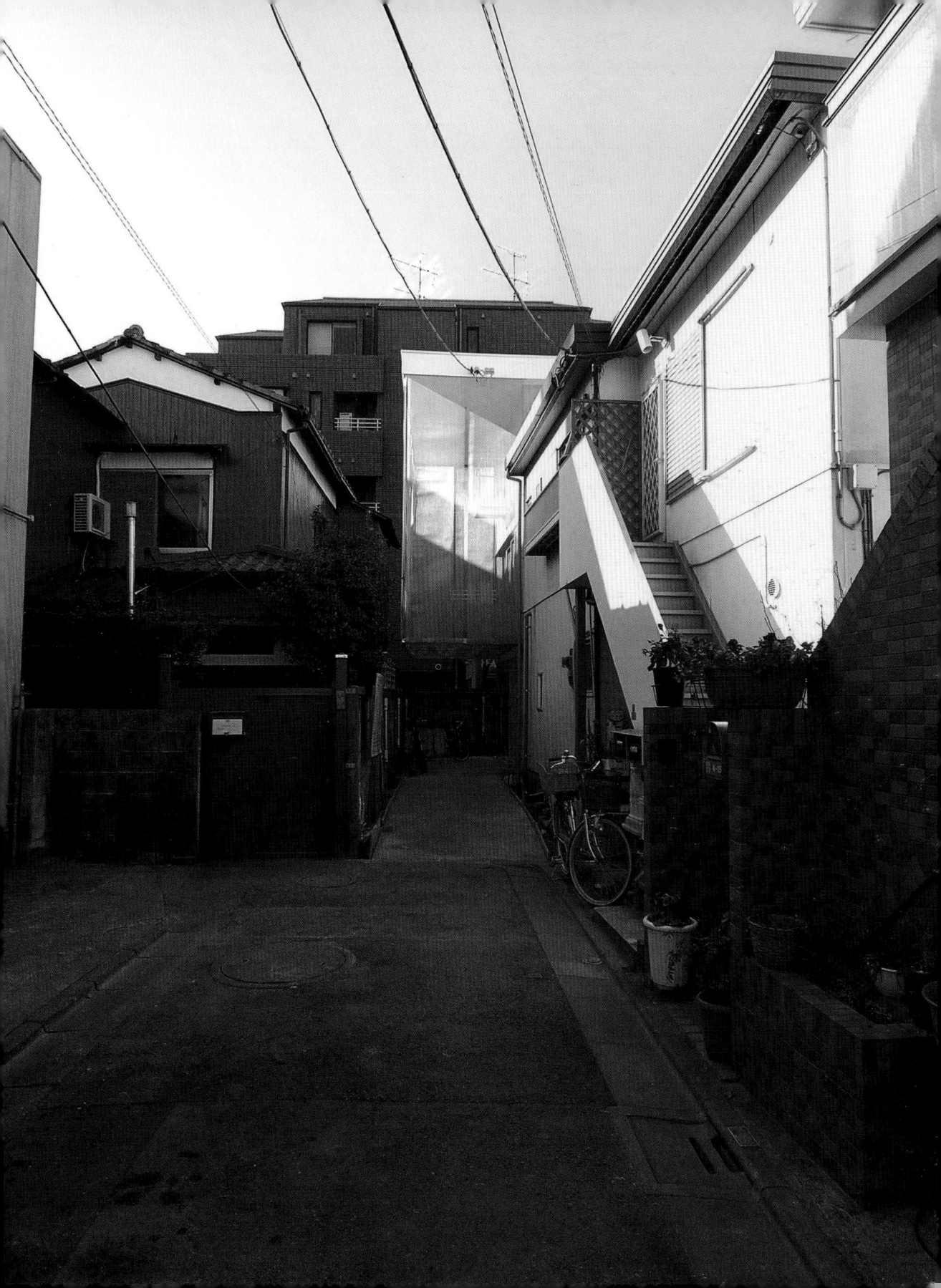

Location Map

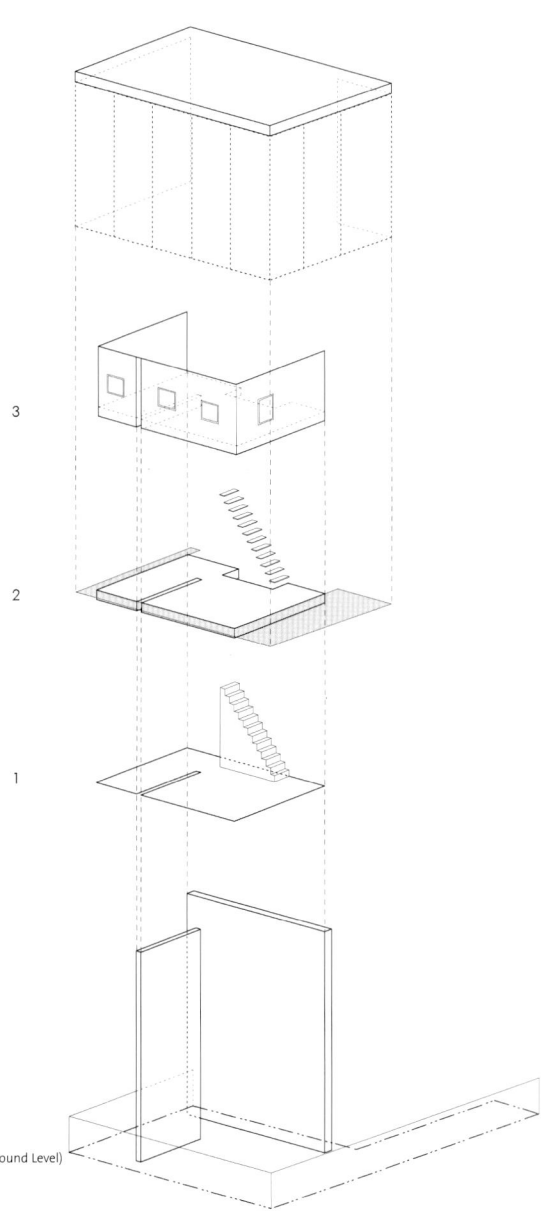

3

2

1

GL (Ground Level)

Exploded Axonometry

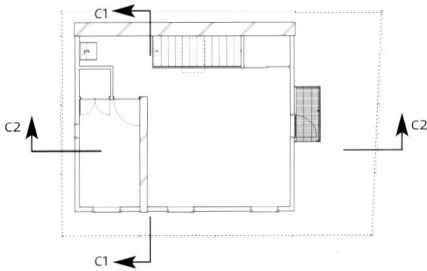

Third Floor Plan

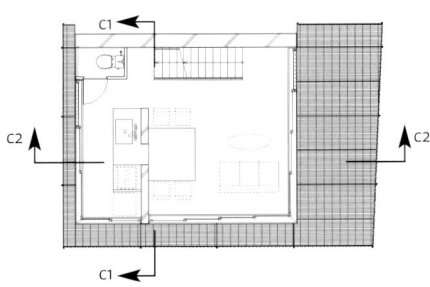

Second Floor Plan

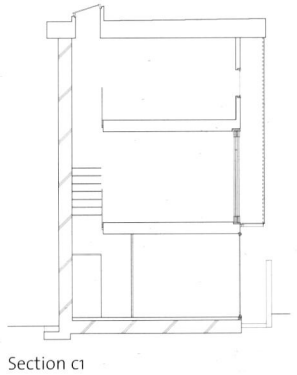

Section c1

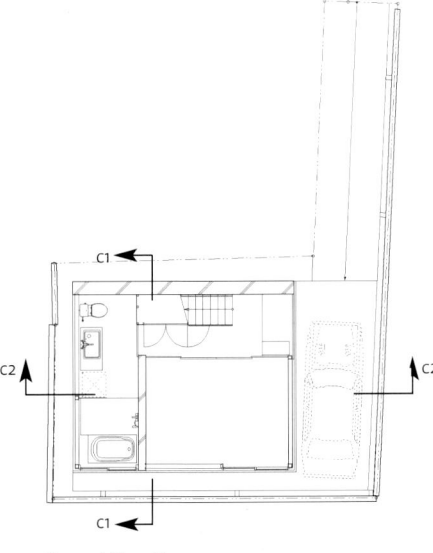

Ground Floor Plan

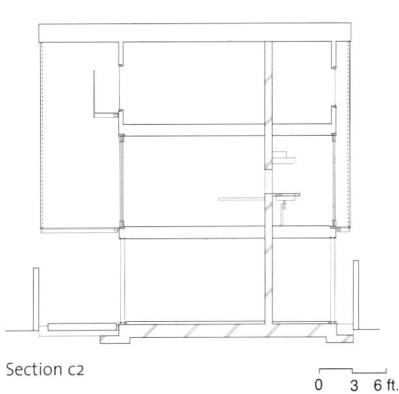

Section c2

0 3 6 ft.

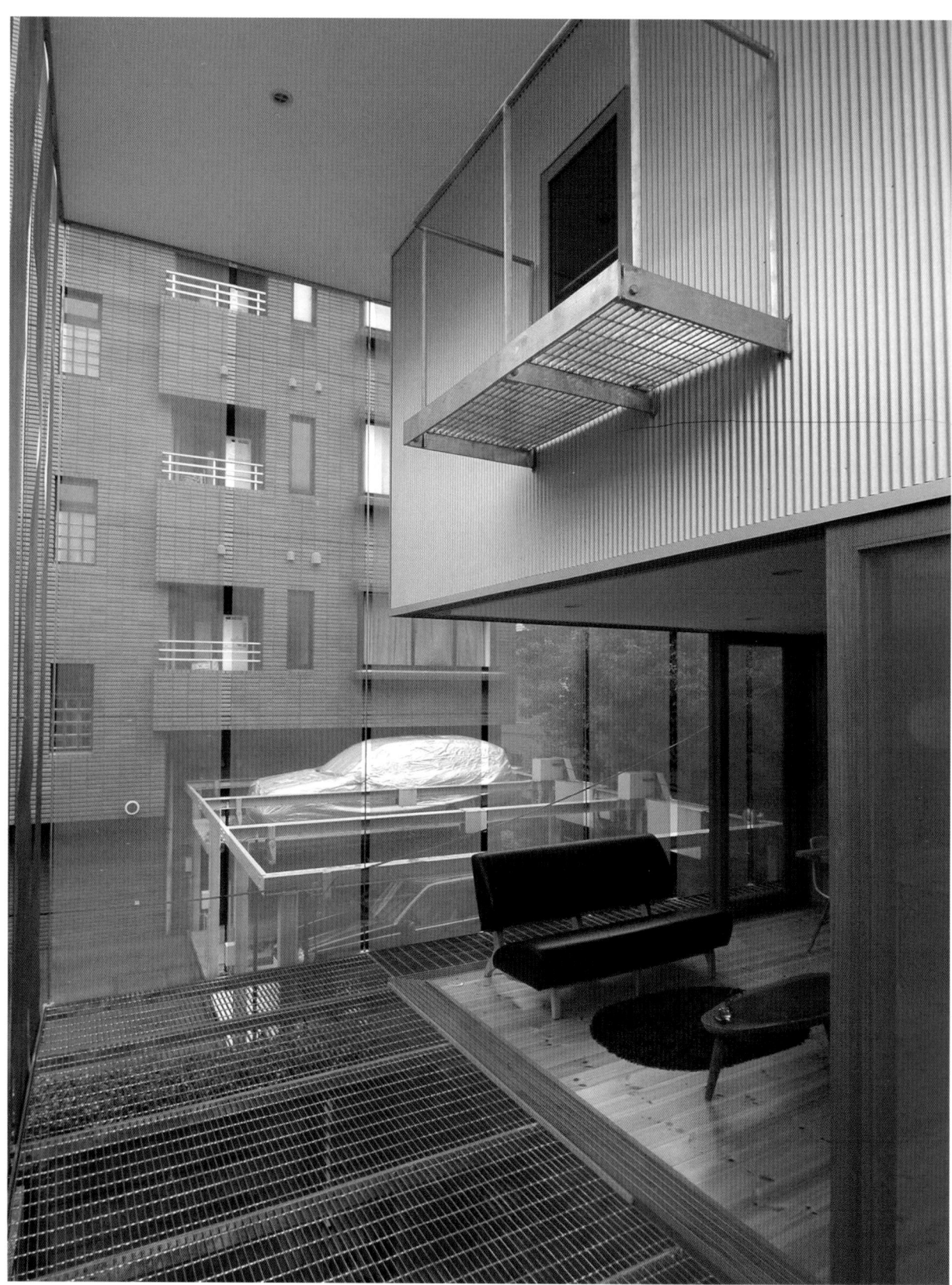

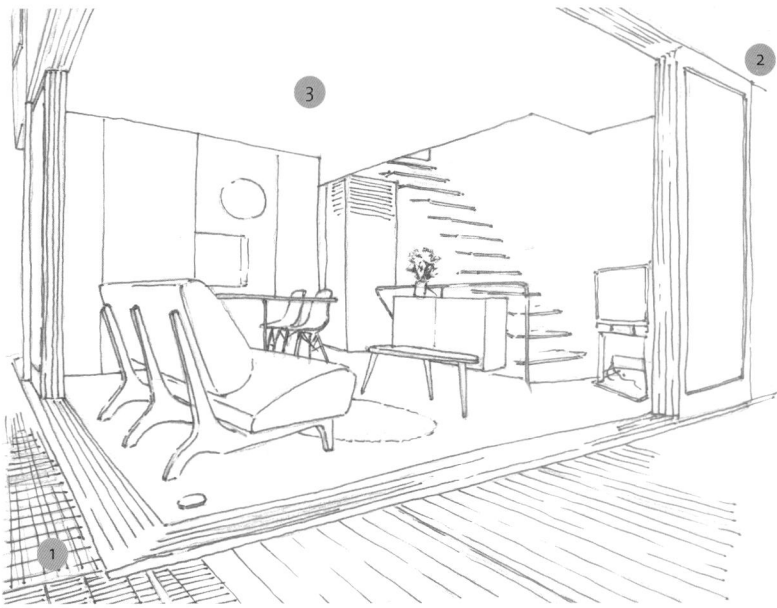

1_ The metal grill deck is accessible via the sliding doors, which allows the expansion of the area of the living room.

2_ The metallic fabric that wraps the building acts as a protective outer skin while allowing direct contact between interior and exterior.

3_ To satisfy the need for some privacy, the bedroom on the top floor is enclosed in a metal clad cube which cantilevers over the living room.

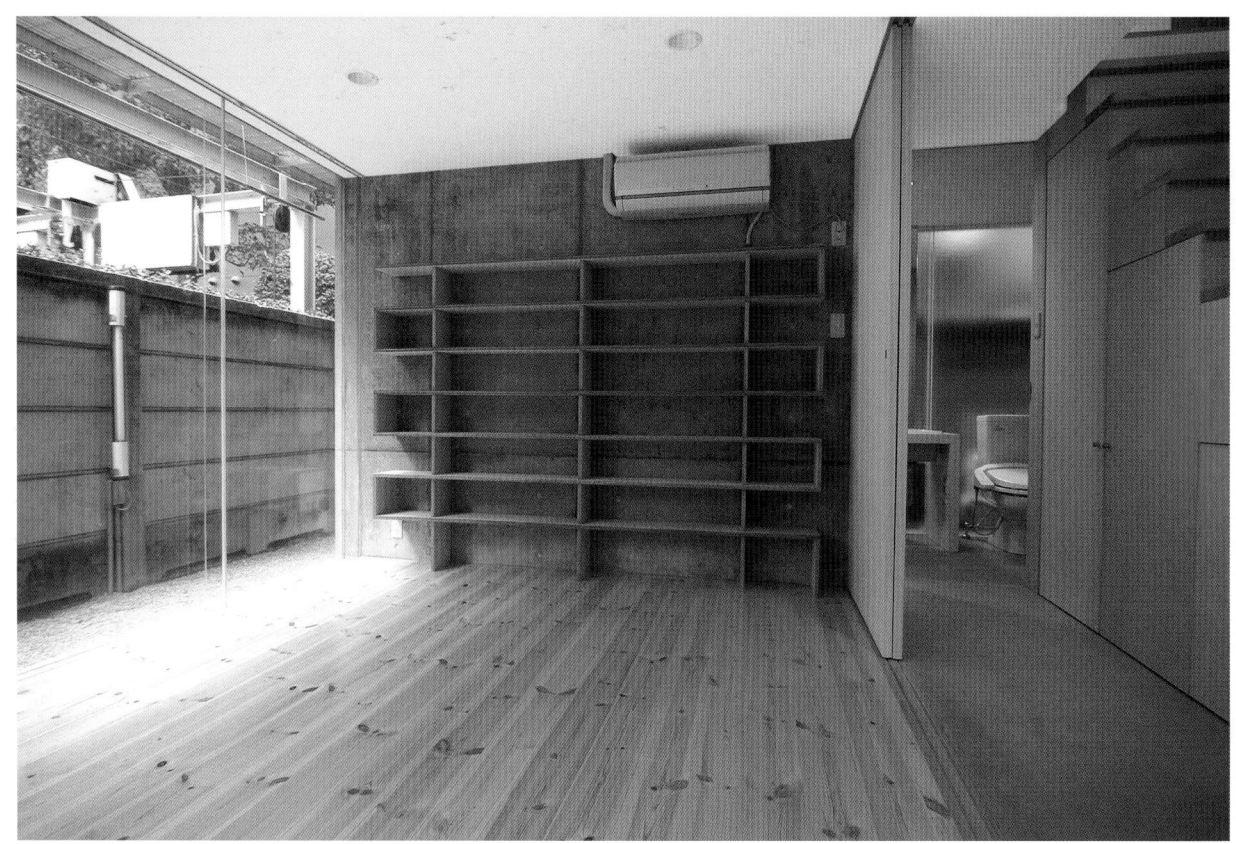

The two concrete walls play an essential role both as structural elements and as organizers of the spaces on all floors. Their presence is reinforced when they are directly in contact with large floor-to-ceiling panes of glass.

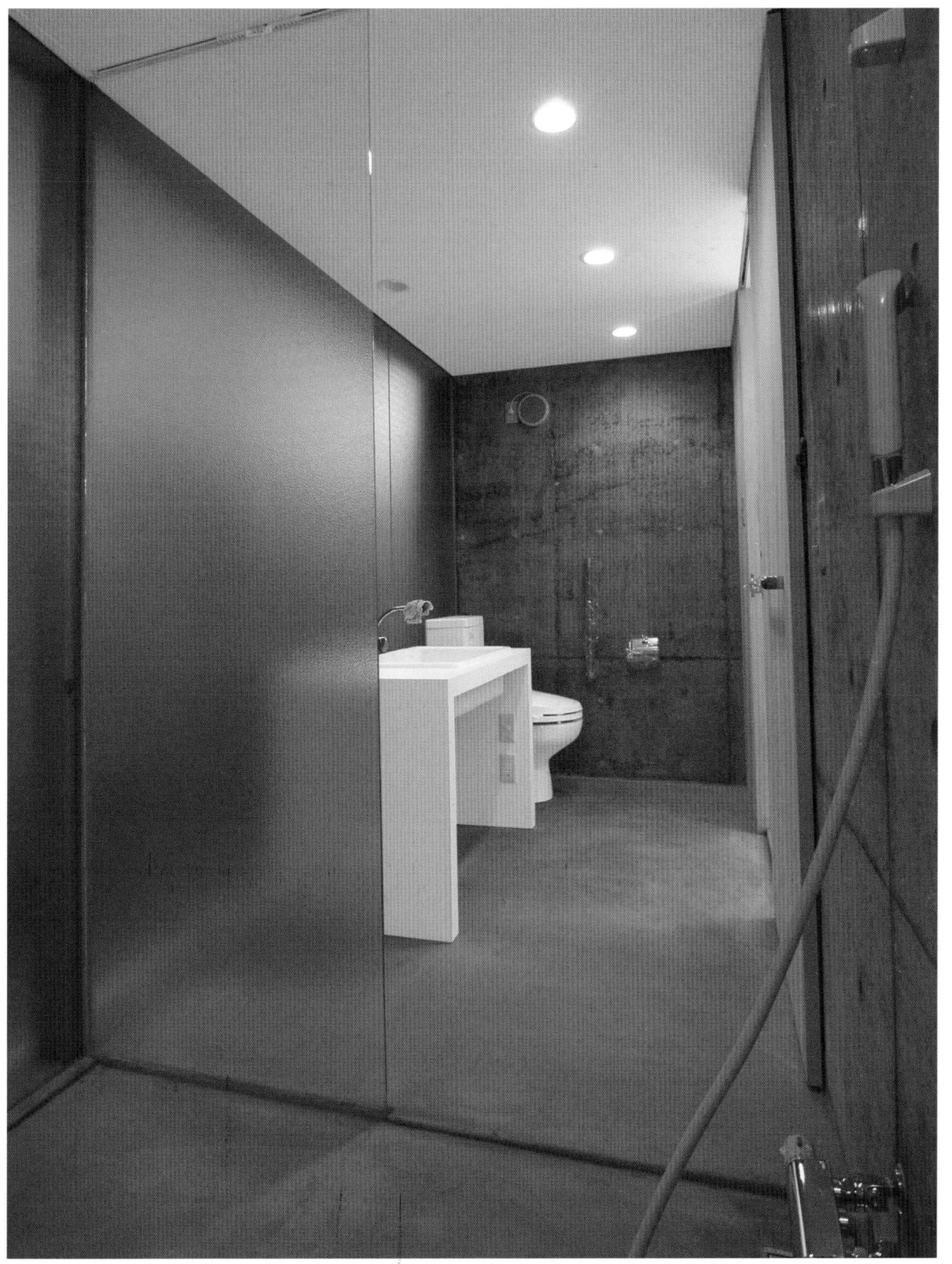

Richmond Place
888 sq. ft.

The house is located close to Dublin's city center, on a small but prominent infill corner site. This modest house consists of a living area, a kitchen, two bedrooms, two bathrooms and a utility room distributed over two stories. The house remains in character with the nearby houses and forms a book-end building at the intersection of two streets. The intention was to maximize the footprint of the building and extend the living area into the courtyard. The house exploits its section to create a series of interconnected but separate spaces of varying heights and dimensions.

On the outside, the house is faced entirely in brick, referencing the neighboring context. On the inside, a simple palette of materials is deployed.

Architect: Boyd Cody Architects

Location: Dublin, Ireland

Completion date: 2005

Photographer: © Paul Tierney, Boyd Cody Architects

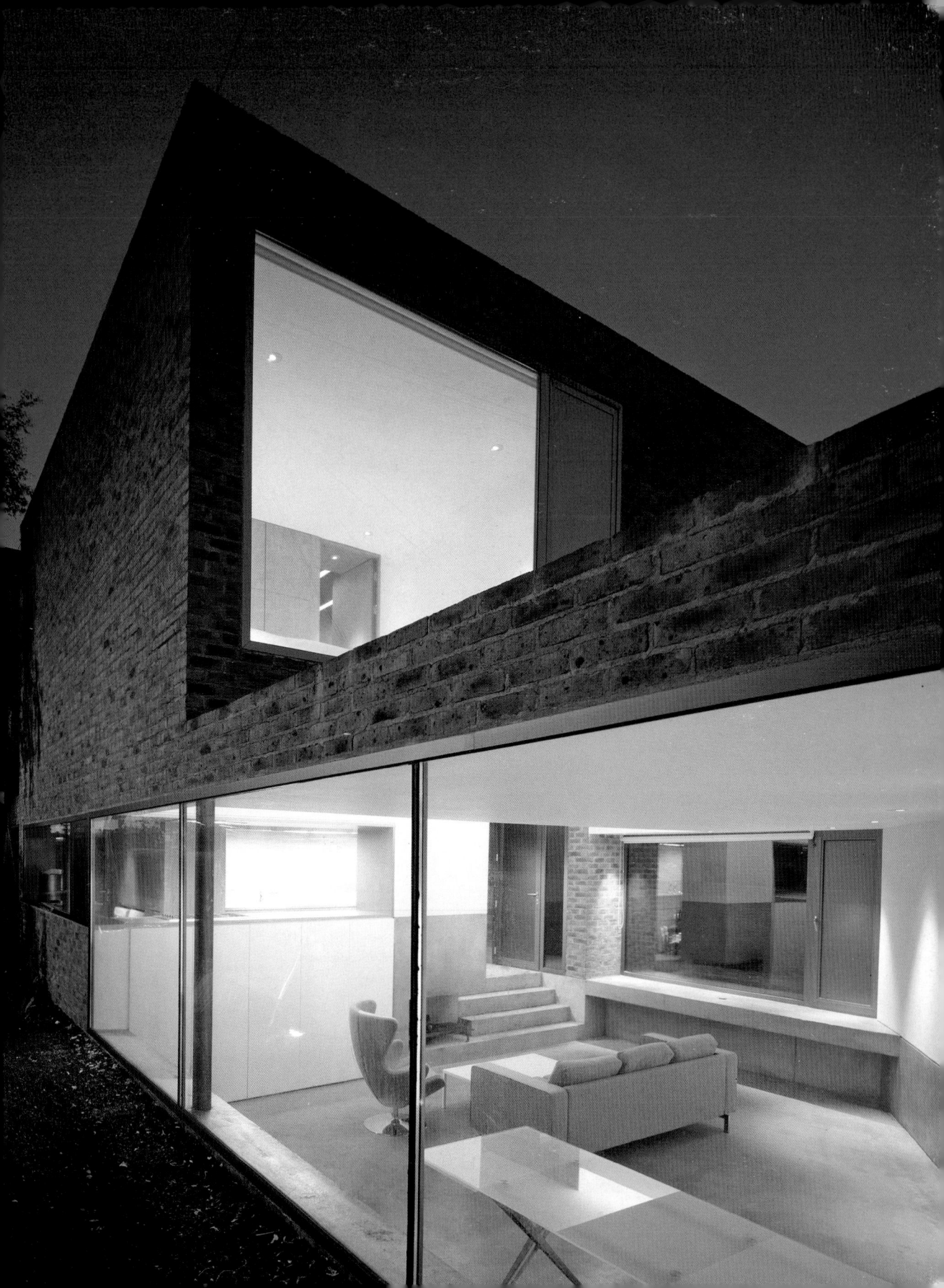

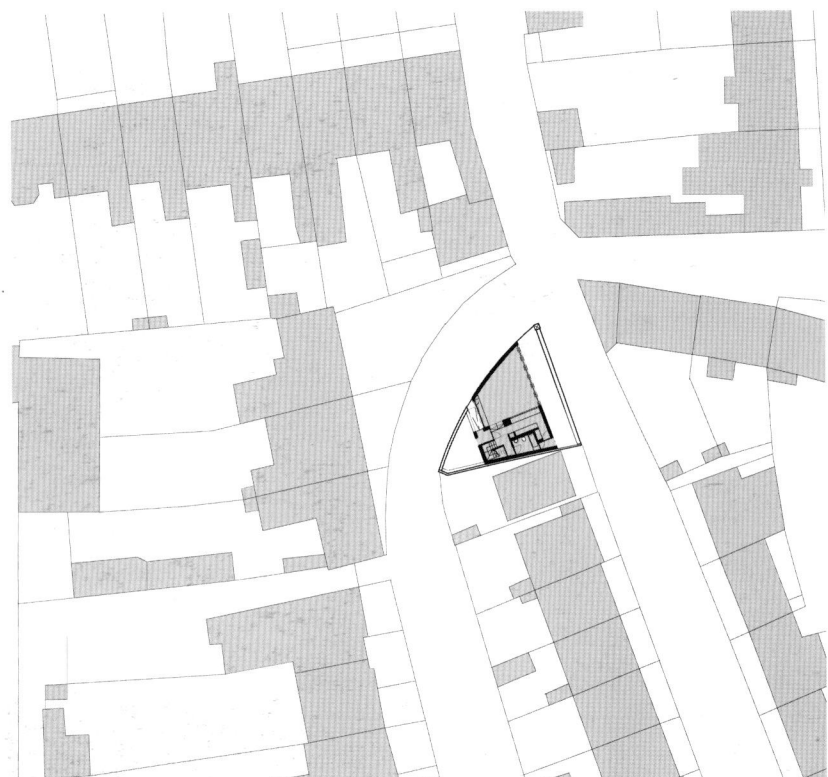

Site Plan

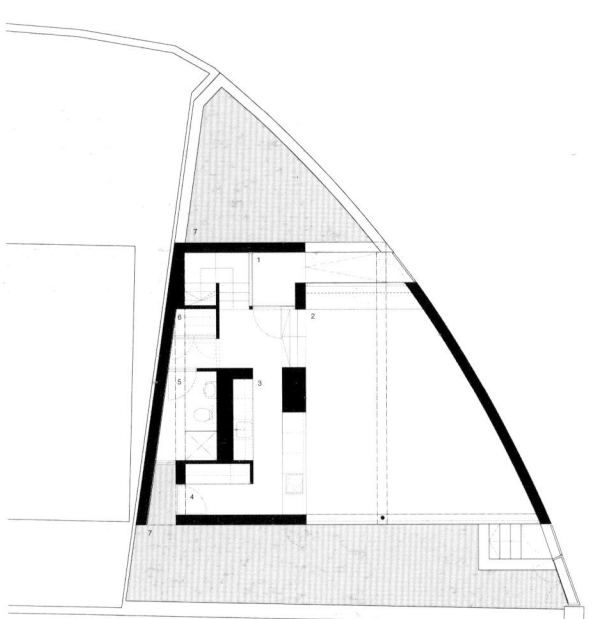

Ground Floor Plan

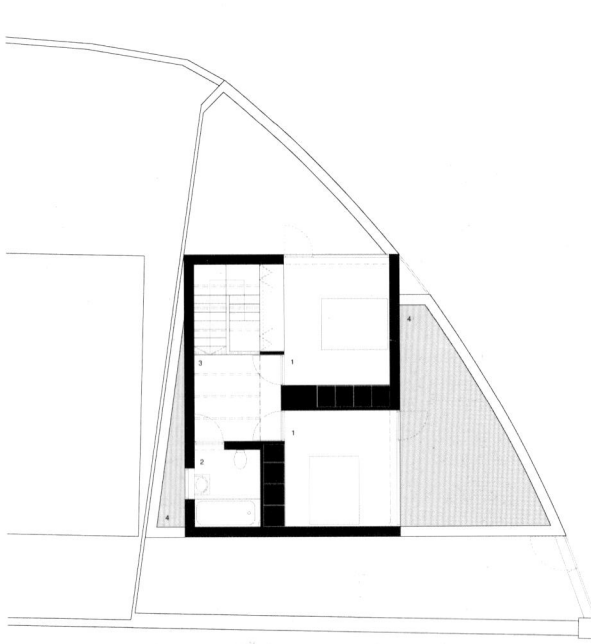

Second Floor Plan

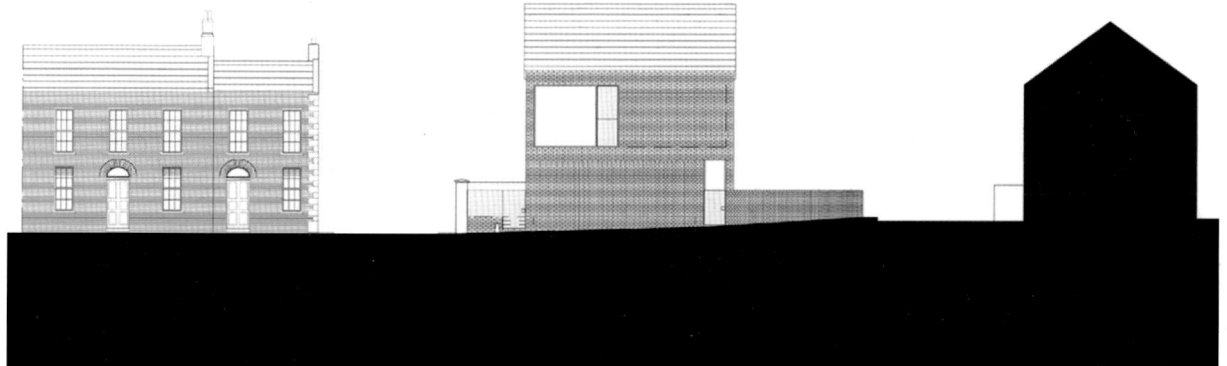

North Elevation

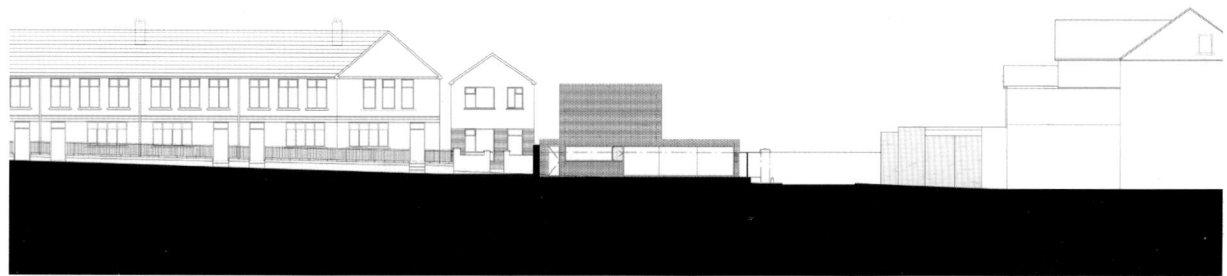

East Elevation

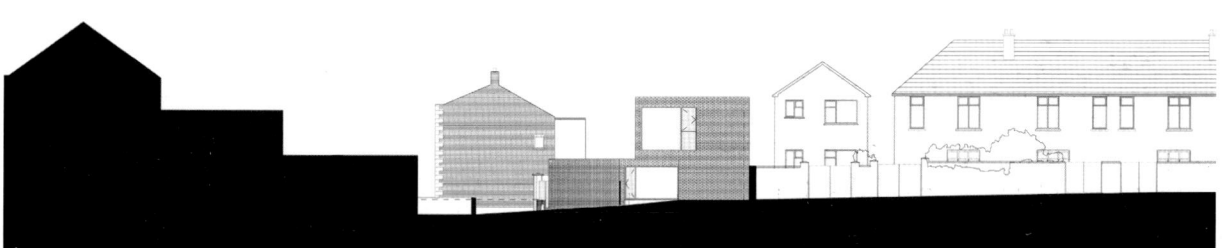

West Elevation

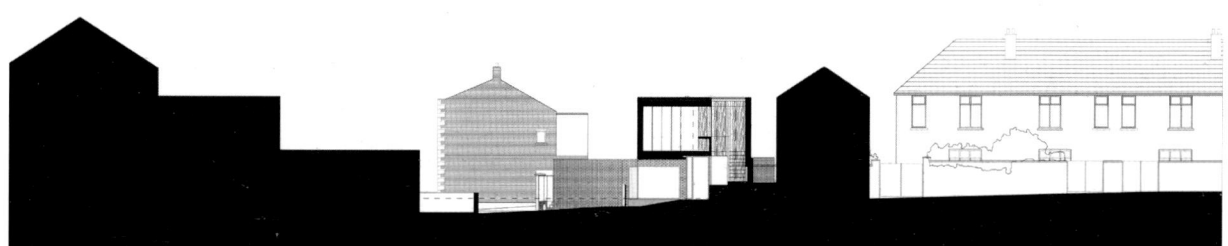

Section

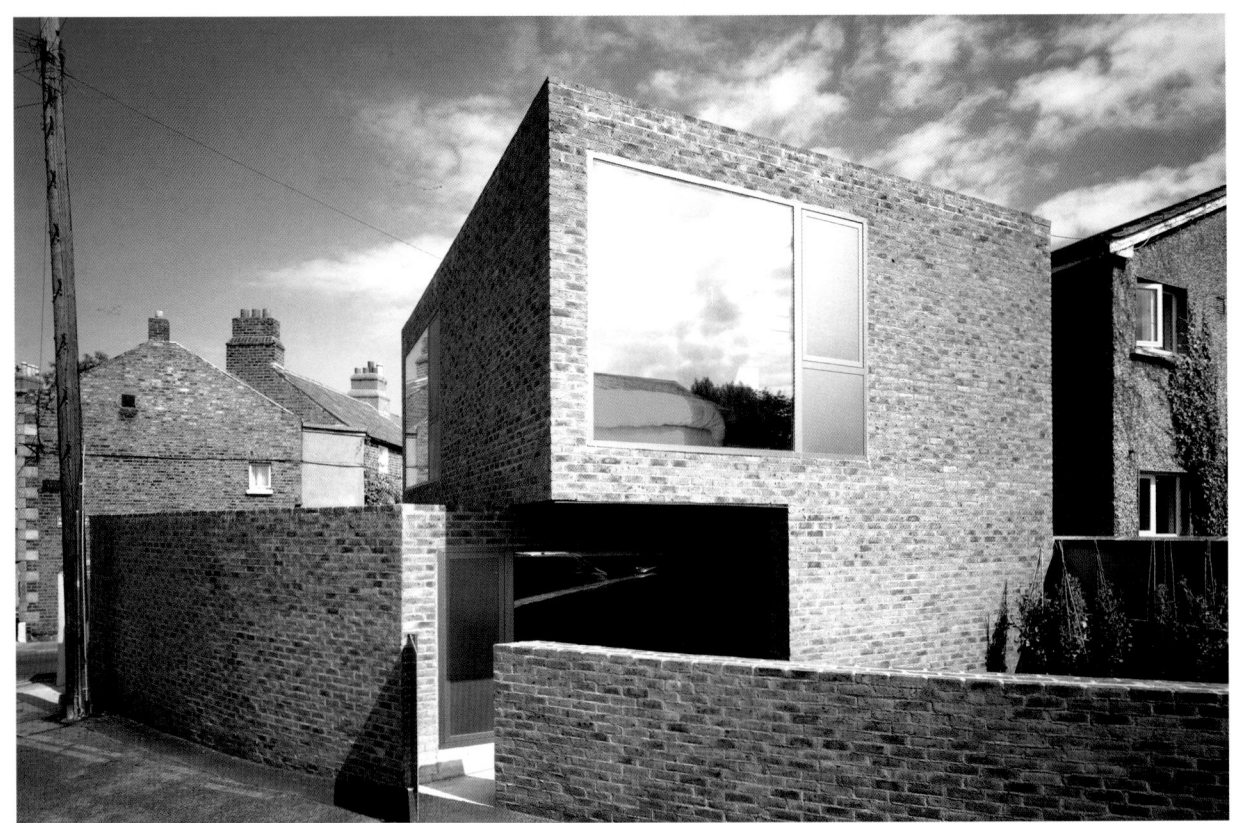

The geometry of the site is the principal generator of the building form. It is triangular in shape, with a pronounced curve along one side. The building adopts the site boundary line along its north and south sides and aligns with the adjacent terrace to the east and west. In order to maintain the low-lying nature of the block, the living area floor is sunk below the grade line.

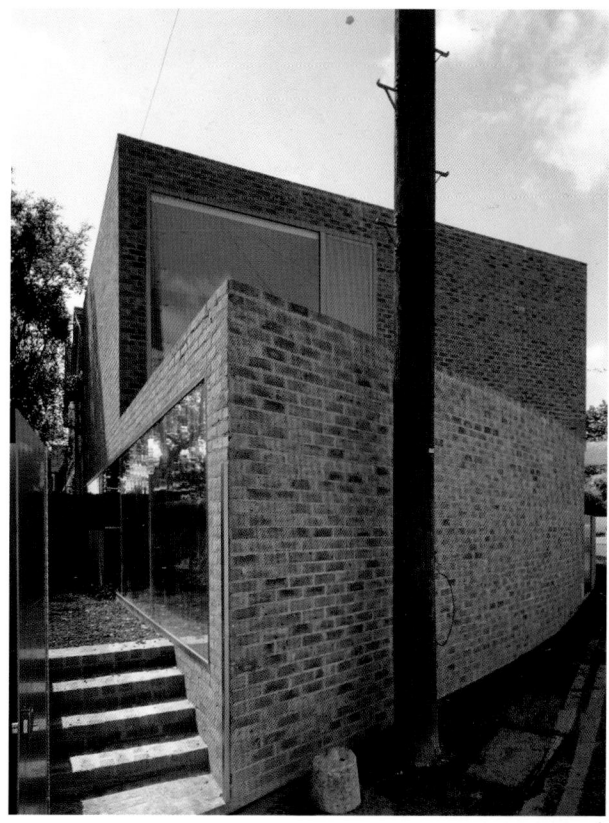

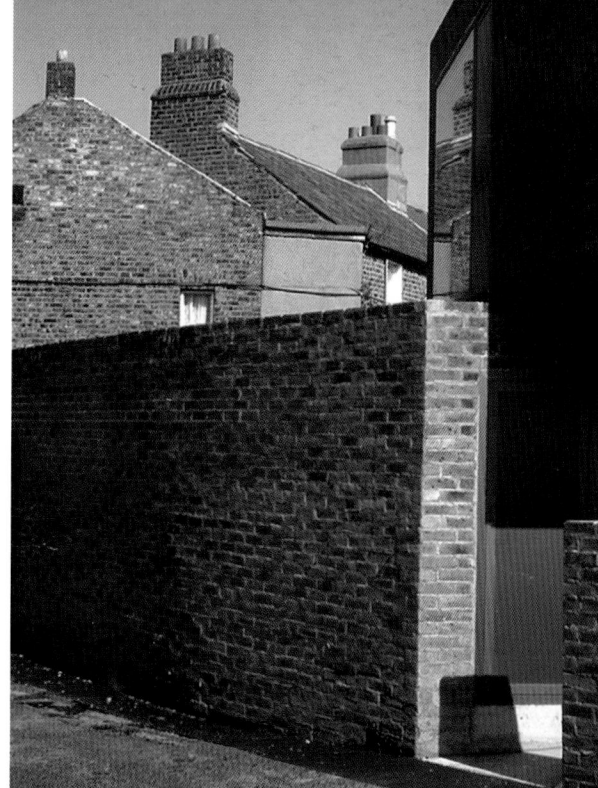

The new house makes a strong contextual response to both the unusual site configuration and the prevailing architectural context. Two entry spaces are carved in the building: one at the front and a smaller one at the rear.

Satin anodized aluminum windows are brought flush to the surface of the outer skin to accentuate the substantiality of the form and emphasize the two entry points.

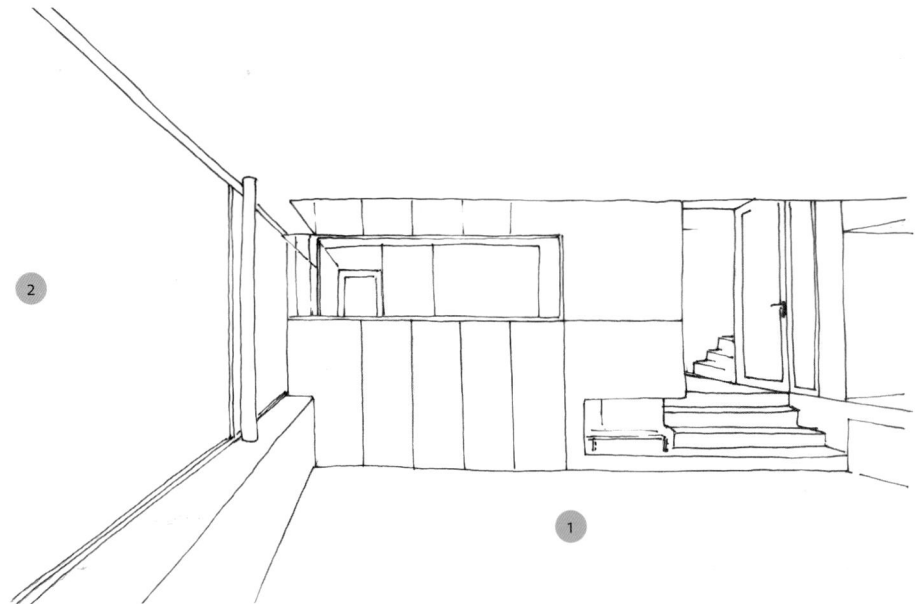

1_ The palette of colors and materials is kept minimal: white oak for the stairs and service areas, and in the living areas is a combination of concrete, plaster and rubber, giving uniform reading to the interior.

2_ Picture windows, with their sills at the level of the exterior grade, provide an uninterrupted connection to the gardens and brighten up the interior. The plane of the exterior grade is projected inside at the window sill to form a deep concrete platform.

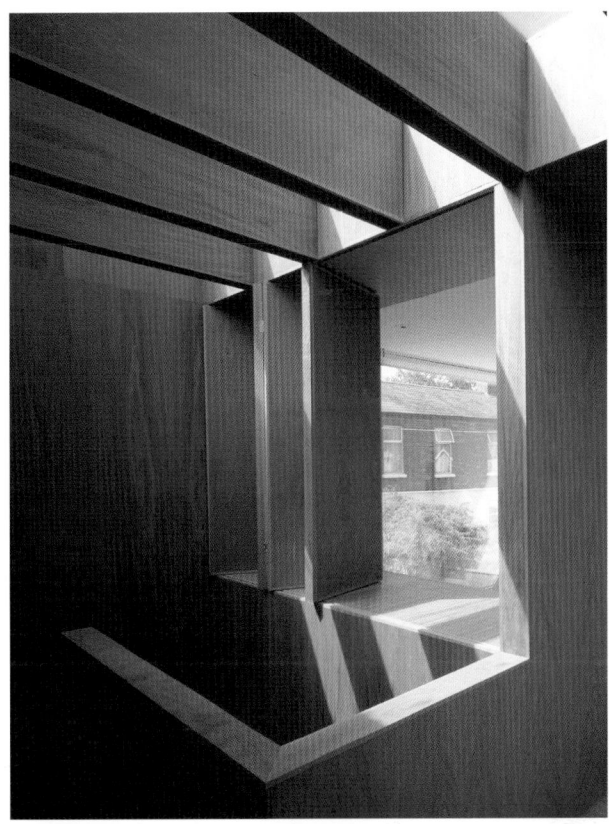

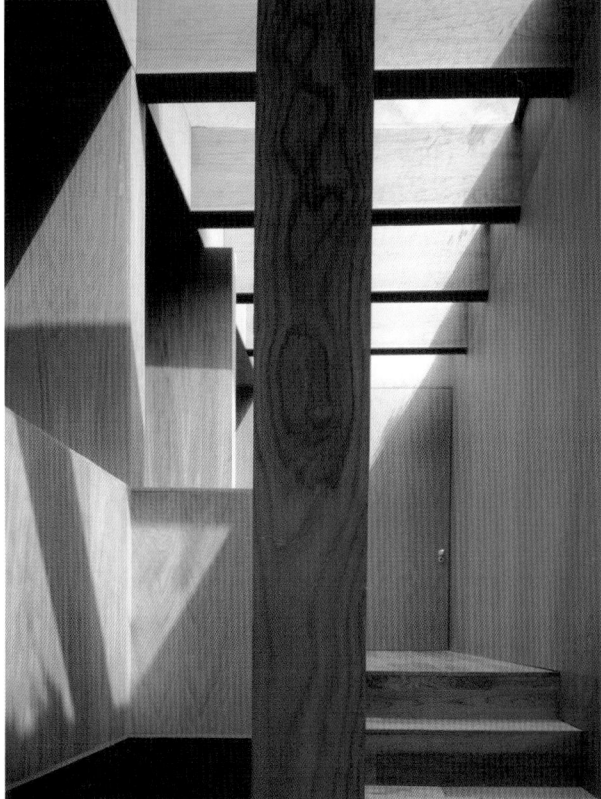

The skylight above the stairwell floods light through the core of the house, creating sharp shadows that are cast by the strong, cubic forms of beams, walls and stairs. Their sculptural qualities are emphasized by the consistent cladding in white oak. Bedrooms open onto the stair hall to take advantage of the light.

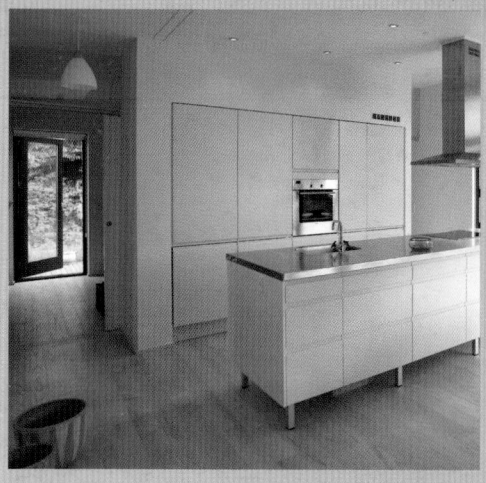

ONV House

893 sq. ft.

Architect: ONV Arkitekter

Location: Gilleleje, Denmark

Completion date: 2003

Photographer: © ONV Arkitekter

This house responds to the goal of creating a modern home using only indigenous materials and processes. This brought the designers to focus on quality materials such as Siberian larch, ash wood flooring and natural stone. The wood house, reminiscent of the traditional construction type found in northern countries, is built from modules that can be combined to form six different configurations. If a need for additional space arises, the house can be expanded with similar modules. The interior is dominated by spacious rooms and most configurations feature a built-out kitchen and a dining and a living room combined in one open space with access to a covered deck.

The result is an attractive wood house which is suitable for vacation as well as year-round use.

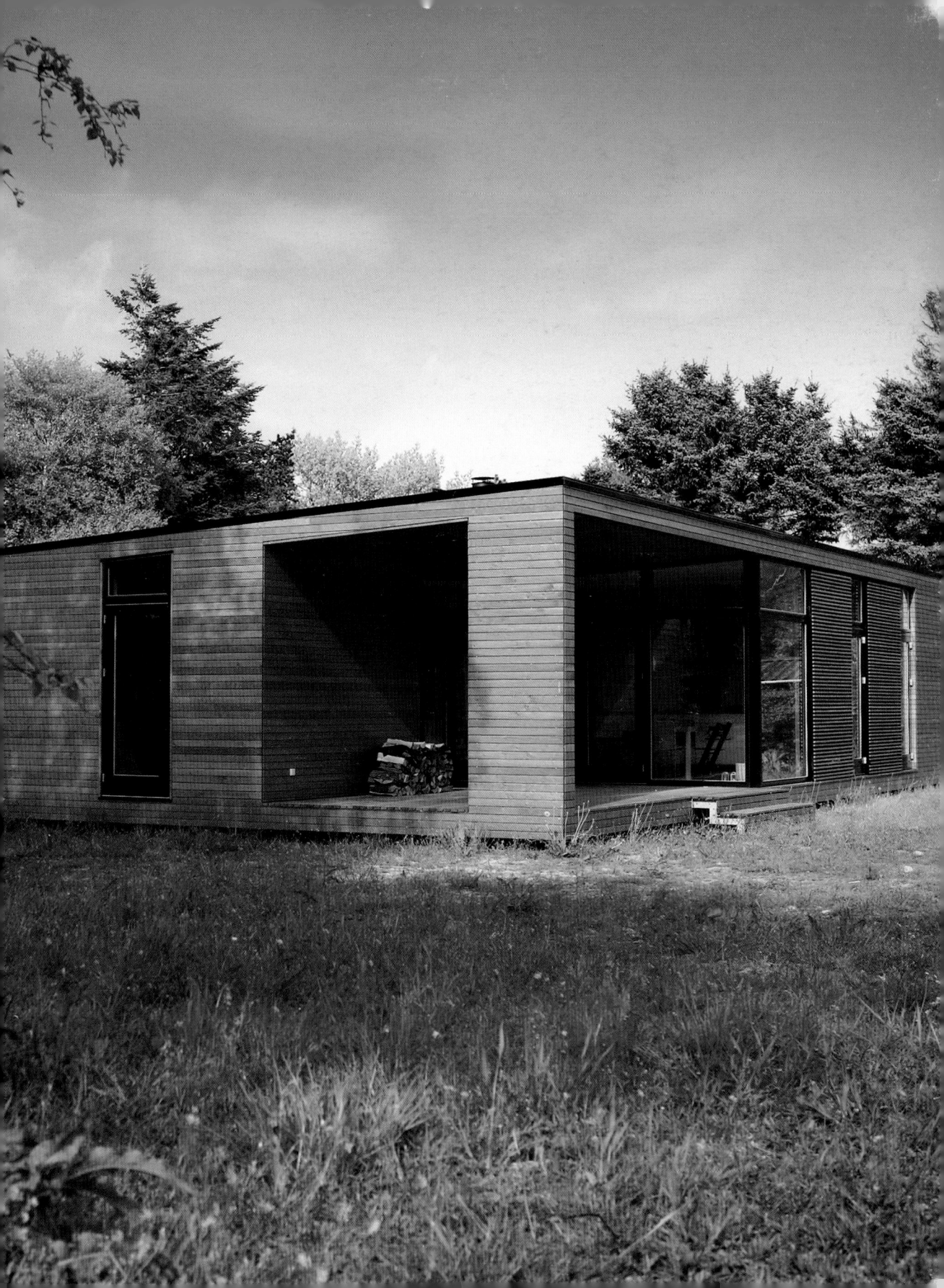

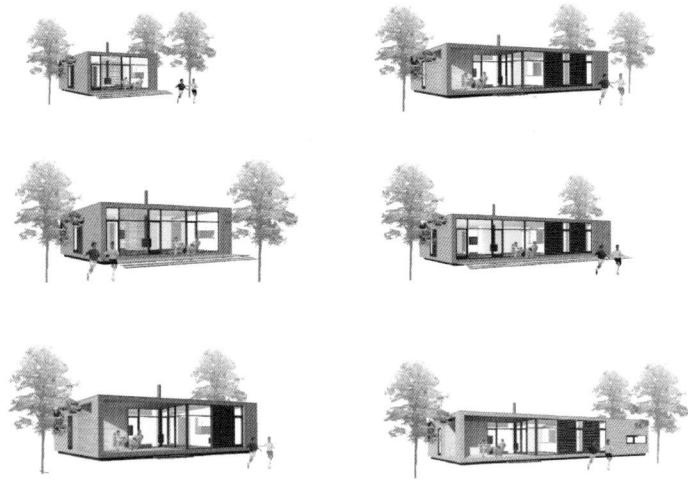

Available Configurations

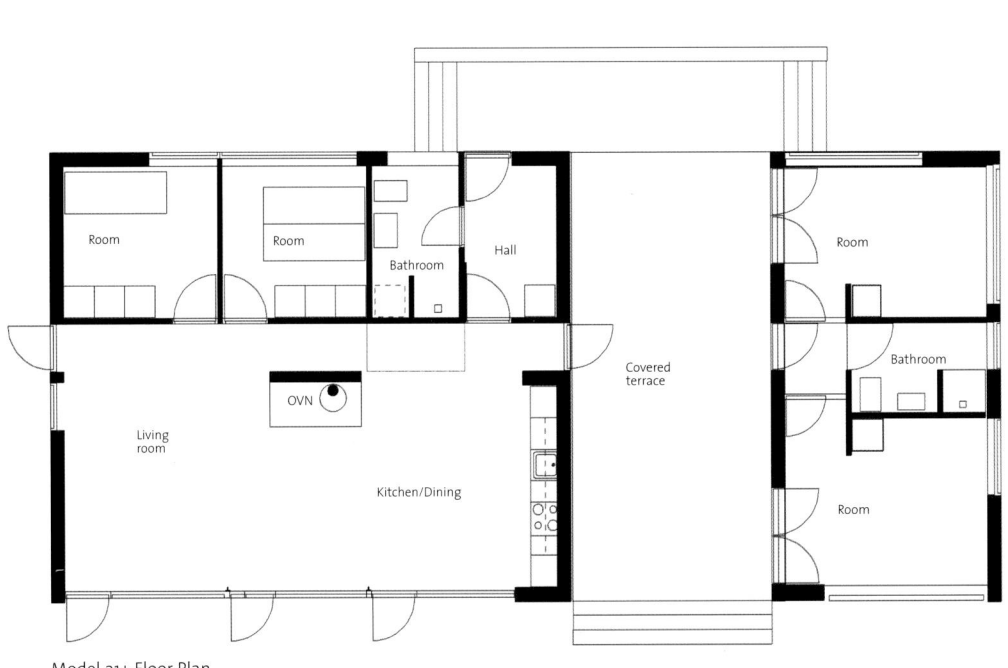

Model a1+ Floor Plan

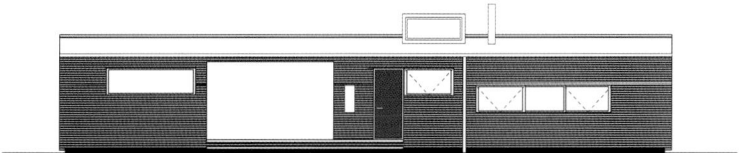

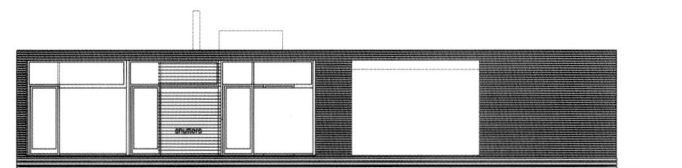

Typical Front and Back Elevations

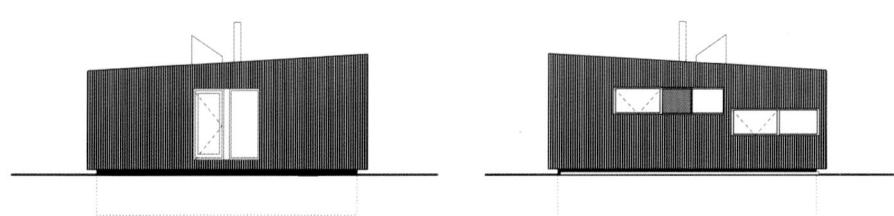

Typical Side Elevations

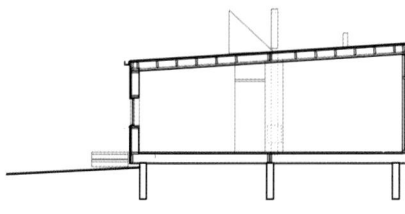

Section

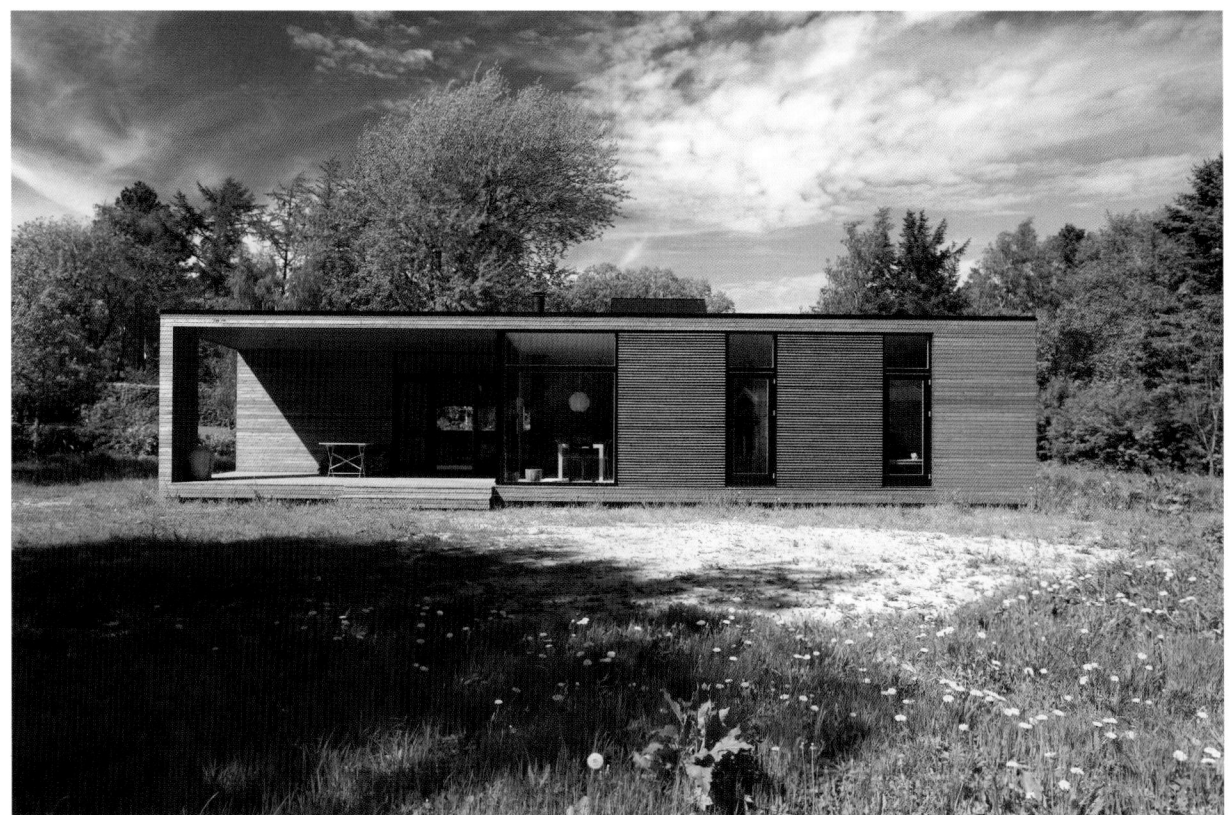

The exterior walls can be designed to have louvers mounted on them to filter the light into the interior or to offer more protection for the deck, thus prolonging the season for outdoor living.

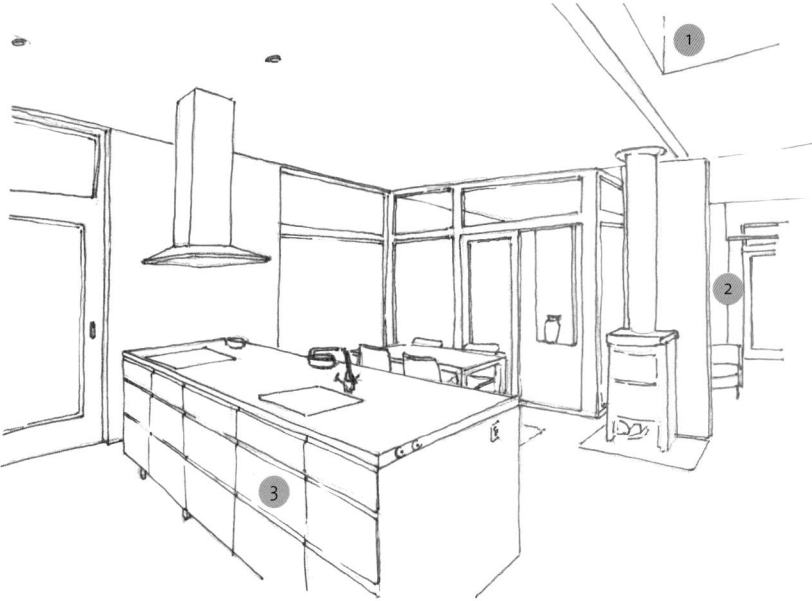

1_ By means of large openings on the exterior walls and skylights on the roof, good lighting is assured.

2_ Circulation is made fluid and a sense of greater space is achieved by avoiding any unnecessary partitions.

3_The kitchen equipment is designed so it can be almost hidden when not in use.

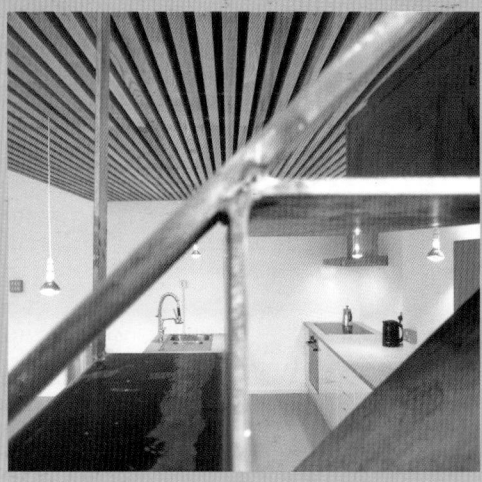

Bavaria Road Loft

900 sq. ft.

The project is the complete refurbishment of a double-height living space and incorporation of a new mezzanine in a former Methodist chapel in North London. All utilities have been replaced, the new kitchen is located in a different part of the plan, and underfloor heating is incorporated into a poured-resin floor.

The plywood balustrade to the mezzanine is solid to give privacy to the sleeping space while it also provides the primary support for the mezzanine structure in the form of a very thin deep beam which is suspended from the existing roof structure above which is strengthened with additional timbers to take the new loads. This is formed from three layers of 12mm birch-faced plywood laminated together. The middle layer is offset by half its length effectively forming a huge mortise and tenon joint.

Architect: West Architecture

Location: London, U.K.

Completion date: 2006

Photographer: © Peter Cook

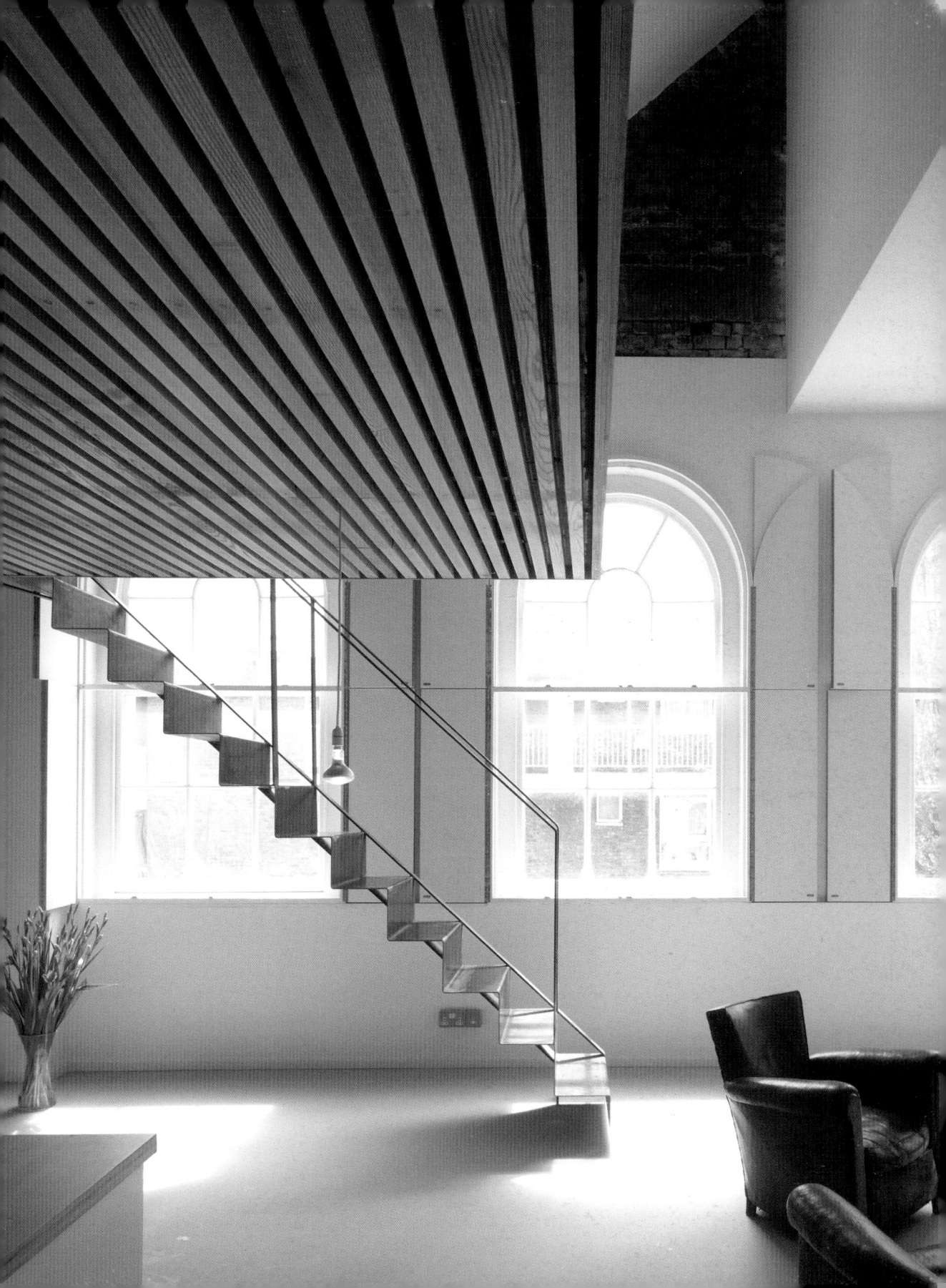

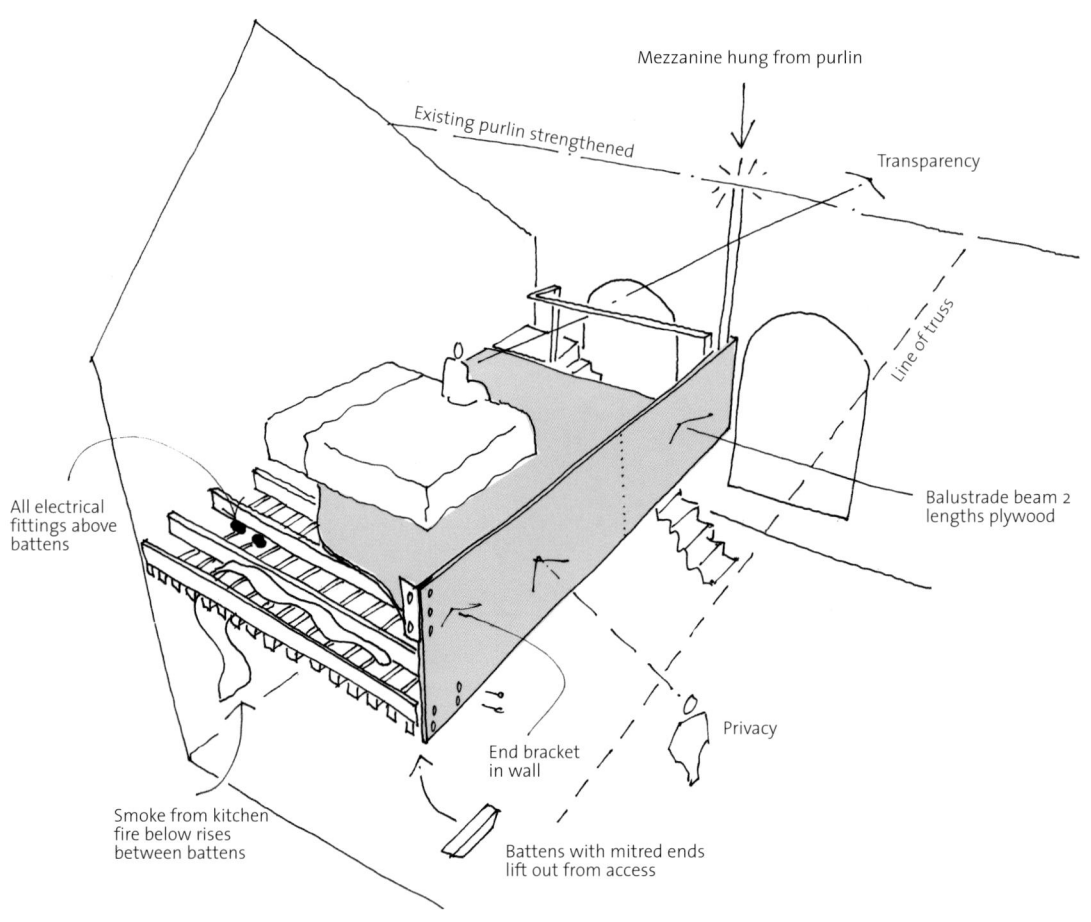

Mezzanine hung from purlin

Existing purlin strengthened

Transparency

Line of truss

All electrical
fittings above
battens

Balustrade beam 2
lengths plywood

Privacy

Smoke from kitchen
fire below rises
between battens

End bracket
in wall

Battens with mitred ends
lift out from access

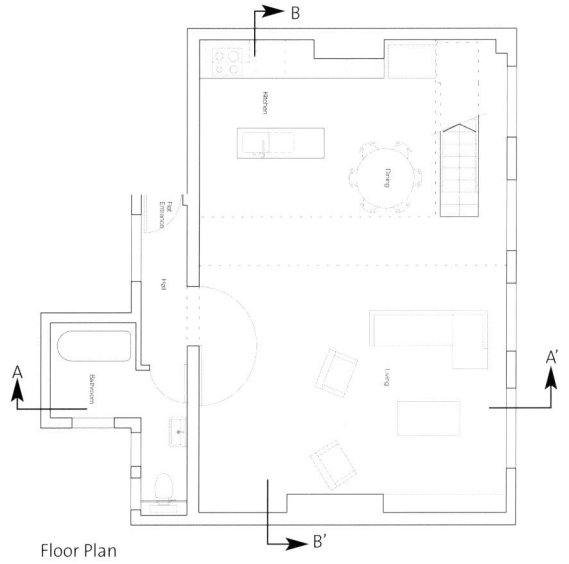

Floor Plan

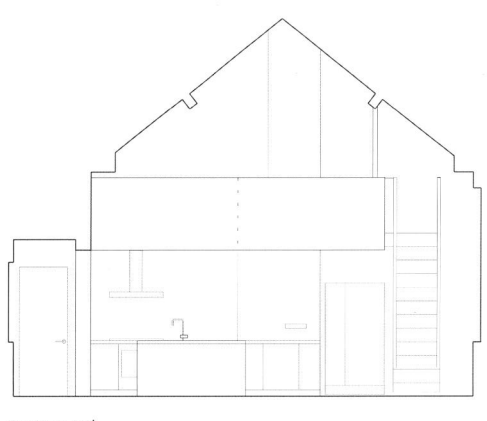

Section AA'

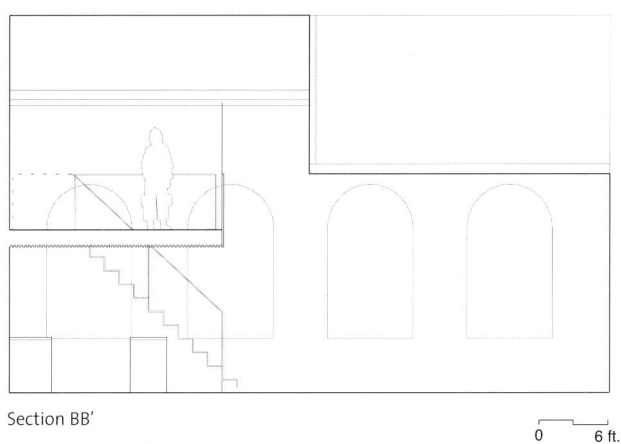

Section BB'

0 6 ft.

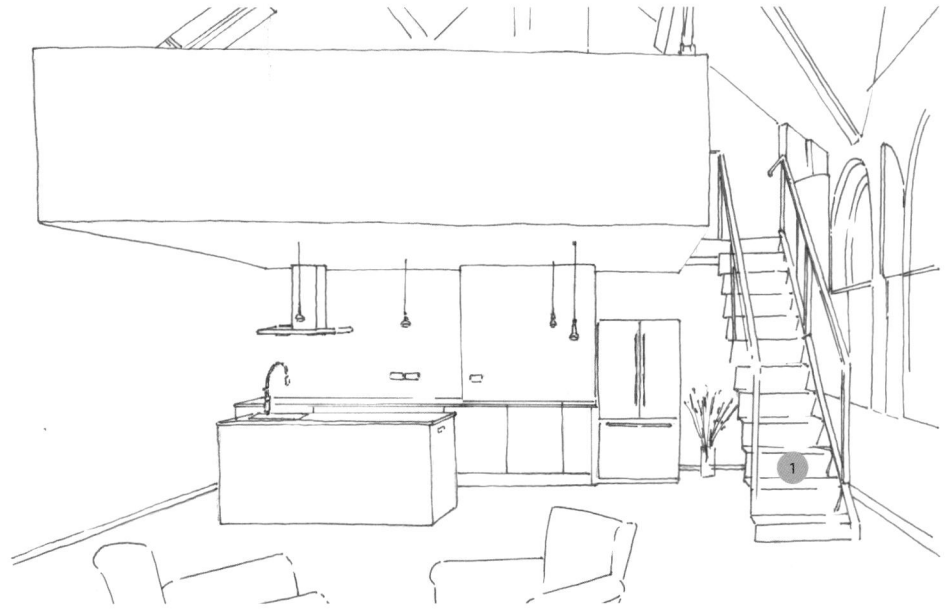

1_ Access to the mezzanine is via a steel folded-plate staircase which only touches it once at the extreme end of one of its handrails. The staircase is untreated mild steel and the intention is that it will gently oxidize over time.

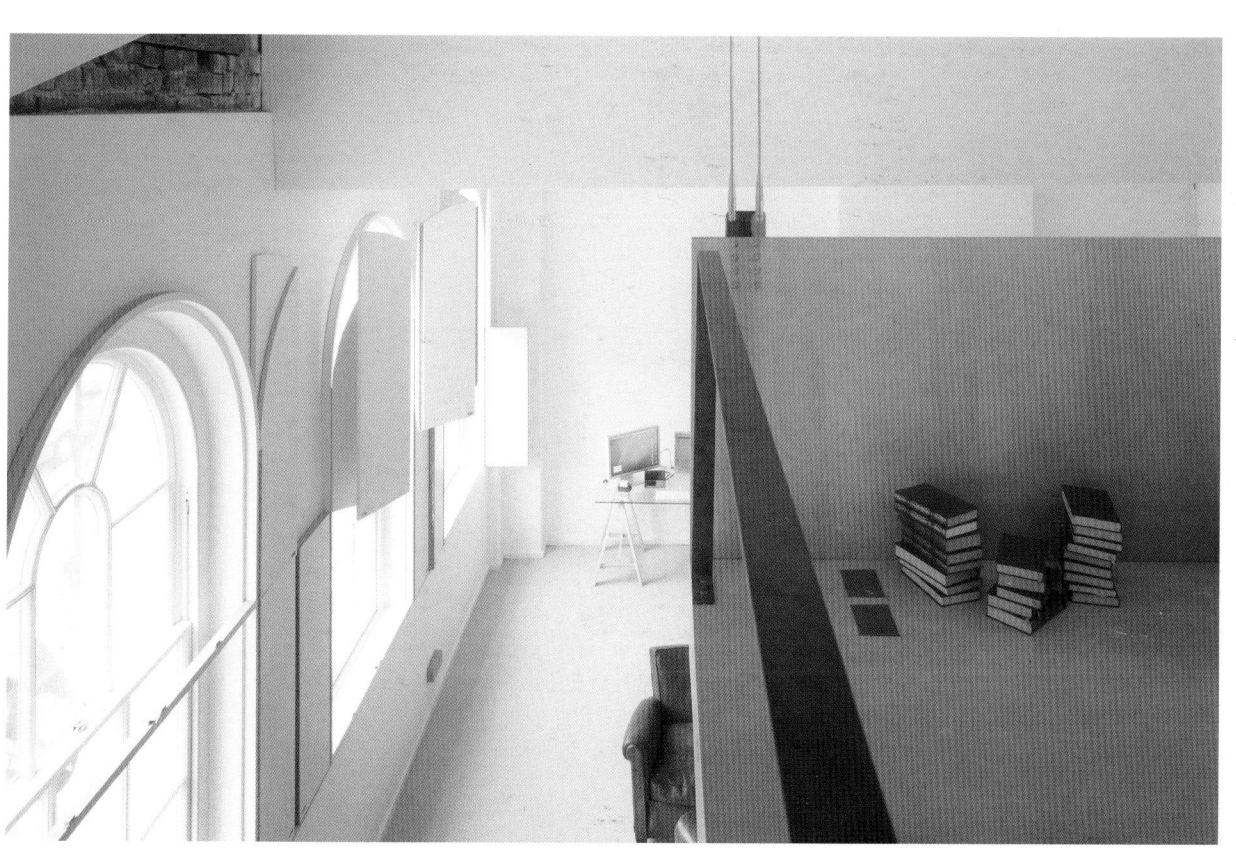

Cabin in the Woods

797 sq. ft.

The cabin is situated in the natural reserve of Grimeton, a couple of miles east of Varberg. It is a dramatic landscape that rises above Sweden's coastal plain. On the top of the hill, by one of the smaller lakes (Lake Rörsjön) the refuge cabin appears discreet and unobtrusive with its dark wood façade interrupted only by an entryway sheltered by a shallow eave and side walls. The enchanting view beyond of the mist-shrouded lake is hidden until you pass through the entry. Floor-to-ceiling windows flanking a white concrete chimney give onto this vista. The building respects the pristine landscape by touching lightly on the ground with a pier foundation, leaving the terrain as intact as possible as the cabin floats slightly above. It is rendered in simple yet sophisticated details of stained wood, concrete, galvanized metal and glass. Its carefully limited palette of materials lend the structure a serenity in keeping with its context.

Architect: Strata Arkitektur

Location: Varberg, Sweden

Completion date: 2007

Photographer: © Björn Lofterud

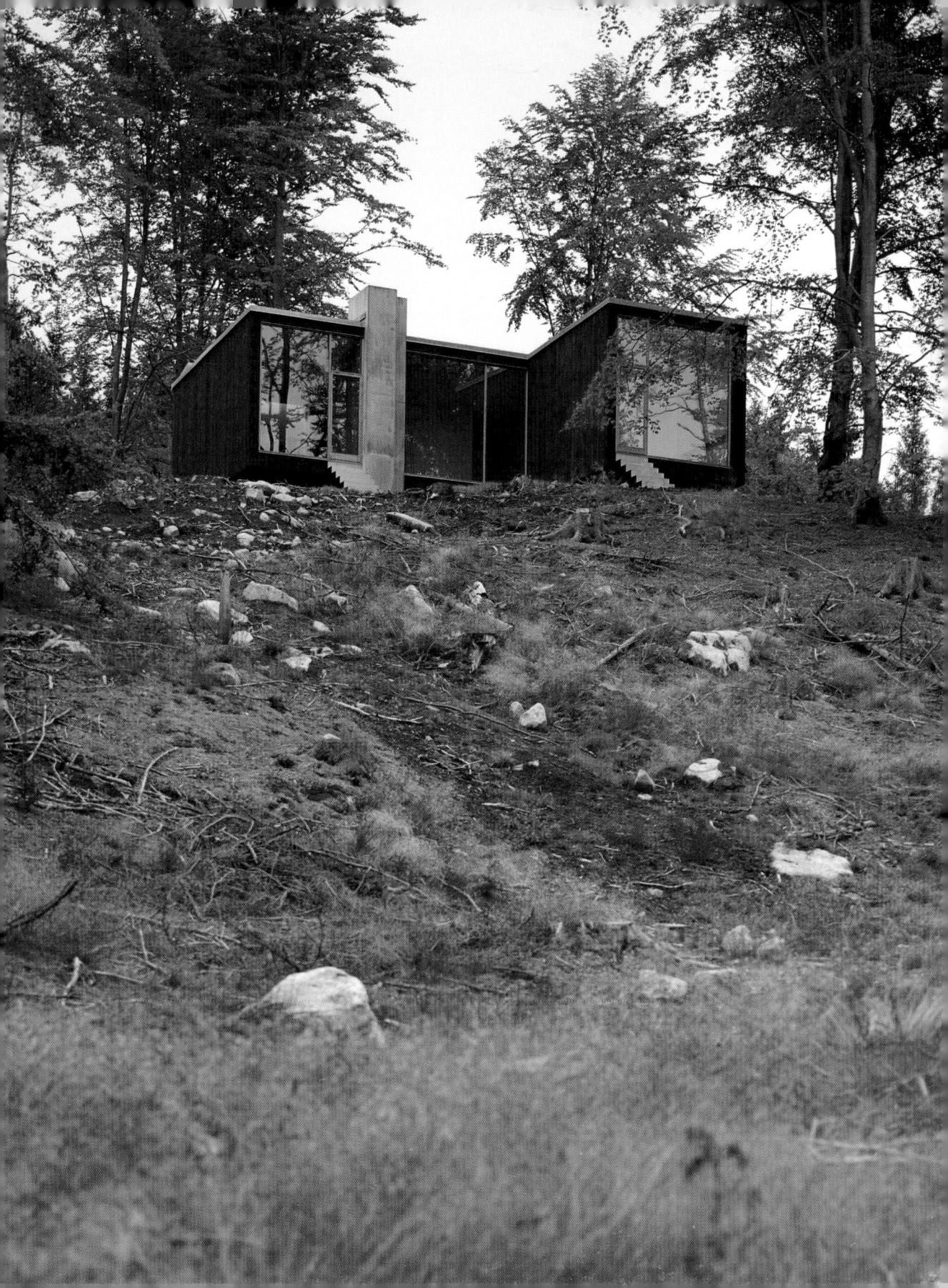

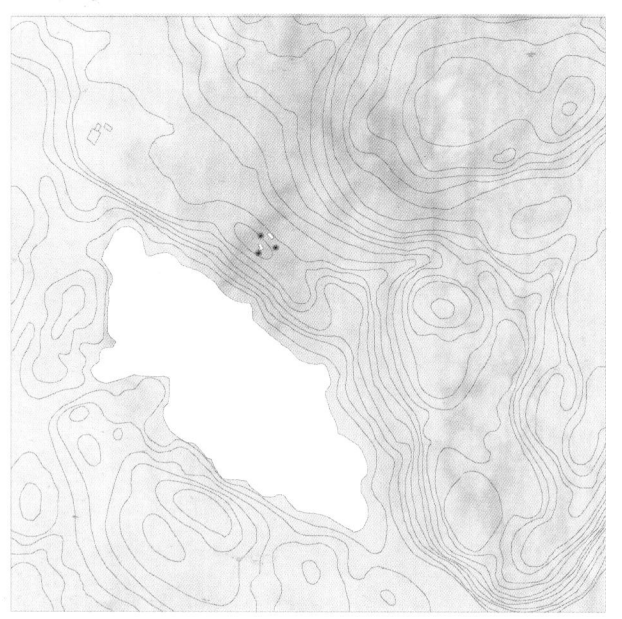

Site Plan

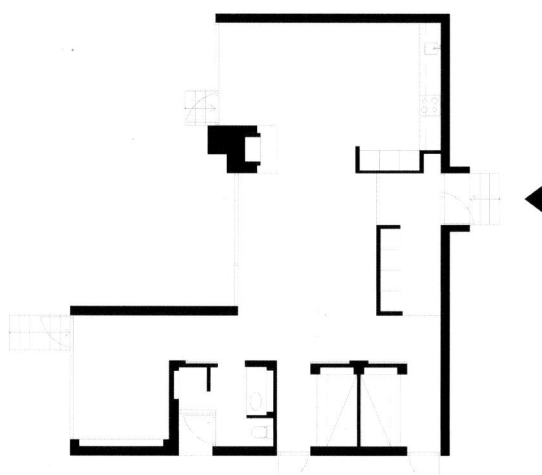

Floor Plan

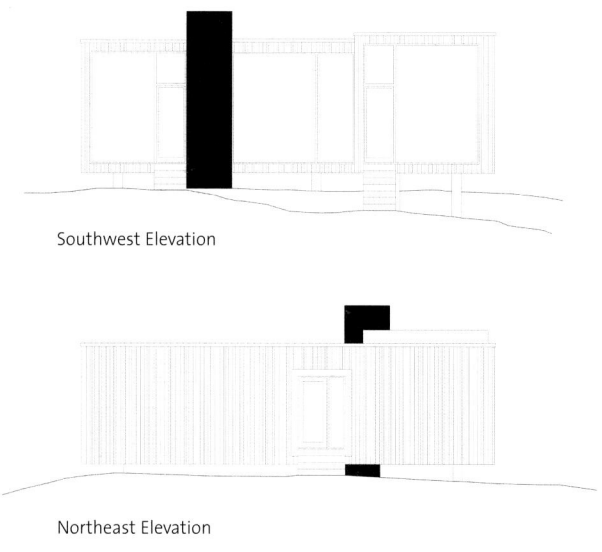

Southwest Elevation

Northeast Elevation

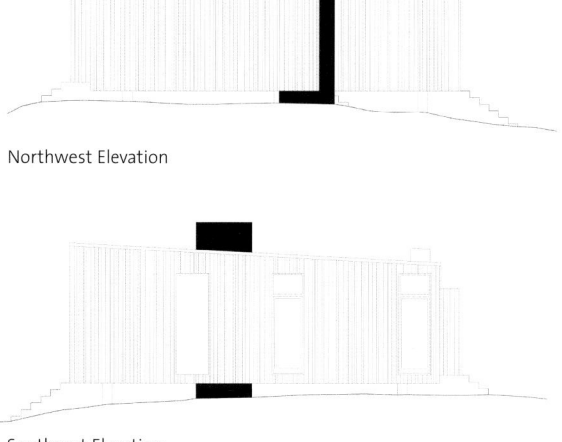

Northwest Elevation

Southeast Elevation

0 6 ft.

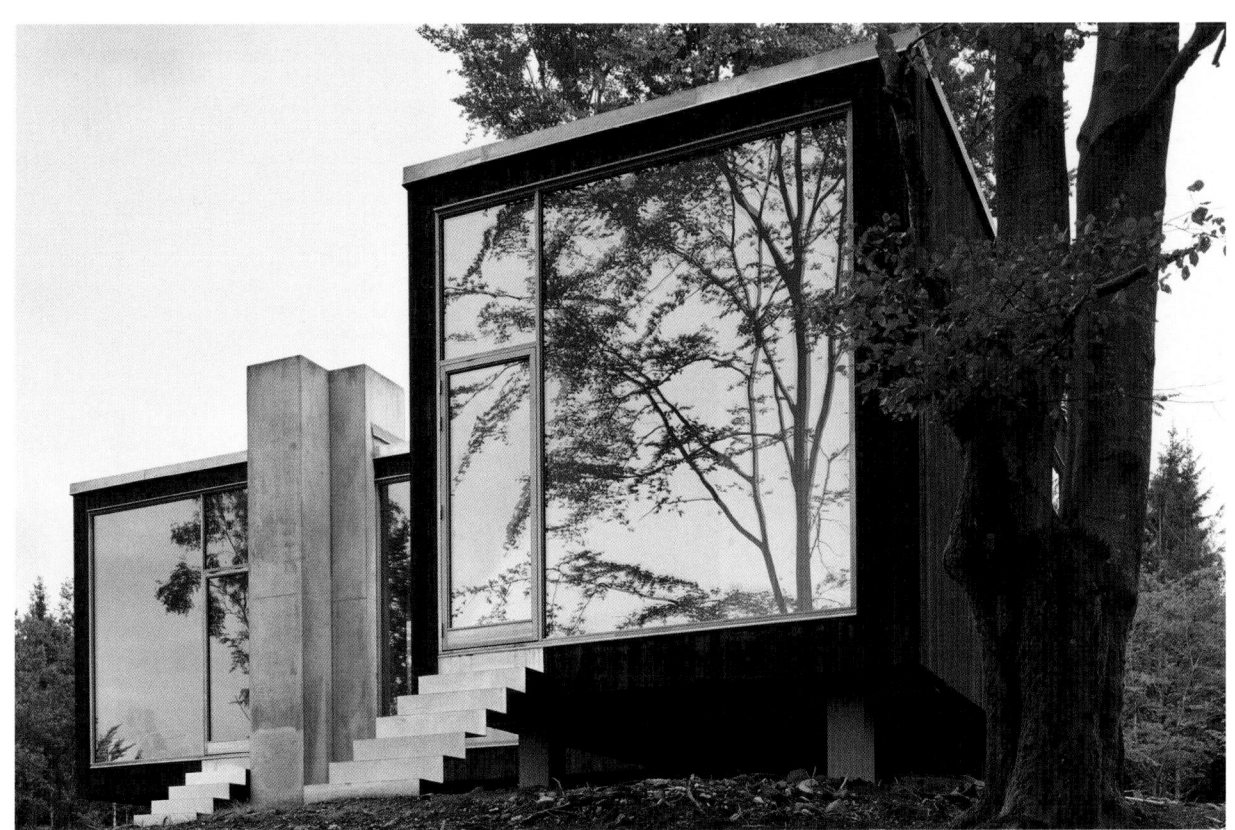

The site benefits from a magnificent view of the woods and the lake, of which the designers have taken full advantage through the use of an architecture that attempts to adapt to the natural environment. The scenery is reflected in the picture windows, blending the small refuge with the landscape, while piers keep its footprint to a minimum.

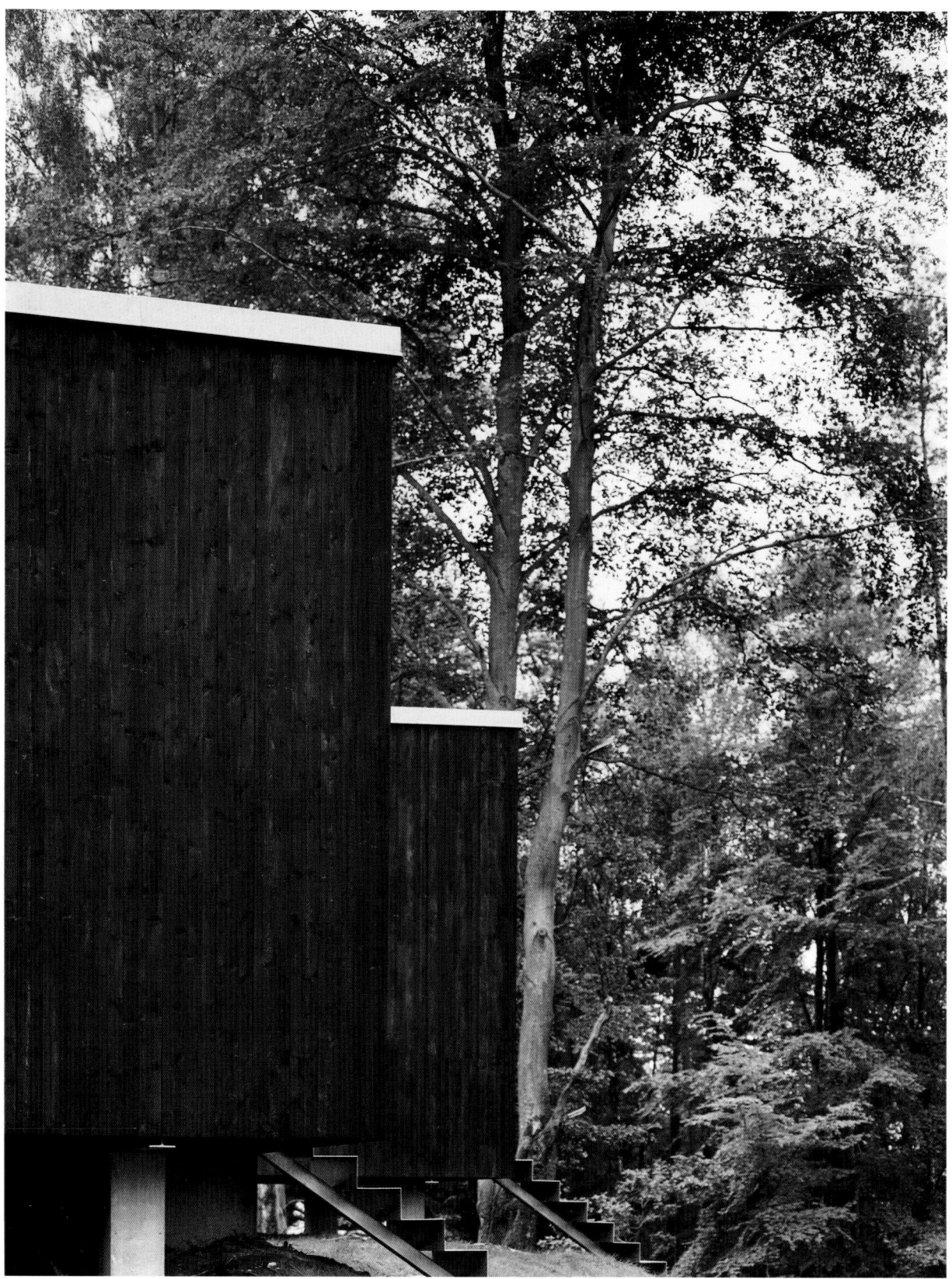

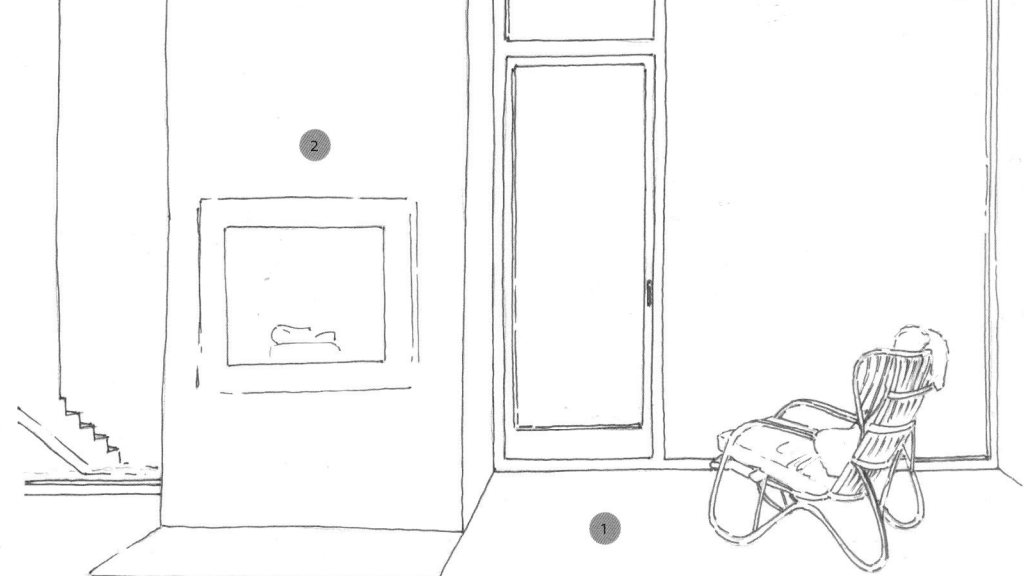

1_ The interior is spare, with whitewashed planks and teak windows. The limited palette of materials and colors harmonizes the interior with the unspoiled natural surroundings.

2_ Surfaces that take heavy wear, such as the fireplace, the entry area floor, the bathroom and the kitchen's work surfaces are all made of exposed concrete. The repetition of this material in various locations throughout the cabin contributes to its visual unity.

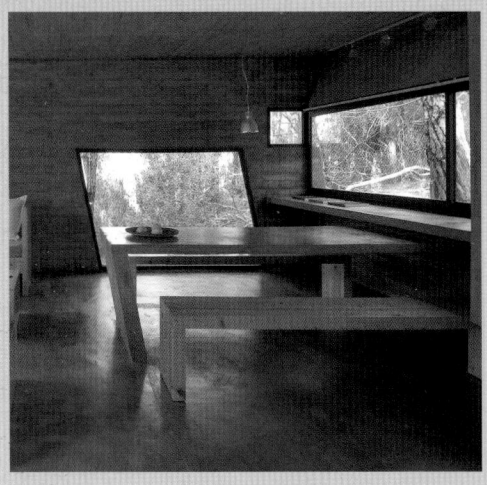

Concrete House

797 sq. ft.

Mar Azul is a spa resort 250 miles south of Buenos Aires with a long beach and a lush coniferous forest. The owners of the studio, who were familiar with the area, picked a plot of land in the woods with steep topography, far from the sea, and consequently away from the most populated areas, to build a summer house with a presence that would not interfere with the natural environment. The main challenge was to adapt the new construction to the abrupt topography. But the project had other limitations too: it should have a low environmental impact, it should be designed to a limited budget, its maintenance should be practically nonexistent, and the time frame for construction should be as short as possible given that the management of the construction would take place offsite.

The house is shaped as a concrete prism with a flat roof, which will eventually be covered with dry foliage.

Architect: Besonias Almeida Kruk Arquitectos

Location: Mar Azul, Argentina

Completion date: 2007

Photographer: © Daniela Mac Adden

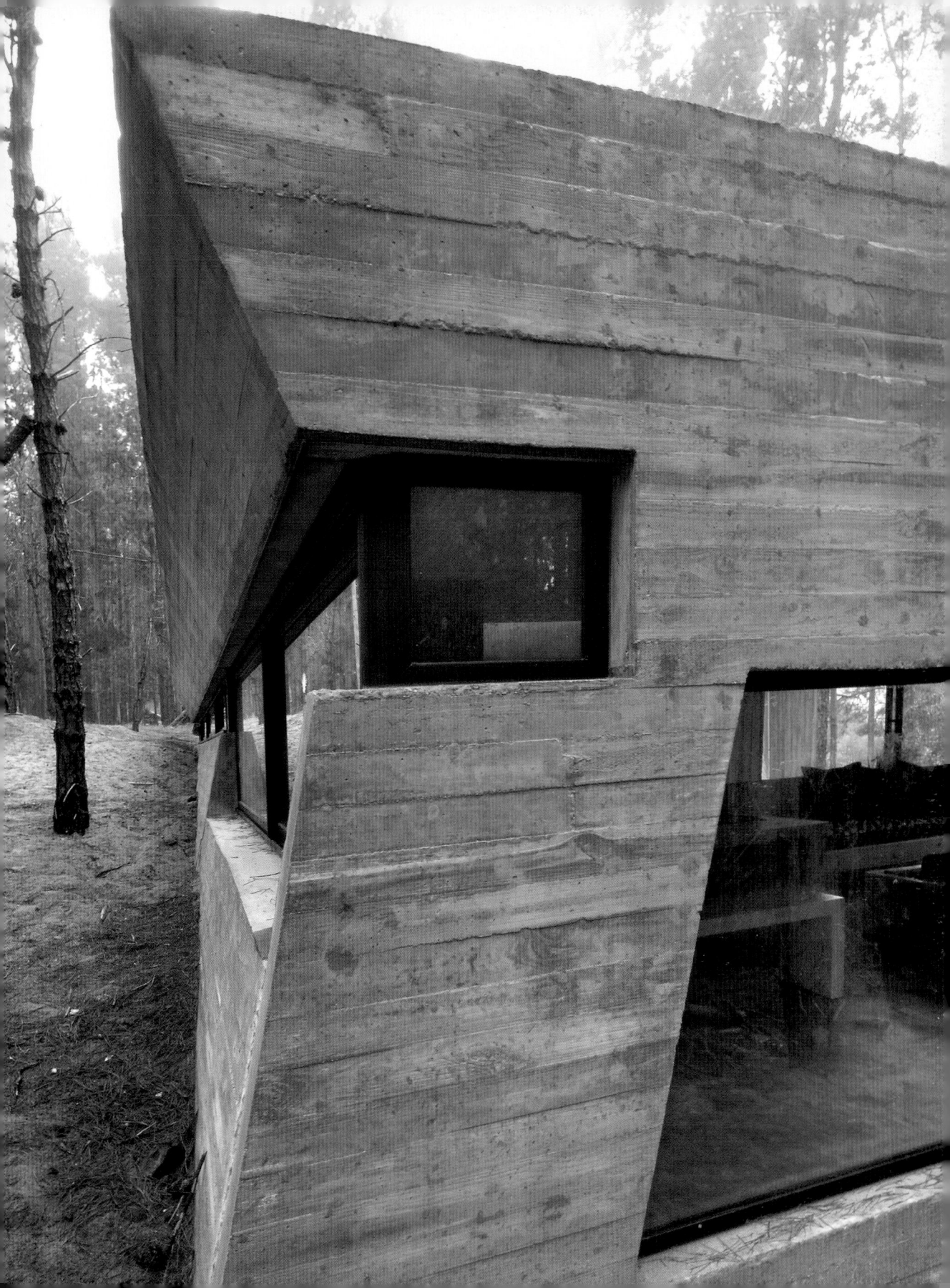

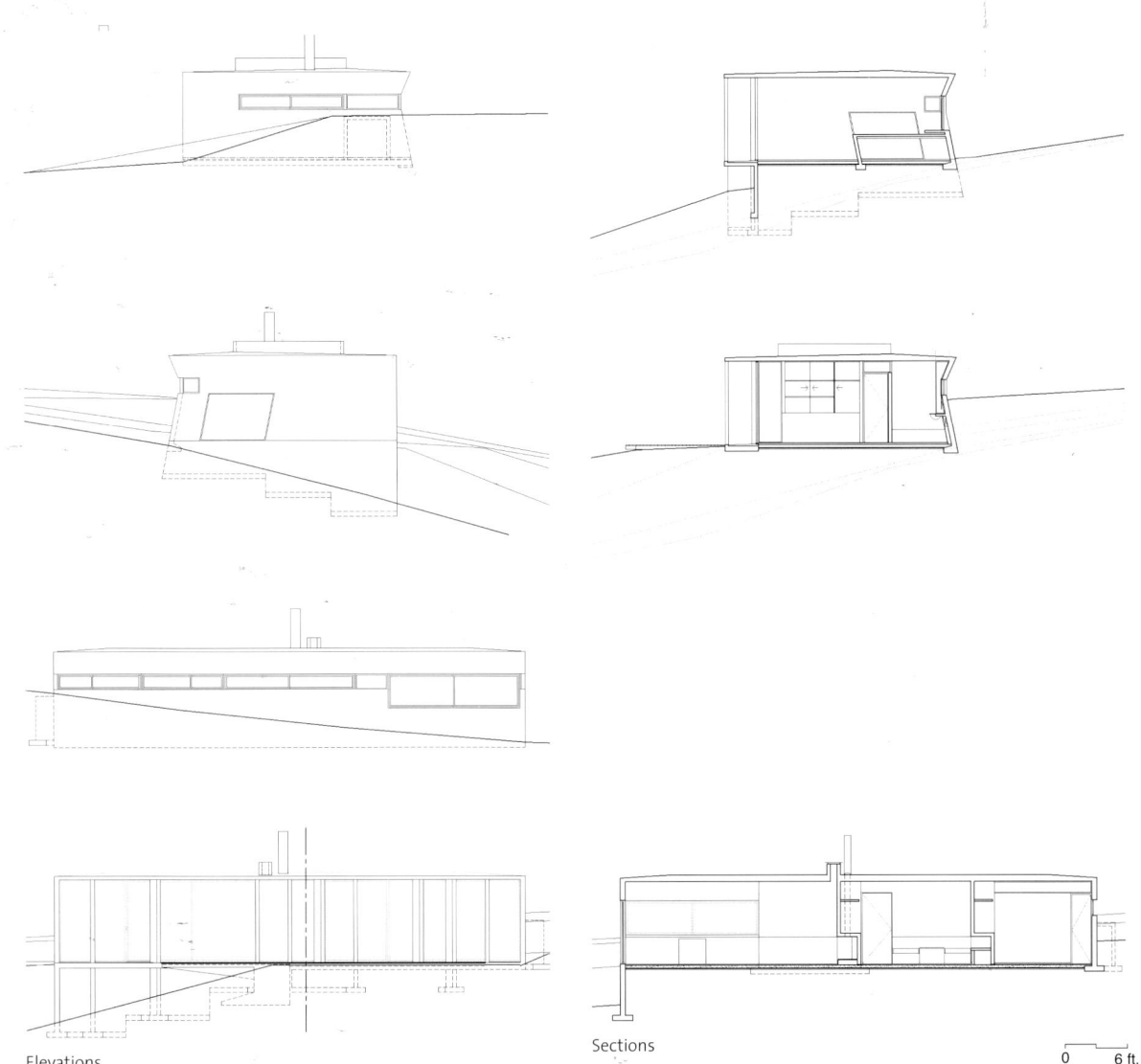

Elevations

Sections

0 6 ft.

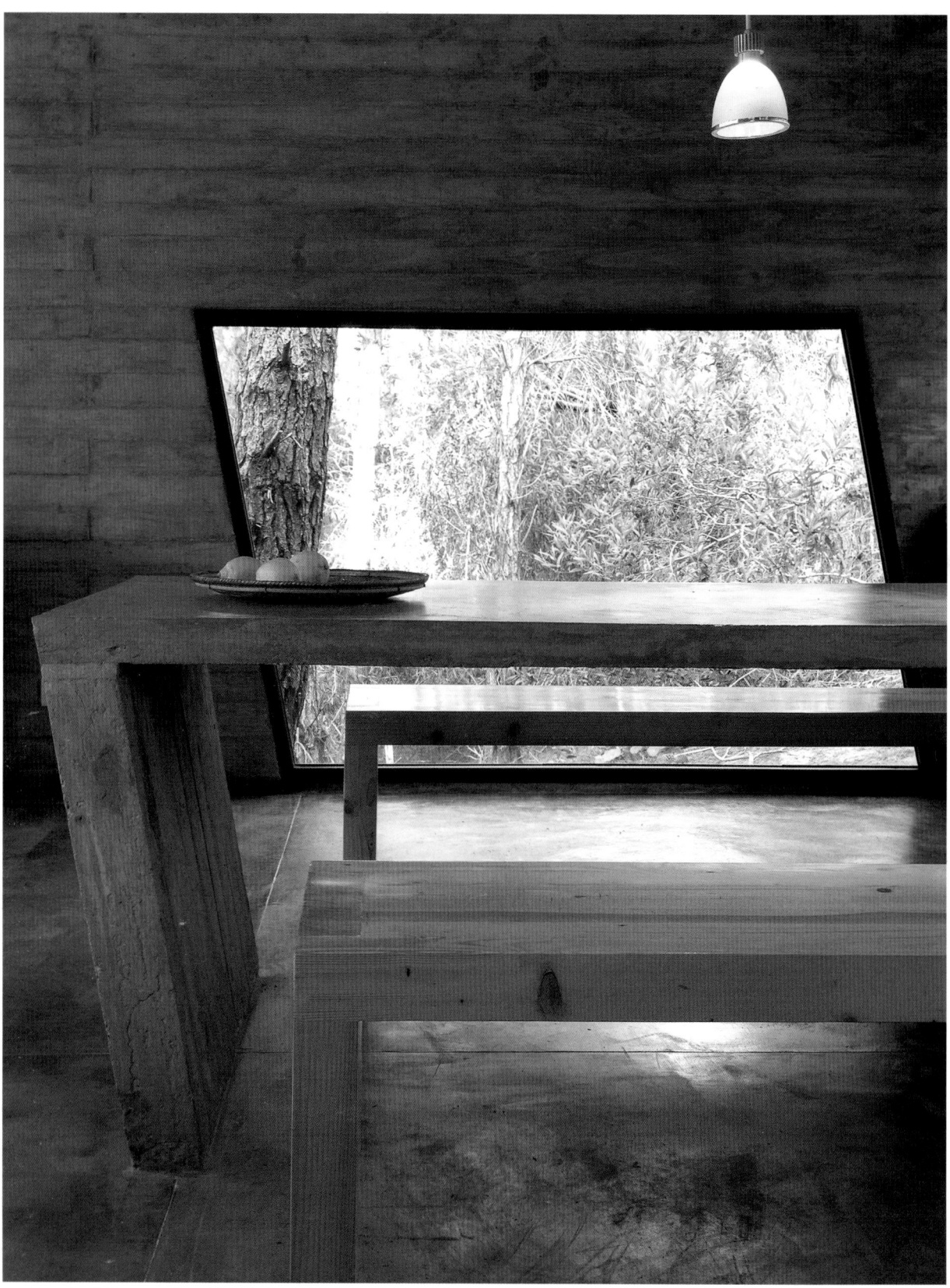

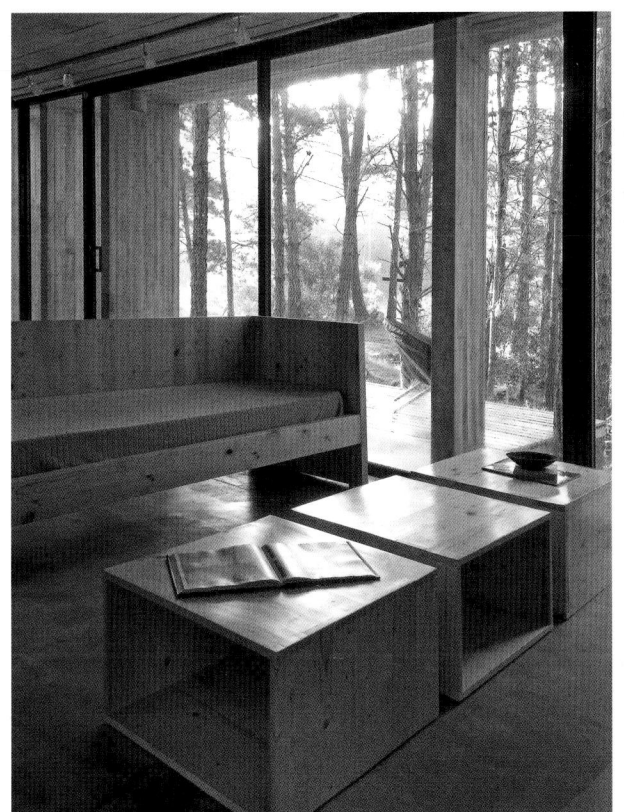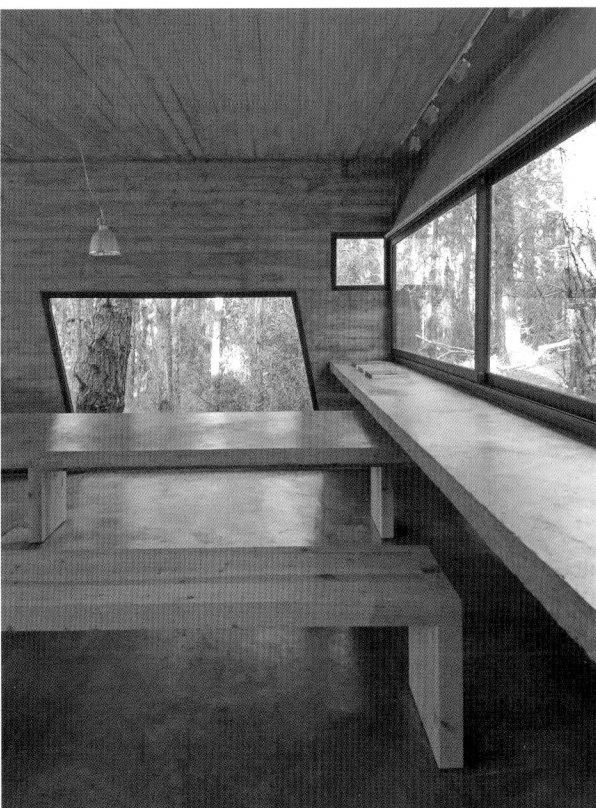

On the long side of the house, the south wall is partially buried with a high opening that follows the slope of the terrain. The north elevation is entirely glassed-in and allows long views, while from the exterior the glass reflects the surrounding landscape and emphasizes the symbiosis between the house and the natural environment.

1_ The main spaces are arranged along the glassed-in wall and a deck outside, while the bathrooms and the kitchen are organized along the partially-buried wall.

2_ The properties of concrete make any kind of finish unnecessary. The texture generated by the board-formed concrete helps the house to harmonize with the forest.

3_ The furniture, designed by the architects, is made of Canadian pine from recycled crates for motors. The wood adds some color and warmth while blending with the concrete interior.

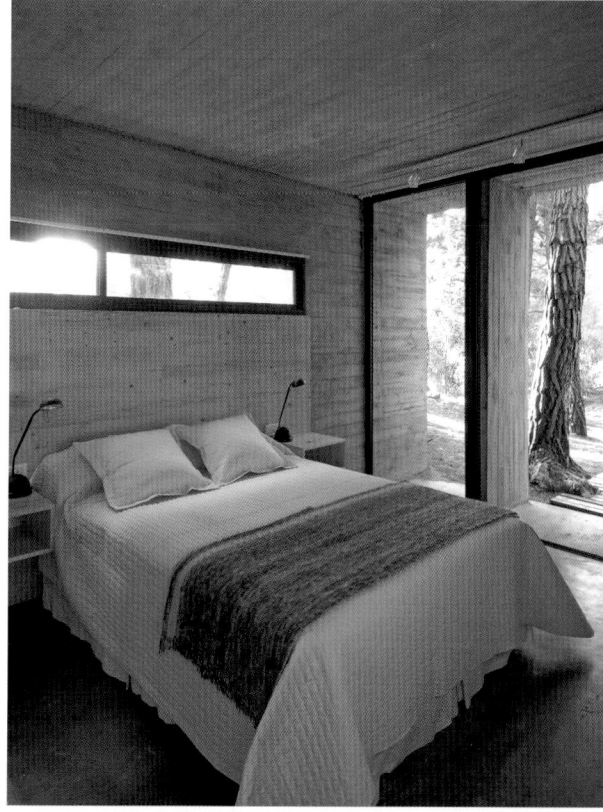

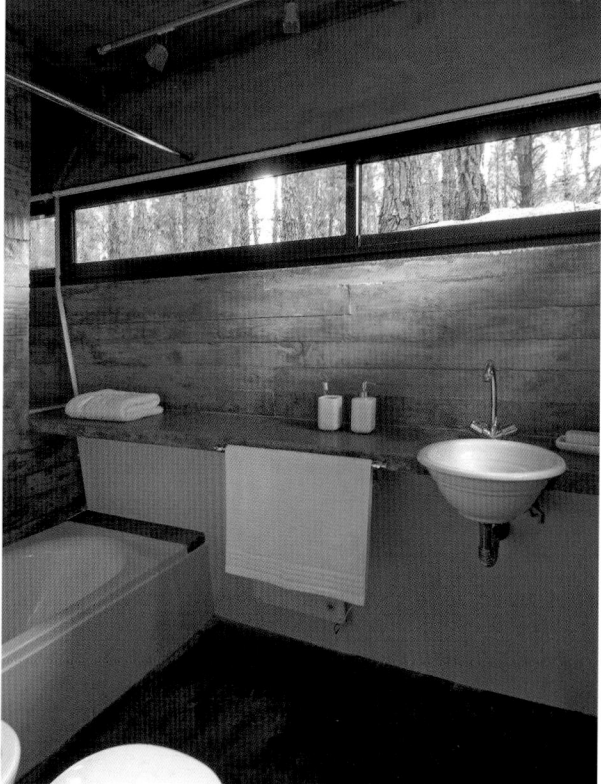

Fully aware of the particular atmosphere that the woods generate, it was important to ensure that all the interior spaces would receive a generous amount of natural light. A skylight above the fireplace was planned to reinforce lighting in the main space. This opening in the ceiling projects interesting light effects that continuously change during the day.

Small House on a Hillside

301 sq. ft.

The house is constructed on the periphery of a suburban village where a housing development turns gradually into an open natural landscape. The sloping grounds of the plot and its unfavorable orientation to the north were decisive factors that determined the shape of the house and its internal arrangement. Partly buried into the hillside, the house cuts into a massive retaining wall made of granite blocks of different size and shape. The difference in grade makes the house accessible on its two levels, opening the house to the exterior. Two bedrooms, sanitary facilities, a technical room and a storage room are located on the lower floor. The upper floor is dedicated to a spacious living area adjacent to the kitchen. Directly outside, the ground needs time to recover from all the excavation and construction work. It will eventually become a nice sunny outdoor space off the living room.

Architect: Vladimír Balda

Location: Czech Republic

Completion date: 2007

Photographer: © Ales Jungmann

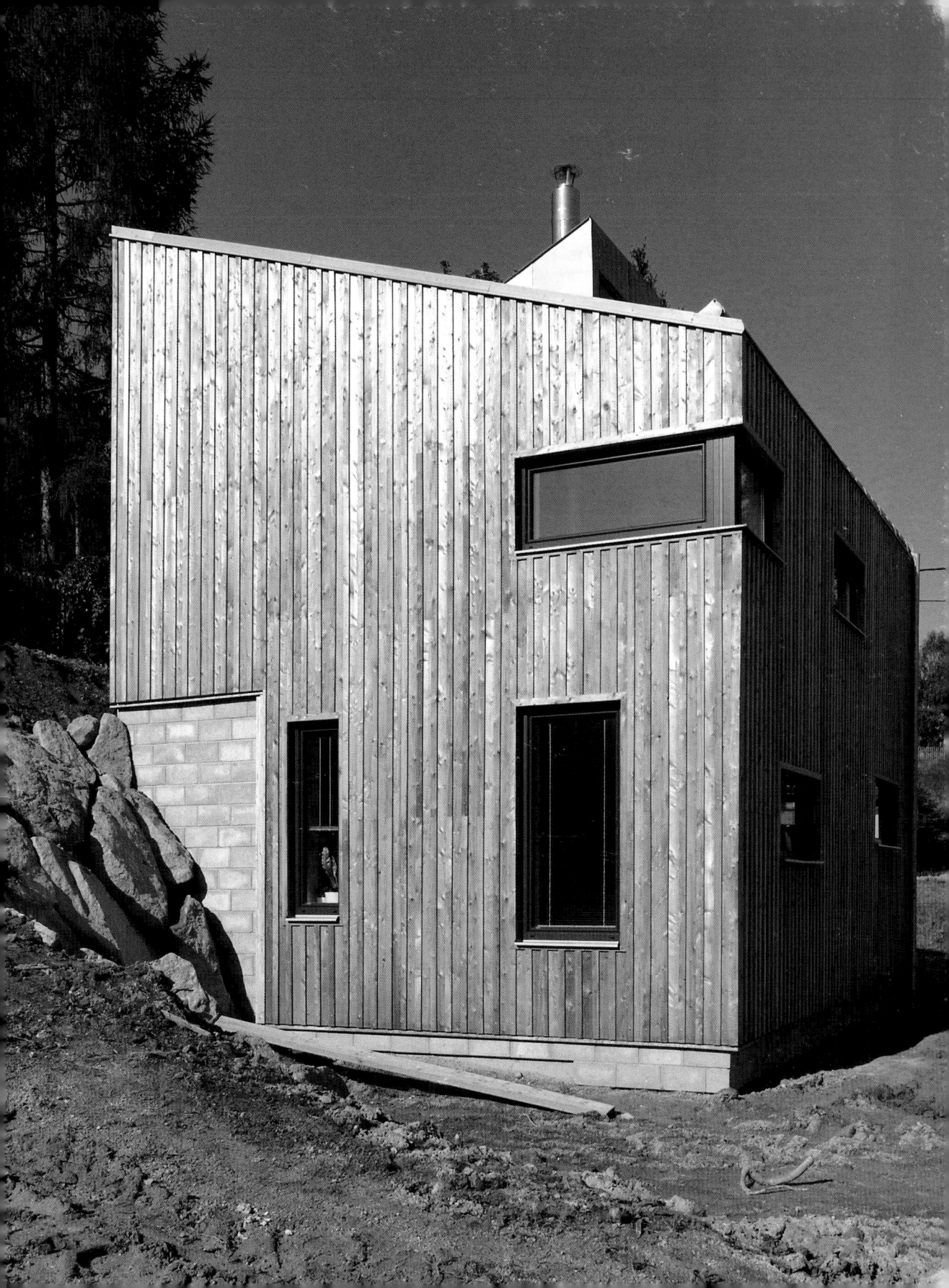

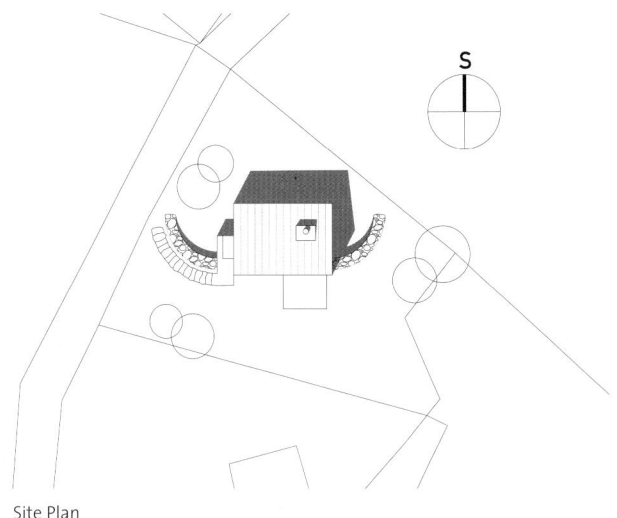

Site Plan

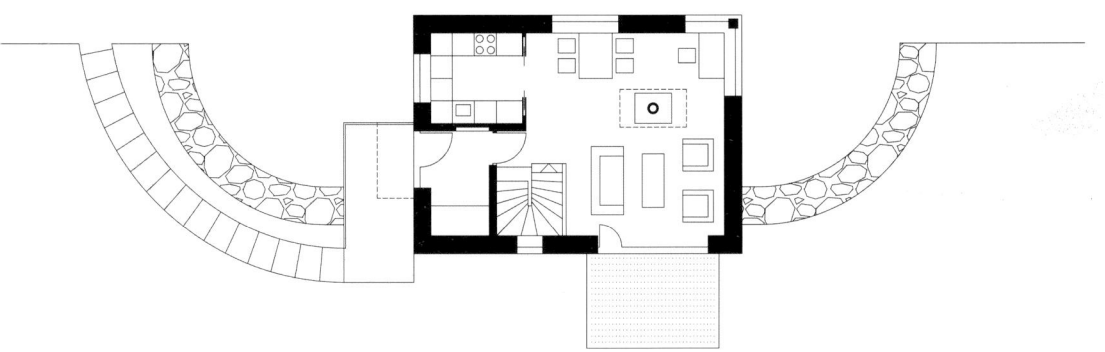

Upper Floor Plan

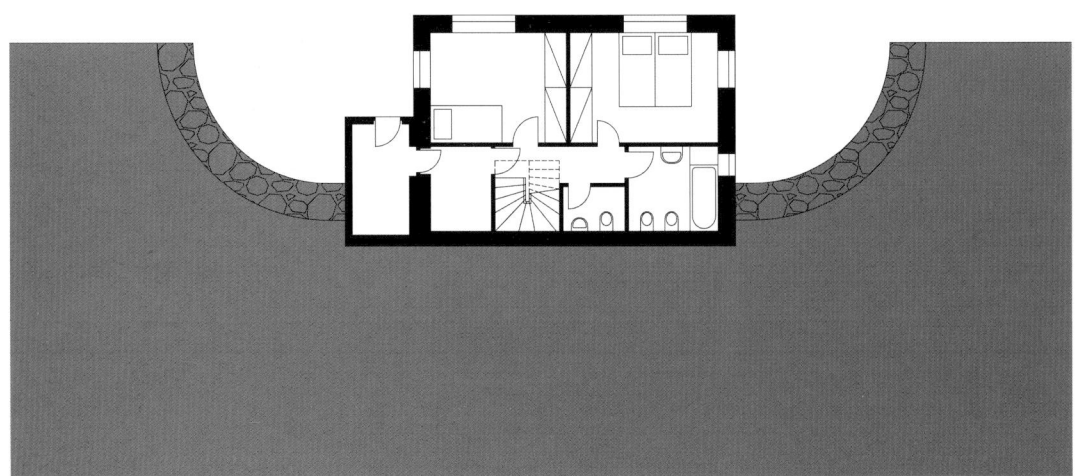

Lower Floor Plan

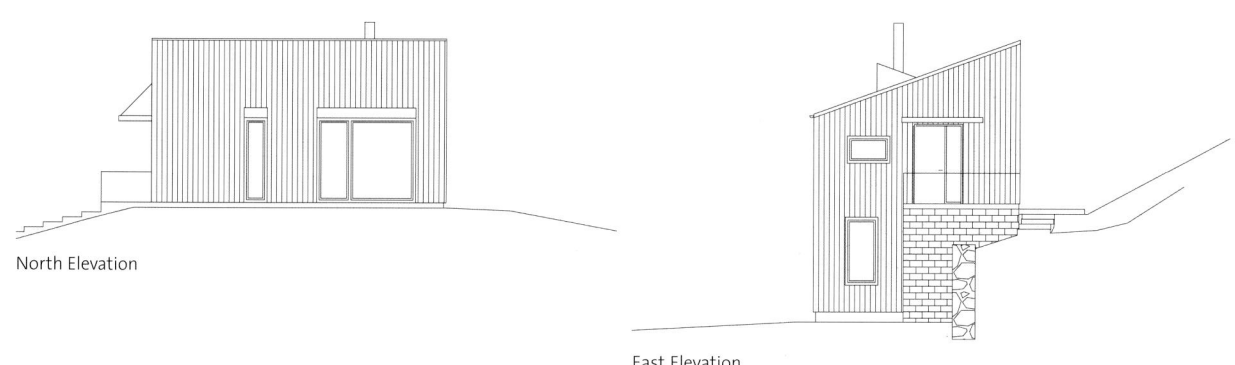

North Elevation

East Elevation

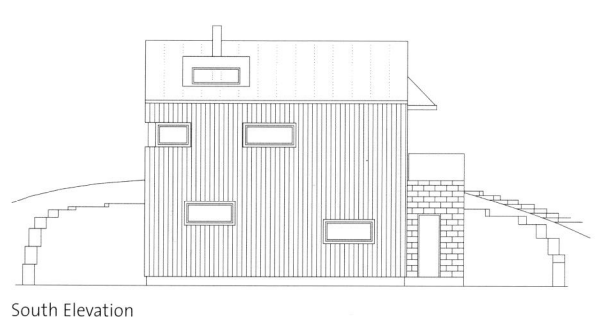

South Elevation

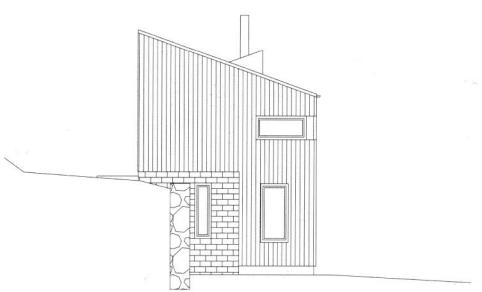

West Elevation

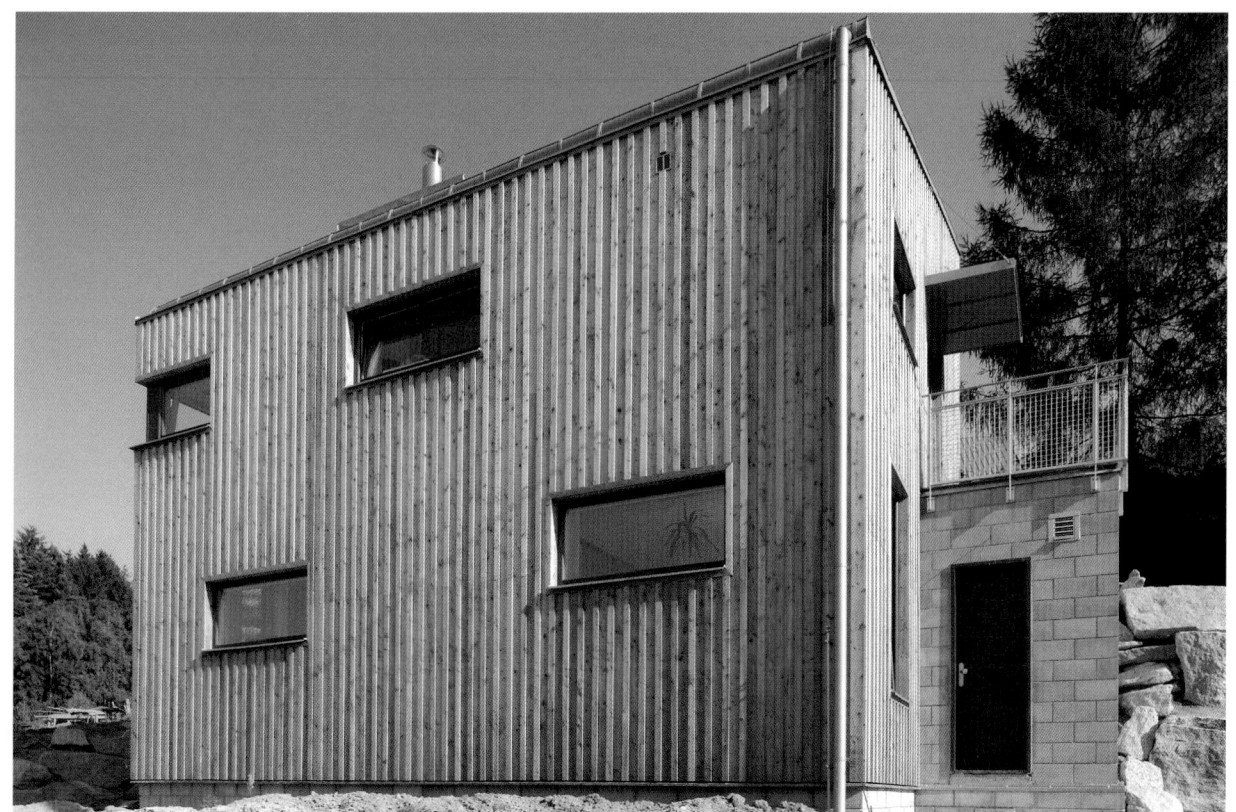

The exterior walls, faced with vertical larch boards,
allude to the surrounding landscape and to the
strong tradition of timber in the area. This wood
skin seems to peel off to expose the concrete block
walls where the house is in contact with the terrain.

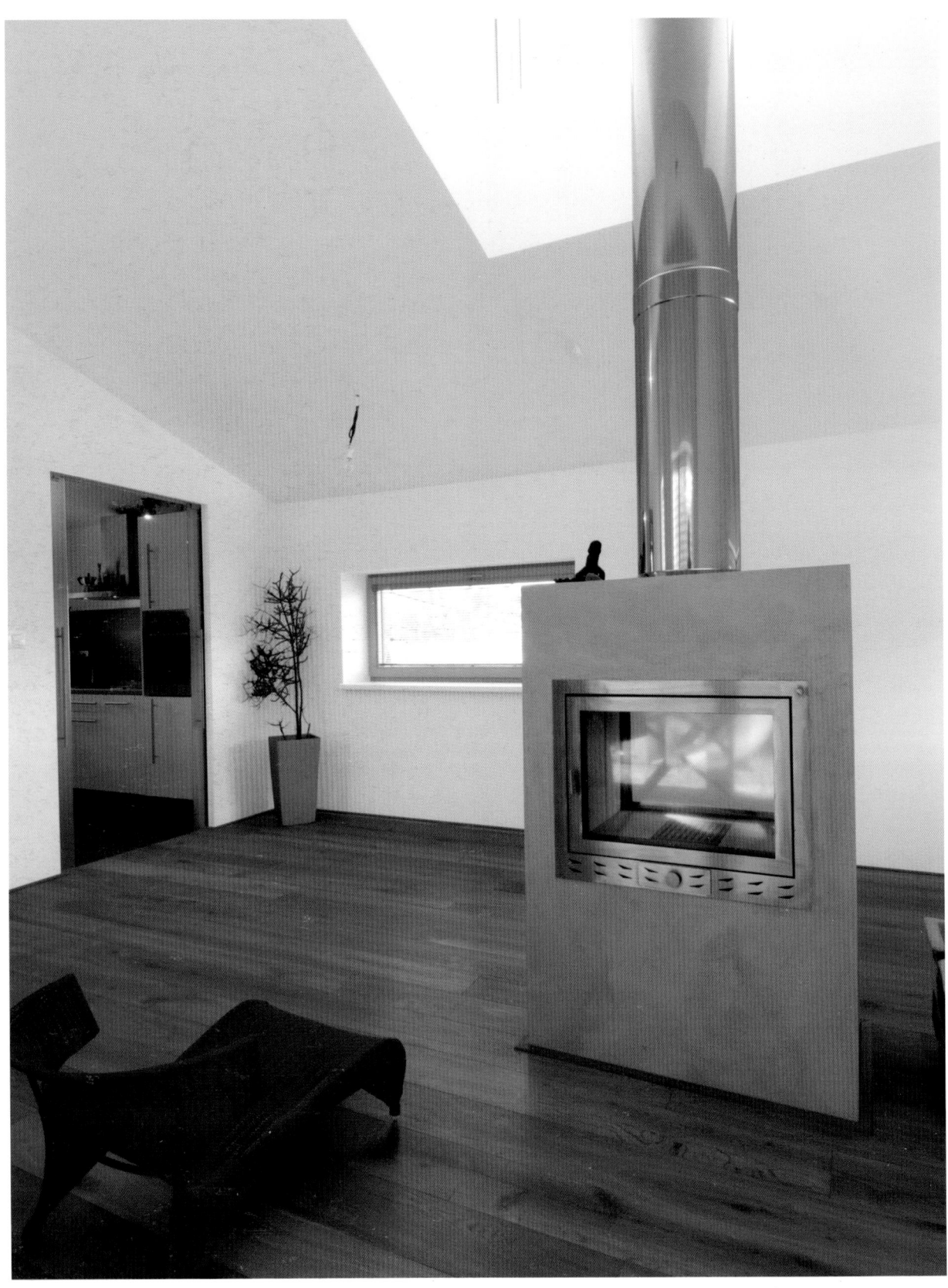

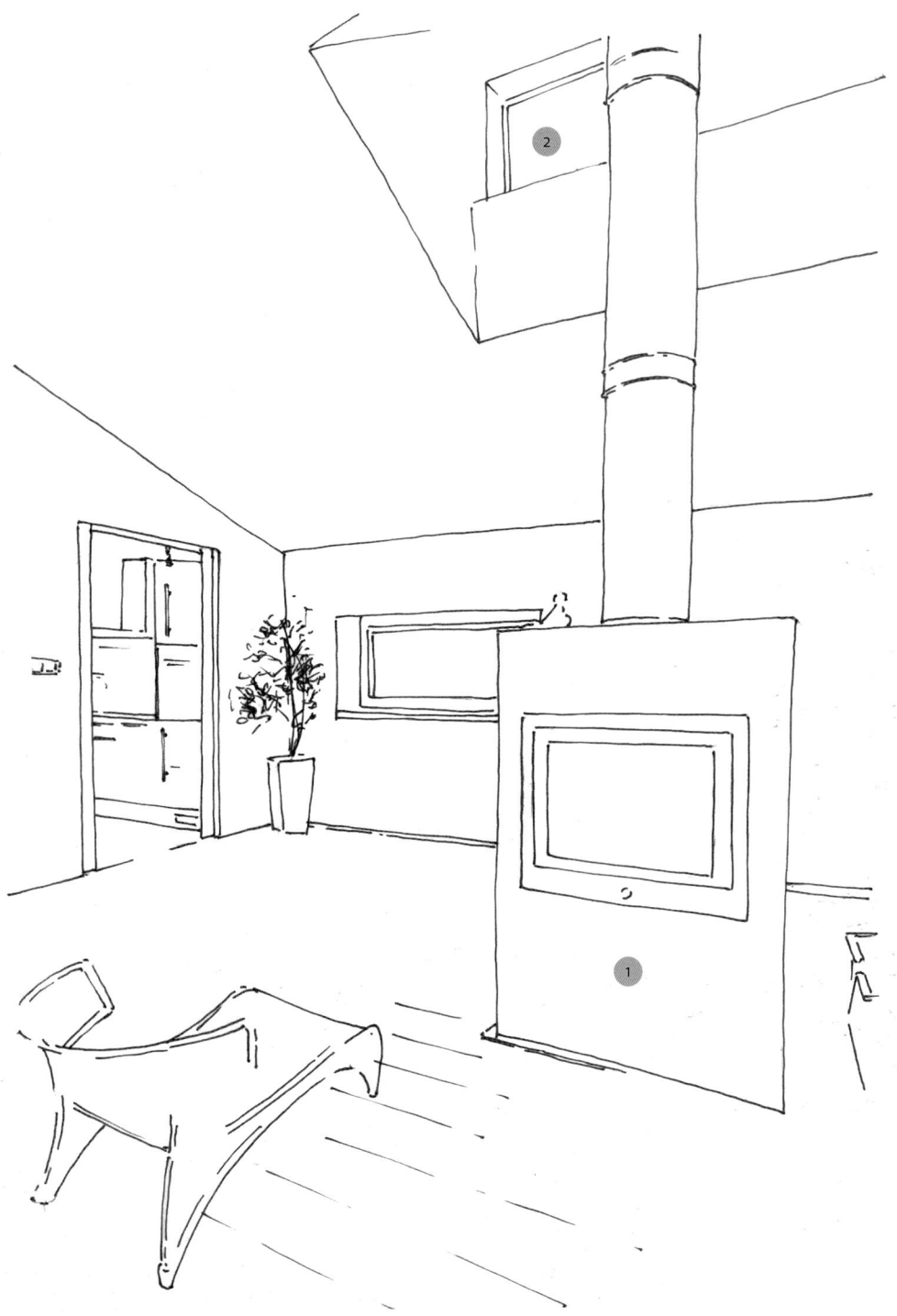

1_ The house is heated by an electrical system that is supplemented by a stove that occupies a central place in the arrangement of the living area.

2_ The small footprint of the house is compensated by the tall ceiling, and the various openings on the walls and ceiling in the living area making this interior more spacious.

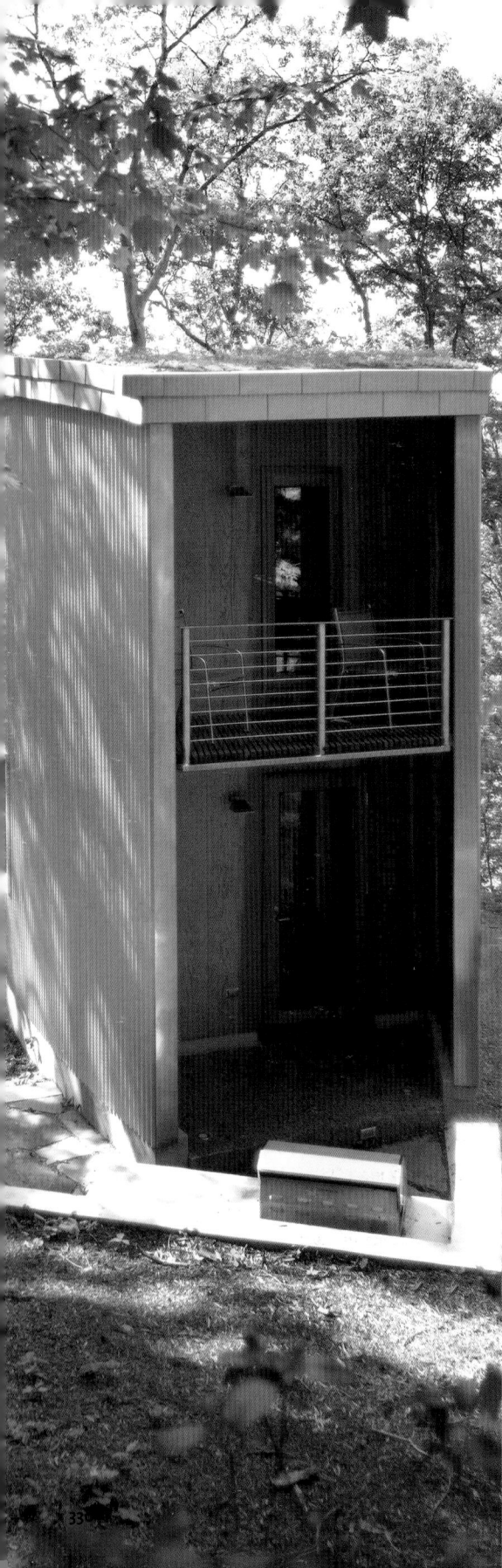

Directory

FLOAT Architectural Research and Design
Ph. +1 520 400 2900
www.floatarch.com

Dan Hisel Design
11 Village St. #2
Somerville, MA 02143, U.S.
Ph. +1 617 547 3151
www.danhiseldesign.com

Henning Stummel Architects Ltd
42a St. Michael's Street
London W2 1QP, U.K.
Ph. +44 207 262 1778
www.henningstummelarchitects.co.uk

Alchemy Architects
856 Raymond Avenue
St. Paul, MN 55114, U.S.
Ph. +1 651 647 6650
www.weehouse.com

Sami Rintala
www.samirintala.com

Andrea Lupacchini
Via Andrea Pitti 18
00147 Rome, Italy
Ph. +39 06 57 59 930
architer@libero.it

Peanutz Architekten

Elke Knöß & Wolfgang Grillitsch GbR

Brückenstraße 1

D-10179 Berlin, Germany

Ph. +49 30 27879377

www.peanutz-architekten.de

Guerrilla Office Architects

Penitentienenstraat 44

3000 Leuven, Belgium

Ph. +016 22 45 39

www.g-o-a.be

Piero Camoletto & Luca Rolla

Corso Venezia, 8

20121 Milan, Italy

Ph. +39 02 76 00 24 71

lucarolla@katamail.com

Queeste Architecten

Looijerstraat 70

2512 DX Den Haag, The Netherlands

Ph. +31 70 358 68 34

www.queestearchitecten.nl

Altius Architecture Inc. & Sustain Design Studio

1 Atlantic Avenue #120

Toronto, Canada M6K 3E7

Ph. +416 516 7772 ext 35

andy@sustain.ca

Dekleva Gregoric

Dalmatinova Ulica 11

SI-1000 Ljubljana, Slovenia

Ph. +386 1 430 52 70

www.dekleva-gregoric.com

Studio De Carlo

Santa Croce 2235/A

30135 Venice, Italy

Ph. +39 329 33 43 928

www.leodecarlo.com

James & Mau

Jaime Gaztelu

Ph. +34 676453361

jaime.gaztelu@terra.es

Abel Erazo

3-4-1 Okubo,Shinjuku-ku

Tokyo 169-8555, Japan

Ph. +81 332093212 (2232)

abelerazo@gmail.com

http://abelerazo.blogspot.com/

CCS NY Architecture

44 Varick Street #902

New York, NY 10014, U.S.

Ph. +1 212 274 1121

www.ccs-architecture.com

Drop Architectes

4 Grégoire de Tours

75006 Paris, France

www.drophouse.fr

André Hodgskin Architects Ltd.

23 Victoria Street East

Auckland 1001, Australia

Ph. +09 377 4691

www.architex.co.nz

Tag Front

818 S Broadway 700

Los Angeles, CA 90014, U.S.

Ph. +1 213 623 2330

www.tagfront.com

Carter & Burton Architecture, P.L.C.

11 West Main Street

Berryville, VA 22611, U.S.

Ph. +1 540 955 0410

www.carterburton.com

PTang Studio Ltd.

Rm 603-604, Harry Industrial Building

49-51 Au Pui Wan Street, Sha Tin,

New Territories, Hong Kong, China

Ph. +852 2669 1577

www.ptangstudio.com

Jabier Lekuona

San Esteban kalea 8

31780 Bera, Nafarroa, Spain

Ph. +34 948 62 54 03

jabier@leku.e.telefonica.net

Sculp(it) Architecten

Huikstraat 47

2000 Antwerpen, Belgium

Ph. +03 289 07 24

www.sculp.it

Koshi Architects Studio

302-1-36-21 Takada Toshima-ku

Tokyo 171-0033 Japan

Ph. +81 3 3986 0095

www.kkas.net

Michelle Kaufmann Designs, Inc.

580 Second Street, Suite 245

Oakland, CA 94607, U.S.

Ph. +1 510 271 8015

www.mkd-arc.com

Macy Architecture

55 Sumner Street

San Francisco, CA 94103-3919, U.S.

Ph. +1 415 553 3655

www.macyarchitecture

Matali Crasset Productions S.A.R.L.

488 Green Street

Cambridge, MA 02139, U.S.

Ph. +617 547 0128

www.kswa.com

Shuhei Endo Architect Institute

6F. 3-21, Suehiro-cho, kita-ku

Osaka 530-0053, Japan

Ph. +81 06 6312 7455

www.paramodern.com

Mohen Design International

Suite 2106, 600 Lu-Ban Road

Jiang Nan Bld., Shanghai, 200023 China

Ph. +021 6304950707

www.mohen-design.com

CENTRALA Designers Task Force

Jakub Szczesny

Ph. +48 602 316 374

www.centrala.net.pl

Peter Ebner & Franziska Ullmann Architects

Windmühlgasse 9/26

1060 Vienna, Austria

Ph. +43 58 68522

ebner-ullmann@aon.at

Fabrizio Miccò Architetto

Via C. Beltrami 15/a

00154 Rome, Italy

Ph. +39 06 97 84 08 35

f.micco@awn.it

Hiroaki Ohtani

4- 11- 4 Himoyamate-dori, Chuo-ku

Kobe 650-0011, Japan

ootan@nikken.co.jp

Filippo Bombace, Oficina de Arquitectura

1, Via Monte Tomatico

00141 Rome, Italy

Ph. +39 06 86 89 82 66

www.filippobombace.com

Atelier A5 Architecture and Planning

3-33-12 Daita Setagaya-ku

Tokyo 155-0033, Japan

Ph. +81 3 3419 3830

www.a-a5.com

Boyd Cody Architects

36 College Green

Dublin 2, Ireland

Ph. +353 1 6330042

www.boydcodyarch.com

OVN Arkitekter

Frode Jakobsens Plads4,3.sal

2720 Vanløse, Denmark

Ph. +45 32 960461

www.ovn.dk

West Architecture Ltd.

C/O The Manser Practice

Bridge Studios, London, W& 9DA, U.K.

Ph. +44 20 8741 4381

www.westarchitecture.co.uk

Strata Arkitektur

Kapellgränd 17

S – 116 25 Stockholm, Sweden

Ph. +46 8 714 90 95

www.strataarkitektur.se

Besonias Almeida Kruk Arquitectos

Buen Viaje 1011 – 1ro. B

Morón - (1708), Buenos Aires, Argentina

Ph. +5411 4489 5424

www.bakarquitectos.com.ar

Vladimír Balda

Na Jezírku 625

460 06 Liberec 6, Czech Republic

Ph.+420 777 620 261

www.balda.biz